Imaginary Relations

Aesthetics and Ideology in the Theory of
Historical Materialism

◆

MICHAEL SPRINKER

V

VERSO

The imprint of New Left Books

First published by Verso 1987
© Michael Sprinker 1987
All rights reserved.

Verso
UK: 6 Meard Street, London W1V 3HR
USA: 29 West 35th Street, New York, NY 10001 2291

Verso is the imprint of New Left Books.

British Library Cataloguing in Publication Data

Sprinker, Michael
 Imaginary relations: aesthetics and
 ideology in the theory of historical
 materialism.
 1. Historical materialism
 I. Title
 335.4'119 D16.9

Library of Congress Cataloging-in-Publication Data

Sprinker, Michael.
 Imaginary relations.

 Includes index.
 1. Communist aesthetics. 2. Historical
materialism. I. Title.
BH191.S67 187 700'.1 87-10629

ISBN 0-86091-168-3
ISBN 0-86091-879-3 (pbk.)

Printed by The Thetford Press, Norfolk, England

Ideology, then, is the expression of the relation between men and their 'world', that is, the (overdetermined) unity of the real relation and the imaginary relation between them and their real conditions of existence.

Louis Althusser, 'Marxism and Humanism'

In order for any political problem to be solved in reality, the way lies through the aesthetic...

Friedrich Schiller, *On the Aesthetic Education of Man*

Contents

Preface

The itinerary charted in this book turned out rather differently from what had been anticipated when it was orginally conceived several years ago. I expect this is a fairly common experience among authors, but in the present case the interest of the shift in terminology and concepts from portions of the earlier chapters to the later (in part attributable to their being written at widely separated periods), as well as in the trajectory which the project begins somewhat abruptly to follow after the sixth chapter, derives not only from its having been largely unforeseen, but also from its instancing much the same pattern which the book cites in the end as characteristic of aesthetic texts and empirical scientific inquiry alike. It is for others to decide whether the turn from a more or less straightforward critique of aesthetic ideology that is clearly in evidence in the opening chapters to a more accommodating position towards the aesthetic as a conceptual tool for materialist inquiry which emerges in the final chapters represents a plausible development in the argument of the entire book, or merely an antinomy on the order of Marx's notorious observations on Greek art posed at the outset.

Whatever else may be said about this aspect of *Imaginary Relations,* I should like to make it clear that on my reading the shift in focus and direction does not yet constitute an epistemological break with the problematic with which it opens. The questions that have traditionally vexed materialist aesthetics remain as much unresolved today as they were for Marx and Engels, and I have few illusions about having settled them unequivocally here. Georg Lukács once remarked that only with the disappearance of

capitalist social relations would the problem of the aesthetic be posed with full clarity and only then could an authentically materialist resolution be achieved. Setting aside the dubious historicism that underwrites Lukács's view, it would be in keeping with the drift of our argument to say that the social and political conditions of capitalist society have produced a spontaneous ideology of art inimical to materialist aesthetics. This book aims at no more than a preliminary clarification of terms and concepts and the creation of a theoretical space within which the problem can be rigorously interrogated.

Among the names and theories invoked throughout the text, none are more crucial to its argument than those of Paul de Man and Louis Althusser, the subjects of the two final essays. Since de Man's work is currently more familiar to (and more widely approved by) those who follow recent debates in literary theory and philosophy in the Anglophone world, no particular justification is required for invoking him repeatedly throughout the book. Althusser is another matter entirely. The eclipse of his authority both in France and in Britain has been widely remarked, even if the reasons for this development have not, to my mind, been adequately accounted for. The impact of Althusserianism in the United States has never been especially great, at least in philosophy and literary theory. If the present book has a single over-arching polemical purpose, it is to suggest the continuing importance of the project inaugurated by Althusser and his students to a broad range of inquiries in the human sciences, among which literary theory and aesthetics are surely to be numbered. To the extent that the current horizon of understanding in these disciplines is demarcated by the relationship between the aesthetic and the ideological, it can be said with justice that we remain determinately within the Althusserian problematic. Like Molière's ingenuous M. Jourdain, we have all been speaking the language of Althusserianism for some time without knowing it.

* * * * * * * * * *

Without wishing to preempt the reader's privilege in deciding where and how to enter this text, it may nevertheless be useful at the outset to project the structure of the chapters as they are presently organized. We have all come to be properly suspicious of an author's *post festum* thoughts about his work, in particular when these appear in the guise of a prefatory essay. My own

account of how *Imaginary Relations* is constructed constitutes but one story among many that might be told of it. Readers can judge for themselves whether it be convincing or not.

Opening with the dilemma posed by Marx in the Introduction to the *Grundrisse* concerning the relation between the historical determination and the permanent aesthetic value of Greek art, the text turns to a series of readings in bourgeois aesthetic theory: the concept of imagination in Ruskin; the ideology of art proposed in Henry James's preface to *The Golden Bowl;* the limits of aesthetic formalization in a poem by Gerard Manley Hopkins and in Nietzsche's *Birth of Tragedy.* In each case, the attempt to harmonize contradictory elements in a closed, unified totality which reflects a classical notion of poetic or aesthetic form fails to resolve the semantic, conceptual complications immanent in the structure of the artifacts themselves. The concept of the aesthetic that emerges from this highly selective survey of bourgeois writings on art thus proves more recalcitrant to definition and control than has often been assumed, both by Marxist critics of the supposed idealism inherent in bourgeois aesthetics and by bourgeois ideologues of art.

For Marxism, of course, the problem of art and its relation to ideology turns on the historicity of the artifact. In chapters 4 through 6, Marx's fragmentary ruminations over this question are extended via consideration of several contemporary attempts to square the circle of poetic structure and historical contingency. These chapters are unified by their focus on the comparatively narrow problem of literary history. The difficulties besetting this now almost moribund discipline are addressed differently in the work of Jauss and *Rezeptionsästhetik,* by the Prague School, and by Michael Riffaterre. What unites them, however, is a tendency towards teleological totalization in their concept of historical structure. What Jauss specifically calls the 'ongoing totalization of the past through aesthetic experience' is at work in the deepest strata of the theoretical projects of all these thinkers, in the attempts to reconstruct the bases of literary history in the later work of R.S. Crane (the subject of chapter 5), and, somewhat surprisingly, in recent efforts within historical materialism itself to rethink such axial notions as determination and totalization.

The burden of chapters 6 through 8 is to show how Marxism has by no means achieved a permanent epistemological rupture with the historicist problematic of bourgeois historical writing. Chapter 6 takes up the project of Fredric Jameson, while chapter 7 compares the differing concepts of history underwriting the work

of Sartre and Althusser. It is there for the first time in the present text that Althusser's significance for the theory of historical materialism emerges, although the exposition of his texts is in the first instance mainly defensive and polemical. The chapter attempts only to establish that the political objections often raised against Althusserian theory are misplaced, when they are not simply scurrilous, and that the break Althusser achieved with notions of teleology and historical totalization remains a more viable option for theorizing materialist political practice than the ultimately poetic concept of history developed in Sartre's *Critique*. Chapter 8 develops this same line of argument, defending Althusserianism against charges of unmitigated political betrayal during the 1970s, while arguing for the continuing relevance of Althusser's major innovations in Marxist theory (especially in the area of ideology) for the research program of historical materialism. The foil for these reflections is provided by Perry Anderson's most recent book, *In the Tracks of Historical Materialism*.

Chapter 9 would seem at first an inexplicable detour in our itinerary, since it intervenes between the polemical defense of Althusserianism, mounted in chapters 7 and 8, and the exposition of Althusser's scattered writings on art which brings the book to a close. How, one might legitimately ask, does Paul de Man's life-long meditation on language contribute to the project of a materialist aesthetics? The question itself is expressed in somewhat different form by the various opponents of deconstruction, for whom Terry Eagleton here stands as a typical instance. While Eagleton is quite right to point to the 'steady, silent anti-Marxist polemic running through de Man's work', he is certainly wrong to attribute to de Man a naively idealist conception of language and its functioning. Eagleton's own view of Walter Benjamin, for example, overlaps considerably with de Man's, while the latter's account of Rousseau's political theory is largely compatible with Althusser's exposition of the ideological operations that govern the march of the argument in the *Social Contract*. The limits of de Man's own insight into the parallel paths he and Althusser pursued ought not to prevent our recognizing that one of the principal vectors of deconstruction follows the path of what Marxism has traditionally identified as the theory of ideology. That the ideological features of literary and philosophical texts are manifested in their linguistic and conceptual structure will hardly come as a surprise to Marxists, but the 'quite specific relations', as Althusser would say, between art and ideology are often enough

occluded in the familiar forms of ideological critique which remain a staple of much Marxist literary criticism. De Man's inquiry into language and the structure of texts marks the horizon from which materialist aesthetics will perforce have to advance.

This is surely not the place, nor am I the proper person, to assess the outcome of the final chapter of *Imaginary Relations*. I have already suggested that the turn in this chapter towards a concept of the aesthetic as an empirical rather than a formal moment may itself simply be a return to the antinomy with which the book began. What can be stated with a certain degree of confidence is that the purview of the aesthetic as a category within historical materialism is considerably greater than has generally been supposed, extending beyond the relatively confined subject-matter of the fine arts to economic (and other) theory, thus to the very mechanisms of knowledge production itself. My own path to this conclusion has proceeded via Althusser's writings on art, but there would be other possible routes to follow.

While I am somewhat wary of projecting the future trajectory of my own work — indeed, to do so unequivocally would run counter to the drift of the argument developed in this book — two projects seem to me immediately to follow from the inquiry pursued in *Imaginary Relations*. First, the standard account of aesthetics as a region within the theory of historical materialism requires revaluation. One of the lessons I have been able to draw from the essays incorporated here is that the Marxist theory of art has for the most part not been extended beyond the horizon of classical aesthetic theory. The genealogy of Marx's own thought suggests that Kant, Schiller, and Baumgarten were as integrally important to the emergence of historical materialism as Hegel or Ricardo. Nor is it clear that Marx, however strenuously he labored to overcome the historicism and humanism of his youthful writings, achieved a definitive break in all the theoretical regions that fall within the continent of history. As Althusser has continually reminded us, no epistemological rupture is ever permanent, and this because ideology is so. The history of Marxist aesthetics should be subjected to the kind of 'symptomatic reading' Althusser devoted to the texts of Marx. Among its many silences, one is likely, I suspect, to hear the name of 'Kant' sounded fairly often.

A second line of inquiry follows from some of the remarks hazarded in the closing pages of this book. The epochal debate in Marxist literary criticism that raged during the 1920s and 1930s over realism and modernism remains as much alive in

6

contemporary theory and criticism as ever. The apparent shift in terrain to modernism versus postmodernism should not obscure the fact that the real agenda in both cases involves concepts of history and art linked to determinate forms of social existence and the relative value these latter have in relation to each other. My own sense is that the entire debate is at least partly misdirected in its premature valorization of certain aesthetic forms. The judgment of superiority (modernism over realism, or vice versa) is usually made prior to any careful exposition and analysis of the particular relations between the specific historical (i.e., primarily ideological) determinations that are manifested in individual texts and the aesthetic forms characteristic of the era. Generally absent from this type of historical criticism (for instance, from Lukács's several attacks on modernism as aesthetically and socially regressive) is an account of the contradictory position of modernist art in relation to the overall social project of the Euro-American bourgeoisie. It follows that one must chart with some precision the historical trajectory of the bourgeois social formations (themselves unevenly developed, as Marx and Engels were among the first to point out), at the same time that the artifacts of high modernism need to be mapped in their aesthetic and ideological effectivity against different moments in this trajectory. One place to begin is with the apparently contradictory phenomenon of the manifest hostility among the great bourgeois modernists from Flaubert to Proust, Henry James, Thomas Mann, and Faulkner towards most aspects of bourgeois society. If modernism is the art form of a conquering and confident bourgeoisie, it remains to be explained why many of its highest achievements (produced by writers who were for the most part themselves of bourgeois origins) represent scathing critiques of bourgeois forms of social life. The key to this historical investigation lies, I think, in the early Althusserian concept of overdetermination. It would be imprudent for me to speculate any further at present.

* * * * * * * * * *

The debts owed to numerous colleagues, friends, and even a few intellectual (I hope not personal) foes are too extensive to be acknowledged individually here. Most will be evident from the notes or, in some cases, in detailed engagements with previous work with which I have found it productive in pursuing my argument to disagree. There are, however, some institutional

obligations which need to be discharged, and I do so gladly by expressing my gratitude to the following organizations for their assistance: the Society for the Humanities at Cornell University; the National Endowment for the Humanities; the American Council of Learned Societies; the Center for the Humanities at Oregon State University; and the English department in the State University of New York at Stony Brook. Their generosity in supporting my work made completion of this book a pleasure, rather than a burden.

Earlier versions of chapters 1, 3, 4, 5, 6, and 7 appeared either wholly or in part in the following journals: *Studies in Romanticism; Comparative Literature; MLN; Kodikas; boundary 2;* and *diacritics.* I am grateful to the editors of these journals and to the Trustees of Boston University (publishers of *Studies in Romanticism)* for allowing me to reprint this material.

To the editors and other comrades at Verso and *New Left Review,* I owe more than they can possibly imagine. The meager recompense of the present book will hardly make up for all they have given me over the past three years. In particular, this book owes a signal debt to Gregory Elliott, whose patient, informed, and intelligent editing saved me from innumerable errors of fact and interpretation.

If I may be allowed to end on a somewhat personal note, with the promise that what follows will seem, if anything, all too detached for a book claiming alignment with the partisan traditions of historical materialism, it would be unconscionable to omit to thank my wife Kristyanne Beenfeldt for all that she has contributed to these pages. She will no doubt, with characteristic modesty, deny having done anything for this project. All of our friends know better, and so of course do I. Most pertinently, perhaps, her own career has been a constant chastening example to me to proceed more cautiously and circumspectly when talking about the matter of science.

Setauket, New York
August 1986

PART ONE

Aesthetics and Ideology

1
Mimesis and Allegory:
Imagination in Ruskin

The history of modern literary criticism is coeval with the inauguration of aesthetics as a systematic discipline and the hypostatization of the aesthetic as a distinct modality of cognition. For the sake of convenience, this moment can be located in Kant's grounding of aesthetic judgment in models of non-referentiality (the arabesque and music), and in Schiller's conception of the aesthetic as a supererogatory harmonizing of the cognitive faculties that transcends the conflicts which otherwise inhere in their ordinary, or non-aesthetic, operation.[1] The turn towards formalism, while it has been a recurrent feature of the history of literary theory since Aristotle, found a powerful new expression in the subjugation of theoretical poetics by aesthetics at the end of the 18th century. The attraction of the aesthetic, as the late Paul de Man once remarked, lies precisely in its universality, which is linked to its status as a mode of cognition: '[In the usual understanding of the concept], the *aesthetic* is not a separate category but a principle of articulation between various known faculties, activities, and modes of cognition. What gives the aesthetic its power and hence its practical, political impact, is its intimate link with knowledge, the epistemological implications that are always in play when the aesthetic appears over the horizon of discourse.'[2]

1. Immanuel Kant, *Kritik der Urteilskraft*, section 16; in English, *The Critique of Judgement*, trans. James Creed Meredith (Oxford, 1952), Part I, p. 72; Friedrich Schiller, *On the Aesthetic Education of Man*, trans. E.M. Wilkinson and L.A. Willoughby (Oxford, 1967), Twentieth Letter, pp. 140-3.
2. Paul de Man, 'Aesthetic Formalization: Kleist's *Über das Marionetten-*

The aesthetic offers to transcend the usual conditions that determine human activity and thus to position literature outside the domain of ideology and history. That this model of the aesthetic can itself be shown to have specific historical determinations (e.g., Schiller's writing the *Aesthetic Letters* in response to the French Revolution), and that it is in its own right a powerful ideology (as de Man correctly remarks), does nothing to diminish its claims to universality nor to disprove the assertion that the modality of aesthetic cognition transcends particular historical determinations. Schiller and his followers can plausibly claim that even though the aesthetic as a category was unknown to the ancients, they nevertheless did think and act aesthetically, at least at certain times. The aesthetic is a species-specific capacity, a potential that all human beings possess, even if some realize this potential more fully and more often than others.

The power of this model is nowhere more apparent than in the history of Marxist commentary on art, which from Marx and Engels down to Lukács and Marcuse has persistently maintained that authentic works of art transcend the ideological determinations of their moment of creation. The *locus classicus* for this view within Marxism is Marx's comments on Greek art at the end of the Introduction to the *Grundrisse*: 'But the difficulty lies not in understanding that the Greek arts and epic are bound up with certain forms of social development. The difficulty is that they still afford us artistic pleasure and that in a certain respect they count as a norm and as an unattainable model.'[3] Marx's solution to this dilemma follows the path laid down by Schiller and Goethe, positing the aesthetic as a capacity inherent in the human species although not always fully realized in every epoch:

> A man cannot become a child again, or he becomes childish. But does he not find joy in the child's naivete, and must he himself not strive to reproduce its truth at a higher stage? Does not the true character of each epoch come alive in the nature of its children? ... The Greeks were normal children. The charm of their art for us is not in contradiction to the undeveloped stage of society on which it grew. [It] is its result, rather, and is inextricably bound up, rather, with the fact that the unripe social conditions under which it arose, and could arise, can never return.[4]

theater', in idem, *The Rhetoric of Romanticism* (New York, 1984), pp. 264-5.

3. Karl Marx, *Grundrisse: Foundations of the Critique of Political Economy (Rough Draft)*, trans. Martin Nicolaus (Harmondsworth, 1973), p. 111.

4. Ibid. We must pass over the complex problems which this famous passage poses for interpretation here. It is taken up again throughout the following

Marx's pessimism about the fate of art in the modern world has, *mutatis mutandis,* been shared by many Marxists since. At the same time, the aesthetic has remained a privileged means of access to that mode of existence which, *ex hypothesi,* mankind will one day attain when the realm of necessity has been transformed into the realm of freedom. As Terry Eagleton tersely puts it: 'Men do not live by culture alone: far from it. But the claim of historical materialism is that, in effect, they will.'[5] Classical Marxism shares with bourgeois aesthetics the conviction that in art one attains freedom, and that this freedom consists, among other things, in the liberation from ideological determination and historical contingency.

It could be shown, I believe, that the category of the aesthetic is intimately involved in the Marxist theory of history at every moment of its development, not only in those obvious places in the early writings of Marx himself where the Feuerbachian notion of species-being appears to dominate the concepts of labor and value, but also in such mature texts as *Theories of Surplus Value* and *Capital* where, arguably, Marx's 'humanism' no longer controls the conceptual structure of the theory. Following this line of argument, one would have to revise slightly Perry Anderson's hypothesis that among the distinctive features dividing so-called Western Marxism from the classical tradition is the former's emphasis on philosophy and aesthetics in comparison to the latter's focus on politics and economy.[6] According to the

chapters, and a way of resolving the antinomy it presents for materialist theory is suggested in chapter 10.

5. Terry Eagleton, *Criticism and Ideology* (London, 1976), p. 187. Maynard Solomon's less succinct commentary illustrates the full force of aesthetic ideology within Marxist philosophy: 'Art is itself (like Marxism) a strategy of demystification, a withdrawal from the negative reality of an alienated class society into a different order of reality which common sense deems illusion but which is actually the symbolic precipitate of the materialist-sensuous substructure of human relations and desires. Art is a distinct form of the labor process in which — amid the myriad effusions and narcotic productions of class culture — is kept alive the materialized imagery of man's hope and of that very same human essence which Marxism seeks to reveal. Marxism, having supplied the theoretical means of analyzing the historically shaped contradictions which give rise to art, has the greater task of preserving and liberating the congealed symbols of beauty and freedom which live on within the masterworks of art' (*Marxism and Art: Essays Classic and Contemporary*, selected and with a historical and critical commentary by Maynard Solomon [New York, 1973], p. 20). The relevant text on the transformation from the realm of necessity to the realm of freedom can be found in Marx, *Capital*, vol.III, trans. David Fernbach (Harmondsworth, 1981), pp. 958-9.

6. Perry Anderson, *Considerations on Western Marxism* (London, 1976), pp. 49, 75-8.

hypothesis advanced here, the aesthetic has played a central role in Marxist theoretical work from its inception, whether the explicit object of attention is the special domain of art or the more general question of the nature and structure of human societies. One need not conclude from this, as do various post-Marxists, that Marxism itself is merely an outmoded historical ideology, but one is forced to confront the possibility that Marxist theory, insofar as it continues to make claims for epistemological generality, must necessarily pass through the aesthetic at crucial moments. The tension between the aesthetic as a model of transcendental cognitive power and the aesthetic as a historical and ideological social practice remains a constitutive and productive feature of Marxist theory down to the present moment.

One slightly tendentious way of posing the problem of Marxism's relation to aesthetics is to say that Marxist theory (and *a fortiori* Marxist aesthetics) continues to be contaminated by the categories it inherited from bourgeois thought. Thus Terry Eagleton, in commenting on a famous passage in Althusser, observes: 'Althusser and Macherey appear to want to *rescue* and *redeem* the text from the shame of the sheerly ideological; yet in these passages they can do so only by resorting to a nebulously figurative language ("allude", "see", "retreat") which lends a merely rhetorical quality to the distinction between "internal distantiation" and received notions of art's "transcendence" of ideology. It is as though the aesthetic must still be granted mysteriously privileged status, but now in embarrassedly oblique style.'[7] Without endorsing completely Eagleton's reading of Althusser here, the force of his claim supports our thesis and at the same time suggests a way of coming at the problem of Marxist theory that can productively engage its relation to bourgeois thought without simply condemning this latter to the ash heap of history. The thrust of the polemic against Althusser — that he simply recovers the idealist concept of art in bourgeois aesthetics — echoes a charge that has been levelled at aesthetic theory from Schiller, Goethe, and the German Romantics down to Anglo-American New Criticism. The problem of the aesthetic, while it poses special difficulties for historical materialism, remains equally recalcitrant for thinkers outside the ambit of Marxism. It is far from certain that the ideological image of art familiar in the idealist tradition from Kant and Fichte through Nietzsche,

7. Eagleton, *Criticism and Ideology*, p. 84.

Heidegger, and the early Sartre is any more resolute in avoiding the seemingly irreducible conflict between material determination and transcendental significance that is readily apparent in Marx's observations on Greek art. What is often dismissively termed 'bourgeois aesthetics' may well contain the key to a properly materialist theory of art, albeit in a form that has most often led to understandable confusions. In the pages that follow, if we are not exactly intent upon standing bourgeois aesthetics on its head, we will nonetheless strive to discover some portion of the rational kernel inside the mystical shell of the bourgeois theory of art. What may initially appear as a needless detour will, one hopes, prove a fruitful path to have pursued. The dependence of Marx's own theoretical project upon the prior development of classical political economy is well known. If we may somewhat presumptuously invoke his example, it would be to suggest the necessity for passing through the problematic of bourgeois aesthetics in order one day to break with it definitively. There is, after all, no royal road to the materialist science of art.

* * * * * * * * * *

The deeply-rooted conceptual difficulties that inhabit Romantic aesthetics are perhaps nowhere more openly in evidence than in the work of John Ruskin. Ruskin's own understanding of his relation to Romanticism, apparent in his ambivalence towards, among others, Wordsworth, Byron and Walter Scott, and clearly focused in his equal veneration of the classical landscapes in Homer's poetry alongside the exuberant seascapes in Turner's paintings, reveals a paradigmatic tension in his aesthetic theory which no amount of exegetical homogenization can entirely remove. This tension, which is often framed in ethical or (less frequently) political terms, can also, and with greater powers of generality, be understood as epistemological. In brief, it concerns the relation between subject and object, mind and nature, the self and the physical or natural world.

In modern scholarship and commentary on Romanticism, it has generally been assumed that the distinctive project of the Romantics was to recover for the human spirit its natural bond with the physical world which a sensationalist empiricism had seemed to shatter. M. H. Abrams's remarks on Wordsworth are representative: 'This experience of the one life within us and abroad cancels the division between animate and inanimate, between subject and object — ultimately, even between object and

object.'[8] The experience, however, is neither a direct perception of the realia of the physical universe, nor an intuition of the sensory unity of the manifold: Romantic aesthetics is neither a naive realism nor a phenomenology. Rather, the unifying experience that links mind to nature depends on a powerful analogy: 'The key event in this development was the replacement of a metaphor of the poem as imitation, a "mirror of nature", by that of the poem as heterocosm, a "second nature", created by the poet in an act analogous to God's creation of the world.'[9] Understood thus, Romantic aesthetics proposes less a solution to the epistemological problem that generated it than a displacement of the problem from epistemology to ontology. Paul de Man's commentary on this view is acute: 'The relationship with nature has been superseded by an intersubjective, interpersonal relationship that, in the last analysis, is a relationship of the subject toward itself. Thus the priority has passed from the outside world entirely within the subject, and we end up with something that resembles a radical idealism.'[10] This has been the canonical view of the Romantics from Goethe onwards, summarized in Arnold's terse judgment on the poetry of the 19th century: 'the dialogue of the mind with itself has commenced.'[11] Ruskin's accusation against Wordsworth, Keats, and Tennyson, that their poetry exhibits the 'pathetic fallacy', belongs to this tradition as well.

Ruskin's intuition about the radical idealism of 19th-century poetry and his recommendation to contemporary artists to recover 'innocence of the eye' generated his project to overcome the impasse of Romantic aesthetics. But it is far from certain that his own aesthetic theory escapes from the conceptual problematic which it criticizes. For example, writing to the Rev. W. L. Brown on September 28, 1847, more than a year after the publication of

8. M.H. Abrams, *The Mirror and the Lamp: Romantic Theory and the Critical Tradition* (New York, 1953), p. 66. Similar views are propsed in W.K. Wimsatt, 'The Structure of Romantic Nature Imagery', in W.K. Wimsatt and Monroe Beardsley, *The Verbal Icon: Studies in the Meaning of Poetry* (Lexington, 1954), pp. 103-16; Robert Langbaum, *The Poetry of Experience: The Dramatic Monologue in Modern Literary Tradition* (1957; rpt. New York, 1963), pp. 38-74; and Earl Wasserman, 'The English Romantics: The Grounds of Knowledge', *Essays in Romanticism* 4 (1964).

9. Abrams, *The Mirror and the Lamp*, p. 272.

10. Paul de Man, 'The Rhetoric of Temporality', in *Interpretation: Theory and Practice*, ed. Charles S. Singleton; rpt. in de Man, *Blindness and Insight: Essays in the Rhetoric of Contemporary Criticism*, rev. edn. (Minneapolis, 1983), p. 196.

11. *The Complete Prose Works of Matthew Arnold*, ed. R.H. Super, 10 vols. (Ann Arbor, 1960-74), I:1.

Modern Painters ii, Ruskin offered the following illustration of the distinction between what he had called the 'theoretic faculty' and the 'imaginative faculty':

> There was a time when the sight of a steep hill covered with pines, cutting against the sky, would have touched me with an emotion inexpressible, which, in the endeavour to communicate in its truth and intensity, I must have sought for all kinds of far-off, wild, and dreamy images. Now I can look at such a slope with coolness, and observation of *fact*. I see that it slopes at 20⁰ or 25⁰; I know the pines are spruce fir — 'Pinus nigra' — of such and such an age; that the rocks are slate of such and such a formation; the soil, thus, and thus; the day fine, and the sky blue. All this I can at once communicate in so many words, and this is all which is necessarily seen. But it is not all the truth; there is something else to be seen there, which I cannot see but in a certain condition of mind, nor can I make any one else see it, but by putting him into that condition, and my endeavour in description would be, not to detail the facts of the scene, but by any means whatsoever to put my hearer's mind into the same *ferment* as my mind. (Ruskin's emphasis)[12]

By the 'theoretic faculty' Ruskin seems to mean approximately the descriptive concepts of empirical science, which adequately represent the sensory impressions of the physical world: 'this is all which is necessarily seen.' But this phenomenal level of experience does not exhaust its reality in Ruskin's view.

A second faculty, which Ruskin terms the 'imaginative', goes deeper or further than sense data to discover the full 'truth' about the physical world.[13] This truth about things, based on perception but not limited to empirical observation, is aesthetic, and it is specifically opposed to the factual descriptions given in scientific naturalism, as in the following passage from *Modern Painters* iii:

> We cannot fathom the mystery of a single flower, nor is it intended that we should; but that the pursuit of science should constantly be stayed by the love of beauty, and accuracy of knowledge by tenderness of emotion.
>
> Nor is it even just to speak of the love of beauty as in all respects

12. *The Works of John Ruskin*, ed. E.T. Cook and Alexander Wedderburn, Library Edition, 39 vols. (London, 1903-12), XXXVI:80; hereafter cited parenthetically by volume and page number.

13. Cf. Richard Stein: '[Ruskin's] antipathy to materialism can never be stated strongly enough ... Ruskin's scientific writing is invariably conservative. It sets out to restore the spiritual element to modern naturalistic research' ('Milk, Mud, and Mountain Cottages: Ruskin's Poetry of Architecture', *PMLA* 100 [May 1985]: 339.)

unscientific; for there is a science of the aspects of things, as well as of their nature; and it is as much a fact to be noted in their constitution, that they produce such and such an effect upon the eye or heart ... as that they are made up of certain atoms or vibrations of matter. (v:387)

The tension in Ruskin's aesthetics between a more or less traditional sensationalism (the effect of objects upon the eye) and a more radical idealism (their effect upon the heart) is readily apparent here. The question that the passage raises, without answering, is the extent to which the affective response of imagination to phenomena is determined by the latter's perceptible properties. If, to cite Hegel, the aesthetic is the 'sensory manifestation of the idea', does imagination, on a Ruskinian view, simply activate the aesthetic potential inherent in all things, or is imagination an autonomous faculty whose affective power derives from an arbitrary signifying potential within the mind? To begin to answer this question, we turn to Ruskin's most extended treatment of the topic in the second and third volumes of *Modern Painters*.[14]

The apparent contradictions or at least ambivalence in Ruskin's key conceptual formulations has sometimes been attributed to his remark that all 'useful truths' are 'eminently biped' (v:169).[15] But

14. Much modern commentary on Ruskin's theories of art and beauty has been inattentive to the full complexity of his concept of imagination. For example, even so acute a commentator as E.H. Gombrich errs when he characterizes *Modern Painters* as 'perhaps the last and most persuasive book in the tradition that starts with Pliny and Vasari in which the history of art is interpreted as progress toward visual truth ... For Ruskin and those who followed him, the painter's aim was to be to return to the unadulterated truth of natural optics' (*Art and Illusion: A Study in the Psychology of Pictorial Representation* [New York, 1960], p. 14). For other comparable views of Ruskin's aesthetics, see: Patricia M. Ball, *The Science of Aspects: The Changing Role of Fact in the Works of Coleridge, Ruskin, and Hopkins* (London, 1971); Edward Alexander, 'Ruskin and Science', *MLR* 64 (1969): 508-21; Van Akin Burd, 'Ruskin's Quest for a Theory of Imagination', *MLQ* 17 (1956): 60-72; and John Rosenberg, *The Darkening Glass: A Portrait of Ruskin's Genius* (New York, 1961), pp. 13-21. An entirely different view would follow from Wlad Godzich's citation of Ruskin in the former's foreword to Paul de Man, *The Resistance to Theory* (Minneapolis, 1986), p. xiv. Godzich claims that the traditional opposition between the concepts of theory and *praxis* conceals a more fundamental dichotomy of theory to *aesthesis*. The source for this view is given as *Modern Painters* ii.

15. This remark is the key trope in Jay Fellows's exposition of Ruskin's epistemology, *The Failing Distance: The Autobiographical Impulse in John Ruskin* (Baltimore, 1975), p. 5 and passim. Fellows's argument establishes two incompatible tendencies in Ruskin's writing: the commitment to 'biped truth' is opposed by what Fellows calls 'the autobiographical impulse', which latter seeks to collapse landscape or the external world into the self. This is what we have been calling the radical idealist pole in Romantic aesthetics, a concept of imagination

the morphological model that would seem to be the basis for this metaphor does not resolve the potential contradiction between, say, the following two passages, which occur within forty pages of each other in *Modern Painters* ii: 'whatever portions of a picture are taken honestly and without alteration from nature, have, so far as they go, the look of imagination, because all that nature does is imaginative' (IV:242); 'the power of every picture depends on the penetration of the imagination into the TRUE nature of the thing represented, and on the utter scorn of the imagination for all shackles and fetters of mere external fact that stand in the way of its suggestiveness' (IV:278). In the first passage, imagination is strictly mimetic, and necessarily so, since the imaginative qualities of a picture are already inherent in the objects represented. In the second passage, imagination 'penetrates' beneath the phenomenal manifestation of things, searching for a truth that is inaccessible to observation, the 'shackles and fetters of mere external fact'. That which is represented in a picture is no longer a copy of the natural object but a phantasm of its figural structure. This second theory of imagination as non-mimetic should be taken for the radical assertion it is, and thus its incompatibility with the first model cannot be missed.

This tension between two models of the imagination is disseminated throughout *Modern Painters* ii and iii. On the one hand, it is asserted that the imagination mimetically reproduces the natural appearance of things: 'if anything looks unnatural, there can be no imagination in it (at least not associative)' (IV:247); 'and the whole power, whether of painter or poet, to describe rightly what we call an ideal thing, depends upon its being thus, to him, not an ideal, but a *real* thing' (V:114); 'We now enter on the consideration of that central and highest branch of ideal art which concerns itself simply with things as they ARE, and accepts, in all of them, alike the evil and the good' (V:111). The greatest poets and painters replicate what they see; representation of the true nature of things is directly correlated to accurate perception; the agency of artistic imagination operates as a passive reflector: 'The whole of [the artist's] power depends upon his losing sight and feeling of

which asserts the autonomy of this faculty from simple perception. Fellows reads Ruskin's autobiography *Praeterita* as, paradoxically, a triumph over the autobiographical impulse itself. *Praeterita*'s textualization of the self produces an authentically distanced figure whose displacement from the autobiographer is temporal rather than spatial (pp. 177-87). A comparable reading of *Praeterita* is presented in Elizabeth K. Helsinger, 'Ruskin and the Poets: Alterations in Autobiography', *MP* 74 (1976): 142-70.

his own existence, and becoming a mere witness and mirror of truth, and a scribe of visions, — always passive in sight, passive in utterance ... ' (V:125).[16] But in these same texts, and sometimes in close proximity to passages which assert a mimetic concept of imagination, Ruskin proposes another model which directly contradicts the mimetic. This second model seems at times to be straightforwardly phenomenological: 'the act of imagination ... is not the selection of [an] image, but the mode of regarding the object' (IV:227). But in expanding upon this model in a figurative description of imaginative perception and representation, Ruskin pushes the concept of imagination beyond any simple phenomenalism of the sign:

> The imagination will banish all that is extraneous; it will seize out of the many threads of different feeling which nature has suffered to become entangled, one only; and where that seems thin and likely to break, it will spin it stouter, and in doing this, it never knots, but weaves in the new thread; so that all its work looks as pure and true as nature itself, and cannot be guessed from it but by its exceeding simplicity. (IV:246)

The metaphor of weaving is, of course, canonical, possessing famous textual warrant in Goethe's image of the red thread in *Die Wahlverwandtschaften.* But the figure here is complicated by the introduction of new material into the structure of the design. The more stoutly spun thread, originally extracted from the tapestry of nature, reappears as 'new thread'. While the appearance of the now imaginatively reconstituted fabric is all but indistinguishable from nature's original, the materiality of the figure has been altered; the phenomenal stability of the sign conceals a disjunction between nature and art on the level of the materiality of the signifier.

From this privileging of phenomenality over materiality, it is but a short step to a thoroughly idealist concept of the imagination. Thus Ruskin in *Modern Painters* iii:

> The power, therefore, of thus fully *perceiving* any natural object depends on our being able to group and fasten all our fancies about it as a centre, making a garland of thoughts for it, in which each separate

16. The same metaphor (producing a similar ethical charge) is employed in *Modern Painters* IV: 'in [the imagination's] work, the vanity and individualism of the man himself are crushed, and he becomes a mere instrument or mirror, used by a higher power for the reflection to others of a truth which no effort of his could ever have ascertained ...' (VI:44).

thought is subdued and shortened of its own strength, in order to fit it
for harmony with others; the intensity of our enjoyment of the object
depending, first, on its own beauty, and then on the richness of the
garland. (V:359)

Full perception begins with sense data, but it culminates in
imaginative restructuring. The mimetic naturalism of 'innocence
of the eye' often attributed to Ruskin does not survive a thorough
inspection of the function of the imagination in his aesthetic
theory.

When we pass from the visual model of imaginative perception
to the more properly linguistic model on which such a theory
depends, the full implication of Ruskin's anti-mimetic concept of
imagination is more readily grasped. The passage from
phenomenalism to an authentically figural model is already
implicit in *Modern Painters* ii:

> Hence there is in every word set down by the imaginative mind an
> awful under-current of meaning, and evidence and shadow upon it of
> the deep places out of which it has come. It is often obscure, often half-
> told; for he who wrote it, in his clear seeing of the things beneath, may
> have been impatient of detailed interpretation: but, if we choose to
> dwell upon it and trace it, it will lead us always securely back to that
> metropolis of the soul's dominion from which we may follow out all
> the ways and tracks to its farthest coasts. (IV:252)

The presence of a perceptual figure (the 'clear seeing of the things
beneath' attributed to the imaginative mind) should not blind us to
the fact that what is represented in language is no longer grounded
in the realm of the perceptible. The surface/depth model here
employed to describe the relation between language and its
ultimate referential dimension is not a happy one, since it can
readily be accommodated to a classical phenomenalism of the sign
and a realist theory of representation. That Ruskin's concept of
the imagination is not constrained in this way can be shown by
considering his discussion of the grotesque, a key category in his
aesthetics (especially in *The Stones of Venice* and the later volumes
of *Modern Painters*), and a complementary concept to the theory
of imagination we have been considering.

Ruskin's most concise definition of the grotesque comes in
Modern Painters iii:

> A fine grotesque is the expression, in a moment by a series of symbols
> thrown together in bold and fearless connection, of truths which it

would have taken a long time to express in any verbal way, and of which the connection is left for the beholder to work out for himself; the gaps, left or overleaped by the haste of the imagination, forming the grotesque character. (V:132)

In other works, Ruskin attributes the grotesque to 'ungovern-ableness of imagination', praising just this quality as characteristic of 'the noblest forms of imaginative power', which 'have in them something of the character of dreams' (XI:178). The grotesque is defined by its distortion of natural forms, a feature that distinguishes it from its opposite in the Ruskinian aesthetic vocabulary, the sublime: 'Now, so far as the truth is seen by the imagination in its wholeness and quietness, the vision is sublime; but so far as it is narrowed and broken by the inconsistencies of the human capacity, it becomes grotesque; and it would seem to be rare that any very exalted truth should be impressed on the imagination without some grotesqueness' (XI:181).[17]

17. The standard English work of historical scholarship on the sublime remains Samuel H. Monk's *The Sublime: A Study of Critical Theories in Eighteenth-Century England* (1935; rpt. Ann Arbor, 1960). In his treatment of the transition between 18th and 19th-century aesthetics, Monk contends that the sublime, hypostatized in Burke's *Enquiry*, became the rock on which neo-classical aesthetics broke, introducing into critical terminology a category of aesthetic value dependent upon subjective, emotional experience rather than on the rules that dominated neo-classical theory from the time of Boileau. This was also Schiller's view of Burke: see *On the Aesthetic Education of Man*, Fifteenth Letter, pp. 102-3. George Landow, arguing from the subjective/objective polarity outlined by Monk, says that Ruskin marks a regression, in certain ways, to pre-Burkean aesthetic theory. Landow contends that Ruskin's attempt in *Modern Painters* i to reconcile subjective and objective aesthetic experiences failed, and that *Modern Painters* ii constitutes a return to the traditional 18th-century distinction between the sublime and the beautiful. Ruskin retained the former concept in his aesthetic vocabulary to designate an emotive, subjective kind of aesthetic experience; the beautiful was reserved as the category for truly objective aesthetic experience (*The Aesthetic and Critical Theories of John Ruskin* [Princeton, 1971], pp. 183-221). Thus beauty and the grotesque are not opposed in Ruskin's system.

A recent work in the Burkean/Longinean tradition is Thomas Weiskel's *The Romantic Sublime: Studies in the Structure and Psychology of Transcendence* (Baltimore, 1976), which characterizes the 'true function of the sublime' as a means 'to legitimate the necessary discontinuities in the classical scheme of signification' (p. 17). The Romantic sublime is thus a solution to the epistemological problem of the mind's relation to nature. The productive aspect of Weiskel's theorization of the sublime involves his distinction between what is termed, following Jakobson's famous division of language into two characteristic functions, the metaphorical or reader's sublime, and the metonymical or poet's sublime. The former expresses an excess of the signifier; the latter an excess of signifieds. In Ruskin's terminology, the metaphorical sublime corresponds to pathetic fallacy, while the metonymical sublime would be allegory. Despite the resort to linguistic terminology to name

In accounting for this epistemological condition, Ruskin characteristically appeals to theological doctrine, while continuing on a thematic level the aesthetic problematic which is his principal concern here:

> Most men's minds are dim mirrors, in which all truth is seen, as St. Paul tells us, darkly; this is the fault most common and most fatal; dullness of the heart and mistiness of sight, increasing to utter hardness and blindness; Satan breathing upon the glass, so that if we do not sweep the mist laboriously away, it will take no image. But, even so far as we are able to do this, we have still the distortion to fear, yet not to the same extent, for we can in some sort allow for the distortion of an image, if only we can see it clearly. (XI:180-1)

If the moral difficulties that plague human understanding and representation can be overcome, this does not eliminate the epistemological liability. The latter remains, the theologically orthodox Ruskin avers, as a consequence of the Fall. For Ruskin, the aesthetics of the grotesque signify both a moral and a cognitive limitation, at the same time that they connote the imaginative ambition of the artist, grasping for a deeper truth than can be represented in natural forms. As he writes elsewhere, 'noble grotesque' manifests a 'delightfulness ... which belongs to the effort of the mind to unweave the riddle, or to the sense it has of there being an infinite power and meaning in the thing seen, beyond all that is apparent therein, giving the highest sublimity even to the most trivial object so presented and so contemplated' (V:133).

The grotesque denotes the imagination's attempt to mediate between the sacred and the profane: 'And thus in all ages and among all nations, grotesque idealism has been the element through which the most appalling and eventful truth has been wisely conveyed, from the most sublime words of true Revelation, to ... the more or less doubtful teaching of dreams; and so down to ordinary poetry. No element of imagination has a wider range, a more magnificent use, or so colossal a grasp of sacred truth' (V:134).

The grotesque, we might say, instances the more general aesthetic tendency of imagination to disrupt the relation between signifier and signified. The latter's range is always in excess of the former's representational power. In grotesque art, there is no continuity between signifier and signified on the phenomenal level

both types of sublime experience, only the latter is a properly linguistic function; the former is an aesthetic mode grounded in perception.

of the sign. Still, the resilience of a perceptual model in Ruskin's aesthetic vocabulary maintains the hope that signification is not simply uncontrollable, even in the figures of the grotesque: 'we can only see [spiritual truth] as flies or serpents or birds see men; they not understanding much about us, and never seeing us wholly or rightly but seeing what facets of their eyes permit them to see, and conceiving as their several minds enable them to conceive' (XXII:526). The conception of grotesque art as distorted perception carries the promise, however flimsy, of correction (presumably moral) and potentially accurate representation and understanding. It is on the basis of such hope that Ruskin can distinguish good, truthful art from bad, false art, Turner from Claude, Dante from Tennyson.

This promise, however, remains subject to considerable suspicion. Ruskin's championing of Turner was a moral crusade that largely failed, at least during Ruskin's own lifetime. By postulating an irreducible heterogeneity between signifier and signified in the grotesque, which becomes, then, a general figure for all imaginative representation, Ruskin opens the floodgates of potentially uncontrollable signification, a truly unlimited semiosis of a kind Peirce scarcely dreamed. Ruskin's characterization of the grotesque gone wild is framed in a predictable moral judgment. While 'noble grotesque' is always a sign of mental health, there yet lurks the possibility that the 'reinless play of imagination' can turn into 'evil grotesque': 'there is ... a strange connection between the reinless play of imagination, and a sense of the presence of evil, which is usually more or less developed in those creations of the imagination to which we properly attach the word *Grotesque*' (V:103). Later in the same text, Ruskin remarks that '[the imagination's] ambition is insatiable', and that 'this avarice of the imagination increases with the stimulus; and the more it obtains, the more it conceives it possible to obtain; and it may be pushed at last into morbid hunger, in which it has nearly lost its own inherent power, but continually craves an increase of external excitement — and at last dies of pure repletion' (V:436).

The need to subdue the epistemological aberrancy of the imagination by moral fiat can become so urgent that Ruskin will anthropomorphise the imagination, transforming it from a mental faculty, a signifying potential of human cognition, into a fully conscious and responsible moral agent, capable of, among other things, deceiving or telling the truth:

For it might be at first thought that the whole kingdom of imagination

was one of deception also. Not so: the action of the imagination is a voluntary summoning of the conceptions of things absent or impossible; and the pleasure and nobility of the imagination partly consist in its knowledge and contemplation of them as such, i.e. in the knowledge of their actual absence or impossibility at the moment of their apparent presence or reality. When the imagination deceives, it becomes madness. It is a noble faculty so long as it confesses its own ideality; when it ceases to confess this, it is insanity. All the difference lies in the fact of the confession, in there being *no* deception. It is necessary to our rank as spiritual creatures, that we should be able to invent and behold what is not; and to our rank as moral creatures, that we should know and confess at the same time that it is not. (VIII:58)

The personification of an abstraction which this passage instances marks the transition from an ostensibly theoretical discourse to a moral one. We might say that the text here allegorizes the imagination, figuralizing the concept in a manner characteristic of allegorical paintings or narratives. But allegory itself is subject to theoretical description, and nowhere more perspicaciously than in Ruskin.

One of the earliest definitions of allegory in the Ruskin canon comes in the following description of 'imagination contemplative' in *Modern Painters* ii:

[D]epriving the subject of material and bodily shape, and regarding such of its qualities only as it chooses for particular purpose, it forges these qualities together in such groups and forms as it desires, and gives to their abstract being consistency and reality, by striking them as it were with the die of an image belonging to other matter, which stroke having once received, they pass current at once in the peculiar conjunction and for the peculiar value desired. (VI:291)

The process delineated here is the production of the allegorical sign, which 'deprives the subject [i.e., the phenomenal object of perception] of material and bodily shape' and imparts a value to the thing represented by giving it 'an image belonging to other matter'. The decisive aspect in allegory is the disjunction between the phenomenal appearance of the sign and the value which the sign possesses. The relation between the sensory features of the sign and its meaning is arbitrary; the aesthetic value of an allegorical sign cannot be generated by reference to the natural object that the image of the sign resembles.

The most extensive treatment of Ruskin's conception of allegory is George Landow's *The Aesthetic and Critical Theories of John Ruskin*. Landow argues that Ruskin's early religious training

familiarized him with the tradition of typological readings of scripture, and that this mode of reading underpins Ruskin's allegorical interpretations of Turner, Veronese, Tintoretto, and Dürer. On Landow's account, typology 'emphasizes the reality and the importance of the literal', and this literalism recurs in Ruskin's seemingly anachronistic view of allegorical representation: 'Unlike most nineteenth-century critics, including Arnold, who believe that once the meanings of allegory make themselves clear the narrative tends to disappear like a useless husk, Ruskin places essentially equal emphasis upon both signifier and signified.'[18] This conception of allegory as a stable and hierarchically organized system of signification (a generalization of Quintilian's definition of allegory as a single metaphor sustained over an extended and continuous series — see the *Institutes* 8.6:14-15), while it does justice to that tendency in Ruskin's aesthetics we have called mimetic, occludes the equally powerful account of non-phenomenal signification which has been our focus over the preceding pages. Moreover, it leads Landow to claim for allegory a dubious conception of language and signification:

> Allegory and allegorical representation both depend upon and implicitly create a Realistic view of language, a view which since the late seventeenth century has become increasingly difficult to accept. As long as men assumed that language had corresponded to, or participated in essences, allegorical art and an allegorical reading of scripture were possible and perhaps inevitable. But after Hobbes and Locke referred language not to metaphysics but to psychology, a Realistic conception of language which provides the basis for allegory became largely untenable.[19]

On Landow's view, allegory becomes impossible once the natural link between signs and things is broken. At best, Ruskin's faith in the power of words to represent things is anachronistic; at worst, it is naive. Landow himself does not avoid contradiction on this point, for earlier in his study he had remarked: 'According to Ruskin, then, the greatest painting, like the greatest verse — both of which deserve the title "poetry" — reproduce[s] the artist's impression of fact rather than the fact itself. In other words, art concerns itself with man and his human, phenomenological relations to the world.'[20] To concede this much is already to have

18. Landow, *The Aesthetic and Critical Theories of John Ruskin*, pp. 369, 351.
19. Ibid., pp. 352-3.
20. Ibid., p. 63.

opened up the field of signification and representation beyond the naive realism or naturalism that Landow will later assert characterizes all allegories. Moreover, this view cannot be squared with the altogether praiseworthy epistemological rigour (nor with the understandable ethical concern) of Ruskin himself when he discusses imaginative representation. The modern commentary imposes a pleasing aesthetic unity on Ruskin's texts that they resist both at the level of theory and in their textual performance.

The deficiency in Landow's characterization of allegory is typical of post-Romantic discussions of the concept. As Paul de Man suggests, the confusion over the true nature of allegory can be traced to late 18th-century attempts to discriminate rigorously between the terms 'symbol' and 'allegory' and to privilege the former aesthetic mode over the latter. But Romantic theory, at least in its explicit valorization of symbol over allegory, did not generally reflect the poetic practice of the major Romantics. Theoretical polemics aside, the major poetry of the Romantics tended to be allegorical rather than symbolic, according to a conception of allegory (which was the Romantics' own) that denies any necessary or natural relationship between a sign and its referent, between word and thing:

> Whether it occurs in the form of an ethical conflict, as in *La Nouvelle Héloise,* or as an allegorization of the geographical site, as in Wordsworth, the prevalence of allegory always corresponds to the unveiling of an authentically temporal destiny. This unveiling takes place in a subject that has sought refuge against the impact of time in a natural world to which, in truth, it bears no resemblance ... The relationship between the allegorical sign and its meaning *(signifié)* is not decreed by dogma ... We have, instead, a relationship between signs in which the reference to their respective meanings has become of secondary importance. But this relationship between signs necessarily contains a constitutive temporal element; it remains necessary, if there is to be allegory, that the allegorical sign refer to another sign that precedes it. The meaning constituted by the allegorical sign can then consist only in the *repetition* (in the Kierkegaardian sense of the term) of a previous sign with which it can never coincide, since it is of the essence of this previous sign to be pure anteriority. (de Man's emphasis)[21]

De Man's conceptualization of allegory as a repetition of signs in a structure of temporal difference substantially clarifies Ruskin's description of the imagination acting upon the forms of nature by

21. 'The Rhetoric of Temporality', pp. 206-7.

stamping them 'with the die of an image belonging to other matter' (VI:291). The meaning of the allegorical sign is not determined or dictated by reference to the natural object it resembles, however vaguely. Signifier and signified have been sundered by the imagination's objective homelessness in the natural world (recall Ruskin's lament to the Rev. Brown about the difference between seeing and knowing); a purported natural bond between signifier and signified (word and thing) has been replaced by the figural relationship of one sign to another. Allegory does not, as Landow claims, bind man to nature, but frankly attests to the distance separating the figural from the natural or the phenomenal. It is only in light of this conception of allegory that one can comprehend Ruskin's comparatively unorthodox (for the 19th century) privileging of allegory over symbolism. The symbol, in the commonplace usage of the term in Romantic aesthetic theory, posits the homogeneity of mind and nature. Once again, de Man's commentary is helpful: 'Whereas the symbol postulates the possibility of an identity or identification, allegory designates primarily a distance in relation to its own origin, and renouncing the nostalgia and the desire to coincide, it establishes its language in the void of this temporal difference. In so doing, it prevents the self from an illusory identification with the non-self, which is now fully, though painfully, recognized as a non-self.'[22] The aesthetic

22. Ibid., p. 207. For similar theorizations of allegory, see Angus Fletcher, *Allegory: The Theory of a Symbolic Mode* (Ithaca, 1964), and Walter Benjamin, *Ursprung des deutschen Trauerspiels*, trans. *The Origin of German Tragic Drama* by John Osborne (London, 1977), pp. 159-235. Cf. also Joel Fineman''s 'The Structure of Allegorical Desire', in *Allegory and Representation*, Selected Papers from the English Institute, 1979-80, ed. Stephen J. Greenblatt (Baltimore, 1981), which authoritatively surveys the history of traditional conceptions of allegory only to overturn them in the following pronouncement: 'the structurality of the text holds out the promise of a meaning that it will also perpetually defer, an image of hermeneutic totality martyred and sacralized by and as the poetical. This is the formal destiny of every allegory insofar as allegory is definable as continued metaphor. Distanced at the beginning from its source, allegory will set out on an increasingly futile search for a signifier with which to recuperate the fracture of and at its source, and with each successive signifier the fracture and the search begin again: a structure of continual yearning, the insatiable desire of allegory' (pp. 44-5). Despite its virtual identity with de Man's formulation, Fineman's essay nowhere acknowledges the prior intervention of 'The Rhetoric of Temporality'. This is the more astonishing in light of the fact that Fineman's essay appears in the same volume with and immediately after another by de Man on 'Pascal's Allegory of Persuasion'. The repression of a potentially threatening prior text in an essay shot through with references to psychoanalysis is too interesting not to be significant.

One should also acknowledge in this context the work of Fredric Jameson on the relationship between Marxist hermeneutics and allegory. The conjecture is first

of the symbol would thus correspond to what Ruskin calls pathetic fallacy, and its opposite, allegory, would designate precisely that art which Ruskin consistently valued and praised.[23]

In the famous passage from *Modern Painters* iii in which he praises Dante for not committing the characteristic modern error of mistaking qualities in nature for emotional states in the human mind, Ruskin's understanding of the difference between symbol and allegory is perfectly clear:

> Thus, when Dante describes the spirits falling from the bank of Acheron 'as dead leaves flutter from a bough', he gives the most perfect image possible of their utter lightness, feebleness, and passiveness, and scattering agony of despair, without, however, for an instant losing his own clear perception that *these* are souls, and *those* are leaves; he makes no confusion of one with the other. (V:206)

Dante's poetry is allegorical, declining any effort to annul the irreducible distance between nature and imagination, fact and fancy, signified and signifier. Kingsley's 'cruel, crawling foam', on the other hand, fails to maintain this distance and thus preserve the difference between nature and imaginative representation. Its symbolism (like the symbolism in Wordsworth, Keats, and Tennyson) is 'eminently characteristic of the modern mind' (v:221). Ruskin convicts his Romantic predecessors and

made in passing in his *Marxism and Form: Twentieth-Century Dialectical Theories of Literature* (Princeton, 1971), pp. 398-400; it is developed more fully in *The Political Unconscious: Narrative as a Socially Symbolic Act* (Ithaca, 1981), especially chapters I and II. Jameson's work is treated more fully in chapter 6 below.

23. Whether Ruskin's concept of imagination 'renounced' entirely 'the nostalgia and the desire to coincide' and thus achieved a truly rigorous and exclusive conception of the imagination as allegorical is open to doubt. His continued commitment to 'the truth of natural optics' is apparent in many of the passages we have cited to show that another, and more properly semiotic, concept of imagination is also at work in his aesthetics. One would not wish to dissent entirely from the view recently expressed by Paul L. Sawyer: 'Ruskin's declaration of independence [of the imagination's autonomy from simple perception] cannot so easily be distinguished from romantic nostalgia. His own nostalgia, if that is the right word, consists in a belief not only in myth as the manifestation of an eternal imaginative consciousness in cooperation with nature but also in virtue as a pure essence, like inner light. His thought, in other words, remains radically logocentric' (*Ruskin's Poetic Argument: The Design of the Major Works* [Ithaca, 1985], p. 140). Sawyer substitutes a moral for an epistemological account of Ruskin's theory, and this is certainly in keeping with Ruskin's own explicit ideology. But it leaves the theory of language, over which Ruskin's aesthetics stumbles (even if against his intentions), untouched. The relationship between moral and aesthetic categories is discussed in our next chapter apropos of Henry James's *The Golden Bowl*.

contemporaries of that 'nostalgia and the desire to coincide' with nature which de Man associates with the aesthetic of the symbol, while praising Dante for being properly allegorical.[24]

Another dimenson of Ruskin's concept of imagination, which largely confirms the theory of allegory we have been examining, concerns his theory of myths — possibly his most enduring achievement.[25] Elaborated at length in *The Queen of the Air,* it provides perhaps the fullest articulation of his concept of imagination as a non-phenomenal power of signification. Earlier in his career, in the final volume of *Modern Painters* (1860), in an interpretation of Turner's allegorical painting *Garden of Hesperides,* Ruskin distinguished between the 'physical' or 'natural' meaning of a myth and its 'moral significance' (VII:393). Nine years later, while delivering the first of the lectures on Greek mythology that became *The Queen of the Air,* he stated categorically: 'in all the most beautiful and enduring myths, we shall find, not only a literal story of a real person, — not only a parallel imagery of moral principle, — but an underlying worship of natural phenomena, out of which both have sprung, and in which both for ever remain rooted' (XIX:300). It would appear that, in the first instance, Ruskin is proposing a naturalistic account of the origin of myths. This would correspond to the purely mimetic concept of imagination which we noticed earlier. The 'worship of natural phenomena' underlies all mythical figures, and thus these figures can, in a certain sense, be said to represent nature. Never is one further from a properly allegorical art than at such moments in Ruskin, or in any aesthetic discourse that maintains the semantic priority of the phenomenal features of the sign over its linguistic or figural structure. But the figural dimension of myths cannot be so readily mastered, as Ruskin's subsequent treatment of the relation of natural to human myths discloses: 'all guidance to the right sense of the human and variable myths will probably depend on our first getting at the sense of the natural and invariable ones. The dead hieroglyph may have meant this or that — the living hieroglyph means always the same; but remember, it is just as much a hieroglyph as the other; nay, more,

24. Lest one be tempted into an overly hasty historical typology by the example of Dante versus the Romantics, it should be recalled that among the greatest of allegorical artists, in Ruskin's estimation, was J.M.W. Turner.

25. So opines Harold Bloom in his Introduction to *The Literary Criticism of John Ruskin* (New York, 1972), p. xvi. On Ruskin's theory of myths as a key sector in his epistemology see J. Hillis Miller, 'Myth as "Hieroglyph" in Ruskin', *Studies in the Literary Imagination* 7 (1975): 15-18.

— a "sacred or reserved sculpture", a thing with an inner language' (XIX:361). The opposition of the natural to the human is analogous to that of the phenomenal to the figural. The passage seems to assert at the outset that the figural representations of human myths replicate the phenomenal reality of natural myths: to read the former one need simply recall (or observe) the sensory manifestations of the latter. But the simple translation from the phenomena of nature to the language of men turns out to be more complicated, for the 'living hieroglyph ... is just as much a hieroglyph as the other', it is 'a thing with an inner language'. This puts natural myths squarely on the side of the figural, in language, and thus in need of interpretation in their own right. The hermeneutics of myth in Ruskin is not resolvable in a realist epistemology of language; it generates a dialectic of non-transcendence.

Reference to a specific exegesis may clarify the point. Commenting on the natural properties of serpents and birds, Ruskin claims that the comparative weakness of the serpent as a creature in nature is transformed in its mythic representation into 'a divine hieroglyph of the demoniac power of the earth, — of the entire earthly nature. As the bird is the clothed power of the air, so this is the clothed power of the dust; as the bird the symbol of the spirit of life, so this of the grasp and sting of death' (XIX:363). Ruskin emphasizes that the universal horror induced by the figure of the serpent is out of all proportion to its physical strength or natural danger; the power of the serpent to denote the 'grasp and sting of death' derives from its investment with significance by imagination. Some pages later, in a reading of the allegory in Turner's *Garden of Hesperides,* Ruskin shows that the image of the Hesperian dragon reproduces no natural creature nor a set of features to be observed in actual serpents, but figural descriptions taken from the painter's reading of Dante, Spenser, and Milton, who in turn took their conceptions of dragons from poetic predecessors, Dante from Virgil, Spenser from both Dante and Virgil, and Milton from all three as well as from Homer and Hesiod (VII:401-8). The figures produced by imagination in myths correspond to dream-like recollections of all the figural elements of the mythic tradition available to the poet or painter:

> For all the greatest myths have been seen, by the men who tell them, involuntarily and passively seen by them with as great distinctness (and in some respects, though not in all, under conditions as far beyond the control of their will) as a dream sent to any of us by night

when we dream clearest; and it is this veracity of vision that could not be refused, and of moral that could not be foreseen, which in modern historical inquiry has been left wholly out of account ... (XIX:309)

Mythic representation is not a mimesis of nature, but a phantasmatic recollection of figural structures. The significations associated with natural phenomena, once appropriated by imagination, are released into a domain of potentially limitless new meanings whose generative power results from the syntagmatic and paradigmatic potentials of imaginative memory. The imagination is structured like a language:

> Imagine all that any of these men [Dante, Scott, Turner, and Tintoretto] had seen and heard in the whole of their lives, laid up accurately in their memories as in vast storehouses, extending, with the poets, even to the slightest intonations of syllables heard in the beginning of their lives, and with the painters, down to minute folds of drapery, and shapes of leaves or stones; and over all this unindexed and immeasurable mass of treasure, the imagination brooding and wandering, but dream-gifted, so as to summon at any moment exactly such groups of ideas as shall justly fit each other: this I conceive to be the real nature of the imaginative mind. (VI:42)

* * * * * * * * * *

Our itinerary through Ruskin's aesthetics has been rather circuitous, but this was to some extent necessitated by the nature of the object itself. Ruskin's theory of imagination, which began as a polemical defence of the greatness and the naturalistic truth of Turner's late paintings, produces, alongside its avowed commitment to the 'truth of natural optics' and as if against its own intentions, a semiotic theory of representation which postulates an irreducible heterogeneity between the meaning of signs and their phenomenal features. This is to say that Ruskin's aesthetics is premised upon the necessary co-existence of two radically incompatible modes of representation, one of which is, paradoxical as this may sound, non-aesthetic. The transcendental model of cognition which aesthetic judgment promises does not survive its passage through what could be characterized as the linguistic structures of imagination. This rather surprising conclusion goes some way towards undermining the confidence with which the ideology of the aesthetic asserts art's freedom from historical and material determination.

The precise connections between the structures of history and the figures of art were, of course, an increasing preoccupation in Ruskin's later works, from *The Stones of Venice* to *Fors Clavigera* and *Unto This Last*.[26] It would be incorrect to call Ruskin a coherent and thorough materialist, and yet the supposed idealism characteristic of bourgeois aesthetics is nowhere more openly in crisis than in his theory of the imagination and his privileging of allegory as an aesthetic mode. Seldom in the aesthetics of the Romantics and their heirs are we further from that freedom which art is said to manifest than in Ruskin's understanding of how the artistic imagination functions: 'Thus we may reason over the way a bee builds its comb, and be profited by finding out certain things about the angles of it. But the bee knows nothing about those matters. It builds its comb in a far more inevitable way. And, from a bee to Paul Veronese, all master-workers work with this awful, this inspired unconsciousness' (v:122). Rather than the free creative play of imagination most often attributed to aesthetic production, this representation of the artist is closer to Marx's mature characterization of human subjects as products of history. It is not too much to say that in Ruskin's aesthetics, artistic subjects are on occasion scarcely more than the bearers of imaginative structures.

26. The point has been neatly summarized recently by Raymond Williams in his characterization of the 'Romantic anti-capitalism' to which Ruskin has often been related: 'A whole succession or even tradition of writers were influential opponents of industrial capitalism and, in a rather different way, of bourgeois society, and one common factor in their opposition was their conviction that the art they valued was incompatible with any such social order. Thus their precise positions as artists or as valuers of the arts were the factors through which they expressed a critique which was also being powerfully made from political and economic positions, and which became sufficiently general to give some sense of centrality' ('Ruskin among Others', *London Review of Books* 7 [20 June 1985]: 18). Our analysis here has been programmatically limited to the formal features of Ruskin's aesthetic theory, although the implications of the theoretical impasse there could without difficulty be extended to the social and political criticism in the later works. The patent 'nostalgia' for medieval culture and its art, visible in *The Stones of Venice* for example, or the ostensible privileging of artisanal labor over modern mass production in *Unto This Last*, would be subject to a similar deconstruction of values to that instanced here in our analysis of imagination. The postulation of art as a domain of unalienated labor is no less ideological for its possessing textual warrant in the Marxist classics.

2
Monument and Organism: Henry James and the Ideology of Art

In his notes, 'Toward a Reworking of the Dostoevsky Book' (1961), Mikhail Bakhtin comments on the historicity of artifacts in a manner that illuminates a fundamental attitude toward works of art common to both Marxist and non-Marxist traditions in aesthetics:

> The 'final significance' of a monument in a specific epoch, the interests and demands of that epoch, its historical strength and weakness. Final significance is limited significance. The phenomenon here is equal to itself, coincides with itself.
>
> But in addition to the monument's final significance there is also its living, growing, evolving, changing significance. It is not (fully) born in the limited epoch of the monument's birth — it is prepared for in the course of centuries prior to its birth and continues to live and develop centuries after its birth. This growing significance cannot be portrayed and explained solely within the limited conditions of a single given epoch, the epoch of the monument's birth. Cf. Karl Marx on antique art. This growing significance is in fact the discovery made by every great work of art. Like all discoveries (scientific ones, for example), it is prepared for by centuries, but is accomplished under the optimal conditions of the single specific epoch during which it ripened.[1]

The reference to Marx's hypostatization of Greek art in the Introduction to the *Grundrisse* locates the theoretical terrain of the passage. Bakhtin's partly Marxist conviction that works of art are

1. Mikhail Bakhtin, *Problems of Dostoevsky's Poetics*, ed. and trans. Caryl Emerson (Minneapolis, 1984), pp. 299-301.

determined by the historical conditions of their production comes up against one of the commonplaces of aesthetic theory: despite their demonstrable historicity and material and social determination, works of art seem to possess transhistorically dynamic features that enable them 'to live and develop centuries after [their] birth'. The conceptual opposition between the 'final significance' (i.e., the historical and ideological determination) of a work of art and its 'living, growing, evolving, changing significance' (i.e., its transcendence of historical contingency) repeats a basic figural opposition in the history of aesthetics, one that was implicit in Ruskin's contrast between the 'living' and the 'dead' hieroglyph and that has often been invoked to represent the historical nature peculiar to aesthetic objects.[2] It is evident in Bakhtin's choice of image for the static, immutable artifact: the monument, which is subsequently transformed into a living entity. The figural dyad, dead/living, or inorganic/organic, entirely governs the logic of the passage, which articulates a whole philosophy of history not limited, as the parenthetical reference to science shows, to the history of art. At issue are two different models of historical understanding: the structural versus the historicist or teleological. As soon as the figure of the 'living monument' is introduced, the argument must follow a predictable course in which the figures of birth, growth, and maturity appear in a logical progression indicating a historical process. The transformation of an artifact with a determinate structure into an organism with the capacity to change its form over time is the sign of that methodological shift from poetics to aesthetics which, as we noticed at the beginning of chapter 1, has been characteristic of literary theory since the end of the 18th century. Bakhtin faithfully adheres to the tradition of Kant, Schiller, and Goethe, as Marx did before him, and many others have done since.

The interest of the passage, however, lies less in its reproduction of a classical model of aesthetic form (the organism) than in the

2. The non-Marxist *locus classicus* for this view is surely T.S. Eliot's assertion in 'Tradition and the Individual Talent': 'what happens when a new work of art is created is something that happens simultaneously to all the works of art which preceded it. The existing monuments form an ideal order among themselves, which is modified by the introduction of the new (the really new) work of art among them. The existing order is complete before the new work arrives; for order to persist after the supervention of novelty, the *whole* existing order must be, if ever so slightly, altered; and so the relations, proportions, values of each work of art toward the whole are readjusted; and this is conformity between the old and new' (*Selected Essays*, new edition [New York, 1950]. p. 5).

contradiction it so blithely ignores between two opposed concepts of the aesthetic. If aesthetic works are monuments, like a building or a statue, it is difficult to imagine, outside the realm of myth, how they can be transformed into living beings. The properties of the monument which recommend it as a figure for the work of art (fixity of structure, permanence) cannot be readily accommodated to the ideology of organic growth which the image of the work's 'living, evolving, changing significance' proposes. The condition of the work's monumentality would preclude its changing in form or function. Artifacts can be appropriated for different purposes in different epochs (Roman funerary urns became chamber pots during the middle ages, Melville once observed), but precisely this transformation renders the monument no longer monumental. However accustomed we are to thinking about works of art as simultaneously artificial things with determinate structures and as organisms with a capacity to evolve through time, these two concepts of aesthetic form remain radically incompatible. Poetics and aesthetics are not easily reconciled as models for literary theory.

Nonetheless, the ideological lure of this conceptual sleight of hand is difficult to resist. One would like to believe that the permanence canonically associated with great art can be accommodated to a model of aesthetic vitality which would allow for art's continuing participation in the ongoing life and history of human culture, rather than assigning art to a position of perpetual exteriority to the present. One possible solution to this dilemma would be what is called *Rezeptionsgeschichte*, which promises to square the circle of poetics and aesthetics, or, in the terminology of the Konstanz School, poetics and hermeneutics.[3] Rather than focusing immediately on the writings of this group, however, it may be more useful to examine a particular instance in the history of the reception of a major writer, in order to consider, if only pragmatically for the one case, the potential difficulties raised by such a model of literary and historical inquiry. When the example involves a writer who was himself a distinguished theoretician of the poetics of the novel, the interest of the case is considerably enhanced, for the relation between theory and interpretation, or

3. See Paul de Man's introduction to Hans Robert Jauss, *Toward an Aesthetic of Reception*, trans. Timothy Bahti (Minneapolis, 1982), especially pp. ix-xv. As de Man rightly observes: 'The boldness of the Konstanz school in calling their approach a poetics as well as a hermeneutics measures the scope and the burden of its contribution' (x). Jauss's historicism is treated in chapter 4 below.

theory and fictional practice, cannot for that very reason easily be avoided.

* * * * * * * * *

The figure of monumentality is a familiar feature in writings by and about Henry James. Leon Edel first pointed out that James conceived the New York Edition of his novels and tales in imitation of, and in rivalry with, the twenty-three volume collected edition of Balzac, who remained for James the very embodiment of aesthetic success. James once described the author of the *Comédie Humaine* as 'the only member of his order really monumental, the sturdiest-seated mass that rises in our path'.[4] Richard Blackmur, James's most assiduous and among his most perspicacious readers, opened his introduction to the collected prefaces to the New York Edition by invoking the same figure to express his admiration of James's towering aesthetic achievement: 'The Prefaces of Henry James were composed at the height of his age as a kind of epitaph or series of inscriptions for the major monument of his life, the sumptuous, plum-coloured, expensive New York Edition of his works.'[5] In the Prefaces, James often presents his own fictions through architectural metaphors, as buildings that house or structures that support the subjects and incidents of the texts. Like the English country and town houses, Florentine villas, Venetian palazzi, and Parisian hotels that provide the environment for and symbolize the social and psychological relations in his novels, James's descriptions of the structural integrity of his fictions are often figuratively presented as a bridge, a house, or a grand edifice that stands for 'the literary monument' (AN,52) itself.

4. Henry James, 'Honoré de Balzac' (1902); rpt. in *Notes on Novelists with Some Other Notes* (New York, 1914), p. 121. The figure appears throughout the several essays James devoted to Balzac. See, for example, *French Poets and Novelists* (1878; rpt. London, 1908), especially p. 77, where the *Comédie Humaine* is said to be Balzac's monument, and p. 148, where it is called 'a monumental excuse'. See also 'The Lesson of Balzac' (1905); rpt. in *The House of Fiction*, ed. Leon Edel (London, 1957), where the concluding image of Balzac is that of a 'towering idol .. gilded thick, with so much gold' (p. 85). Finally, see James's last essay on Balzac, 'Honoré de Balzac' (1913); rpt. in *Notes on Novelists*. James characteristically contrasted the monumentality of the *Comédie Humaine* with the mechanical system of Zola's Rougon-Macquart series (for example, in the 1902 Balzac essay; see *Notes on Novelists*, p. 131).
5. R.P. Blackmur, Introduction to *The Art of the Novel: Critical Prefaces by Henry James* (New York, 1934), vii; hereafter cited parenthetically in the text as AN.

Blackmur's estimation of the Prefaces's relation to the New York Edition was astute, but he seems not to have reflected (in the 1930s at any rate) on the disquieting implications of the figure he employed. To write one's own epitaph, as Blackmur indicates James did in the Prefaces, can hardly have been a cheerful or comforting task. In light of the commercial failure of the New York Edition itself, James might reasonably have regarded this 'major monument of his life' as something of a mausoleum, certainly not cause for the celebration Blackmur seems to have believed it merited. But Blackmur himself was in the process of memorializing and monumentalizing James for literary history, transforming him from a minor and largely unread American man of letters into 'the Master', a novelist to rank with Tolstoy and Balzac, and one of the major architects of Anglo-American literary modernism. The canonization of James in literary history that Blackmur inaugurated with the publication of *The Art of the Novel* was largely completed in 1972, with the appearance of the fifth and final volume of Leon Edel's massive biography. Blackmur and Edel (along with some others: F.O. Matthiessen, F.R. Leavis, F.W. Dupee) accomplished what James had signally failed to do for himself: to replace Balzac as the dominant figure in the history of the European novel. James attained a stature after his death and in the subsequent history of his reception denied him in life — a sure indication of the historical dimension of literary understanding insisted upon in *Rezeptionsgeschichte*.

Blackmur's mission on behalf of James is evident from his introduction to *The Art of the Novel*. In the very choice of title, as well as in his explicit comparison of these texts to Aristotle's *Poetics* (AN,vii), Blackmur canonized for all subsequent readers the scope of the Jamesian project and the depth of its achievement. Moreover, Blackmur established the two ways of reading the Prefaces that have dominated their interpretation ever since. On the one hand, the Prefaces can be read as descriptive guides to understanding the fictional texts which they introduce; they give 'the story of a story' (AN,ix). On the other hand, when taken together as a whole, the Prefaces constitute a series of theoretical speculations on the novel as an aesthetic form. Both readings possess textual warrant, but rarely have the two been combined in a reading of a fictional text by James in light of the general theory adumbrated in the Prefaces as a whole.

One reading that does synthesize practical criticism and theory is Hillis Miller's essay, 'The Figure in the Carpet'. Miller argues that James's short story of the same title provides theoretical

insight about the structures of narrative, and that narrative is in turn theorized in the Prefaces to the New York Edition, which latter, Miller says, 'taken together form the most important treatise on the novel in English.'[6] Miller repeats Blackmur's original claim, but he does so with apparently greater sophistication, since he further takes into account the figural richness of the Prefaces themselves, citing their 'dense metaphorical texture' (FC,107). The Prefaces are judged to be literary in their own right. This puts in question the generic or categorial boundary separating literary from theoretical texts, and makes possible an easy passage in the commentary from the fictions to the Prefaces.

Miller comments on the representation of figure in the preface to *Roderick Hudson* in order to focus his own narratological concerns in the essay. He writes: 'Figure is at once a name for the actual "figures" or characters of the story, and at the same time it is the name for relation, for design which emerges only from the retracing of "the related state, to each other, of certain figures and things" ' (FC,110-11). Attention to the figural level of narrative leads Miller, unsurprisingly, to the most programmatically metafictional of James's texts, 'The Figure in the Carpet'. Miller encounters there, as other readers have also, a fitting emblem for Jamesian narrative structure. But unlike even so theoretically well informed a commentator as Todorov, Miller does not claim that the question of figure is resolved simply by stating that 'The Figure in the Carpet' presents an interpretive paradigm for James's fiction. In Miller's account, the status of figure remains as elusive as the 'figure in the carpet' does for the narrator in the story. The tale does not offer a reliable model for reading and interpretation; instead, it 'dramatizes the experience of unreadability, or, rather, since this experience can only be named in figure, it presents figures for it, not least in the recurrent pattern of interpersonal relations which forms the human base for the story's allegorizing of its own unreadability' (FC,113).[7]

6. J. Hillis Miller, 'The Figure in the Carpet', *Poetics Today* 1 (Spring 1980): 107; hereafter cited parenthetically in the text as FC.
7. The force of Todorov's semiological theorization of Jamesian narrative structure is epitomized in the following quotation: 'The Jamesian narrative is always based on *the quest for an absolute and absent cause*. Let us consider the terms of this phrase one by one. There exists a cause: this word must here be taken in a very broad sense; it is often a character but sometimes, too, an event or an object. The effect of this cause is the narrative, the story we are told. It is absolute: for everything in this narrative ultimately owes its presence to this cause. But the cause

Miller's claim, that 'The Figure in the Carpet' allegorizes unreadability, or presents figures for the experience of the failure to read, seeks to forestall the recuperation of his argument by either of two critical models which it might otherwise seem to resemble: the 'plurisignification or richness of meaning' associated with Anglo-American New Criticism; and the 'perspectivism' characteristic of certain forms of reader response criticism (FC,112-13). The figure in the carpet is immanent in the text ('an effect of the rhetoric or of the play of figure, concept, and narrative in the work' [FC,113]), yet it cannot be named or described. The figure is therefore not, *stricto sensu,* something produced by the reader, nor is it an entity that can be located and delineated in any particular feature or combination of features which the text presents. The figure thus theorized designates a poetic system

is absent and must be sought: it is not only absent but for the most part unknown; what is suspected is its existence, not its nature. The quest proceeds; the tale consists of the search for, the pursuit of, this initial cause, this primal essence. The narrative stops when it is attained' (Tzvetan Todorov, 'The Secret of Narrative [*Récit*]', in idem, *The Poetics of Prose,* trans. Richard Howard [Ithaca, 1977], p. 145). The image of closure in a Jamesian fiction is admittedly powerful but it remains delusive. As this essay will argue, Jamesian aesthetic theory cannot be wholly accommodated to the semiotic totalization proposed in Todorov's narratology.

More in line with the pragmatics of Jamesian theory is Wolfgang Iser's functionalism, which locates the determinate structure of the literary work in its interaction with the reader. Writing of the two paradigms of interpretation offered in 'The Figure in the Carpet' (the text-immanent model of the narrator-critic and the functionalist model suggested by Vereker himself and ultimately represented in the hypostatized interpretation of Vereker's work by George Covick), Iser locates the protocols for a theory of reading in the latter: 'Such a meaning [of the literary text] must clearly be the product of an interaction between the textual signals and the reader's acts of comprehension. And, equally clearly, the reader cannot detach himself from such an interaction; on the contrary, the activity stimulated in him will link him to the text and induce him to create the conditions necessary for the effectiveness of that text. As text and reader thus merge into a single situation, the division between subject and object no longer applies, and it therefore follows that meaning is no longer an object to be defined, but is an effect to be experienced' (*The Act of Reading: A Theory of Aesthetic Response* [Baltimore, 1978], pp. 9-10). Iser understands the figure in the carpet as a virtual object, rather than as a thing immanent in the text. This conception of reading apparently opens up aesthetic theory to the praxis of interpretation, although at a price. Iser's hypostatization of the merging of text and reader in 'a single situation' cancels 'the division between subject and object' in a movement that resembles that radical idealism noted in our first chapter apropos of certain theories of Romanticism. The pragmatic or historical dimension of reading is ultimately controlled in Iser's view by the stability through time of the cognitive structures of the reader. Iser's 'reader' is a Husserlian pure consciousness, a Transcendental Ego. The epistemological authority of this Ego will be contested in the Jamesian conception of revision discussed below.

which, like the Althusserian concept of structure, is only 'immanent in its effects'.[8]

But Miller also says, and at the same moment when he refers to the immanence of the structure in the text, that the figure in the carpet is a 'transcendent pattern within and behind the work, present both in the part of it and the whole, and at the same time above and beyond the work as its presiding paternal genius' (FC,114). This projects an entirely different model of poetic structure than the one which asserts the immanence of the structure in the text's effects. Miller's divergence from the Althusserian concept of structure derives, one surmises, from his taking Hugh Vereker's asseveration of a design in his work that 'stretches ... from book to book' to indicate the existence of a transcendent figural structure. Once Vereker's work is complete, this structure will present a logical articulation of the whole. Implicit in this reading is a teleological motivation that attributes a hermeneutic motive to Vereker's works which will over time be resolvable into a 'complete representation' (Vereker's own words) of the figure in the carpet. The phenomenality of the figure, its presence 'both in the part of it and the whole', grounds the stability of its interpretation in an intuition. Miller then takes this intuition of structure to be the foundation of James's fiction, and of fiction generally. The structure of representation is irresolvable on the figural level (where one encounters only unreadability), but is recuperated on the thematic level, which ultimately organizes all the other levels of the tale: ' "The Figure in the Carpet" is a story which mimes this unreadability, on the thematic level, on the figurative level, and on the overall level of its organization as a text' (FC,112). Unreadability is the negative tropological knowledge achieved in the text.

The passage from a poetics of incomprehensibility to a negative hermeneutics of reading in Miller's argument accounts for two of the essay's curious features. In the first place, one is struck by the

8. Louis Althusser and Etienne Balibar, *Reading Capital*, trans. Ben Brewster (London, 1970), p. 189. A more fully elaborated account of Althusserian theory's concept of aesthetic structures must be deferred until our final chapter. At this point, however, we should observe that Pierre Macherey, in explicating Lenin's essays on Tolstoy, invokes 'the figure in the carpet' to exemplify the relations among the contradictory features in Tolstoy's fiction 'which structure the whole of the work' and 'shape its fundamental disparity' (*A Theory of Literary Production*, trans. Geoffrey Wall [London, 1978], p. 127). What speaks *in* the text is precisely this overdetermined structure of contradiction; what speaks *through* it are the various ideologies out of which it has been constructed and which the text's presentational mode allows the reader to behold.

ineluctable cheerfulness of the reading. James is perhaps exemplary, as Miller avers, but that his example is one that can be easily or painlessly affirmed is less certain. Miller repeatedly refers to 'The Figure in the Carpet' as a comedy, but what the story narrates might as readily be described as a tale of pathos. Three of the principal characters die in the course of the narrative, and the narrator's quest for the elusive figure in Hugh Vereker's work ends in utter failure. Rather than celebrating the theoretical subtlety of the tale, one might instead endorse Blackmur's less consoling judgment: '[The figure] is rather like Kafka, manqué, the exasperation of the mystery without the presence of the mystery, or a troubled conscience without any evidence of guilt.'[9]

The second difficulty presented by Miller's reading concerns the position of the Prefaces in relation to the fictions they introduce. Miller outlines with great skill the theoretical problem generated in the fictional text of 'The Figure in the Carpet', but despite his initial acknowledgement of the 'dense metaphorical texture' of the Prefaces, the essay generally overlooks the obstacles that prevent one's pursuing a straight course between preface and fictional text. The narrative of Miller's essay presents a smooth transition from preface (to *Roderick Hudson*) to fictional text ('The Figure in the Carpet') and back to preface again. By naming the figural (even negatively), Miller can proceed between preface and text without detour or interruption via the vehicle of a stable thematic entity whose phenomenality is never finally in doubt: the figure in the carpet. The power of his hermeneutic derives from this postulation of an aesthetic emblem which effectively stabilizes the semantic indeterminacy of figural language in an intuition. This contradiction structuring his reading is admitted by Miller himself when he notes somewhat ruefully at the beginning of the essay his implication in 'the impossible attempt to achieve Apollonian reduction of Dionysiac materials' (FC,107).[10] Whether James's

9. R.P. Blackmur, 'In the Country of the Blue', in idem, *A Primer of Ignorance*, ed. Joseph Frank (New York, 1967), p. 193.

10. The tension between an immanent structure of contradiction and a transcendental structure of cognition grounded in intuition continues to characterize Miller's understanding of reading in his most recent work. In the final chapter of *The Ethics of Reading* (forthcoming from Columbia University Press in 1986; citations are from the galley proofs with no page references therefore available), Miller summarizes the notion of reading to be learned from James's meditation upon revision in the Preface to *The Golden Bowl*: 'Reading is not of the text as such but of that thing which is latent and gathered within it as a force to determine in me a re-vision of that which has been the latent law of the text I read ... This law forces the readers to betray the text or deviate from it in the act of reading

theory of fiction can be thus controlled is just the question that remains unresolved in Miller's reading, as it has for many of James's admirers from Blackmur on down.

* * * * * * * * *

An economical means for investigating the relation between fictional and theoretical texts in James's work is to consider a single preface and attempt to unpack the structure of its argument. The preface to *The Golden Bowl* will serve this purpose quite well. Its position at the end of the Prefaces, its comparatively slight dependence on the novel which it introduces, and its frequently cited passages in defense of art — all these features recommend this text as an ideal site on which to engage Jamesian theory. The preface is constructed around three topics presented in the following order: narrative point of view, what James calls 'the register of consciousness' (AN,239) through which the events of the novel are perceived; the question of illustration, that is, of Alvin Langdon Coburn's photographs on the frontispieces of the several volumes of the New York Edition; finally, and at greatest length, the meaning and practice of revision, a task James had undertaken in collecting and arranging his works for this monument to his career. One is struck immediately in reading this text how little it has to say about the novel it introduces, particularly in comparison to other prefaces. A few perfunctory remarks are made about the major division in point of view between the Prince in the first half and Maggie Verver in the second. Some pages are devoted to the search James and Coburn undertook to discover the proper 'type' of an antique shop for the frontispiece to the first volume of the novel: it had to avoid looking like any particular shop and aspire to being 'a shop of the mind' (AN,134), James writes. A couple of sentences then argue the necessity for

it, in the name of a higher demand that can yet be reached only by way of the text. This response creates yet another text which is a new act. Its performative effect on yet other readers is of the same kind, for better or for worse, as the effect the text it reads has had on it.' The truth of the text is situated outside its borders, that which Miller here and throughout *The Ethics of Reading* terms 'the law'. (A citation from Kafka's 'Vor dem Gesetz' provides the first epigraph to the book, and this parable is invoked on various occasions throughout the text.) But this transcendental principle is yet present in the text itself, 'latent and gathered within it as a force'. The passage from immanent features to transcendental principle is made possible by the phenomenal stabilization of intuition, what makes reading an ethical rather than an empirical or historical act. The relation of James's aesthetics to the discourse of ethics is discussed below.

'some generalized view of Portland Place' (AN,335) in the illustration for the second volume. The matter of *The Golden Bowl* is then summarily dropped, yielding to James's expansive reflections on revision, culminating in a grand crescendo in defense of art. The preface focuses most of its energy on these latter topics, and it is surely not wrong to see it as a continuation of that line of 19th-century texts descending from Wordsworth's and Coleridge's critical writings through Shelley's *Defence of Poetry,* down to Pater's aesthetic treatises in *Appreciations* and *The Renaissance* and Wilde's criticism. James has often, and justly, been lumped together with Pater and Wilde (James had contributed to *The Yellow Book* during the 1890s) in the late 19th-century flowering of British aestheticism. The aesthetic interpretation of his work can enlist an extensive catalogue of supporters, from younger contemporary admirers like T. S. Eliot and Ezra Pound, to Percy Lubbock and Richard Blackmur, down to Laurence Holland and, more recently, Stephen Donadio, John Goode, and Gabriel Pearson. James's vocabulary in the Prefaces valorizes such words and phrases as 'appreciation', 'intensity', 'sensibility', 'the exquisite economy of art', 'the play of representational values', and 'the spiritual and aesthetic vision'. The deployment of these terms lends considerable weight to those readings that have claimed the Prefaces for a defense of the novel as a literary form. Abundant evidence for this view could also be cited from James's other literary essays and from his reviews.

Perhaps in no better way can James be linked to *fin de siècle* aestheticism than by invoking the canonical image of Proust, who has passed into the European literary tradition as author of the archetypal novel of recollection and ideologue of the recuperative power of aesthetic presentation over the pathos of one's past.[11]

11. The interpretation of Proust's novel invoked here is not meant to stand as a critical estimation of Proust's text; it is, to say the least, highly debatable. Nevertheless, this image of Proust has passed into the conventional wisdom of literary scholarship, as well as into the popular mythology about Proust's isolation and complete devotion to art. Edel's biography ends on exactly this note: 'Like Proust [James] saw that art alone retains and holds the life — the consciousness — of man long after the finders and the makers are gone. The true immortality was the immortal picture or statue, the immortal phrase whether of music or words. This was his deepest faith. He sought beauty instead of ugliness, kindness instead of cruelty, peace instead of violence; he preferred the poetry of prose, the magic of style, the things shaped within the past given sacredness by their survival' (*Henry James: The Master, 1911-1916* [Philadelphia, 1972], p. 564). The image was equally well assimilated by the late François Truffaut, who linked James and Proust in his adaptation of 'The Altar of the Dead', *La chambre verte* — a bitter homage, one surmises, to André Bazin.

The ideology of this figure is clearly at work in the following passage from James's reflections on revising and reappropriating his own work near the end of the preface to *The Golden Bowl:*

> To revise is to see, or look over, again — which means in the case of a written thing neither more nor less than to re-read it. I had attached to it, in a brooding spirit, the idea of re-writing — with which it was to have in the event, for my *conscious* play of mind, almost nothing in common ... What re-writing might be was to remain — it has remained for me to this hour — a mystery. On the other hand the act of revision, the act of seeing it again, caused whatever I looked at on any page to flower before me as into the only terms that honourably expressed it; and the 'revised' element in the present Edition is accordingly these terms, these rigid conditions of re-perusal, registered, so many close notes, as who should say, on the particular vision of the matter itself that experience had at last made the only possible one. (AN,338-9)

One of the commonplaces of scholarship on James, first proposed by F. O. Matthiessen, is that James's revisions of the later novels and tales were much less extensive than his detailed rewriting of earlier works like *The American* and *The Portrait of a Lady.* One could easily compare, although it would be a tedious and quite lengthy exercise, the first published editions of James's fictions with the revised texts to show how James's intentions changed from the time of writing the original to the period of his composing the New York Edition. Entire academic and scholarly careers could be erected upon and consumed in such an enterprise. One might then come to the conclusion, like Matthiessen, that the 'later James' is the more mature writer, or, like F. R. Leavis, that the convolutions of James's later style evince a decline in the novelist's artistic powers and moral seriousness.[12] In either case, one would have to posit a temporal progression from one set of intentions to another, the record of which could be traced in the different versions of the work under examination. These hermeneutic enterprises could be categorized as interpretations of 're-writing', not, as James says of his own interpretive labors, 'revision'. We have James's word for the fact that he did not 'change his mind' about the structure or the language of his earlier fictions, but rather, that the texts took on new life with his 're-perusal': 'the act of seeing it again caused whatever I looked at on

12. See F.O. Matthiessen, *Henry James: The Major Phase* (London, 1944), especially the Appendix, pp. 152-86; and F.R. Leavis, *The Great Tradition* (London, 1948), pp. 126-72.

any page to flower before me as into the only terms that honourably expressed it ... ' Revision, on James's account, is a kind of recognition, related to the famous scenes in *The Ambassadors, The Portrait of a Lady, The Golden Bowl,* and *The Wings of the Dove* in which a protagonist discovers — characteristically quite by chance in a moment of visual perception — what has been going on around her for some time but of which she has hitherto been entirely ignorant. Recognition does not generate a history (as the Matthiessen/Leavis scheme of James's career suggests), for what is now recognized has already come to pass; recognition, on the contrary, imposes on the random events of historical succession a formal logic, transforming them into a plot: 'The term that superlatively, that finally "renders", is a flower that blooms by a beautiful law of its own (the fiftieth part of a second often so sufficing it) in the very heart of the gathered sheaf; it is *there* already, at any moment, almost before one can either miss or suspect it — so that in short we shall never guess, I think, the working secret of the revisionist for whom its colour and scent stir the air but as immediately to be assimilated' (AN,342).

It could of course be argued that James here and throughout the Prefaces is merely making excuses, that he understands perfectly well the comparative weakness of his earlier fictions, and that revision presented him with an opportunity to plaster over, in some cases without complete success, the formal fissures in these texts. The preface to *The Golden Bowl* explicitly remarks 'the very different dance that the taking in hand of my earlier productions was to lead me' (AN,336), 'the sorry business of "The American"' (AN,344), and the 'altogether better literary manners of "The Ambassadors" and "The Golden Bowl" ...' (AN,344). James's sense of the formal weakness of some of his fiction prompts him to rueful reflection and embarrassed apology:

> Inevitably, in such a case as that of 'The American', and scarce less indeed in those of 'The Portrait of a Lady' and 'The Princess Casamassima', each of these efforts so redolent of good intentions baffled by a treacherous vehicle, an expertness too retarded, I could but dream the whole thing over as I went — as I read; and, bathing it, so to speak, in that medium, hope that, some still newer and shrewder critic's intelligence subtly operating, I shouldn't have breathed upon the old catastrophes and accidents, the old wounds and mutilations and disfigurements, wholly in vain ... I have prayed that the finer air of the better form may sufficiently seem to hang about them and gild them over — at least for readers, however few, at all *curious* of questions of air and form. (AN,344-5)

What remains most puzzling in this confession and apology is not the discrepancy between the failures of the past and the skill of the present, but the implicit claim that the temporal gap between the two has been annulled. The historical event of the original text is effaced in revision, which, to use the terminology of the Konstanz School and of their precursor Felix Vodička, 'concretizes' the work in a new way. But unlike the theorists of *Rezeptionsgeschichte,* for whom the succession of historical concretizations constitutes a continuous series of possible interpretations of the work, James claims here that the original artifact has been formally altered in such a way as to cancel (so he hopes) the memory of the earlier failure. The stable phenomenal entity that would link one concretization with another, what Vodička terms quite correctly the *aesthetic* object (as distinct from the material work), cannot be sustained during revision. The dream of revision is to cancel without preserving the memory of the original. Revision does not generate a historical dialectic betwen past and present; it replaces one synchronic structure with another.[13]

To return to James's initial distinction, revision demands not re-writing but re-reading. The appearance of a history (of an intelligible sequence of intentional acts) is undone by the coercive formality of the text's structure. Contrary to the Konstanz model (or that of Bakhtin invoked at the beginning of this chapter), in which historical changes in the interpretation of a text involve continual adjustments of an originary understanding, James's account of revision rests on a theory of reading that posits the non-self-identity of the literary sign and the complete heterogeneity of one textual event to another. The passage from unrevised to revised text is a non-purposive, non-intentional submission to an entirely new and completely irresistible formal cognition: 'What was thus predominantly interesting to note, at all events, was the high spontaneity of these deviations and differences, which became thus things not of choice, but of immediate and perfect necessity: necessity to the end of dealing with the quantities in question at all' (AN,336).

Jamesian poetics thus diverges from the hermeneutic model

13. The distinction is the same as that drawn by Paul de Man between *Erinnerung* (which corresponds to re-writing in James) and *Gedächtnis* (which corresponds to revision) in Hegel. Memory (*Gedächtnis*) is entirely mechanical and devoid of phenomenal significance; its connection to the past is not established by any interiorization of sense perception (as would be the case with recollection, or *Erinnerung*). See de Man, 'Sign and Symbol in Hegel's *Aesthetics*', *Critical Inquiry* 8 (Summer 1982); 773-4.

proposed by Hillis Miller in the essay cited previously. Miller's account of representation posits an intentional structure discovered through the temporal accumulation of elements perceived in the text. The text on his view projects a dispersion of possible relations which are then resumed in a totality whose randomness is figurally harmonized: 'the initial requirement was for total completeness in the retracing of all possible relations' (FC,109). James's notion of revision, by contrast, suggests that the relations between two text-events (earlier version versus later) is not one of figural totalization or hermeneutic progress, the gradual unfolding of the design of the figure in the carpet, but the arbitrary, although necessary, substitution of one text for another. Reading understood as a controlled hermeneutic process governed by a teleology of phenomenal representation cannot occur in the realm of necessity which Jamesian revision inhabits. Necessity is that which escapes representation; it is the unmotivated disruption of the totalizing power of figural reading.[14]

* * * * * * * * *

Richard Blackmur once observed that interpreters of James have tended to divide into two camps: on the one hand, extreme formalists like Percy Lubbock; on the other, more expansively moral critics like Leavis, Yvor Winters, and Lionel Trilling. Blackmur himself sought to straddle this divide, performing a precarious balancing act that would leave its mark on all his work. In a famous essay in defense of James's art, Blackmur identified what he called the 'technical' or 'executive' or 'theoretic' form which structured James's major novels.[15] Blackmur understand-

14. Hillis Miller's commentary on this aspect of James's text in *The Ethics of Reading* is entirely just: 'This act of re-reading is free, unbound, in the specific and again somewhat surprising sense that it is not chained by the shackles of theory. I suppose what James means by that is that what happens when he re-reads is not determined by any theoretical presuppositions about what is going to happen when he re-reads. What happens happens, when we really read, as opposed to imposing on the text assumptions about what we are going to find there.' Miller then cites Paul de Man, who asserts the same force of necessity in reading which is evident in James's formulation on revision. This necessity constitutes, Miller argues throughout *The Ethics of Reading*, the ethical moment in any interpretive act. The question remains whether, as Miller posits, this moment can be subject to transcendental principles of description and cognition.

15. R.P. Blackmur, 'The Loose and Baggy Monsters of Henry James: Notes on the Underlying Classic Form in the Novel', in idem, *The Lion and the Honeycomb: Essays in Solicitude and Critique* (New York, 1955), pp. 268-9.

ably appeals to the Prefaces for authority in constructing the Jamesian theory of narrative form, keying his analysis to what has since become a famous image in criticism on the novel form. The image occurs in the preface to *The Tragic Muse:*

> A picture without composition slights its most precious chance for beauty, and is moreover not composed at all unless the painter knows *how* that principle of health and safety, working as an absolutely premeditated art, has prevailed. There may in its absence be life, incontestably, as 'The Newcomes' has life, as 'Les Trois Mousquetaires', as Tolstoi's 'Peace and War', have it; but what do such large loose baggy monsters, with their queer elements of the accidental and the arbitrary, artistically *mean*? ... There is life and life, and as waste is only life sacrificed and thereby prevented from 'counting', I delight in a deep-breathing economy and an organic form. My business was accordingly to 'go in' for complete pictorial fusion, some common interest between my first two notions, as would, in spite of their birth under quite different stars, do them no violence at all. (AN,84-5)

Blackmur's exemplary reading of this passage, which invokes classical figures of formal integrity (composition, organic form), turns on the notion of 'theoretic form', which he elsewhere calls 'a way of seeing: no more'.[16] The concept derives from James's own insistence on the 'organic form' of his fiction. Theoretic or aesthetic form is neither rigid nor inflexible as, say, the structure of a building or a statue would be, but is rather a malleable and capacious potential for ordered development. Blackmur identifies its most visible manifestation in the transformation from consciousness to conscience in the protagonists of James's fiction.[17] He thus trumps the critical opposition between formalism and moralism by showing how the form of the Jamesian novel, particularly in the later works, coincides with the cognitive and ethical growth of the protagonist. Perhaps the most eloquent defense of this view of James comes in the introduction Blackmur wrote to *The Golden Bowl* in 1952, where he locates the coincidence of the aesthetic and ethical vectors of the plot in Maggie Verver's 'holding together' the fragments of the shattered bowl. Maggie's action is said to be the very type of the 'poetic symbol'.[18] The novel narrates the breakdown of social relations

16. Blackmur, 'Between the Numen and the Moha: Notes Toward a Theory of Literature', in *The Lion and the Honeycomb*, p. 290.

17. Blackmur, 'The Loose and Baggy Monsters of Henry James', p. 279.

18. R.P. Blackmur, Introduction to Henry James, *The Golden Bowl* (New York,

that have been sustained by deception, but it also tells the story of how social equilibrium and moral harmony are restored by facing the necessity for lying. The bowl symbolizes aesthetic reintegration of a social reality shattered by a destructive consciousness aware of the fissured substance of truth. Blackmur's defense of the novel's fusion of aesthetic power and moral significance rests upon a prior epistemological claim: the novel as a 'theoretic form' constitutes 'the medium absolutely necessary if we are to see anything at all' (GB,vi).[19] *The Golden Bowl* clarifies and rectifies the distortions of vision produced in the story's disruptive sequence of events and in the ordinary, non-aesthetic perception of everyday life.

As we saw in the first chapter, the perceptual grounding of the aesthetic holds out the possibility of an epistemologically reliable standard for cognition, and this is the principal attraction of the aesthetic as a model for understanding. In Ruskin, this epistemology is disrupted in the mode of allegory, which Ruskin privileges over the symbol. With James, the disruption of the formal harmony of the aesthetic begins in his concept of revision, but to the degree that this model retains the traces of perceptual categories, it is difficult not to fall back into an ideology of aesthetic rectification, since misperception is always, in principle, corrigible. That perception may not, however, be an ultimate principle of cognition, that it may rest upon a prior epistemological faith in the reliability of understanding (i.e., one must already have a definite mode of understanding before transforming sense data into perceptions), is a possibility that Nietzsche, James's contemporary and an equally astute

1952), p. xvii; hereafter cited parenthetically in the text as GB.

19. A recent interpretation of *The Golden Bowl* that resumes Blackmur's view from the perspective of contemporary ethical theory is Martha Nussbaum's essay, 'Flawed Crystals: James's *The Golden Bowl* and Literature as Moral Philosophy', *New Literary History* 15 (Autumn 1983). Nussbaum argues that Maggie Verver's maturation in the novel instances a shift from a naive, childish, call it Kantian, concept of morality (a system of rules, injunctions, and prohibitions that function without exception), to a mature, tragic understanding that moral problems perpetually present dilemmas which render categorical solutions impossible. Nussbaum cites Maggie's maturation in aesthetic judgment as a positive sign that she has overcome the categorical position of her youth and attained the mature stance of prudential ethics. Nussbaum then concludes, like Blackmur, that poetic representation offers a superior model for ethical action to the imperatives and inflexible rules set down in conventional ethical treatises. This was predictable, since Nussbaum only follows tradition on this point. The smooth assimilation of the ethical to the aesthetic has been a consistent feature of aesthetic theory from the moment of the latter's birth.

theoretician of the aesthetic, may help us to formulate more precisely. Here is Nietzsche writing in 1873 about the bearing of truth and falsehood on the presentation of sense perceptions:

> But on the whole, right perception [*die richtige Perception*] — which would mean the adequate expression of an object in the subject — appears to me an impossibility full of contradictions [*ein widerspruchsvolles Unding*]: for between two absolutely different spheres, as between subject and object, there is no causality, no exactness [*Richtigkeit*], no expression, but at most an aesthetic condition [*ästhetisches Verhalten*], I mean an intimated transference [*eine andeutende Übertragung*], an after-stammering translation [*eine nachstammelnde Übersetzung*] into a wholly strange tongue. But for which at all events there is needed a freely composing and freely inventing middle sphere, a mediating force.[20]

On a Nietzschean view, perception, or more precisely intuition, does not establish a reliable basis for knowledge. Perception itself functions linguistically, as Nietzsche's designations for it, *Übertragung* and *Übersetzung,* indicate. Transference, the carrying over of meaning from one entity to another, is the classical definition of metaphor (see Aristotle, *Poetics,* 1457b. 7-9), so it would not be wrong to say that on Nietzsche's account perception is structured like a trope. And since the passage is perfectly explicit about the implication of aesthetic representation in this same metaphorical structure, we can conclude that the aesthetic, far from guaranteeing the accuracy of a cognition, is constrained and controlled by the 'freely composing and freely inventing middle sphere' which transfers objects into the subject, translating inchoate sense data into structured intuitions. As was the case in Ruskin's theory of imagination, aesthetic representation, which has conventionally been linked to epistemological realism, is shown in the Nietzschean theory of perception to be based upon a linguistic model of the arbitrary and unmotivated relationship between entities. Aesthetic understanding, to the degree that it is founded upon intuition, can scarcely offer the security of reliable knowledge or rectification of error.

The serenity of Blackmur's account of the Jamesian aesthetic is disturbed by an incompatibility between the epistemology of perception on which the aesthetic is founded and the ideology of

20. Friedrich Nietzsche, 'Ueber Wahrheit und Lüge im aussermoralischen Sinne', *Werke: Kritische Gesamtausgabe,* ed. Giorgio Colli and Mazzino Montinari (Berlin, 1967-), III.2:378; my translation.

transcendence of moral categories which Blackmur attributes to aesthetic representation. The claim that the aesthetic opens up a path to superior knowledge does not survive an elucidation of the formal structure of representation, either at the level of theory (the unreliable epistemology of perception) or in the practical difficulties presented to the characters in the novel. Maggie Verver's supreme act of aesthetic will, which Blackmur argued is the perfect emblem for Jamesian formalization, is not only a deception (the achievement of *schöne Schein,* in Schiller's terminology), but also a destruction of the very order and substance of human relations which she had sought to protect. Blackmur himself, not many years before his death, came to a similar recognition. After a lifetime of celebrating James and defending the moral, even the political significance of his later fiction and essays, Blackmur came to doubt James — and thus his own faith in the value of the aesthetic. His 1963 introduction to *The Golden Bowl* exactly reverses his 1952 judgment on the novel. No longer is the sacrifice of truth compensated for in the embrace of the beautiful. Blackmur stares once more into the 'ultra-moral sense' of James's aesthetics and for the first time measures the full price which this theory commands. *The Golden Bowl,* he says, 'if it goes beyond the human, ... does not go to God but to the inhuman.'[21] Maggie Verver's aesthetic formalization of her world exacts from those around her, as well as from herself, the highest cost. The last and most rigorous representative of James's aesthetic theory, she delivers, by renouncing the possibility of life with her father and intimacy with her husband, the Jamesian verdict on the pathos that remains permanently in force to threaten the surface calm of the work of art. Her sacrifice of life on the altar of the aesthetic elevates art to the position of 'a supreme end worth any loss and any surrounding waste to attain.'[22]

Blackmur's reversal of the valence of James's aesthetics does not, however, elude the power of aesthetic formalization, which continues to govern Blackmur's conception of James's fiction and the ideology it incarnates. In Martha Nussbaum's terms (see above, n.19), Blackmur reverts from the model of prudential ethics which Maggie herself comes to embrace to categorical ethical judgments based on transcendental principles that apply without exception. The aestheticizing of ethics has been supplanted by a

21. R.P. Blackmur, Introduction to Henry James, *The Golden Bowl* (New York, 1963), p. 6.
22. Ibid., p. 12.

traditional moralizing against the dangers of art. In either case, the assumption of a potentially totalizable system of relations, be the principle of totalization the invariant functioning of moral precept or the evolving movement of aesthetic form, governs the theorization of Jamesian formalism absolutely. Whether the poetics James himself outlines in the preface to *The Golden Bowl* can be squared with these totalizing models is a question that persists in the face of both these interpretations of the novel's formal unity.

* * * * * * * * * *

The other topic, which we have hitherto neglected, organizing James's argument in the preface to *The Golden Bowl* is illustration. James had alluded to this question in an earlier preface (with reference to Beardsley's work for *The Yellow Book* [AN,218-19]), but its full implications are left to near the final moment. Coburn's photographs, the 'couple of dozen decorative "illustrations" ' (AN,331) used as frontispieces for each of the twenty-four volumes in the original New York Edition published between 1907 and 1909, were intended to 'ornament' (AN,331) the work. They were to give it an added luster, to decorate it, like a border or a frame surrounding a painting. The photographs would adorn the monument itself, supplement its intrinsic beauty and symmetry, add to its grandeur. At the same time, however, James recognized in them a threat. Although certainly conceived, as Kant said all ornamentation should be,[23] to harmonize with the form of the whole, James feared they might be perceived in competition with the novels and tales themselves. Such is the very nature of illustration, James avers, that the reader could be tempted to take the photograph for the thing — a possibility directly presented by the illustration proposed for the first volume of *The Golden Bowl*: the photograph of the antique shop where Charlotte purchases the fated *objet d'art* of the title. The purpose of literary representation is to 'bristle with immediate images' and induce in the attentive, ' "artistically" inclined' reader 'such a state of hallucination by the images one has evoked as doesn't permit him to rest till he has noted or recorded them, set up some semblance of them in his own other medium, by his own art ...' (AN,331-2). Literary representation stimulates not only the hermeneutic activity of the

23. Immanuel Kant, *Kritik der Urteilskraft*, section 14; in English, *The Critique of Judgement*, trans. James Creed Meredith (Oxford, 1952), Part I, p. 68.

reader but also her aesthetic capacity: 'the images one has evoked ... set up some semblance of them in his own other medium.' No transcendental principle guarantees that the two representations (the text's and the reader's) will produce identical images, even though the reader's cognitive structures must, James seems to suggest and cognitive psychology assumes, produce a reasonable adequation between them if reading is to take place at all.

James's concern is that the intrusion of illustrations will disrupt the already difficult transaction between reader and text by presenting the reader with a palpable sensory datum (the photograph) which, if it is understood to be a definitive representation of objects or events or figures in the text, will be used as a key to the text's formal code. Should this occur, the illustration would have effectively usurped the text's representational authority:

> [The writer's] own garden, however, remains one thing, and the garden he has prompted the cultivation of at other hands becomes quite another; which means that the frame of one's own work no more provides place for such a plot than we expect flesh and fish to be served on the same platter. One welcomes illustration, in other words, with pride and joy; and also with the emphatic view that, might one's 'literary jealousy' be duly deferred to, it would quite stand off on its own feet and thus, as separate and independent subject of publication, carrying its text in its spirit, just as that text correspondingly carries the plastic possibility, become a still more glorious tribute. (AN,332-3)

James hypothesizes that illustration is an independent representational mode. He defines the relationship between text and illustration, portrait and ornament, by establishing a boundary that at once joins and separates the two realms. Conjoining the two produces a disjunctive relationship which precludes the possibility of their formal commensuration. Successful deployment of Coburn's photographs rests precisely on their differential relation to the texts they illustrate: 'the proposed photographic studies were to seek the way, which they have happily found, I think, not to keep, or to pretend to keep, anything like dramatic step with their suggestive matter. This would have disqualified them, to my rigour, but they were "all right", in the so analytic modern critical phrase, through their discreetly disavowing emulation' (AN,333).

In James's tale 'The Real Thing', the most appropriate subjects for a portrait of a typical English lady and gentleman turn out not to be a once prosperous husband and his wife now reduced to the

indignity of earning their own way as models (the 'real thing' of the title). On the contrary, the unnamed artist in the story discovers his image of the English leisured classes in a Cockney charwoman and an unemployed Italian immigrant. Similarly in the case of Coburn's illustrations, the real thing would prove just the wrong thing. What is 'all right' (Nietzsche's *Richtigkeit,* exactness of correspondence) about the photographs chosen is their having resisted the temptation to stabilize in a perception the images represented in the fictions. Illustration achieves rightness or adequacy to the degree that it renounces its claim to referentiality, i.e., by refusing to be illustrative or exemplary. James writes of the photograph of the shop that was to be 'the proper compliment' to the first volume of *The Golden Bowl:* 'It might so easily be wrong — by the act of being at all' (AN,334).

The theory of illustration elaborated here can be shown to operate throughout the Prefaces and to dissolve the concept of aesthetic totalization which they have generally been thought to authorize for the theory of the novel. For example, in the opening preface to *Roderick Hudson,* James relates how the asymmetry between Mary Garland and Christina Light shatters the formal unity of the text and necessitates the production of another novel about the latter character, *The Princess Casamassima* (AN,18-19). Even more directly, James gives the following account of the formal structure of the novel in the preface to *The Portrait of a Lady:*

> Here we get exactly the high price of the novel as a literary form — its power not only, while preserving that form with closeness, to range through all the differences of the individual relation to its general subject-matter, all the varieties of outlook on life, of disposition to reflect and project, created by conditions that are never the same from man to man (or, so far as that goes, from man to woman), but positively to appear more true to its character, in proportion as it strains, or tends to burst, with a latent extravagance, its mould. (AN,45-6)

Like the passage from Bakhtin with which this chapter began, James's poetics projects two distinct and incompatible models of the novelistic text — here shoved side by side in a single meandering periodic sentence. A completely traditional conception of organic form encompassing the potential for growth and expansion is juxtaposed with the equally conventional image of formal unity as a structure with definite boundaries and a fixed shape. The latter concept of form is properly poetic; the former

aesthetic. The tension between these modes of representation militates against a strict aesthetic reading of James's theory and fiction. One of the hallmarks of the aesthetic reading has been a relatively unproblematic passage from theoretical texts like the Prefaces to fictional texts like *The Golden Bowl* and 'The Figure in the Carpet', a passage that can be traversed in either direction, as Miller and Blackmur both attest. In either case, the tendency is to restrict the movement of reading and to stabilize its signifying potential in an intuition: Miller's hypostatization of the figure in the carpet as a phenomenal emblem; Blackmur's positing of theoretic form as a mode of apprehension that saturates the narrative field and harmonizes the potential heterogeneity of events and characters.

In *The Golden Bowl,* the highest expression of aesthetic consciousness has canonically been attributed to Maggie Verver and to her arranging or managing the lives of the other characters in the second half of the novel. This power of formal integration is symbolized in her assembling the pieces of the shattered bowl and holding them together in her hands. On the conventional view, this gesture becomes an emblem of the altered relations among the characters in the novel after Maggie's discovery of the Prince's and Charlotte's duplicity, relations which now require the force of Maggie's moral or aesthetic (it matters little which label one prefers) will to sustain them. Mastery of the situation derives from Maggie's superior knowledge and understanding, her skill — to invoke another classic figure for the aesthetic which is also a *topos* in the novel — at playing the game of social and psychological relations. This has always been the promise which aesthetic formalization holds out: its claim to ground reliable and universal epistemological judgments that confer ethical and political authority on the aesthetic condition. If the Prefaces do not quite achieve this state of serenity and confidence, and if James's own life and career ultimately failed to attain that monumentality for which he continually strove, it would nonetheless seem that, within the boundaries of certain of the fictions, aesthetic apprehension remains a possibility. One might say that Maggie Verver is, by the end of *The Golden Bowl,* the successful artist James could hypothesize but not be. Thus the hope or promise of the aesthetic survives precisely where it has always been claimed to thrive most: in authentic works of art.

Do James's texts, then, sustain the ideology of the aesthetic on a thematic and figural level? Full elucidation of this question would require a lengthy exposition of the major themes and figures in

James's fiction and their poetic functioning over a substantial range of texts. An indication of how to begin can be obtained by considering the final narrative situation in *The Golden Bowl* itself. Having manœuvred Charlotte and the Prince into accepting a permanent separation that will also entail her own separation from her father, Maggie observes with Adam the final conversation between the two lovers. In a chapter overflowing with terms taken from the discourse of aesthetics (particularly from criticism of the visual arts), and in a novel that has by this point rendered all aesthetic terminology highly overdetermined, the following passage must appear like a summation of the text's figural pattern:

> The two noble persons seated, in conversation, at tea, fell thus into the splendid effect and the general harmony: Mrs. Verver and the Prince fairly 'placed' themselves, however unwittingly, as high expressions of the kind of human furniture required, aesthetically, by such a scene. The fusion of their presence with the decorative elements, their contribution to the triumph of selection, was complete and admirable; though, to a lingering view, a view more penetrating than the occasion really demanded, they also might have figured as concrete attestations of a rare power of purchase. (GB, Book Second, 368-9)

In a word, the Prince and Charlotte have been 'bought'. Of course nothing in the figural structure of the novel would suggest that this intrusion of a commercial metaphor is inappropriate, since the intersection of economic with aesthetic concerns has been amply prepared from the first, from Charlotte's haggling over the price of the golden bowl to the accounting (in both senses of the term) of Adam Verver's art collection housed in American City. If the matter of *The Golden Bowl* attests to anything, it is to James's complex understanding of the different semantic possibilities contained in the phrase, 'the sublime economy of art'.

This is not to say, however, that the values of economy and art can be readily or thoroughly reconciled. Moreover, it is far from clear that the aesthetic understanding which Maggie has purportedly acquired by the end of the novel encompasses the more vulgarly materialistic possibilities implied in the final disposition of the characters. We cannot be certain that hers is the 'view more penetrating than the occasion really demanded', for nothing in her response to her father's assessment of this situation betrays the least consciousness of its commercial tenor: 'There was much indeed in the tone in which Adam Verver spoke again, and who shall say where his thought stopped? *"Le compte y est.* You've

got some good things." Maggie met it afresh — "Ah, don't they look well?"' (369). If, as is surely plausible, Maggie has become the representative of aesthetic consciousness in the novel, her reply shuts down precisely that potential threat to the aesthetic harmony of the scene she has constructed which is contained in the semantic ambivalence of her father's remark. The line in Adam's career and his speech separating the authentic aesthetic object from the commodity is characteristically thin, but in Maggie's aestheticizing vision, the exhange value of her husband and her mother-in-law must never be calculated or even acknowledged. For to think of works of art simultaneously as fixed, monumental structures and as commodities which circulate and fluctuate in value is to undermine that confidence in the semantic stability of signs upon which the power of the aesthetic depends. If the aesthetic is opened up to all the vicissitudes of history, if its value is left to float, then no force, however apparently hegemonic and capable of regulating the situation, can protect it from collapse in a catastrophic devaluation of the market.

James himself may have been more perspicacious than either his characters or his admirers when he remarked near the end of the preface to *The Golden Bowl* that, given the burden of the aesthetic as a structure of action, one can never simply put one's valuable works safely and securely out of circulation: 'if one is always doing, he can scarce, by his own measure ever have done ...' (AN,348). At the novel's end, Maggie's full understanding of her new position is indicated in her presumably accurate reading of her husband's face, which assures her of his loyalty, his understanding, and most of all his acceptance of the terms of their arrangement. The moment of her suspense, when the Prince is absent from the room, is succeeded by a reinvigoration of confidence when she beholds him and calculates the sum of their relationship: 'She had thrown the dice, but his hand was over her cast. He opened the door, however, at last — he hadn't been away ten minutes; and then, with her sight of him renewed to intensity, she seemed to have a view of the number' (376). What Maggie's totalizing and teleological vision fails to take into account is suspicion, the permanent potential for disruption that has been introduced into the system of her marriage and threatens at every moment to undo its structure of truth. Never is she further in ideological commitment and in epistemological rigour from James himself than when she lays claim to a knowledge and a confidence that at best express a temporary respite from the moral and psychological anxiety of not knowing what her husband might be

up to each time he is absent from her vision. As she might profitably have learned from another of James's contemporaries: 'Un coup de dés ne jamais abolira le hasard.' The calculus of probability leaves the exact position of any element in a system indeterminate from one moment to the next. The aesthetic in James is the unsuccessful attempt to master this potential for randomness in any linguistic or figural system. In acknowledging the counter-entropic force of his project, one should nonetheless resist the temptation to deprive it of the potential to have its configuration altered. Nothing is less in keeping with the spirit of James's own texts than the desire to monumentalize them for all time.

3

Poetics and Music:
Hopkins and Nietzsche

It is now entirely possible that consonance may be reached
only by passing through the most extreme dissonance.
Karl Marx, *Grundrisse*

In the examples considered thus far, Ruskin's aesthetics and
James's poetics of the novel, the aesthetic has proven remarkably
resistant to simple definition and consistent application as a
theoretical category. Despite the continuing promise of the
aesthetic to deliver representation from the notorious in-
determinacy that attends the semantics of natural languages, the
aesthetic itself can hardly be said to operate without ambiguity,
and ultimately contradiction, in the discourse of its theoreticians
and practitioners. On another level, the belief that art offers
liberation from the realm of necessity into the realm of freedom
may now appear to have been based on an ill-founded faith in the
possibility of intuitively apprehending the meaning of aesthetic
signs, or indeed of phenomena generally. The incapacity of
aesthetic judgments to place our intuitions completely above
suspicion condemns art to a more worldly and humble role in
human affairs than its ideologues have consistently claimed for it.
It is therefore more difficult to avoid the conclusion that even
genuine art must almost certainly be ranked among the ideologies.

One might object, however, that the persuasiveness of the case
against traditional conceptions of the aesthetic is severely
compromised by having focused primarily on theoretical texts in
which the modality of the text's language militates against its

attaining a degree of formalization to which other genres of art may legitimately aspire. In the case of Ruskin, the theory of allegory is still indisputably anchored in a semantic universe whose connection to the ideological is hardly in doubt. Had Ruskin lived to see the revolutionary break with visual perspective accomplished by analytical cubism, one could argue, his aesthetic theory might have achieved the thorough liberation from naturalism towards which Turner's later seascapes could only point him. Similarly, James's fiction now appears, for all the attenuation of the material and historical world accomplished by means of syntactic vagueness and figurative complication in his later works, remarkably 'realistic' by comparison with Beckett, Joyce, or Philippe Sollers. To continue with the drift of this essentially historical argument, one could say that certain genres (the essay, the novel) are composed in a transitional phase of art's history, and that they are at best improvised and imperfect forms on the road to more comprehensively formalized art works. It has of course been claimed that each artistic genre itself tends historically towards an ever greater degree of formalization, so that the passage from *The Golden Bowl* to *Ulysses* and finally *Finnegans Wake* and *Nombres* is but a logical and necessary progression in the history of the novel from a relatively non-aesthetic condition to a more purely and completely aesthetic incarnation. Doubtless the most famous formulation of this notion is Pater's dictum that 'all art aspires ultimately to the condition of music.'

The positing of a typology and hierarchy among artistic genres suggests a further step in our argument. We may leave behind, if only for a moment, the domain of theoretical and narrative texts to consider a genre in which the capacity for formalization is considerably greater than in either of these. Lyric poetry not only aspires to the condition of music, it offers instances (in meter and in its various phonic devices) of genuine musicality. In addition, because of the particular example chosen, we will be able to raise theoretical questions posed by the aesthetics of music itself. That the original hierarchy of genres which motivated our choice of texts may prove less stable and certain than was supposed is a possibility that cannot be summarily dismissed. The common-place opinion that lyric poems are more musical (and therefore more fully aesthetic) than prose narratives or essays conceals a difficulty that is itself far from being definitely resolved even in the more specialized branches of contemporary psychology and the physiology of perception: to wit, what is the nature and structure of musical composition? The strength of the traditional view of

music as the least semantic, most purely formal among the arts depends vitally on how this question is answered.

* * * * * * * * *

A few words are perhaps necessary first to justify the seemingly eccentric linking of the two figures named in the subtitle of this chapter. Friedrich Wilhelm Nietzsche and Gerard Manley Hopkins were nearly exact contemporaries: both were born in 1844; Hopkins died in June 1889, some five months after Nietzsche went insane in Turin. Mere contemporaneity, of course, is hardly a sufficient guide either to the problem of direct influence — judging from the present state of the scholarly record, neither knew the work of the other — or to more general questions of intellectual or philosophical affinity. The parallels between Hopkins and Nietzsche, once they have been noticed, however, are striking and significant. Each was touched directly by the tenets of received religion: Hopkins converted to Roman Catholicism during his undergraduate years at Oxford; Nietzsche was the son of a Lutheran pastor. Nietzsche's training for and brief career in classical philology parallels Hopkins's life-long philological interests and studies. Moreover, Hopkins's rank amateurism in the field is possibly not, as one might think, a sign of his distance from Nietzsche, the professor. On the contrary, in the eyes of contemporaries like Wilamowitz, Nietzsche was quite as unprofessional a philologist as Hopkins. During their comparatively short respective careers as university lecturers, each gave courses on rhetoric from which notes have survived providing rich material for understanding the less fragmentary of their productions. Both were interested in music, particularly in the relationship of music to literature, although neither was an accomplished musician. The point of my main title, which will emerge more fully in the course of the argument, alludes to this fundamental topic in the writings of both thinkers. A broadly theoretical problem — the degree to which formal linguistic structures (the domain of poetics) can be said to share features in common with musical forms — justifies the historical and biographical conjuncture suggested in the subtitle. Moreover, the relationship of historical understanding to theoretical concepts, which is at the center of Nietzsche's concern in *Die Geburt der Tragödie*, is directly linked, for Nietzsche at least, to the category of the aesthetic. Hegel's famous definition of the aesthetic as 'das sinnliche Scheinen der Idee' captures the very difficulty Hopkins

and Nietzsche together address: in what sense are ideas manifested in sensory form?

To consider how music and poetry may be related, one obvious place to begin would be the well-known passage in Hopkins's letter of October 1878 to Canon Dixon in which Hopkins recounts the genesis of 'The Wreck of the Deutschland', a passage that could justly be entitled 'the birth of sprung rhythm out of the spirit of music':

> I had long haunting my ear the echo of a new rhythm which now I realised on paper. To speak shortly, it consists in scanning by accents or stresses alone, without any account of the number of syllables, so that a foot may be one strong syllable or it may be many light and one strong. I do not say the idea is altogether new; there are hints of it in music, in nursery rhymes and popular jingles, in the poets themselves, and, since then, I have seen it talked about as a thing possible in critics ... But no one has professedly used it and made it the principle throughout, that I know of. Nevertheless to me it appears, I own, to be a better and more natural principle than the ordinary system, much more flexible, and capable of much greater effects.[1]

The passage has been a touchstone for commentators on Hopkins's poetry, among whom it is generally agreed that the discovery of sprung rhythm was the decisive moment in the break between Hopkins's youthful Keatsian poetry and his mature poetic practice.[2] The common view holds that sprung rhythm is a means of making poetic language approximate the rhythms of speech or of music. On another occasion, Hopkins wrote to his friend and subsequent editor Robert Bridges apropos of 'Spelt from Sibyl's Leaves': 'Of this long sonnet above all remember what applies to all my verse, that it is, as living art should be, made for performance and that its performance is not reading with the

1. *The Correspondence of Gerard Manley Hopkins and Richard Watson Dixon*, ed. Claude Colleer Abbott (London, 1955), pp. 14-15. Citations from Hopkins's other writings refer to the following editions and will be given parenthetically: L —*The Letters of Gerard Manley Hopkins to Robert Bridges,* ed. Claude Colleer Abott (London, 1955); J — *The Journals and Papers of Gerard Manley Hopkins*, ed. Humphry House and completed by Graham Storey (London, 1959); P — *The Poems of Gerard Manley Hopkins*, ed. W.H. Gardner and N.H. Mackenzie, 4th edition (London, 1967); S — *The Sermons and Devotional Writings of Gerard Manley Hopkins*, ed. Christopher Devlin, S.J. (London, 1959).

2. The canonical view was established by Robert Bridges; see his Preface to *Poems of Gerard Manley Hopkins*, 2nd edition (London, 1930), p. 104. See also Paul L. Mariani, *A Commentary on the Complete Poems of Gerard Manley Hopkins* (Ithaca, 1970), pp. 43-5.

eye but loud, leisurely, poetical (not rhetorical) recitation, with long rests, long dwells on the rhyme and other marked syllables, and so on. This sonnet shd. be almost sung' (L,246). A considerable body of further evidence could be adduced from letters and journals to show that Hopkins's poetic theory was founded on an attempt to accommodate poetic language more closely to certain qualities in music, and that sprung rhythm was the principal means for achieving this *rapprochement*. The difficulty, however, lies in the performance of the appointed task. Despite all the good will in the world on the part of Hopkins and his most sympathetic readers, one cannot simply presume its successful realization in Hopkins's poetic practice.

An economical means of engaging this difficulty in Hopkins is to consider his youthful terms for distinguishing between two modes of aesthetic representation: the chromatic and the diatonic. The two terms are taken from music and refer, respectively, to the scales that include or exclude the half-notes. The diatonic scale is structured by parallelism; the chromatic by transition. In the early essay on poetic diction in which this opposition first appears, Hopkins's preference for the diatonic (here called 'marked parallelism') over the chromatic is evident:

> The structure of poetry is that of continuous parallelism, ranging from the technical so-called Parallelisms of Hebrew poetry and the antiphons of Church music up to the intricacy of Greek or Italian or English verse. But parallelism is of two kinds necessarily — where the opposition is clearly marked, and where it is transitional rather or chromatic. Only the first kind, that of marked parallelism, is concerned with the structure of verse — in rhythm, the recurrence of a certain sequence of rhythm, in alliteration, in assonance and in rhyme. Now the force of this recurrence is to beget a recurrence or parallelism answering to it in the words or thought and, speaking roughly and rather for the tendency than the invariable result, the more marked parallelism in structure whether of elaboration or of emphasis begets more marked parallelism in the words and sense. And moreover parallelism in expression tends to beget or passes into parallelism in thought. (J,84-5)

To the degree that verse possesses structure, it exhibits parallelism, and parallelism is in principle diatonic. But the matter is soon complicated when the text asserts that chromatic art, too, exhibits parallelism: 'To the marked or abrupt kind of parallelism [i.e., the diatonic] belong metaphor, simile, parable, and so on, where the effect is sought in likeness of things, and antithesis, contrast, and

so on, where it is sought in unlikeness. To the chromatic parallelism belong gradation, intensity, climax, tone, expression (as the word is used in music), *chiaroscuro*, perhaps emphasis ...'(J,85). Diatonic parallelism is at first equated with structure as such, but it turns out that the more highly articulated a structure becomes, the more it appears to have no structure at all, that is, to be chromatic. This paradoxical fact about the formal properties of aesthetic objects is described in a series of notes on Greek philosophy written a few years later: 'The further in anything, as a work of art, the organisation is carried out, the deeper the form penetrates, the prepossession flushes the matter, the more effort will be required in apprehension, the more power of comparison, the more capacity for receiving the synthesis of (either successive or spatially distinct) impressions which gives us the unity with the prepossession conveyed by it' (J,126). A sharp distinction between the chromatic and the diatonic is mediated in this passage, which asserts that the more fully elaborated diatonic structure becomes in a work of art, the closer the intervals approach to chromatic transitions. The more highly and intricately structured the work, the more it will appear to be devoid of structure or organization: 'the more effort will be required in apprehension, the more power of comparison.' The sensory features of the sign, whether they be auditory or visual, are necessarily mediated by the structure of the relations among the elements in the work, a structure that can only be apprehended in a cognition. Hopkins's aesthetic theory, like Kant's, holds that the aesthetic structure of a work cannot be determined solely by considering its sensory features, but requires comprehension of its logical form as well. Whether or not these two aspects of works of art are entirely commensurable is just the question.[3]

The difficulty of commensurating sensation and cognition can be illustrated in a reading of a poem. 'As kingfishers catch fire' recommends itself on a number of grounds. The poem is familiar

3. Hopkins's appeal to musicological concepts to represent general aesthetic structures is hardly fortuitous. Its Kantian provenance (which Hopkins might readily have assimilated from his tutor Walter Pater) determines Hopkins's theory in an entirely predictable manner. While I am not competent to judge whether Hopkins has accurately represented the phenomena denominated by the technical terms 'chromatic' and 'diatonic', it would seem that his speculations on problems of aesthetic structure are at least not totally at odds with technical developments in musical composition that followed in the wake of post-Wagnerian music and the recognition of dissonance as a conventional structure rather than a natural phenomenon; cf. Charles Rosen, *Arnold Schoenberg* (New York, 1975), pp. 24-7; 42; 57-61; 96-104.

to most readers of Hopkins and has often been cited in explications of his aesthetics. In addition, it stands in a long line of English lyrical poems, including Hopkins's own 'The Windhover', whose explicit or covert theme is the accommodation of natural phenomena within an overarching metaphysical or ideological (in Hopkins's case overtly theological) scheme which the phenomena express. Man and nature, the divine and the natural, the divine and the human — these are the polarities that structure and are harmonized in the expressed ideology of what has been termed the 'major Romantic lyric'. Finally, and most interestingly in the present context, 'As kingfishers catch fire' openly asserts the connection between the cognitive intention of signs and their sensory appearance:

> As tumbled over rim in roundy wells
> Stones ring; like each tucked string tells, each hung bell's
> Bow swung finds tongue to fling out broad its name. (P,90)

This 'sensory appearance of the idea' can without difficulty be assimilated to an incarnationist reading of the poem and of Hopkins's theology. It can also be made to complement numerous interpretations of texts like 'The Windhover' and 'The Wreck of the Deutschland', in which the aesthetic structure of the poem, it is claimed, exemplifies the doctrinal truth of Christ's taking flesh and entering into human history. The poem itself makes this very assertion in the sestet:

> I say more: the just man justices;
> Keeps gráce: that keeps all his goings graces;
> Acts in God's eye what in God's eye he is —
> Chríst. For Christ plays in ten thousand places,
> Lovely in limbs, and lovely in eyes not his
> To the Father through the features of men's faces.

The canonical reading is summarized by W. H. Gardner: 'God the Son assumes *all* Nature; hence the individual, intrinsic degree of Christ sums up the degrees of all men. The whole sonnet is a poetic statement of the Scotist concept that the individual substances, according to the metaphysical richness of their being, make up one vast hierarchy with God as their summit' (P,281). An otherwise manifest cacophony of sounds produced by the infinity of individual voices in nature is harmonized in the presence of Christ, the Word, in creation. The threat to the orderly structure of nature posed by what Hopkins here calls 'selving' ('Each mortal

thing does one thing and the same:/Deals out that being indoors each one dwells;/Selves — goes itself, *myself* it speaks and spells,/Crying *What I do is me: for that I came*') is avoided in the perspective in which nature is beheld by God through the agency of the Incarnation. There is of course an obvious shift from sound to sight between the octave and the sestet, but this is comparatively trivial, since the ordering of the sensory data of experience could easily be hierarchized (sight being taken as the organizing structure for sound, or vice versa) according to the same principles alluded to by Gardner. The point of the poem is not to determine whether seeing and hearing are commensurable, for surely they are (as, for example, in Baudelaire's 'Correspondances', a poem whose assertion of the analogy of being, despite its theological heterodoxy, closely resembles that proposed in Hopkins). The point, rather, is to establish the cognitive perspective in which all sensation is ordered. God, on this view, is the site of the regulative categories of understanding, and Christ is the phenomenal entity structured by the categories as a perception. This is to say that Christ is the aesthetic object *par excellence,* in Hegel's words, 'the sensory manifestation of the idea'.

This reading could be elaborated to encompass analyses of the rhyme scheme, the metrical organization, and other specifically sensory features of the poem's structure. It would not be difficult to harmonize these features into a univocal structure that is commensurable with the semantic or logical structure exemplified by Gardner's reading. Although Hopkins's poetry may not always, by neoclassical standards, fail to 'give offence' by its 'harshness', it would nonetheless be in keeping with the general drift of his thought to observe Pope's famous dictum: 'The sound must seem an echo to the sense.' In Hopkins's terms: 'parallelism in expression tends to beget or passes into parallelism in thought.'

An obvious example of this principle in 'As kingfishers catch fire' would be the half-line 'the just man justices.' The semantic content, which asserts the identity between a quality (being just) and an action (to justice — the noun here being employed, against conventional usage, as a verb), is 'echoed' in the phonic similarity realized in the polyptoton. This sort of harmonizing of sound with sense, of sensory with semantic features of signs, could be extended virtually without limit in the poem, from the alliteration between 'kingfishers' and 'catch' and 'dragonflies' and 'draw' in the opening line, to the alliterative chain from 'Father' to 'features' to 'faces' in the last. Nothing is more familiar in exegeses of Hopkins, and other poets as well, than the claim for the aesthetic

unity of a work based upon the congruence of the work's phonic and semantic features.

But not every instance of sound echoing sense exemplifies the semantic commensurability of the entities illustrated by the resemblance between 'just' and 'justices.' In the lines 'Each mortal thing does one thing and the same:/Deals out that being indoors each one dwells;/Selves — goes itself, *myself* it speaks and spells,' the alliteration of 'speaks' and 'spells' attempts to gloss over a semantic split between the two actions that would disrupt the aesthetic unity of the entire poem. Speaking is an instance of denomination or 'selving' (the term used by Hopkins here and elsewhere), which the octet asserts is the characteristic action of all things in the world. Each 'mortal thing' 'finds tongue to fling out broad its name.' In the terminology of speech act theory, the constative significance of the proposition is exhausted in the performative action of its utterance. But spelling, which the alliteration suggests should be commensurable with speaking, denotes an altogether different action, the performance of which shatters the unity of action and being (*'What I do is me'*) achieved in speaking or denomination. To speak 'myself', that is, to utter the word, is to perform an action that, on the evidence of the poem's explicit assertion, exhausts the being of the utterer. 'I am I', or, 'I am Gerard', or more precisely, 'I am Gerard Manley Hopkins' — all of these propositions are the 'one thing and the same' that the poem claims 'each mortal thing does'. But to *spell* 'myself', that is to pronounce each letter in the order given in the lexicon, m-y-s-e-l-f, is in effect to dismember the word — and not even to the level of the morphemes, *my* and *self*, but to the level of the letters, so that the constitutive elements of language exhibit no connection between sensory datum (visual or auditory) and semantic significance. Spelling 'myself' abolishes precisely that unity of the self in its action which speaking accomplished and which the poem as a whole attempts to protect — for example, in the next half-line: 'Crying *What I do is me.*' But if 'what I do' is not merely to speak my own name but also to spell it, the unity of my being with my action is no longer manifest. To spell a word disarticulates the harmony between sound and sense upon which its unity as an aesthetic object depends, for the sensory appearance of the letters themselves has no connection with any determinate semantic content, or, to recall Hegel once more, with any idea.[4]

4. To forestall the obvious objection that the reading is forced by considering only one meaning of the word 'spell', it should be noted that the possibility of

This shattering of the identity of the self in its phenomenal manifestation is immediately acknowledged in the poem's next line: 'Í say more.' But who or what is this 'I' which can say more than 'I'? What kind of entity or being can exist that is not exhausted in its own activity of self-utterance? To what does this 'I' refer? The obvious answer is the poet, and to give it would seem to save the poem from contradiction, for then the 'I' speaking here would be the voice that has uttered the entire poem and could therefore be said to be entirely consumed in its utterance: the poem speaks itself and nothing more. But the salvaging of the poem's coherence is only temporary. The next half-line and the five lines that follow assert much more than the poem's self-proclamation of its own being. The 'more' which this 'I' says is nothing less than the knowledge of the ontological status of all things in the world. In order to assert that 'the just man justices', this 'I' would, *ex hypothesi*, have to be God Himself, since only from the perspective of divine omniscience can it be known that 'the just man justices;/Keeps gráce' and 'Acts in God's eye what in God's eye he is — Chríst.' Either what the 'I' says is empty, which is not at all a comforting thought (although one that would occur to Hopkins with increasing frequency in subsequent poetry), or it is blasphemous — the 'I' which speaks the poem occupies the same perceptual position as the 'eye' of God. Only in God's eye, the poem explicitly asserts, can it be the case that 'the just man justices.' Insofar as the poem is a 'mortal thing', it cannot possibly speak the sestet. The poem cannot, therefore, speak itself, or, at best, it possesses features of which it can have no knowledge. This does not at all prevent the poem from performing the action of the

construing the word in other ways (as is done, for example, apropos of the same word in 'Spelt from Sibyl's Leaves', in Michael Sprinker, *A Counterpoint of Dissonance: The Aesthetics and Poetry of Gerard Manley Hopkins* [Baltimore, 1980], pp. 124-5) does not affect the point at issue here: to wit, whether the relationship between meaning and sound is an entirely natural and harmonious one. The potential to recuperate other meanings of 'spell' within a structure of aesthetic unity cannot avoid the challenge to its power presented by the disarticulation of sound from sense in spelling except by an arbitrary fiat which suppresses or denies the construal of 'spell' as signifying the utterance of individual letters. A reading of the poem that ignores or disallows the threatening construal of 'spell' would itself 'speak' the poem but not 'spell' it, would fail, that is, to read the poem entirely literally. Textual warrant elsewhere in Hopkins for taking 'spell' as a mode of signifying is given both in S, p. 305, n. 195.4, as well as in Robert R. Boyle, S.J., 'The Thought Structure of *The Wreck of the Deutschland*', in *Immortal Diamond: Studies in Gerard Manley Hopkins*, ed. Norman Weyand, S.J. and Raymond V. Schoder, S.J. (New York, 1949), p. 335.

sestet, but the performance of the utterance is radically at odds with the constative significance it asserts, to the point that the sestet cannot mean what it says because it has been deprived by the argument of the octet of the capacity to say what it appears to mean. Another way of putting this, of spelling it out more explicitly, is that the sensory features of the poem, the poem's speaking, manifest no idea whatsoever. The poem is not aesthetic and cannot, therefore, be like Christ.[5]

The argument has strayed somewhat from the topic of poetics and music, but the detour through a poem in which the possibility of harmonizing sound with sense is denied by the incompatibility in the poem's structure between performative and constative language has shown how the concept of poetic language in Hopkins is related to theological and philosophical problems of great personal urgency for the poet. This insight can be readily applied to other, non-poetic texts, for example to Hopkins's devotional writings, in which the figure of Lucifer is represented metaphorically in the act of musical performance:

> This song of Lucifer's was a dwelling on his own beauty, an instressing of his own inscape, and like a performance on the organ and instrument of his own being; it was a sounding, as they say, of his own trumpet and a hymn in his own praise. Moreover it became an incantation: others were drawn in; it became a concert of voices, a concerting of selfpraise, an enchantment, a magic, by which they were dizzied, dazzled, and bewitched. They would not listen to the note which summoned each to his own place (Jude 6) and distributed them

5. The conclusion reached here raises questions about incarnationist readings of other poems, for example, 'The Windhover', in which the dedication, 'To Christ Our Lord', has been taken as a warrant for interpreting the text as a poetic *imitatio Christi* (see Gardner's commentary in P, 267-8; and Sprinker, pp. 4-15, where the attempt to avoid the orthodox theological reading of the poem reconstitutes the immanence of language to the world at the level of the poem's formal structure). In addition, the incompatibility between the posited aesthetic structure and the literal significance of the language in 'As kingfishers catch fire' undermines the power of claims to interpret Hopkins's poetry as an instance of genetic schemas of birth and decay (see, for example, Sprinker, pp. 96-145). The relationship of late Hopkins texts like 'Spelt from Sibyl's Leaves' or the so-called 'terrible sonnets' to earlier writings like 'The Wreck of the Deutschland' would have to be reconsidered in light of the incompatibility between the aesthetic and the linguistic structure in 'As kingfishers catch fire'. It would no longer be possible to attribute the difficulty Hopkins encountered in writing poetry late in life directly and unambiguously to the poet's spiritual despair, since the very problems thought to have influenced his darkening emotional outlook, preeminently the conviction that poetry and the imitation of Christ were completely at loggerheads, were already constitutive features of his poetic practice in his earlier, ostensibly happier period.

here and there in the liturgy of the sacrifice; they gathered rather closer and closer home under Lucifer's lead and drowned it, raising a countermusic and countertemple and altar, a counterpoint of dissonance and not of harmony. (S,200-1)

The passage reworks the opposition between the chromatic and the diatonic from Hopkins's undergraduate paper on poetic diction. The proper, harmonious, hierarchically organized music of God — 'the note which summoned each to his own place' — would be diatonic; the dissonant music of Lucifer would be chromatic. In addition, the familiar terms of Hopkins's poetic epistemology, instress and inscape, are associated with the music of Lucifer, thus linking the production of poetry to the dissonant, chromatic music of the devil, rather than to the diatonic music of God. One is reminded of the hero of Thomas Mann's *Doktor Faustus*, Adrian Leverkühn, whose musical genius derives from a pact with the devil. To think of Leverkühn, or indeed of Thomas Mann, is also to think of Nietzsche, and most pertinently of the latter's meditation on music and poetry, not only because of the historical connection of these topics in German literature and thought, but also because the concept of dissonance presented in the passage from Hopkins's devotional writings is at the center of the Nietzschean theory of tragedy.

* * * * * * * * *

In the penultimate section of *The Birth of Tragedy*, Nietzsche identifies the experience of the Dionysian with the 'pleasurable sensation [*die lustvolle Empfindung*]' of musical dissonance, which is at the same time the very representation of the 'artistic game' that 'the will, in the eternal fullness of its pleasure, plays with itself.'[6] Similarly Hopkins recognized in Lucifer's rebellion against the divine harmony an instance of what he called the arbitrium or elective will. It would be incorrect, however, to interpret this passage as a simple moral condemnation of an aberrant aesthetic form. It is by no means certain whether the dissonance referred to is a perversion of an original harmony, or the constitutive conditon for the existence of any music whatsoever. In Nietzsche,

6. Friedrich Nietzsche, *Die Geburt der Tragödie*, in *Werke: Kritische Gesamtausgabe*, ed. Giorgio Colli and Mazzino Montinari (Berlin, 1967-), III.1:148. References to this and other of Nietzsche's texts are to this edition, hereafter cited parenthetically as W. Translations are from the Kaufmann version of *The Birth of Tragedy* (New York, 1967), occasionally modified.

this problem is thematized in the relationship of Apollo to Dionysus, the deities of Greek religion. In Hopkins's Christian rendition, the genetic historical schema is figured in the Scotist doctrine of the Incarnation, according to which Christ's being is before time (S,113-14). In the musical cum theological terminology of the passage from his devotional writings quoted previously, this concept translates into the insight that the song of Lucifer, far from being a derivation from or subsequent deformation of an original divine harmony, is a necessary moment in a dialectical structure generated by the opposition between divine harmony and satanic dissonance. This insight sets the stage for a return to Nietzsche, in whose *Birth of Tragedy* the relationship between theoretical concepts and historical understanding is explored in sufficient detail to shed light on a problem that emerges only intermittently in Hopkins's writings. This is not to suggest that theological or even poetic questions must be laid aside when one turns to history — far from it, as the exposition of Nietzsche will show — but that the poetic and theological impasse reached by Hopkins is entangled in problems of historical understanding which Nietzsche's text may potentially illuminate.

One method of approaching the problem of history in Nietzsche is to examine the textual history of *The Birth of Tragedy* itself. A convenient means for this purpose lies to hand in the recent commentary by M. S. Silk and J. P. Stern, *Nietzsche on Tragedy*.[7] The third chapter of this book bears the subtitle 'the genesis of *The Birth of Tragedy*'; it presents a detailed itinerary of the emergence of Nietzsche's text out of his early lecture courses in the University of Basle and from his more general interests in music and philosophy. Silk and Stern argue that the genesis of the text marks a moment of decisive convergence among Nietzsche's varied interests, one that 'reflects his first full-scale, and characteristically self-conscious, attempt to oppose fragmentation in favour of a whole response to experience' (NT,31). In Nietzsche's own terms, *The Birth of Tragedy* would, on this view, be an Apollonian rather than a Dionysian achievement. That Nietzsche himself subsequently said just the opposite (in the 'Versuch einer Selbstkritik' appended to the reissue of the treatise in 1886) should put one on guard against presuming that the text's history and, *a fortiori*, its structure will necessarily prove to be entirely coherent.

The origins of *The Birth of Tragedy* go back in Nietzsche's life

7. M.S. Silk and J.P. Stern, *Nietzsche on Tragedy* (Cambridge, 1981); hereafter cited parenthically as NT.

several years before the writing and publication of the work. Silk and Stern cite three focal points of influence: Schopenhauer, Greece, and Wagner (NT,17-30). Each affected Nietzsche in different ways, but the central polarity, around which the text of *The Birth of Tragedy* itself will turn, is represented by Nietzsche's dualistic conception of Greece. Silk and Stern illustrate the opposition by citing two different modes of apprehending Greek culture regnant in the Germany of Nietzsche's day: Winckelmann's, for whom Greece was an object for imitation in the classical notion of *Bildung*; and Wolf's, the father of academic philology and the representative of scientific discipline (NT,24). The opposition of science to art is figuratively realized in the antagonism between Socrates and tragedy in the published text. To rest with this opposition, however, would threaten the integration Silk and Stern claim is the special achievement of *The Birth of Tragedy*. The potential antinomy is quickly subsumed under the aegis of Wagner, whose *Zukunftsmusik* became the model for its transcendence: 'Wagnerian music in general had now [by late 1868] taken its hold and was irresistibly leading Nietzsche to admit a response diametrically opposed to the objectivity that had commended itself to him before' (NT,28). Wagner would even recuperate an earlier enthusiasm for Schopenhauer, since the composer 'began to assume ... a heroic, aesthetic, *Schopenhauerian* status' (NT,29; emphasis in the original) in Nietzsche's philosophical universe.

Wagner's situation in the history of music and opera is summarized in terms familiar from our discussion of Hopkins: 'lovers of the traditional harmonic idiom and formal structuring in which German music had excelled since Handel and Bach' were opposed by the *Zukunftsmusik* 'represented by Berlioz, Liszt, and above all, Wagner, whose restless chromatic explorations ... most radically undermined traditional diatonic stability.' The chromaticism of Wagner's music was generalized as a formal principle in the structure of the opera as a whole which had traditionally maintained a strict opposition between dramatic action, reserved for non-musical dialogue or recitative, and music, the purest embodiment of which was the aria. Wagner's innovation was to employ 'music as a means to a dramatic end' and thereby to destroy the conventional diatonic separation between music and drama (NT,25). Here again, it is not difficult to see in these oppositions and in the formal problems which they figure versions of the themes that will be presented in *The Birth of Tragedy*, preeminently the opposition of Apollonian plastic art to

Dionysian music. On this account, Wagnerian opera would be the overcoming of the strict opposition between drama and music, just as Attic tragedy was the synthesis of Apollo and Dionysus. Evidence for this view exists in Nietzsche's dedication of the first edition of *The Birth of Tragedy* to Wagner and in the ostensibly Wagnerian final sections of the text (*Tristan* is discussed in section 21), as well as in the title of Wilamowitz's famous attack, *Zukunftsphilologie,* which equates Wagnerian 'music of the future' with what he believed was the spurious 'philology of the future' in Nietzsche's book.

Despite their acceptance of the influence of Wagner on Nietzsche, Silk and Stern contend that *The Birth of Tragedy* is not merely a tract for the times in celebration of Wagnerian music. They show with great authority that the published text, however Wagnerian in inspiration, was finally not Wagnerian in substance. One could summarize their account by saying that *The Birth of Tragedy* is a Wagnerian book from which the presence of Wagner is gradually effaced in revision (NT,59-60). This would accord with their generally Apollonian view of the text. Elements with the potential to disrupt the integrity of Nietzsche's philosophical project are either rejected or revised in order to preserve the harmonious structure of Nietzsche's then recently achieved integrated vision.[8] The genetic model of Nietzsche's development as a thinker produces a concept of the text as a historical totalization of its own past in which the *telos* of an integrated

8. Silk and Stern are in agreeement on this point with Paul de Man whom they otherwise treat rather harshly (NT, 427, n. 72). De Man writes: 'The unpublished fragments, contemporaneous with the main text, deny this very possibility [of a unified teleological narrative structure] and thus reduce the entire *Birth of Tragedy* to being an extended rhetorical fiction devoid of authority. "One could object that I myself have declared that the 'Will' receives an increasingly adequate symbolic expression in music. To this I reply, in a sentence that summarizes a basic principle of aesthetics: *the Will is the object of music, but not its origin*" (Musarion, 3:344). This sentence could never have stood in the final version if *The Birth of Tragedy* had to survive as a text' (*Allegories of Reading: Figural Language in Rousseau, Nietzsche, Rilke, and Proust* [New Haven, 1979], p. 101).

The effacement of these obvious features of contradiction from the published text may be the reason commentators (even so scrupulous a one as de Man) have been led to assume the formal coherence of *The Birth of Tragedy.* Moreover, it is even possible if one takes at face value some of the assertions which the text does undeniably make, to attribute to the text a naive Schopenhauerian view of music, and to turn Nietzsche into an ideologue of aestheticism along the lines of Pater and Valéry. See, for example, John T. Irwin, 'Self-Evidence and Self-Reference: Nietzsche and Tragedy, Whitman and Opera', *New Literary History* 11 (Autumn 1979): 185-92. Such readings necessarily and systematically ignore the complication imposed by the text's rhetorical mode. The point is elaborated below.

structure can now be seen, in the fullness of present knowledge, to have been that towards which events occurring in an apparently random and disordered manner in the past had in reality been tending all along. Nietzsche himself expressed considerable doubt about this concept of the text, whose confident tone he came to mistrust, recognizing it as a symptom of the text's erstwhile philosophical bad conscience:

> What spoke here — as was admitted, not without suspicion — was something like a mystical, almost maenadic soul that stammered with difficulty, a feat of the will, as in a strange tongue, almost undecided whether it should communicate or conceal itself. It should have sung [*Sie hätte singen*], this 'new soul' — and not spoken [*und nicht reden*]! What I had to say then — too bad that I did not dare say it as a poet: perhaps I had the ability. Or at least as a philologist: after all, even today practically everything in this field remains to be discovered and dug up [*zu entdecken und auszugraben*] by philologists! Above all, the problem that a problem exists [literally, lies before — *vorliegt*] here — and that the Greeks, as long as we lack an answer to the question 'what is Dionysian?' are as totally unknown and unrepresentable [*gänzlich unerkannt und unvorstellbar sind*] as ever. (W.III.1.9)

The passage is a virtual reprise of the figural structure of *The Birth of Tragedy*, which it appears to comment on critically and potentially to transcend. Nietzsche finds fault with the 'speaking' text, whose will falters and produces the characteristic stammer in the text's voice.[9] He suggests that this defect might have been overcome had the text been capable of singing. The argument thus establishes a conceptual opposition between song (*singen*) and speech or ordinary language (*reden*), which is the very opposition figured in *The Birth of Tragedy* between the prosaic language of philosophy and science (represented by Socrates) and musical expression (embodied in tragedy). Nietzsche seems here to consider his text comparable to the Platonic dialogue described in section fourteen: both strike an unsatisfactory bargain between conflicting modes of presentation. The transcendence of stammering could have been achieved in poetry, which would have

9. The textual stammering in *The Birth of Tragedy* is treated definitively in Carol Jacobs, *The Dissimulating Harmony: The Image of Interpretation in Nietzsche, Rilke, Artaud, and Benjamin* (Baltimore, 1978). pp. 3-22, 121-4. Her focus is on the preliminary fragments rather than on the completed text; however, as she argues, following de Man, the conceptual structure of the fragments undermines the authority of the book from which they were finally excluded. Silk and Stern do not consider her work in their commentary.

served the function for Nietzsche that tragedy served in Greek culture or that, if one takes Nietzsche's youthful Wagner enthusiasm at face value, Wagnerian opera was supposed to serve in Germany.

The sufficiency or authority of poetry as a mode of expression is, however, short-lived. Nietzsche immediately compromises the power of his model by saying that he might well have expressed himself as a philologist, that is, as a scientific thinker and observer in the tradition of Socrates. Nothing could authorize the belief that philological investigation can reach the truth about Greek culture except the very Socratic optimism upon which science is founded and to which tragic pessimism is inexorably opposed. Nietzsche implicitly concedes the justice of Wilamowitz's criticisms, saying that he ought to have been a better philologist than he was in writing *The Birth of Tragedy*. He is, at the same time, critical of the achievements of philology to date, for 'everything in this field remains to be discovered and dug up', the problem of Greek culture 'lies before' and not behind historical science. But this in no way undermines, at this moment at least, his faith in historical and philological investigation. The continuing ignorance of scientists concerning fundamental aspects of the objects of knowledge they interrogate is simply the normal condition of any empirical science. Far from being a sign of the defeat of the scientific project, this merely confirms that one is proceeding in a scientifically valid manner. Nietzsche is as orthodox as any Popperian on this point. Moreover, he recognizes that, like a good scientist, he had discovered a genuine problem in writing *The Birth of Tragedy*, and one that still remained to be solved: what is the Dionysian? This is the key concept that the historical science of philology must investigate and explain. But even presuming, as Nietzsche seems to do, that philology can illuminate the problem and produce knowledge adequate to the phenomenon designated by the concept, there remains the unresolved question of an appropriate mode of expression: how can such knowledge be represented? It cannot be assumed, given the circumspection with which Nietzsche approaches the question here, that the demands of knowledge (*Erkenntnis*) and representation (*Vorstellung*) can be easily reconciled.

The problem Nietzsche had already glimpsed in *The Birth of Tragedy*, that any *rapprochement* between knowledge (Dionysus) and representation (Apollo) would entail the achievement of a wholly new form of expression (tragedy), remains as alive for Nietzsche as it was for the Greeks. The 'Versuch einer Selbstkritik'

ends with a quotation from *Also sprach Zarathustra*. Whether the laughter commended to 'higher men' in that passage represents knowledge, or merely points towards a knowledge that is not susceptible of representation, is not immediately clear in the context. To decide what Nietzsche meant by pointing to Zarathustra would necessitate a hermeneutical itinerary from *The Birth of Tragedy* through *Also sprach Zarathustra* and beyond; it would, in short, entail the same kind of historical and philological inquiry Nietzsche recommends to students of Greek culture but implicitly gives up in his own practice by citing Zarathustra rather than undertaking further philological study. The alternatives of philological science and poetry remain as forcefully opposed for Nietzsche in 1886 as they had been in 1871-2.

Enough has been said to cast considerable doubt upon the Silk and Stern hypothesis that Nietzsche's thought during the final composition of *The Brith of Tragedy* achieved an integration of the conceptual elements which formed the basis of the text. But of course Nietzsche's late commentary on his own text may not be reliable; what is said in 1886 does not necessarily provide an authoritative view on what was written in 1871. This raises the problem on which Carol Jacobs and Paul de Man have commented: the relationship between the ancillary material surrounding *The Birth of Tragedy* and the structure or argument of the text published in 1872. The subsequent criticisms made by Nietzsche himself can be considered part of this same theoretical question, which concerns the possibility of reconstructing the authorial intention in a text from conflicting data concerning the text's production. The straight way to a solution would be simply to ignore all the material that lies outside the published text, perhaps even setting aside the author's subsequent reflections because they could not possibly duplicate his thoughts at the time of composition.

No one, in the case of *The Birth of Tragedy*, is willing to overlook entirely the evidence provided by recent scholarship. The task these materials present to the interpreter of *The Birth of Tragedy* is to give an account of the text's formal intentions that establishes protocols by which extratextual evidence (be it the preliminary fragments, the 'Versuch einer Selbstkritik', or other writings by Nietzsche, published and unpublished) can be judged relevant or not to understanding the text. The question posed is as follows: how can the textual structure of *The Birth of Tragedy* be most accurately characterized? Is it a unified meditation, a coherent expression of mature speculation, a text of Socratic optimism, as

Silk and Stern tend to argue? Or is it a dissonant, even incoherent text, a sometimes embarrassing symptom of the youth of the author, as Nietzsche himself later claimed and as Walter Kaufmann affirms?[10] Silk and Stern believe that the text is admirably scientific or aesthetic, Nietzsche that it was never either musical or scientific enough, Kaufmann that it is too poetic by half.

Readers familiar with *The Birth of Tragedy* will recognize in this dilemma a version of Nietzsche's analysis of the two poles of Greek culture represented by Apollo and Dionysus. Insofar as *The Birth of Tragedy* can be said to repress or sublimate (NT,66) those elements which would threaten the integrity of its structure, it would be a classically Apollonian text, for this is precisely how the Apollonian myth of the Olympian gods manages and contains the disruptive Dionysiac knowledge of existence: 'The Greek knew and felt the terror and horror of existence: in order to be able to live at all, he had to raise up before him [*vor sie hinstellen*] the radiant dream-birth of the Olympians' (W.III.1:31). As in Freud, repression of what cannot be contemplated without pain erects a barrier against the threatening knowledge or feeling, such that the psyche, or here the Apollonian Greek, is shielded from the unpleasurable experience of beholding the truth. The aesthetic transfiguration (for such Nietzsche designates it a few sentences later) of knowledge is an operation of a perceptual system that blocks or inhibits the production of affect: the horrific is made beautiful only when it is blotted out or kept from sight by a vision of the Olympian gods. An Apollonian reading of the text is therefore a preservation of the text's integrity, indeed, to take Nietzsche at his word here, of the text's very life: 'in order to be able to live at all [*um überhaupt leben zu können*].'

The confidence with which this view is asserted of Nietzsche and of the aesthetic modality of *The Birth of Tragedy* is perhaps less a sign of the validity of its understanding of the text than a symptom of the repression that must be practiced in order to sustain it. Nor is it simply the case that the text itself, by suppressing the ancillary material surrounding it, has successfully accomplished the repression which the reading then reproduces. The relationship of art to existence, which is here posited as antithetical, turns out to be complementary. Art (*Kunst*) and existence (*Dasein*) are part of a single process or structure in which art is not the denial of existence

10. Kaufmann's view is expressed in his Translator's Introduction to *The Birth of Tragedy*, ed. cit., pp. 3-13; hereafter cited parenthetically as BT.

but its fulfilment: 'Derselbe Trieb, der die Kunst in's Leben ruft, als die zum Weiterleben verführende Ergänzung und Vollendung des Daseins, liess auch die olympische Welt entstehen, in der sich der hellenische "Wille" einen verklärenden Spiegel vorhielt. So rechtfertigen die Götter das Menschenleben ...' (w.III.1:32). The crux of the matter comes in the participial phrase that modifies *Kunst*. Nietzsche's double designation of art as 'complement and consummation' (Kaufmann's translation) suggests that art is at once a part of existence, its *telos* perhaps (*Vollendung* — fulfilment), and outside of or supplementary to it (*Ergänzung* — supplement or amendment, as in an amendment to a law). Art 'seduces' or 'leads astray' (*verführen*), even though this wandering from the path of truth is a necessary detour in the journey of *Dasein*, its completion or consummation. If the gods justify (*rechtfertigen*) the life of men, they can do so only in the manner of art itself, which can no more elude the necessary itinerary mapped out by *Dasein* than subatomic particles can avoid obeying the laws of quantum mechanics. This is to conceive of art as an ontologically necessary phenomenon, as in the famous formulation some pages later: 'nur als aesthetisches Phänomen ist das Dasein und die Welt ewig gerechtfertigt' (w.III.1:43). This sentence could only be spoken from a position of truth and knowledge, from the standpoint of *Dasein*. At the moment it utters this proposition, the text could not be Apollonian, i.e., aesthetic, since it is the very condition of art, in Nietzsche's figural scheme, to be deprived of knowledge.

When the same thought appears later in the text, a slight change in wording produces a potentially different position in the utterance: 'nur als ein aesthetisches Phänomen das Dasein und die Welt gerechtfertigt erscheint' (w.III.1:148). The difference between 'ist gerechtfertigt' and 'erscheint gerechtfertigt' is just the difference between being and appearing which marks the distinction between existence (truth, knowledge) and art (illusion), or, in the terminology of this text, Dionysus and Apollo. To the degree that *The Birth of Tragedy* is Apollonian, it can perform the action of its utterance: it can speak sentences like the ones just quoted and thus make existence and the world appear as justified. It reconciles us to our fate. But if this is the modality of the text, then the authority of its statements is denied, and its power to reconcile or comfort is severely compromised. The truth stated by the text deprives it of the power to state the truth aesthetically, which is nevertheless the only mode in which this truth can be made to appear. The text can enact an aesthetic performance, or it

can state the truth about the aesthetic in the mode of knowledge, but it cannot know that its performance is only an illusion, not if it is to remain an integrated structure. As in the relationship between octave and sestet in the Hopkins sonnet, 'As kingfishers catch fire', so here too an impasse is reached in the incompatibility between the performative power and the constative significance of an utterance.[11]

This insight leads to a reconsideration of the structure of the text in which moments of ostensibly Socratic optimism — in the last ten sections where the rebirth of tragedy in 19th-century Germany is prophesied,[12] or in the apparent confidence with which Nietzsche narrates the history of the genesis of tragedy in Greek culture in sections 1-10 — now appear in a different light. It may be that the whole of *The Birth of Tragedy* is neither a tract for Socratic optimism, nor a mournful lament in the spirit of tragic pessimism, nor even an Apollonian representation successfully masking Dionysian truth. Rather, *The Birth of Tragedy* can be seen to have retained traces of its fragmentary origins that reverberate through the text with a dissonant shudder. The point can be illustrated by focusing on several passages which have not been entirely overlooked in previous commentaries, but which have perhaps not been put in just the right light.

The problem Nietzsche faces is to discover a mode of representation that will articulate the essential knowledge of the

11. One is therefore constrained to disagree with Benjamin Bennett who in an otherwise judicious exposition of the mutual implication of the Apollonian and the Dionysian in Nietzsche's text claims that *The Birth of Tragedy* overcomes in its own rhetorical mode (what Bennett calls 'aesthetic science') the impasse of aesthetic theory from Lessing and Schiller down to Schopenhauer: 'Simply by being, on the one hand, "wissenschaftlich," Socratic, epistemologically scrupulous and dealing, on the other hand, with the metaphysical forces of art, calling attention directly to the unfathomable mystery of music, Nietzsche's book attempts not only to describe but also to *be* "the birth of tragedy," the crucial historical meeting ground of two forces that, once joined, will tend to realize Socratism's artistic destiny' ('Nietzsche's Idea of Myth: The Birth of Tragedy from the Spirit of Eighteenth-Century Aesthetics', *PMLA* 94 [May 1979]: 420-33). Nietzsche's own doubts about the success of the representational mode of his text are simply set aside in Bennett's argument.

12. Kaufmann's suggestion that these sections could be dropped altogether without significant impairment to the argument of the book — and with substantial gains for its formal integrity and the value of its historical insights — suggests the difficulty of harmonizing all elements of the published text, as well as the powerful impulse the text imposes upon its readers to make it a unified and coherent whole — even when this would involve amputating as much as a third of its body (see BT, 98-9, n. 11).

Dionysian with the aesthetic mode of the Apollonian. For the moment, the question of whether his own text was presented in such a mode or not can be set aside in order to concentrate on the possibility of a solution to the conceptual dilemma it poses. The system that brings together, unifies, harmonizes Apollonian illusion with Dionysian knowledge, appearance and essence, poetry and music, is Attic tragedy, the origin and significance of which is given definitive exposition in sections 7-10 of *The Birth of Tragedy*. On the formidable authority of Aristotle, Nietzsche states that tragedy 'arose from the tragic chorus': 'die Tragödie aus dem tragischen Chore enstanden ist und ursprünglich nur Chor und nichts als Chor war ...' (w.III.1:48). Nietzsche is quick to point out how this fact has been misunderstood in the past: 'Hence we consider it our duty to look into the heart of this tragic chorus as the real proto-drama, without resting satisfied with such arty clichés as that the chorus is the ideal spectator or that it represents [*vertreten*] the people in contrast to the aristocratic region of the scene' (w.III.1:48). Nietzsche pours scorn on the socio-political interpretation of the chorus and rejects it outright, but despite the sneering remark about 'arty clichés', he does not entirely give up the view (here attributed to A. W. Schlegel) that the chorus is the 'ideal spectator' of tragedy. In the Nietzschean reinterpretation of Schlegel, the key to comprehending the chorus lies in the relationship between the audience for the tragedy, who behold the satyr chorus, and the chorus itself, which beholds, first the suffering Dionysus, and later the masked actor who is the representative of the suffering god. The former is the moment when tragedy is still 'nur Chor und nichts als Chor', while the latter is the moment of drama proper (w.III.1:59). Nietzsche endorses the insight of Schiller, who in the Preface to *The Bride of Messina* proposed a conception of the chorus as a 'living wall that tragedy constructs around itself in order to close itself off from the world of reality and to preserve its ideal domain and its poetical freedom' (w.III.1:50). The chorus sees the truth and makes possible its representation for the audience, who are shielded from the truth by the 'living wall' of the chorus. The satyr chorus, itself the servant of Dionysus, becomes the agent of Apollonian illusion for the audience (w.III.1:67-8). Nietzsche therefore approves of Schlegel's formulation 'in a deeper sense': 'Der Chor ist der "idealische Zuschauer", insofern er der einzige Schauer ist, der Schauer der Visionswelt der Scene. Ein Publicum von Zuschauern, wie wir es kennen, war den Griechen unbekannt: in ihren Theatern war es Jedem, bei dem in concentrischen Bogen sich erhebenden

Terrassenbau des Zuschauerraumes, möglich, die gesammte Culturwelt um sich herum ganz eigentlich zu übersehen und in gesättigtem Hinschauen selbst Choreut sich zu wähnen' (w.III.1:55). The chorus is a spectator (*Zuschauer*), just as the spectator becomes a chorister by means of his fancy (*wähnen*). This act of identification is made possible by the structure of the Greek theater, its concentric arcs erected in a terraced structure creating the space from which the spectators can overlook (*übersehen*) the entire cultural world.

'Overlook' is the literal rendering of 'übersehen' given by Kaufmann, who glosses the passages as follows:

> *Übersehen,* like overlook, can mean both survey and ignore. Francis Golffing, in his translation, opts for 'quite literally survey', which makes nonsense of the passage. The context unequivocally requires oblivion of the whole world of culture: nothing is between the beholder and the chorus. Golffing's translation is althogether more vigorous than reliable. (BT,63, n.6)

The passage is scarcely as unequivocal as Kaufmann maintains, for what it establishes is the relationship between a structure of representation (the terraced structure of the Greek theatre) and the perceptual phenomenon which this structure presents. The spectacle of the drama is what the audience 'quite literally surveys', and in this 'surveying' (taking in at a glance, running the eye over — actions made possible by the structure of the theater) overlooks, in the sense of ignores, the truth that is represented in the spectacle. To overlook, in both senses (survey and ignore), is precisely not to know, to refuse or avoid knowledge, and this is just what tragedy in its aesthetic structure (*bei dem in concentrischen Bogen sich erhebenden Terrassenbau des Zuschauerraumes*) makes possible (*möglich*). Perception is the necessary condition for ignorance, the Apollonian veil of illusion cast over the Dionysian experience of knowledge. So powerful is the illusion produced by the spectacle of the satyr chorus that when the tragic actor (the representative of Dionysus) appears on stage, the audience fails to notice what they in truth have before them, a clumsily disguised human figure, and imagine they are beholding a visionary form born of their own ecstasy: 'wenn der tragische Held auf der Bühne erscheint, nicht etwa den unförmlich maskirten Menschen sehen, sondern eine gleichsam aus ihrer eignen Verzückung geborene Visionsgestalt' (w.III.1:59). The perceptual component in tragic drama, which Kaufmann's insistence on the univocal meaning of *übersehen* tends to elide, forms the basis of its aesthetic power; at

the same time, it deprives tragedy of the capacity to communicate knowledge.[13]

The point is made explicit in a passage in which Nietzsche appeals to an optical metaphor to account for the power of Apollonian representation:

> Thus the language of the Sophoclean heroes so amazes us by its Apollonian precision and lucidity [*Helligkeit*], that we immediately imagine [*wähnen*] that we glimpse the innermost ground of their being [*Wesens*] ... But suppose we disregard the character of the hero as it comes to the surface, visibly — after all, it is in the last analysis nothing more than a projected transparency [*geworfene Lichtbild*] on a dark wall, which means appearance [*Erscheinung*] through and through; suppose we force our way into [*eindringen*] the myth that projects itself in these lucid [*hellen*] reflections: then we suddenly experience a phenomenon that is the reverse of a well-known optical one. When after a forceful attempt [*einem kräftigen Versuch*] to gaze into the sun [literally, to fix the sun in one's eye — *die Sonne in's Auge zu fassen*] we turn away blinded, we see dark-colored spots before our eyes, a sort of cure [*Heilmittel*]. Conversely the transparent appearances [*Lichtbilderscheinungen*] of the Sophoclean hero, in short, the Apollonian aspect of the mask, are necessary effects of a glance into the inside and terrors of nature, as it were, luminous spots for the cure of the glance [or eye — *Blick*] damaged by gruesome night. (W.III.1:60-1)

In nature, darkness heals eyes damaged by the brightness of the sun, while in tragedy the reverse obtains: the lucidity and apparent transparency of the Apollonian language of the hero shields the spectator's eyes from the injury they would suffer by gazing directly into the darkness of tragic knowledge. The relation of Apollonian representation to Dionysian knowledge can be stated, somewhat paradoxically, as the light which makes the darkness visible. But the presentation of the darkness to perception, which is the condition of its aesthetic representation, destroys the

13. The insight could be generalized throughout Nietzsche's texts, beginning with section 301 of *Die fröhliche Wissenschaft* which bears the heading 'Fancy of Contemplatives' and presents the relationship of contemplation to action, of creation to knowledge, by means of the metaphor of a dramatic spectacle and the relationships among spectator, poet, and actor: 'But an illusion remains a constant companion at his side: he supposes he is placed as a spectator and auditor before the great drama and concert which is life; he calls his nature contemplative and yet overlooks [*übersieht*] that he is himself the real poet and creator of life — that he is certainly quite different from the actor of this drama, the so-called active man, but even more unlike a mere observer and festive guest before the stage. To him as poet certainly belong the *vis contemplativa* and retrospection on his work, but at the same time and before all the *vis creativa* which the active man lacks, whatever the visual appearance and the belief of all the world may say. We, the thinking-feeling ones, are those who actually and perpetually make something that is not yet there,

darkness. This is to say, in the terms well established by the argument of the text at this point, that such presentation obliterates all knowledge. The only one who can know anything in a strict sense is neither the spectator, who sees only the illusions presented by the chorus, nor the chorus, whose musical frenzy produces the image but not the reality of the suffering god or hero, but the hero himself, who, as Aristotle was the first to note, moves in the course of the play from a position of ignorance to knowledge, and this by a detour that could not have been foreseen but is understood, in the moment of recognition or discovery (*anagnorisis*), to have been not only probable but necessary. The most perfect exemplar of this process, for Nietzsche as for Aristotle, is Oedipus, whose blindness is the sign indicating his acquisition of knowledge. But Oedipus, once he has gained knowledge and been blinded, is the one person who could never be subject to the attractions of tragedy, for he is no longer capable of beholding the illusions of Apollonian representation. Unlike ordinary mortals, who, Aristotle claimed, would shudder upon hearing the story of Oedipus recounted (Nietzsche would surely add that this was because they saw the events of the plot in their mind's eye — see the passage on metaphor and visualization, w.III.1:56-7), Oedipus regards his own history with total indifference. He, not the audience, undergoes catharsis and is purged of the tragic emotions of pity and fear. The affective power of tragedy, its capacity to heal wounded eyes, depends upon the visual spectacle or phenomenal representation it presents. Anyone who has been totally and irremediably blinded, either physically or in the figural sense of being incapable of grasping the meaning of a phenomenon, will remain unaffected by tragic representation.

Nevertheless, Nietzsche himself claims in this passage to have penetrated beneath the visual surface of tragic representation and to have discovered the truth about tragedy. Nietzsche knows, and the text states this knowledge, that behind the veil of illusion, underneath the perceptual appearance, beyond the precision and

the whole eternally growing world of valuations, colors, weights, perspectives, scales, affirmations and negations. This poem invented by us is continually studied by the practical men (our actors, as they're called), practiced, translated into flesh and actuality, into the mundane. Whatever has value in the contemporary world does not have it in itself, according to its nature — nature is always without value — but has been given, endowed with value once, and we were the givers and endowers! Only we have created the world which concerns man! — But just this knowledge we lack, and if we once catch a glimpse [*Augenblick*] of it, we forget it again the very next moment: we mistake our best power and value ourselves, the contemplatives, in too slight a degree' (W.V.2:220; my translation).

lucidity of the language spoken by the Sophoclean heroes, lies the dark knowledge, the gruesome truth of the terrors of nature, which the phenomenal representations of tragedy, including its language, disguise in a reflex action of protective coloration. But what is the mode of representation in this passage?

A clue to the identity of the speaker, the face behind the mask of the language, is suggested by the fact that the discovery itself is presented in a metaphor — 'one of [Nietzsche's] most striking', Paul de Man says [14] — and is designated as a 'phenomenon the reverse of a well-known optical one'. We know already that phenomenal presentation is the province of the Apollonian. Insofar as the text presents the truth about tragedy in a phenomenal mode, it can only be aesthetic and therefore must necessarily hide the truth from the spectator/reader. This is not to say that Nietzsche himself has not glanced into the inside and terrors of nature, but merely to stipulate, as the text states, that a necessary consequence of this glance is his having to speak the language of the Sophoclean hero, to wear the Apollonian mask. The only way one could decide whether Nietzsche is telling the truth here is to glimpse the inside and terrors of nature directly oneself, but then, blinded like Oedipus by this knowledge, one would be immune to the seductive appearances of Nietzsche's text. Because the text must present its truth in the form of illusion, the reader can never know what the text really means or if she does, could not prove it, since the knowledge she has acquired would lack reliable means of communication. The text declares this to be the case, but in so doing deprives its own utterance of the performative power to which it has ostensibly laid claim.

This insight necessitates a reevaluation of the canonical interpretations of the text and its presentational mode, about which Nietzsche himself expressed the reservations cited earlier from his 'Versuch einer Selbstkritik'. It should now be more difficult to overlook the fissures in the text that threaten to shatter its integrity, or to maintain with serene confidence that the author of *The Birth of Tragedy* composed this text in a moment of integrated consciousness. In addition, one would have to be sceptical of readings that claim Nietzsche in general, and texts like the posthumously published *The Will to Power* in particular, as a progenitor of voluntarist ethics or politics. Nothing could be less wilful, in the sense of an unconditioned and freely acting psyche or subject, than the history of tragedy presented in *The Birth of*

14. de Man, *Allegories of Reading*, p. 93.

Tragedy. Nor is it legitimate to accuse Nietzsche of irrationalism, as Lukács did in *The Destruction of Reason,* an interpretation of Nietzsche's writings that depends upon completely ignoring both the manifest logical rigour of Nietzsche's arguments and the explicit statements of texts like *The Birth of Tragedy* which assert the necessity for the dark, irrational aspects of existence to be mastered, however unsuccessful this may prove in the end, by the light of reason. On this point, Nietzsche is as loyal a follower of the Enlightenment as one could wish. Finally, it would be incorrect to claim that *The Birth of Tragedy* accomplishes a conceptual reconciliation of music with poetry either in its textual performance or in the constative significance of its utterance.

The latter claim cannot be sustained in the face of the direct evidence of those passages where Nietzsche discusses the relationship between poetry and music: for example, in the remarks on lyric poetry which immediately precede the account of the history of tragedy (w.III.1:47-8). Or indeed whenever the Apollonian and the Dionysian are brought together, for it soon becomes clear that the attempt to reconcile the two is frustrated by their structural incompatibility, a fact made all the more disquieting by the recognition of their mutual implication. For instance, near the end of section 16, Nietzsche writes: 'Two sorts of effects are therefore wont to be exercised by Dionysian art on the Apollonian artistic capacity: music incites to the symbolic intuition of Dionysian universality, music, then [*sodann*], allows the symbolic image to step forth in its highest significance' (w.III.1:103). Whether the final two independent clauses are meant to be conceived in a temporal sequence (as my translation, which follows that of Carol Jacobs, indicates), or as simultaneously occuring aspects of a single process (as Kaufmann's linking of the two clauses with 'and' suggests) cannot be determined from the syntax: 'sodann' is ambiguous in the context.[15]

The difficulty resembles that noticed earlier in the passage from Hopkins's devotional writings in which the song of Lucifer, the counterpoint of dissonance that disrupts the divine harmony, cannot unequivocally be said to succeed God's music or indeed to be entirely outside the system it disrupts. Here the indeterminacy of the syntax prevents one from saying definitively whether the incitement to symbolic intuition is the cause of, or is the same thing as, the emergence of the symbolic image. Rather than describing a

15. Jacobs, *The Dissimulating Harmony,* p. 5; BT,103.

historical sequence, the positioning of Dionysus in relation to Apollo may be no more than the arbitrary arrangement of two coequal and coeval moments in a structure that is imposed upon the text by the syntagmatic constraints of language.

Nietzsche's text has, as was promised, shed some light on the relationship of poetics to historical understanding, even though the impasse reached in the reading of Hopkins has not been overcome. On the contrary, Nietzsche's inquiry into the origins of Attic tragedy confirms the intractability of the problem which cost Hopkins such enormous personal suffering. One can sing about nature and God, as Hopkins does in 'As kingfishers catch fire,' or one can speak about poetry and music, as Nietzsche does in *The Birth of Tragedy*, but in the attempt to spell out the differences between singing and speaking, one inevitably discovers that the light shed on the problem by these two writers cannot entirely eliminate the conceptual darkness that lies at its core.

* * * * * * * * * *

That Nietzsche's is a discursive text would seem, as Nietzsche himself intuited in his retrospective commentary on *The Birth of Tragedy*, to place limits on its powers of aesthetic formalization. Such constraints should, in principle, be less evident in Hopkins's sonnet. But the two texts achieve a comparable insight or moment of recognition, although arguably on different levels. Nietzsche's text encounters an insuperable obstacle to aesthetic formalization in its thematization of the relationship between the Apollonian and the Dionysian, or between poetry and music, insofar as this opposition is applied to the presentational mode of the text itself. By contrast, the aesthetic features of Hopkins's poem are untroubled on a strictly phenomenal level by the semantic complications that are bound to come to the fore as soon as Nietzsche posits the opposition of Apollo to Dionysus. This is to say, what hardly anyone would object to, that in reading Nietzsche's treatise we are compelled by the very nature of the genre (leaving aside for the moment just what genre this text belongs to — a by no means simple question, as our critical exposition of Silk and Stern's commentary has shown) to consider the coherence and logical consistency of the argument. But when reading a sonnet or other lyrical form, it seems virtually a category mistake to assume that this kind of text will have an argument of any sort. We do, however, easily (perhaps inevitably — the case of a really pure formalism is comparatively rare in the history of

aesthetics, Kant's authority notwithstanding) impute to lyrics a semantic component which, if it does not generally appear in the guise of well-formed propositions, nevertheless is assumed to harmonize with other elements of the poem's formal structure. An aesthetics of the lyric will always implicate the semantics of the text in the formal unity of the whole.

The generic scheme differentiating lyrics from other, less privileged and incompletely formalized aesthetic genres breaks down at that point, which can be shown to recur throughout the tradition of the lyric, where the signifying potential of natural languages produces semantic values that are at odds or are incompatible with the controlled pattern of meaning dictated by the aesthetic form. Our example from Hopkins located this disruption of the poem's formal tranquility in the opposition between 'speaking' and 'spelling', between a structure of sensory and semantic commensurability and one that makes the link between sound and sense utterly arbitrary and unmotivated. Other poems would arrive at this moment by a different route, but the tendency towards a disruption of the aesthetic harmony of the text is sufficiently general that the pattern appears unavoidable.[16]

Lyrics, it turns out, are potentially as fraught in their manner of formalization as other genres, so that attempts to identify generic (and historical) hybrids like the 'lyrical novel' or the 'prose poem' only acknowledge openly what more traditional generic categories

16. The claim is admittedly a large one and will scarcely be persuasive on the evidence of a single example. But theories, we know, are notoriously underdetermined by the available evidence. The only way to test the validity of the hypothesis advanced here would be to undertake a large number of readings of lyrics from a wide variety of historical periods and a significant selection of sub-genres (idyll, elegy, ode), as well as from a range of cultures and language traditions. In the absence of such a body of empirical evidence, we can only point in the direction such investigations would take. Paul de Man's essay on Baudelaire's 'Correspondances' and 'Obsession', 'Anthropomorphism and Trope in the Lyric' (in *The Rhetoric of Romanticism* [New York, 1984], pp. 239-62), presents examples from a linguistic tradition other than English of the structure hypothesized here. Closer to Hopkins in any number of ways would be the textual crux in Keats's 'Ode on a Grecian Urn', which turns on the reading of the final two lines: 'Beauty is truth, truth beauty/That is all ye know on earth and all ye need to know.' Evidence from the tradition of interpretation, as well as the notorious textual problem of how to punctuate these lines, suggests that the simple equivalence between the beautiful and the true, or between the aesthetic and the epistemological claims often attributed to the lines, may hide the genuine complications that inhere in commensurating claims of knowledge with those of aesthetic illusion. There is no reason to assume, *a priori*, that Keats is any less troubled than Nietzsche by this difficulty.

tend to conceal: to wit, the trans- or supra-generic problem of aesthetic formalization which all genres must seek to solve at some level. The resistance to formalization encountered by all texts, be it on the level of theme or in the uncontrollable semantic power of an utterance, when laid side by side with the persistent impulse to formalization that seems to accompany any attempt to construct textual wholes, suggests that the problem with which we are dealing may transgress the boundaries of what are customarily called literary or poetic texts. We noted in passing in our first chapter that the aesthetic as a model of cognition, while it is perhaps most accessible in works of art, is by no means limited to them. Schiller's program of aesthetic education is but one indication that the purview of the aesthetic far exceeds the limits of contemplative enjoyment of music, poetry, painting, and sculpture. Ruskin's linking of ethical and aesthetic values is another. If the aesthetic presents us before all with an epistemological problem, there is no reason to limit our inquiry to or even to focus primarily on texts which are traditionally thought to exemplify aesthetic representation — e.g., the lyric. On the contrary, our argument has indicated that the degree of apparent formalization in a text is no proof against the resistance to formalization which the iinguistic structure of the text imposes.

We can to some extent forecast the direction in which this observation will take us by quoting from the conclusion to one of Paul de Man's final essays. The pathos with which the quotation is unavoidably infused as a result of de Man's untimely death confirms the point that de Man himself was making when he wrote it:

> The lyric is not a genre, but one name among several to designate the defensive motion of understanding, the possibility of a future hermeneutics ... Generic terms such as 'lyric' (or its various sub-species, 'ode', 'idyll', or 'elegy') as well as pseudo-historical period terms such as 'romanticism' and 'classicism' are always terms of resistance and nostalgia, at the furthest remove from the materiality of actual history. If mourning is called [in Baudelaire's 'Obsession'] a 'chambre d'éternel deuil où vibrent de vieux râles', then this pathos of terror states in fact the desired consciousness of eternity and of temporal harmony as voice and as song. True 'mourning' is less deluded. The most *it* can do is to allow for non-comprehension and enumerate non-anthropomorphic, non-elegiac, non-celebratory, non-lyrical, non-poetic, that is to say, prosaic, or, better, *historical* modes of language power.[17] (de Man's emphasis)

17. de Man, 'Anthropomorphism and Trope in the Lyric', pp. 261, 262. The hypostatization of generic categories as (false) means towards historical

The explicitation of the intimate connection between concepts of historical understanding and aesthetic totalization will be the unifying thread of the next three chapters. Whether the non-aesthetic understanding of history towards which de Man's text gestures is possible (even for de Man himself) is a question we shall have to leave in abeyance for the present. Our immediate concern is to test the powers and limitations of programmatically aesthetic models of historical understanding.

Coda

For reasons of economy as well as for strategic reasons (having to do with the sequential argument of our own text), we have left out of consideration an entire stratum of the text of *The Birth of Tragedy* which was undoubtedly important to Nietzsche: the book's position within the history of German culture since the 18th century, as well as the particular historical moment of its composition. The text was profoundly determined by its having been written in the aftermath of the Franco-Prussian War and the suppression of the Paris Commune, events that are marginally present in its pages and are probably more important to its ideological horizons than has generally been acknowledged. *The Birth of Tragedy* continues, at least in intention, Schiller's programme of aesthetic education; it is an attempt to master historical contingency by means of aesthetic totalization. Our reading of the text has suggested the limits of this project in its actual performance. *The Birth of Tragedy* never attains that conceptual equipoise which would enable the mastery of contingent historical events in a unified aesthetic whole. Like Schiller's *Aesthetic Letters* which is in many ways its model, Nietzsche's text stumbles over that contradiction we have noticed in the aesthetic as a category from the outset of our inquiry: the incompatibility between the aesthetic understood as a species-specific capacity that promises to ground thought in stable intuitions, and the aesthetic experienced as a contingent moment in the history of understanding. Marx's puzzled ruminations over this topic are the *locus classicus* for posing this problem, but it inhabits in various ways all the texts we

understanding is evident both in Marxist and in bourgeois aesthetics. There is no reason to believe that Lukács's historical typology dividing the bourgeois novel into realist and naturalist modes is any less deluded than Northrop Frye's theory of modes. The problem is approached again in chapters 5 and 6 below.

have examined up to this point. Nor is it necessarily the case that a foregrounding of the political dimensions of aesthetic texts will be proof against the temptation towards premature and illicit totalization, a point we shall argue more fully in chapters 6 through 8 below. The relationship between political action and theoretical speculation is no more susceptible to simple hierarchizing in a linear causal sequence than is the historical or conceptual priority of Dionysus to Apollo in Nietzsche's text. We may provisionally propose that Nietzsche's (or Ruskin's or Henry James's) text is aesthetic to the degree that it resists, whether intentionally or not is of no importance, the totalizing impulse which is part and parcel of the explicit ideology of the aesthetic as an epistemologically reliable mode of cognition. How the aesthetic can be said to produce knowledge, rather than mere illusion (*schöne Schein*), is a topic that we must defer until our concluding chapter.

4
Poetics of Reading

So put me on the highway,
And show me a sign,
And take it to the limit,
One more time.
(The Eagles)

We began our inquiry into the discourse of literary criticism and theory by noticing a constitutive tension between aesthetic representation and historical experience that has been a regular feature of the history of aesthetics since its foundation as an independent science in the 18th century. The attempt to square the circle of aesthetics and history, which we have somewhat arbitrarily located in Marx, is by no means confined to those theoretical programs whose founding term is one or another historically oriented category. Whenever the theorization of literary discourse passes from formal poetics to ethical, political, or indeed any social or historical concern (as in the rhetoricizing of the Aristotelian concept of *catharsis* discussed in the following chapter) the aesthetic is certain to crop up as the means by which one negotiates the passage 'beyond formalism'. This was demonstrably true of the shift in center of gravity from the early Shklovskij-dominated formalism of the OPOJAZ to the investigations of Eichenbaum and Tynianov into the dynamics of literary evolution. It was also manifest in the migration within Slavic theory from Russian Formalism proper to its immediate offspring among the theorists of the Prague School. Within the Prague School itself, the opposition between a more or less strictly formalized discipline of aesthetics and a historically calibrated semiotics is apparent in the writings of Jan Mukařovský from the middle 1930s. It is even more patent in the work of Mukařovský's student, Felix Vodička, whose accommodation of semiotics to literary history turns on the notion of 'concretization'. One should also mention Roman Jakobson, in this as in so many ways an

exemplary figure in the history of 20th-century literary theory. Jakobson's entire career can be seen as an unsuccessful effort to incorporate the evolutionary potential of literary and linguistic systems into a formal description of linguistic and poetic structures which preserves the relative autonomy of these latter with respect to other social phenomena.[1]

This is to say, as ought to have been apparent to anyone with even a superficial knowledge of post-Saussurean semiotics, that the two categories which have most often been at opposite poles in ideological struggles over the proper domain of literary study, formalism and history, while they may be opposed in a number of ways, are by no means as alien to each other and mutually exclusive as proponents of either would have us believe. It is equally difficult to avoid formal problems altogether in writing about literature and art as it is to be a really pure formalist for whom any semantic associations produced by aesthetic signs are little more than impediments in the path towards a more authentic aesthesis devoid of content altogether.

That the aesthetic and the historical or ideological can productively inhabit the same theoretical space is nowhere more apparent than in the work of Hans Robert Jauss. The claim of the Konstanz group as a whole on the attention of literary theorists depends, as Paul de Man has remarked, on their 'boldness ... in calling their approach a poetics as well as a hermeneutics ...'[2] It is their project of a general theory of literariness elaborated within the constraints of the historical discipline of hermeneutics that causes the Konstanz program of research to stand out against the background of more avowedly ahistorical formalisms and traditional, generally positivist, literary history.

Jauss's historicism is characterized by, among other things, an unremitting hostility towards Marxism. Political and historical reasons for this virtual blind spot in his work are probably not far

1. I rely here on the excellent recent work of two younger Czech scholars, F.W. Galan and Peter Steiner. The former has produced the authoritative work in English on the Prague School, *Historic Structures: The Prague School Project, 1928-1946* (Austin, 1985), while the latter has written an exceptional study on the pre-history of the Prague School, 'The Roots of Structuralist Esthetics' (in *The Prague School: Selected Writings, 1929-1946,* ed. P. Steiner, trans. John Burbank et al. [Austin, 1982], pp. 174-219), as well as the most theoretically astute account of the Russian Formalists in English, *Russian Formalism: A Metapoetics* (Ithaca, 1984).

2. Paul de Man, Introduction to Hans Robert Jauss, *Toward an Aesthetic of Reception*, trans. Timothy Bahti (Minneapolis, 1982), p. x; hereafter cited parenthetically in the text as TAR.

to seek, but more interesting is the ambivalence that appears in relation to certain Marxist theoreticians. The polemic against Lukács, Jauss's representative of orthodox Marxist aesthetics in 'Literary History as Challenge to Literary Theory' (TAR,13-14), must be balanced against the numerous approving references to Walter Benjamin that appear throughout Jauss's works. Benjamin's association with Marxism is by no means unproblematic, but his credentials as a theoretician of historical materialism are unimpeachable. That Benjamin's criticism would offer no aid or comfort to an aesthetics of reception (as de Man argues; TAR, xv-xvi; xxii-xxiii), provokes the suspicion that the polemical position Jauss takes with respect to Marxist aesthetics cannot be understood as straightforwardly oppositional.

The topic of 'Literary History as Challenge' is not centrally a debate with Marxism, but a later essay, 'The Idealist Embarrassment: Observations on Marxist Aesthetics', obviously is.[3] Jauss commences his argument by citing the passage on Greek art from Marx's 1857 'Einleitung' to the *Grundrisse,* and contends (with some support from Marcuse) that this text established the idealist core of Marxist aesthetics. The force of this text has, in Jauss's view, been obscured in reflection theory and in neo-Marxist criticism, both of which situate all art produced between Greek antiquity and the communist society of the future within ideology.[4] Jauss also refers to the *Economic and Philosophical Manuscripts of 1844* in arguing that 'the work of art could uphold the idea of free productivity and sense-changing receptivity in periods of alienated material labour.'[5] This concept of the work of art 'does not remove the idealist embarrassment of Marx's passage about constructing according to the laws of beauty, but elevates it into an indispensable component of a materialist aesthetic ...'[6] But such a properly materialist aesthetic must also account for the historical effectivity of art works, and it is here that Jauss most severely faults contemporary Marxist accounts of reception for hypostatizing the reader as 'an idealized consciousness'. Focusing on the work of Manfred Naumann and a group of GDR theorists, Jauss notes their neglect of 'the concept of concretization' and concludes: 'Intersubjective categories are entirely lacking on the

3. H.R. Jauss, 'The Idealist Embarrassment: Observations on Marxist Aesthetics', trans. Peter Heath, *New Literary History* 7 (Autumn 1975).
4. Ibid., p. 193.
5. Ibid., p. 199.
6. Ibid., p. 200.

side of reception, so that it comes to seem as though receptive predetermination [*Rezeptionsvorgabe*] ... refers to the individual reception of the work by a *universal reader* ...'[7] The debate here is framed in terms of the economic categories of the *Grundrisse*, production and consumption. Jauss enlists Marx in his own behalf by citing the latter's assertion that not only does production produce consumption, but 'Consumption thus appears as a factor [*Moment*] of production.'[8] The 'idealist embarrassment' of Marxist aesthetics can only be overcome by acknowledging 'the reader's share' in the production of aesthetic objects. Jauss further maintains that this deliverance from idealism can be most economically attained through historical inquiries into the actual readings that works of art have provoked in different eras and cultures. Marxist aesthetics demands, in principle, supplementation by the history of reception.

We can now see more clearly why Jauss, in what might otherwise look like a distraction from the main drift of his argument, attacks Lukács in 'Literary History as Challenge'. Lukács is identified directly with reflection theory, which in Jauss's view forecloses 'the possibility of grasping the revolutionary character of art...' (TAR,14). This possibility is recovered in Jauss's argument through the agency of the Russian Formalists, whose concept of 'estrangement' or 'defamiliarization' (*ostraneniye*) drives a wedge between the literary work and its social ambience, thus undermining the authority of reflection theory. The subsequent development of formalist poetics towards a theory of literary history takes Jauss one step closer to an authentic history of reception. In the formalists' contrasting of 'a dynamic principle of *literary evolution* to the classical concept of *tradition*' (TAR,17), Jauss locates the decisive turn towards an aesthetic model of history that authorizes his own programme of research. Nevertheless, Jauss takes formalism to task for conceiving literary history only as a 'succession of systems', and consequently for failing to account adequately for the historical specificity of literary works: 'The historicity of literature does not end with the succession of aesthetic-formal systems; the evolution of literature, like that of language, is to be determined not only immanently through its own unique relationship of diachrony and synchrony, but also through its relationship to the general process of history' (TAR,18). Both formalism and Marxism signally omit to

7. Ibid., p. 205; emphasis in the text.
8. Ibid., p. 206.

'bridge the gap between literature and history' because they 'conceive the *literary fact* within the closed circle of an aesthetics of production and of representation. In doing so, they deprive literature of a dimension that inalienably belongs to its aesthetic character as well as to its social function: the dimension of its reception and influence' (TAR,18). The project of an aesthetics of reception constructs this missing link between the literary work and its social function and makes a contribution to the general progress of history as 'the ongoing totalization of the past through aesthetic experience [*Erfahrung*]' (TAR,20).

That history is indeed 'progressive' and that it can be seen to be so from the standpoint of the present enables Jauss's postulation of principles for historical understanding: 'The step from the history of reception of the individual work to the history of literature has to lead to seeing and representing [*zu sehen und darzustellen*] the historical sequence of works as they determine and clarify the coherence of literature, to the extent that it is meaningful for us, as the prehistory of its present experience [*als Vorgeschichte ihrer gegenwärtigen Erfahrung*]' (TAR,20). In support of this theory, Jauss cites the concluding sentences of Walter Benjamin's 1931 essay, 'Literaturgeschichte und Literatur-wissenschaft', as he earlier had invoked Benjamin's *Über den Begriff der Geschichte* against Ranke's historicism. As the earlier passage makes clear, Jauss aligns himself and Benjamin against the Rankean sort of historicism and on the side of Enlightenment philosophy of history, above all with Schiller's figure of the universal historian: 'In its turning away from the Enlightenment philosophy of history, historicism sacrificed not only the teleological construction of universal history but also the methodological principle that, according to Schiller, first and foremost distinguished the universal historian and his method: namely, "to join [*zu verknüpfen* — literally 'to knot or tie'] the past with the present" — an inalienable understanding, only ostensibly speculative, that the historicist school could not brush aside without paying for it ...' (TAR,8). Jauss's note directs the reader to the seventh of Benjamin's *Theses on the Philosophy of History,* of which it is asserted that the critique of historicism there 'delivered from the standpoint of historical materialism, leads unnoticed beyond the objectivism of the materialist conception of history [*führt unvermerkt über den Objectivismus der materialistischen Geschichtsauffassung hinaus*]' (TAR,192. n.19). Elsewhere, it is apparent that Jauss is eager to dissociate Benjamin from Marxist theory (see, e.g., TAR,65-6), presumably since, according to Jauss,

Marxism can only produce a teleological philosophy of history and an essentialist theory of art. To cite thesis VII, however, as evidence of Benjamin's overcoming (even if 'unnoticed') of the materialist conception of history is surely an odd — albeit revealing — misreading of the text.

In thesis VII, the explicit target of Benjamin's polemic is the supposed objectivity of historicism, an objectivity that turns out to be thinly disguised empathy with the victors of history.[9] The enabling condition of historicism is precisely the transmission of 'cultural treasures' (*die Kulturgüter*), the 'spoils' (*die Beute*) of cultural progress. Benjamin's vision of history as continual disaster is of course closely allied with the image of the angel in thesis IX, Klee's 'Angelus Novus', whose wings have been caught by a storm blowing from Paradise: 'This storm drives him irresistibly into the future, toward which his back is turned, while the heap of ruins before him grows toward the heavens. That which we call progress [*Fortschritt*] is *this* storm.' But 'progress' has yet another name in the *Theses:* social democracy. Benjamin's critique of historicism is also a political intervention against the SPD, a recognition of their, in his view, complicity in the coming to power of fascism. Against this complicity, historical materialism struggles by opposing the facile idea of historical 'progress', which latter includes the embracing of technological development by social democracy and the corresponding notion of universal history in which historicism culminates (thesis XVII).

No one could be more explicitly opposed to the 'ongoing totalization of the past through aesthetic experience' than the Benjamin of the *Theses*. He writes in thesis XVII: 'The historical materialist approaches a historical object only where he encounters it as a monad. In this structure he recognizes the sign of a messianic placing at rest [*Stillstellung*] of events, or, to put it another way, a revolutionary prospect [*Chance*] in the struggle for the repressed past. He seizes it in order to spring [*sprengen*] a determinate epoch from out of the homogeneous course of history; thus he springs a determinate life from the epoch, a determinate work from the lifework. The yield from this procedure consists in the fact that *in* the work the lifework, *in* the

9. All references to Benjamin's *Theses* are to the text of *Über den Begriff der Geschichte* contained in Band I, Teil 2 of Benjamin's *Gesammelte Schriften*, ed. Rolf Tiedemann and Herman Schweppenhäuser (Frankfurt, 1974), pp. 691-704; my translations. Quotations are identified by the number of the thesis, rather than by pages in the collected edition.

lifework the epoch, and *in* the epoch the entire course of history is deposited and cancelled yet preserved [*aufgehoben*].' For Jauss, the historical object, the work or text, is not a monad but an event which, rather than being 'sprung' from the continuum of history, is integrated into the 'coherence of literature' (TAR,22), in the history of its reception. This process, far from being arbitrary or subjective, can be objectified with systematic rigour:

> If ... one defines the initial horizon of expectations of a text as paradigmatic isotopy, which is transposed into an immanent syntagmatic horizon of expectations to the extent that the utterance grows, then the process of reception becomes describable in the expansion of a semiotic system that accomplishes itself between the development and the correction of a system. A corresponding process of the continuous establishing and altering of horizons also determines the relationship of the individual text to the succession of texts that forms the genre. The new text evokes for the reader (listener) the horizon of expectations and rules familiar from earlier texts, which are then varied, corrected, altered, or even just reproduced. (TAR,23)

As in Husserl's theory of perception, from which it is derived, Jauss's model of reception collapses the temporal displacement produced by the act of reading into what Benjamin called 'homogeneous, empty time'.[10]

The misreading and misappropriation of Benjamin is evident in other essays than 'Literary History as Challenge', notably in 'The Poetic Text within the Change of Horizons of Reading: The Example of Baudelaire's "Spleen II" ', where Benjamin's exposition of the allegorical structure of the Baudelairean lyric is interpolated in a historicist model connecting the present with the past by means of an aesthetic emblem (TAR,178-9).[11] Benjamin's monadic materialism cannot be readily accommodated to Jauss's aesthetic totalization of history.[12] For *Rezeptionsästhetik* to

10. This tendency dominates Jauss's more recent work, especially in his book, *Ästhetische Erfahrung und Literarische Hermeneutik*; in English *Aesthetic Experience and Literary Hermeneutics*, trans. Michael Shaw (Minneapolis, 1982). See also the interview conducted with Jauss by Rien T. Segers which appeared in an English translation by Timothy Bahti in *New Literary History* 11 (Autumn 1979), espcially pp. 89-90.

11. Paul de Man argues for the incommensurability of Jauss's 'classical phenomenalism of an aesthetics of representation' (TAR, xxii) with Benjamin's more properly linguistic concept of allegory; he indicates as well the limitation of Jauss's reading of the Baudelaire poem in question (TAR,xxii-xxiv).

12. Irving Wohlfarth's remark that Jauss's 'position is but an updated version of the historicism it derides' ('History, Literature, and the Text: The Case of Walter

produce an authentically materialist account of the text as historical event, it would have to leave behind the concept of history as a unified series of non-contradictory factors upon which its hermeneutic practice vitally depends. As was the case with readings of Henry James's 'The Figure in the Carpet', the characterization of the text as an aesthetic emblem enables a historical totalization which never fails to carry the promise of successful interpretation. The confident, unified tone of Jauss's writing in comparison with the more hesitant and unsure Benjamin is one symptom of the differences that separate their concepts of history.

The test of Jauss's relation to Marxism cannot rest, however, on the admittedly problematic figure of Benjamin. A more consequent engagement between *Rezeptionsästhetik* and historical materialism (one that, to my knowledge, Jauss himself has not submitted to) can be achieved by juxtaposing two passages that seem on the surface to be saying roughly the same thing. The first is taken from the conclusion to Jauss's essay, 'History of Art and Pragmatic History':

> The history of art is distinguished from other spheres of historical reality by the fact that in it the formation of the immortal is not only visibly carried out through the production of works, but also through the reception, by its constant reenactment of the *enduring features of works that long since have been committed to the past.*
>
> The history of art maintains this special status even if one concurs with the Marxist literary theory that art and literature cannot claim any history of their own, but only become historical insofar as they participate in the general process of historical praxis. The history of art keeps its special position within pragmatic history to the extent that, through the medium of perception and by means of interpretation, it can consciously bring forth [*bewusst zu machen vermag*] the historical capacity of 'totalization, in which human praxis incorporates impulses from the past and animates them through this very integration.' Totalization, in the sense of 'a process of production and reproduction, animation and rejuvenation', is presented in exemplary form by the history of art. (TAR,75; emphasis added)[13]

Nothing in this passage runs counter to the spirit of Jauss's other work, nor to that of his Konstanz colleagues; on the contrary, it enunciates succinctly the ideological core of *Rezeptionsästhetik*.

Benjamin', *MLN* 96 [December 1981]: 1007) makes a point similar to our own here, contrasting Jauss's notion of history directly with Benjamin's.
13. Jauss's notes identify the source of the internal quotations: Karel Kosík's

Moreover, as our emphasis is intended to indicate and Jauss's citation of Karel Kosík suggests, this position is entirely compatible with certain aspects of Marxist aesthetics, notably the conception of aesthetic monumentality we observed in the passage from Bakhtin at the beginning of chapter two and in Marx's hypostatization of Greek art as in certain respects outside of time.

This is not to say, as Jauss would have us believe, that what is most valid in Marxist aesthetics can be approached only through reception theory. Our second passage, which has generally been assumed to recapitulate the 'idealist embarrassment' of the Marxist theory of art, is taken from Althusser's 'Letter on Art in Reply to André Daspre':

> *I do not rank real art among the ideologies,* although art does have a quite particular and specific relationship with ideology ... Art (I mean authentic art, not works of an average or mediocre level) does not give us a *knowledge* in the *strict sense,* it therefore does not replace knowledge (in the modern sense: scientific knowledge), but what it gives us does nevertheless maintain a certain *specific relationship* with knowledge ... I believe that the peculiarity of art is to 'make us see' [*nous donner à voir*], 'make us perceive', 'make us feel' something which *alludes* to reality ... What art makes us *see,* and therefore gives to us in the form of *'seeing', 'perceiving'* and *'feeling'* (which is not the form of *knowing),* is the *ideology* from which it is born, in which it bathes, from which it detaches itself as art, and to which it *alludes* ... Balzac and Solzhenitsyn give us a 'view' of the ideology to which their work alludes and with which it is constantly fed, a view which presupposes a *retreat,* an *internal distantiation* from the very ideology from which their novels emerged. They make us 'perceive' (but not know) in some sense *from the inside* by an *internal distance,* the very ideology in which they are held.[14] (Althusser's emphasis)

The apparent privilege granted to art here can readily be misconstrued. The basic conceptual opposition governing the logic of the passage is not art/ideology, but perception/knowledge. The differentiation of art from among the ranks of the ideologies asserts the relative autonomy of aesthetic practice from other social practices, in the same way that elsewhere Althusser distinguishes economic practice, political practice, *et cetera* from

Die Dialektik des Konkretens (TAR,205). The choice of a Marxisant text to support the theory of history presented here can hardly have been accidental. One would not wish to say that Jauss is ignorant of or inattentive to Marxism, merely that he chooses his Marxist allies (like his foes) with considerable care.

14. Louis Althusser, *Lenin and Philosophy and Other Essays,* trans. Ben Brewster (New York, 1971), pp. 221-3.

each other. The specificity of art or aesthetic practice lies in its perceptual features, its presentation of ideology in phenomenal forms. On the phenomenal level, art is immediately accessible to understanding, and so maintains the illusion of a direct presentation of knowledge. We know, for example, that the Baron de Charlus is a homosexual and a masochist because that is how he appears in Proust's novel, and we tend somewhat naively to infer from this evidence certain conclusions about Proust's own sexual proclivities, about the decadence of the French aristocracy in *la belle époque,* and so on. On Althusser's view, the immediacy of these conclusions is premature, for what we perceive in works of art is not the empirical world to which they apparently refer, but rather the ideological refraction of that world in the aesthetic modality of the text. Althusser is perfectly orthodox in this matter from a historical materialist point of view.[15]

What distinguishes the Althusserian conception of the relative autonomy of aesthetic practice from Jauss's aesthetic historicism is the discrimination in the former between the mode of knowledge production in the sciences and the process of representation in art. Althusser agrees with Jauss that authentic works of art distantiate their materials from reality, or, to adopt Jauss's vocabulary, they displace the contemporary horizon of expectatons (see, for example, the latter's account of the reception of *Madame Bovary,* TAR,27-8; 42-4). But in order for an art work to become an object of knowledge, it is not sufficient simply to describe 'the reception and the influence of a work within the objectifiable system of expectations that arises for each work in the historical moment of its appearance ...' (TAR,22). Jauss's conception of the *Erwartungshorizont* posits the immediate accessibility to understanding of the background against which the work of art is perceived; the 'horizon of expectations', on Jauss's account, is a phenomenally present object whose juxtaposition with the work of art allows the perceiver to comprehend the work in a way denied to those whose perception of it could not have encompassed the

15. Cf. Medvedev/Bakhtin: 'The hero of a novel, for instance Bazarov of Turgenev's *Fathers and Sons,* if taken out of the novelistic structure, is not at all a social type in the strict sense, but is only the ideological refraction of a given social type. Socioeconomic historical scholarship defines Bazarov as a *raznochinets.* But he is not a *raznochinets* in his actual being. He is the ideological refraction of a *raznochinets* in the social consciousness of a definite social group, the liberal nobility to which Turgenev belonged' (*The Formal Method in Literary Scholarship: A Critical Introduction to Sociological Poetics,* trans. Albert J. Wehrle [Baltimore, 1978], p. 21).

work's relevant background. The work of art, which per definition is not knowable within the horizon of expectations of its original appearance, becomes an object of knowledge in the science *(Rezeptionsästhetik)* of a subsequent epoch, which 'can consciously bring forth [*bewusst zu machen vermag*]' the real (phenomenal) object persisting through time.[16]

The operation in thought which renders works of art comprehensible only beyond the immediate environment of their production has a name in the Althusserian lexicon: historicism. Althusser specifically points to its 'inevitable retrospection', which purchases its claim to knowledge, or scientificity, on the condition that 'the present attains the science of itself [Jauss's "consciously bringing forth"], criticism of itself, its self-criticism, i.e., if the present is an *"essential section"* which makes the *essence* visible.'[17] The very essentialism with which Jauss had charged Marxism returns, albeit in a model of temporal dislocation between the work and its material circumstances, to convict Jauss's own theory. Paul de Man's intuition about Jauss's theoretical project proves to have been prophetic, if not in just the way he may have intended, when he judged it an open question 'whether Jauss's own historical procedure can indeed claim to free itself from the coercion of a model that is perhaps more powerful, and for less controllable reasons, than its assumed opponents believe' (TAR,xi).

The methodological *démarche* that could indeed free historical

16. Cf. de Man's commentary on Jauss's procedure: 'At the moment of its inception, the individual work of art stands out as unintelligible with regard to the prevailing conventions. The only relation it has to them is that of contemporaneity or of synchrony, an entirely contingent and syntagmatic relationship between two elements that happen to coincide in time but are otherwise entirely alien to each other. The differentiation that separates the work from its setting is then inscribed in the historical, diachronic motion of its understanding (*Horizontswandel*), which ends in the discovery of properties held in common between the work and its projected history. Unlike the relationship between the work and its historical present, the relationship between the work and its future is not purely arbitrary. It contains elements of genuine paradigmatic similarity that can circulate freely between the formal singularity of the work and the history of its reception. Put in somewhat more technical terms, one would say that, in Jauss's model, a syntagmatic displacement within a synchronic structure becomes, in its reception, a paradigmatic condensation within a diachrony. Attributes of difference and of similarity can be exchanged thanks to the intervention of temporal categories: by allowing the work to exist in time without complete loss of identity, the alienation of its formal structure is suspended by the history of its understanding' (TAR,xiv).

17. Louis Althusser and Etienne Balibar, *Reading Capital*, trans. Ben Brewster (London, 1970), p. 122; Althusser's emphasis.

study from the coercion of the historicist model and allow the event to be 'sprung' from the continuum of 'homogeneous, empty' historical time cannot lightly dismiss Althusser's intervention into this field. The undoubted interpretive achievements of *Rezeptionsästhetik* would be of even greater theoretical interest if the history of reception were reoriented in light of the concepts of mode of production and structural causality elaborated in *Reading Capital*. This is to recognize, despite Jauss's reservations, the necessary theoretical priority of Marxism over *Rezeptionsästhetik*. The historic conjuncture between the mass parties of social democracy and communism which remained a missed opportunity in Germany during the 1920s, might well be realized today in the *prise de position* of a theoretical programme that refuses the temptation of aesthetic totalization masquerading in the guise of a materialist conception of history. Such a programme would have to begin with the challenge posed by the Althusserian slogan: 'History is a process without a subject or goals.' A slogan that demands the reconstitution of the object of knowledge that history could possibly be.

* * * * * * * * *

Rezeptionsgeschichte as practiced and theorized by Jauss attempts to straddle both horns of the dilemma generated by the relationship of history to structure. Jauss's critique of essentialism is aimed not only at the obvious target of the theory of socialist realism, but equally at formalism, particularly at that version of the latter which achieved hegemony in literary study in Germany after the war in the work of Emil Staiger and others. The reasons for the emergence of this struggle within the traditions and institutions of German literary theory at just that moment (the middle 1960s) would take us too far afield, but we should nonetheless note that they are far from being purely theoretical. Whatever one might wish to say about the history of literature and art as immanent evolutionary series, it certainly would not be sufficient to account for the history of literary criticism and theory solely in terms of the intra-theoretical problems generated by the discipline.[18] Still, as we observed at the outset of this chapter, the

18. On the political and institutional context of Jauss's intervention ('Literary History as Challenge [*Provokation*]' was Jauss's inaugural lecture at the newly formed University of Konstanz; it was therefore a 'challenge' in a double sense), see Wlad Godzich's introduction to Hans Robert Jauss, *Aesthetic Experience and Literary Hermeneutics*.

tension between formalism and historicism has been a recurrent feature of literary and aesthetic theory for the past two hundred years, so it can hardly be said that Jauss's dilemma is a uniquely determined historical event. That Jauss and his colleagues tend to think of their intervention in revolutionary terms is probably due not only to the inevitable temptation to see one's own research program as inordinately novel, but more interestingly to the very historicism which the Konstanz conception of literary reception promulgates. One could plausibly and coherently theorize the emergence of *Rezeptionsgeschichte* itself as a new and distinctive concretization of the problems and methods of literary theory, a realization of the potential that literary texts have always possessed but which has remained invisible to researchers before the moment of the Konstanz School's hypostatizing the 'role of the reader' in literary history.

There are, however, two difficulties with this scenario. First, and most obviously, the historical novelty of *Rezeptionsästhetik* is highly dubious when considered in the full context of European literary scholarship during the 20th century. Jauss's and Iser's approving references to Vodička indicate at least one body of previous work that significantly anticipates their own. In a different idiom and in a quite distinct context, one could also cite the debate during the 1940s between Kenneth Burke and the so-called Chicago Neo-Aristotelians as another moment when the history of reception was put on the agenda (however briefly) for theoretical poetics.

Secondly, the picture of literary theory as a more or less autonomous series, independent both from the history of literature and art itself and from the history of other social practices, while it is perhaps not a dogma of *Rezeptionsästhetik*, is yet strongly suggested by Jauss's account of previous scholarship in 'Literary History as Challenge'. Curious as this may at first sound, the Konstanz group's concept of history is quite rigorously formalistic, if by that term one means that the focus of literary study is, or ought to be, literariness, that which distinguishes literary from other social (or indeed natural) phenomena. This need not be a term of absolute reproach, although it does give the impression that what is at stake in *Rezeptionsästhetik* is less the originality of its poetic theory than the particular insights achieved in its critical practice of reading.

Nor is the tension between theoretical mandate and pragmatic accomplishment unique to the Konstanz group. The particular form which it assumes, in the apparently irreconcilable demands

of historical differentiation and aesthetic universality or permanence, was an especially prominent concern of the Russian Formalists and their heirs in the Prague School. Among the latter, the bifurcation in theoretical emphasis was most visibly represented in the split between Mukařovský and his student Vodička, although the constitutive conceptual impasse itself was already figured in Mukařovský's own work. It may prove useful to consider, if only schematically, the way in which the antinomy between structure and history emerged in the project of the Prague School.

* * * * * * * * * *

The mature work of Felix Vodička has often been claimed as the authentic continuation of the Prague School's semiotic programme of literary history. Its importance for *Rezeptions-ästhetik* in particular is not in doubt.[19] The key concept that is indispensable to the structuralist theory of historical evolution is concretization. This is the operation by which a structure (the literary work apprehended as an aesthetic object) is transmitted through time; it is the means by which an otherwise fixed and rigid aesthetic monument is rendered mobile and susceptible of transmission from one cultural and social epoch to others. The concept is related to an earlier formulation by the linguist Sergej Karčevskij on the 'asymmetric dualism of the linguistic sign':

> The signifier (sound) and the signified (function) slide continually on the 'slope of reality'. Each 'overflows' the boundaries assigned to it by the other: the signifier tries to have functions other than its own; the signified tries to be expressed by means other than its sign. They are asymmetrical; coupled, they exist in a state of unstable equilibrium. It is because of this asymmetric dualism in the structure of its signs that a linguistic system can evolve: the 'adequate' position of the sign is continually displaced as a result of its adaptation to the exigencies of the concrete situation.[20]

The rigidity of the relationship between signifier and signified, an

19. See Ladislav Matějka, 'Literary History in a Semiotic Framework', in *The Structure of the Literary Process: Studies Dedicated to the Memory of Felix Vodička*, ed. P. Steiner et al. (Amsterdam, 1982), pp. 341-70. Jauss cites Vodička on concretization in 'History of Art and Pragmatic History' (TAR, 72-3). Iser's debt is also explicit: see Wolfgang Iser, *The Implied Reader: Patterns of Communication in Prose Fiction from Bunyan to Beckett* (Baltimore, 1974); and idem, *The Act of Reading: A Theory of Aesthetic Response* (Baltimore, 1980).

20. Sergej Karčevskij, 'The Asymmetric Dualism of the Linguistic Sign', in *The Prague School*, p. 54.

apparent consequence of Saussure's conception of language as a synchronic system, is openly challenged, creating the potential for what Peirce called 'unlimited semiosis', or the absolutely open text posited by *Tel Quel* theory. The possibility that the production of meaning might be completely uncontrollable and errant is avoided by means of the stabilizing effects of concretization, which is the fundamental mechanism of signification, the basis on which all communication is founded. Vodička writes:

> One and the same literary work read by readers in different circumstances results in many different concretizations of the work. They originate in various periods and, what is more important, frequently in different literary epochs or literary atmospheres, and thus under varied conditions which have an influence on their formation. They are immediately accessible *in concreto* to only a single reader, but they can be made known to other readers through description and in this way, indirectly, they are fixed at least in some of their features ... Descriptions of the concretizations of the same work coming from different periods reveal that despite all the individual differences there is a close relationship among the concretizations of a literary epoch. *The literary atmosphere of a given period compels its readers to read the work in a characteristic manner and thus to concretize it in a specific way.*[21] (emphasis added)

Peter Steiner has noted the indissoluble bond between the concept of function and those of norms and values in Prague School theory.[22] The normative structures of convention (what Vodička terms 'the literary atmosphere of a given period') determine and control the production of meaning in the reading of aesthetic texts. This concept has proven indispensable to Prague theorists and their progeny.[23] It would not be too much to say that in Prague

21. Felix Vodicka, 'The Concretization of the Literary Work: Problems of the Reception of Neruda's Works', in *The Prague School*, pp. 132-3.

22. Steiner, 'The Roots of Structuralist Esthetics', p. 204.

23. This is especially evident in the essays collected in the Vodička *Festschrift* cited in note 19: e.g., in Janice Radway's analysis of the functionality of mass cultural forms (pp. 397-429); in Miloš Sedmidubský's paper when he discusses conventionalization and selection (pp. 489-90); preeminently in Charles Eric Reeves's paper on 'Convention and Literary Behavior' (pp. 431-54); as, predictably, in Iser's contribution on the allegorical structure of Spenser's *Shepeardes Calendar* (pp. 210-41), and in Jauss's account of the historical lag in appreciation of the Polish emigré poet Cyprian Norwid (285-95). But the tendency can also be observed in Mukařovský: for example, in his exposition of immanent development and predetermination in communicative and aesthetic systems (Jan Mukařovský, 'Structuralism in Esthetics and in Literary Studies', in *The Prague School*, pp. 70, 74).

aesthetic theory the existence of conventions is the condition of the possibility of reading. Prague theorists and their admirers must hold onto this concept, the abandonment of which would eliminate the very capacity for historical transmission and understanding which it was their expressed purpose to establish. Steiner puts the matter well: 'The semantic distancing of the writer and the reader essential to literary discourse does not make it non-communication, for to abandon the notion of exchange in literary process would make the very concept of reception meaningless.'[24]

Not all of the expositors and proponents of the Prague theory of literary history are equally sanguine about the possibilities for codifying the history of reception, however. While the promise of concretization was to bridge the gap between the synchronic structure of literary works and the diachronic process of their understanding in history, it is by no means certain that these two poles in reception theory can be so readily accommodated in a single model of literary evolution. The attempt to control and stabilize the history of reading necessarily encounters theoretical obstacles for which the concept of concretization offers an inadequate solution. F. W. Galan, in criticizing Vodička on concretization, shows that the entire structuralist project is jeopardized by its lapse from rigour in the theory of literary reception:

> The crux of Vodička's problem is the same paradox one can detect in Mukařovský's conception of immanent evolution, namely that the structuralists' practice, capable of producing seemingly irrefutable analyses, descriptions and classifications of literary texts, is at odds with their own theory, which suggests that their critical readings, too, are individual concretizations to be discarded by the next generation of readers upholding a new set of literary norms. Analytic empiricism and theoretical relativism collide head-on, paradoxically, to the loss of the Prague scholars' scientifically (statistically, diagrammatically, linguistically) based practical criticism, whose validity is undermined from within by its 'supporting' theory.[25]

The paradox, practically fruitful yet theoretically compromising for the structuralists, consists in the incommensurability between history and theory. The only possible answer to the question

24. Peter Steiner, 'The Semiotics of Literary Reception', in *The Structure of the Literary Process*, p. 518. Steiner's essay is an explicit attack on *Tel Quel* theory.
25. Galan, 'Is Reception History a Literary Theory?', in *The Structure of the Literary Process*, p. 167.

Galan poses in the title of his essay, 'Is Reception History a Literary Theory?' would be 'No'. Or perhaps, 'Not in the form in which this history has hitherto been conceived.' The itinerary from structure to history, if it is to retain the theoretical precision to which semiotics lays claim, cannot follow the path laid down by Vodička.

It would not be entirely just, however, to fix the blame for this deviation in the structuralist project on Vodička alone. In another essay on the Prague School, Galan focuses on Mukařovský to present a sympathetic exposition of the dynamic conception of literary history developed in Prague during the 1930s. Even though the spirit of the article is expository rather than critical, Galan is too scrupulous a commentator to fail to uncover the flaw in Mukařovský's theory. Galan writes concerning the relationship of literary structure to individual works — in Vodička's terms, concretization: 'the relationship of the writer to the structure of literature is not fortuitious but dialectical, and the writer's activity should be construed not as an arbitrary outside intrusion but as the structure's dialectical negation.'[26] The seemingly aberrant (the individual work or author) enters into and is recuperated by the systematicity of the structure (literature as a global system). This can only come about if the two are already compatible or commensurable. But if that is the case, there must be some further system, some metalanguage or metadiscourse, to establish the commensurating terms by means of which the individual text or author is made compatible with or is translated into the existing system. The dialectic between text or author and system turns out to be the ordinary operation of a higher order system, whether it be a natural language, an entire culture, or some deep structure of the human mind. Galan locates this possibility in a citation from Mukařovský, which Galan glosses in a footnote reference to, among others, the Tartu group of Soviet semioticians.[27] Their notion of a 'structure of structures' or a system of cultural universals would provide just the required metalanguage, the ultimately commensurating discourse, or the most comprehensive conceivable manual of translation, to borrow Quine's term, which would constitute the necessary instrument for producing a global science of literature. It would appear that history has, in a sense, reversed its direction at this point, with the project of the Prague

26. F.W. Galan, 'Literary System and Systemic Change: The Prague School Theory of Literary History, 1928-1948', *PMLA* 94 (March 1979): 282-3.
27. Ibid., pp. 282, 285.

School, which had been launched along a vector originating in Moscow, now reversing itself to retrace its path, if only as far as Estonia, towards the place of its conception.

But there is another possible outcome of Mukařovský's theoretical trajectory, one that Galan's essay on Vodička makes explicit and is already hinted at in the earlier piece on Mukařovský. Having proclaimed the relationship between author or text and system to be dialectical, Galan restates this proposition in another form: 'Thus the opposition of literary structure and human individuality turns out to be the most fundamental antinomy of literary evolution.'[28] No longer moments in a dialectic in which a higher synthesis is achieved, the literary structure and the human individual are said to be antinomous. If we take this term in a strong Kantian sense, the dilemma of literary history as conceived by the Prague School becomes evident. On a Kantian view, the only solution is to dissolve the antinomy, to show that it is based upon a misconception in construing one or the other of the terms. But this strategy would be fatal to the Prague project as a whole, since it is premised upon the exteriority to the system of individual concretizations as well as upon the system's capacity to evolve in order to encompass new concretizations as they arise. As Mukařovský put it: 'to evolve means always to become something different, but without impairment of identity.'[29]

The nature of the conventions or norms that determine the formal properties of particular concretizations turns out to be more powerful and transhistorically dynamic than the professed ideology of the proponents of reception theory can envision. Galan shows with exemplary clarity how Mukařovský's poetics culminates in cognitive psychology and in broadly anthropological conceptions about the nature of aesthetic perception.[30] The history versus theory dichotomy in Galan's title is overcome by Mukařovský's dissolving history in a theory of human perception and cognition. Galan's critique of Vodička and of the history of reception which has been spawned by his work ends with the demand for specific protocols to determine the significance of individual critical statements, for only on the condition that concretizations can be judged as valid or not is a science of literature possible. Only when a system is capable of discriminating between genuine signals and mere noise does it

28. Ibid., p. 283.
29. Cited in ibid., p. 282.
30. Galan, 'Is Reception History a Literary Theory?', pp. 177-83.

constitute an authentic system. Reception aesthetics cannot even begin without the prior theorization of a formal poetics.

One consequence of this conclusion is that, far from having overcome the theoretical problems posed by Russian Formalism, Prague structuralism is compelled to return to the basic formalist concept of literariness and to stipulate the conditions under which the system of literature can be said to possess transhistorical dynamism. Galan makes this point by effectively restating Marx's position on Greek art: 'The fact that some works outlast the conflicts of arbitrary taste gives sufficient ground for assuming that their unfading value is not bound up with the transitory aesthetic object but rather with the aesthetic make-up of the material artifact.'[31] That Mukařovský did not stop there, but went on to locate the universality of the aesthetic in the perceptual/cognitive system of the human mind, does not affect the point at issue here: the postulation of transhistorically dynamic properties in aesthetic objects which make the history of reception and literary understanding possible. To conceive of the aesthetic as a modality of apprehending works of art (or indeed any object or experience whatsoever) need not conflict, on the classical view, with the postulation of phenomenal features in the sign which can only be understood aesthetically. There is no inherent contradiction between Mukařovský's psychological realism and the objectivity of the aesthetic posited in the quotation from Galan.

A serious difficulty remains nonetheless. Galan notes in the final paragraph of his essay on Vodička: 'It is not immediately clear, however, how Vodička could have applied Mukařovský's universalist tenets to the study of reception. The universals of language and literature resist ready-made specification.'[32] This is to say that the concept of concretization, the whole purpose of which was to explain how particular aesthetic texts could mediate between the historically variable norms of a given period and the fixed structural features of a textual system, possesses neither the particularity that would allow for genuine historical differentiation nor the generality that would make possible commensuration of any given reading of a text with the system of language or literature of which it is thought to be a part. Concretization is either a name for the historical heterogeneity between text and system, or a recognition of the systematicity of a theory of literary

31. Ibid., p. 180.
32. Ibid., p. 183.

understanding, but it is not and cannot be a theory of history.

The structuralist project thus reaches an impasse that has been, as Galan argues, historically productive. The scientificity of structuralist interpretive practice may be threatened by the attempt to extend this practice to encompass a theory of history, but it is precisely the historical studies generated by Mukařovský, Vodička, Jauss, Iser, and others which have established the authority of the method. It is thus perfectly plausible to recognize two distinct and ultimately incommensurable critical practices authorized by Prague theory. On the one hand, the formalism that persisted in the work of René Wellek and reemerged in the later career of Roman Jakobson represents one legitimate extension of the Prague School project, which never entirely escaped from the problematic of Russian Formalism that spawned it. As Galan's observation cited previously suggests, the major contemporary incarnation of this tendency is to be seen in the semioticians of the Tartu group. On the other hand, the extension of Vodička's work in *Rezeptionsästhetik* would be an equally legitimate interpretation of the aims and methods of the same body of theory. One could therefore say, with some irony, that the Prague School has been capable of generating a history precisely because the structure of its theory was sufficiently flexible to admit of different concretizations. It would, however, be questionable to claim that structuralism provides the commensurating discourse by means of which to compare the respective results of the history of reception with the theory of literature. The circle of structure and history remains unsquared in what is surely the most assiduous attempt to date to bring together the praxis of reading with the theory of literature. That a research program which originated explicitly in formal poetics would reach the same impasse as that encountered in a project whose announced task was to break with the reigning formalism suggests not only the difficulty and the depth of the problem, but also the degree to which formalism and historical understanding can never be entirely separated in the discourse of literary and aesthetic theory.

* * * * * * * * * *

One is tempted to conclude that the poetics of literature and the hermeneutics of reading are, despite the large claims made by the Konstanz theoreticians, finally incompatible, that the two project distinct models of textual production which cannot be accommodated without dissolving one or the other pole of the

antinomy structuring the relations between them. Either the authentically historical dimension of reading will be elided by the postulation of transhistorically dynamic properties in aesthetic artifacts, or the genuine permanence of the aesthetic monument will be denied in a recognition of the historical variabililty of interpretation. Schematically, this can be posed as the Mukařovský/Vodička split within Prague School theory. It may, however, be possible to envision other interpretive options than the history of reception inaugurated by Vodička and elaborated in Konstanz. Not all contemporary theories of reading with a semiotic basis presume that the authentic model for literary understanding is to be derived from investigating the history of reception. One thinks immediately of Eco or the later Barthes as more or less consistent formalists whose attempt to account for 'the role of the reader' does not depend upon any historical dimension of understanding. There would of course be much to say about the differences separating these two, but to the extent that they both assume the possibility of a genuinely unlimited semiosis, they can be conveniently, if somewhat hastily, lumped together with the Vodička tendency, rather than with a stern formalism of the text. The latter is more readily encountered in the work of Michael Riffaterre, whose unswerving commitment to the discipline of formal poetics has established his virtually unique position among contemporary theoreticians of reading.

Riffaterre has been called a 'declared, impenitent and consequential formalist' who insists upon 'a clear separation between the language of poetry and what he calls the "linear" language of cognition and mimetic speech.'[33] Characterized in this way, it is difficult to distinguish his project from that of the Russian Formalists in their earliest stage, and one might legitimately wonder how, except for the interest of the readings of particular texts, Riffaterre's work stands out noticeably from, say, that of Shklovskij. The former's writings would not, on this account, mark a significant theoretical advance beyond the supposedly well-known limits of formalist theory.

To illustrate the distinctiveness of Riffaterre's contribution, we may take a short detour through a problem in the interpretation of Aristotle's *Poetics,* the prototypical formalist text in the Western tradition. The history of commentary on the *Poetics* has been divided on the meaning of the catharsis clause in chapter six

33. Paul de Man, 'Hypogram and Inscription: Michael Riffaterre's Poetics of Reading', *Diacritics* 11 (Winter 1981): 19.

(1149b. 24-9). This debate can be schematized into two conflicting views. On the more or less conventional reading of the past two hundred years (perhaps longer), catharsis occurs in the audience. The viewers of the tragic action are purged of the affections of pity and fear. This view throws the interpretation of the *Poetics* (and of literary texts) outside the domain of poetics proper into psychology or aesthetics. One might say that this turns literary texts into suitable vehicles for rhetorical persuasion. On the other hand, at least a few commentators (Else, Telford, Goethe) have maintained that catharsis is nothing to do with the audience, but is an effect achieved within the plot. The emotional matter of a tragedy is a structural feature of the play; it involves only the intra-poetic structures of character, plot, thought, *et cetera*. This interpretation of catharsis would be more strictly poetic, in the sense that poetics is a science whose object is the nature of artifial things, rather than psychological or moral affect.[34]

The interest of Michael Riffaterre's work consists in his attempt to bring together these two divergent axes of literary theory, to incorporate the rhetorical problem of reading in a formal poetics. Paul de Man's formulation is acute: 'One can ... see [Riffaterre's] entire enterprise as a sustained theoretical effort to integrate reading into the formal description of the text without exploding its borders.'[35] Riffaterre's poetics of reading is a theory of discovery and invention; it is therefore a theory of rhetoric as that art has traditionally been defined. But Riffaterre's model of reading differs from most conventional rhetorics in one crucial respect. We can see what this is in his polemic against Lévi-Strauss's and Jakobson's structural description of Baudelaire's poem, 'Les Chats':

> The appropriate language of reference [in a given poem] is selected from the message, the context is reconstituted from the message, contact is assured by the control the message has over the reader's attention, and depends upon the degree of that control. These special duties, and the esthetic emphasis characteristic of poetry demand that the message possess features corresponding to those functions. The characteristic common to such devices must be that they are designed to draw responses from the reader — despite any wanderings of his attention, despite the evolution of the code, despite the changes in esthetic function.[36]

34. The divergent views of catharsis and their consequences in the history of interpretation are dealt with in the following chapter, with necessary bibliographic references given there.

35. de Man, 'Hypogram and Inscription', p. 20.

Riffaterre's communicational model depends upon the absolute stability of the poetic structure through time; it necessitates the postulation of an entity capable of perceiving and understanding the structures of the text. This entity Riffaterre dubs the 'superreader', whose powers and features he enumerates as follows:

> [The superreader] simply explores that act [of communication] more thoroughly by performing it over and over again. It has the enormous advantage of following exactly the normal reading process, of perceiving the poem as its linguistic shape dictates ... My 'superreader' for 'Les Chats' is composed of: to a limited extent, Baudelaire ...; Gautier ...; and Laforgue ...; the translations of W. Fowlie, F. L. Freedman and F. Duke; as many critics as I could find, the more useful being those whose reason for picking out a line had nothing to do with the sonnet; Jakobson and Lévi-Strauss for those points in the text where they deviate from their method (when they are being faithful, their analysis scans everything with an even hand and is therefore misleading); Larousse's *Dictionnaire du XIXème Siècle* for the entries which quote the sonnet; philological or textbook footnotes; informants such as students of mine and other souls whom fate has thrown my way.[37]

The list of resources available to the superreader suggests what Riffaterre elsewhere makes explicit: that the semantics of poetry is a kind of *bricolage*, the reader a *bricoleur*, albeit one whose lexical range is strictly delimited and dictated by the poetic text itself.[38] This is a somewhat misleading analogy, however, since the entire thrust of Riffaterre's writing, more visibly in later works like *Semiotics of Poetry* and *Text Production*, is toward a more technical method and rigorously controlled procedures. The superreader (the term itself is eventually dropped) of 'Describing Poetics Structures' becomes, as Riffaterre's project unfolds and matures, something like the dialectical opposite of the *bricoleur*: to

36. Michael Riffaterre, 'Describing Poetic Structures: Two Approaches to Baudelaire's *les Chats*', in *Structuralism*, ed. Jacques Ehrmann (Garden City, 1970), pp. 202-3.

37. Ibid., pp. 203-4.

38. '[T]he semantics of the poem is characterized by the *bricolage* that Lévi-Strauss has spoken of: it is based entirely on words arranged in advance, prefabricated groups, whose meaning has to do not with things, but rather with their role in a system of signifiers' (Michael Riffaterre, *Text Production*, trans. Terese Lyons [New York, 1983], p. 41; hereafter cited parenthetically as TP).

wit, the engineer (see TP,11,61).[39]

Reference to these Lévi-Straussian figures indicates a further question to which Riffaterre himself has not always responded with clarity.[40] Given that the recognition of poetic structures is a sophisticated and complex process, one may legitimately inquire into the origins of Riffaterre's reader. By what means does this reader acquire the capacity to perceive and understand the poetic features of the text? One can answer this question by considering further the model of reading Riffaterre presents, i.e., by observing what the Riffaterrean reader does. In determining the protocols Riffaterre establishes for reading, we may come to an understanding of how such protocols are mastered by the reader herself.[41]

First, and to distinguish literary from other modes of language. Riffaterre insists on the appearance of ungrammaticality in literary texts, what he terms the text's 'deictic feature' (TP,12), its 'linguistic mechanism of literariness' (TP,51).[42] He cites, for example, the signifier 'bat' (*chauve-souris*) in poems by Baudelaire and Hugo (TP,27-30), or, more generally, the use of neologism as a poetic device. This latter is distinguished from the neologisms of ordinary language by its sole dependence 'on relationships situated entirely within language' (TP,62). The neologism defamiliarizes or deautomatizes the language of literature: 'new coinings suspend the automatism of perception and force the reader to become aware of the form of the message he is deciphering. This awareness is specifically characteristic of literary communication. Precisely because of its unusual form, the

39. The case of Riffaterre confirms the suspicion of Derrida that the engineer and the *bricoleur* are not entirely separable entities; see Jacques Derrida, *Writing and Difference*, trans. Alan Bass (Chicago, 1978), p. 285.

40. See the interview with him in *Diacritics* 11 (Winter 1981).

41. It must be emphasized that Riffaterre's reader cannot be the idealization of certain species-specific capacities (like Chomsky's native speaker of a language, or the omnicompetent subject of thought in structuralist discourse). Riffaterre argues pointedly in his critique of Lévi-Strauss and Jakobson that the poetic structures actualized in a poem are not coincident or identical with the descriptive systems produced by structural linguistics for the analysis of language. Riffaterre's reader is transhistorically dynamic and competent (she can read texts from other periods than her own), but also historically and culturally constrained (her competence is learned, not given at birth). Riffaterre's reader knows a great deal (more than most of us could master in two lifetimes of intense reading and study), but her perceptual and cognitive apparatus has definite boundaries.

42. Elsewhere he writes: 'ungrammaticalities are special signs, bearers of the poem's literariness' (Michael Riffaterre, 'Interpretation and Undecidability', *New Literary History* 12 [Winter 1981]: 231).

neologism ideally fulfills an essential condition of literariness' (TP,62). The appeal to the vocabulary and the concepts of Russian Formalism is not accidental. Riffaterre's account of literary neologism shows how this species of ungrammaticality is a particulary significant aspect of the literariness of the text, a kind of laying bare of the device of literature itself: '[The neologism's] function is, thus, to bring together or condense the dominant characteristics of the text. Coined expressly and created to meet specific needs, the neologism is the precise word par excellence' (TP,74). Ungrammaticalities in a literary text are analogous, as Riffaterre himself on occasion notes, to neurotic symptoms: 'The text functions like a repression, and anomalies in the mimesis and disruptions of apparent referentiality are its symptoms' (TP,77). To pursue the Freudian model somewhat further, we can say that the literary text is characterized precisely by its linguistic overdetermination.[43]

But Riffaterre is not content to let the matter rest at this point, which would leave him more or less contained by the structuralists whom he had previously criticized for their inability to specify the exact dimensions of the literary within the general structural potentials of language on all its levels. Not every feature which can be posited of a literary text is effectively operative in the text. In order to master the possible errancy, the tendency towards unlimited semiosis in literary interpretation, Riffaterre contends that features must be *actualized*. The break here with formalism is explicit, and resembles, as de Man observes, Vodička's insistence that literary texts be concretized.[44] Riffaterre criticizes formalists for ignoring the primacy of the signifier in literary texts, as he takes Jakobson and Lévi-Strauss to task for attributing structures to *Les Chats* which are not marked or visible in the surface features of the text.[45] The point at issue here can be grasped by referring to the

43. See also Michael Riffaterre, *Semiotics of Poetry* (Bloomington, 1978), p. 19. The reference to Freudian concepts of exegesis is potentially dangerous for Riffaterre, not in the psychologism of vulgar Freudian redactions so much as in the potential break in the scientificity and mastery over interpretation which Riffaterre's system is concerned to protect. Psychoanalysis may not be the most felicitous choice of a model for Riffaterre's scientific work, if 'explication of texts is really a machine for taming a work' (TP, 2). It is far from decided whether the analysis of dreams and neurotic symptoms offers a reliable 'machine for taming'. To show this would require a long detour through Freud's corpus; a shortcut could proceed via Samuel Weber's *The Legend of Freud* (Minneapolis, 1982).

44. de Man, 'Hypogram and Inscription', p. 21.

45. See 'Le formalisme français', in Michael Riffaterre, *Essais de stylistique structurale* (Paris, 1971), pp. 276-80; Riffaterre, 'Describing Poetic Structures', p. 222.

account of the structure/text relation given in the following passage: 'a structure (that which is invariant) is no more latent than is geometry; it is simply an abstraction, like geometry. But its variants are completely tangible and are stylistically encoded.'[46] Riffaterre's phenomenalism is apparent. Like Kant, he posits the real (phenomenal) existence of the figures of geometry, claiming that the relationship of poetic structures to actual texts is like that of geometric postulates to sensible figures. On Riffaterre's view, the structures projected by theory must be present to the observer in the phenomenal form of textual signs; poetic structures must be made manifest. This sensory manifestation of theoretical entities is what Riffaterre means by actualization. It controls and limits the otherwise unrestricted signifying potential of signs.

The stipulation that significant textual features be actualized provides the key to the third protocol of reading on which Riffaterre's theory rests. Riffaterre's notoriety as a theorist undoubtedly derives in large part from his rigorous specification of the notion of intertextuality, which he has recently characterized in more technical language as hypogram or paragram. The intertext is the semantic given of any text, that from which the textual matrix is generated. It can be a cliché, a topos, or a recognizable ideologeme within the cultural-linguistic horizon of the author. For instance, Riffaterre identifies the paragram in a Cocteau poem as the commonplace figure of the road of life with the resting place of death at its end. The paragram appears in the phrase 'auberge de la mort', which occurs in the opening line (TP,78-9). Another example of the procedure occurs in his commentary on *Madame Bovary*, which focuses on two identifiable features in the text: the Virgilian tag line 'Quos ego' from the schoolroom scene that opens the novel, and the more general *topos* of 'la femme adultère' which governs the action of the plot and predicts the significant features of Emma's character and environment once she has arrived on the scene.[47] The intertexts in literary structures are the presuppositions upon which the text is based, the metonymies that generate the semantic structures which the text actualizes (TP,88; FP,7-8). Riffaterre's method proposes a generative semantics of the sort that Chomskean theory has often predicted without ever convincingly achieving.

46. Riffaterre, 'Le formalisme français', pp. 284-5; my translation.
47. Michael Riffaterre, 'Flaubert's Presuppositions', *Diacritics* 11 (Winter 1981); hereafter cited parenthetically as FP.

This raises the problem with which we began, namely, the question of literary competence and how the reader acquires it. Clearly, no one is born knowing how to recognize lines from Virgil and ethical *topoi* like the adulterous woman. Riffaterre is not unaware of this difficulty, which he addresses in a number of places. We will confine our commentary to a representative passage from his more recent writings:

> What happens, one may well ask, when a literary tradition is forgotten and cultural changes wash away the paragram? The efficacy of the text is in no way altered, *because the text remains unchanged*. The text is the starting point of the reader's reactions, not its paragrams. Obviously, the reader who shares the author's culture will have a richer intertext. But he will be able to draw on that wealth only when semantic anomalies in the text's linearity force him to look to nonlinearity for a solution. And the reader who is denied access to the intertextual paragram still sees the distortion, the imprint left upon the verbal sequence by the absent hypogrammatic referent. He does not even have to understand fully: it is quite enough for him to stand before a spectacle, however incomprehensible it may be, in which the inner logic of the hypogram can be seen, provided that spectacle is devoid of internal contradictions. (TP,87-8; our emphasis)[48]

Complete understanding of a text's semantic significance may require study and the aid of scholarly erudition, but the basic impulse to go looking for more information is provoked by textual functions that are independent of the reader's cultural or historical competence. One need only be a relatively mature native speaker of the language in which the text is composed to possess this capacity to interpret. Scholarship is the handmaiden of formal analysis, not its precondition.

At this point, Riffaterre's model of reading seems to veer in the direction of *Rezeptionsgeschichte*, especially when he defends the rights of subsequent readers against the claims of those who argue (call them E. D. Hirsch) that only the meaning of a text contemporary with its production offers a sure guide to valid interpretation: 'Later readings are as legitimate as the initial ones. Both stem from the same phenomenon' (TP,99). But Riffaterre is far from grounding his theory of reading in the history of reception, which, like historical scholarship, is a tool, not a precondition of understanding. The analysis of texts depends

48. See also the *Diacritics* interview, p. 16; Riffaterre, 'Interpretation and Undecidability', p. 239.

upon purely linguistic properties which are, as it were, hard-wired into the text and which the reader cannot without dishonesty or bad faith ignore. The text imposes its meaning on the reader with the force of a command.

Riffaterre himself draws the analogy between the structure of literary texts and computer programs (TP,2). The supposed anarchy of interpretation that the history of reception threatens at every moment to break into (and which is defended with great vehemence by David Bleich, Stanley Fish, and others) is no danger in Riffaterre's view of the text. What controls reading is not the force of convention, as in Vodička, or certain basic biological/psychological structures of the human mind, as in Mukařovský, but the absolutely inexorable force of the text's unified semantic and syntactic structure:

> Generated from a minimal sentence whose components are given without modificiation and are acceptable (verisimilar) solely because their motivation remains implicit, the literary sentence tends, therefore, to be *a sequence of explanatory and demonstrative syntagms that drive arbitrariness from clause to clause, further and further away.* The transformation of simple components into complex representations makes the literary sentence a grammatical equivalent of an allegorical figure rich in symbolic attributes (the vestments, sword, and scales of Justice, the hourglass of Time, and so forth). (TP,61; our emphasis)

Leaving aside the naive notion of allegory presented here, the passage illustrates the extent of Riffaterre's commitment to literary formalism. His formulation corresponds closely to the classical example of how to read a text presented in Aristotle's account of the plot of *Oedipus Rex*, although in Riffaterre the moment of *peripateia* has been muted in a teleological projection of the text's logical syntagmatic progression. The discovery (*anagnorisis*) that the apparently heterogeneous events of Oedipus's life are connected and coherent (probable and necessary in Aristotle) is just that *telos* towards which the reader progresses in Riffaterre's model of interpretation. The text possesses this knowledge prior to its being read, but this is due solely to its having traversed the path of semantic and syntactic organization in advance of the reader. The Riffaterrean reader can legitimately aspire to all the knowledge which the text has achieved.

The time has come to test the power of Riffaterre's model in the reading of a text. His works offer a rich variety of opportunities in this regard, and the particular example hardly matters. For

reasons of economy, I have selected a comparatively brief exegesis of a poem by Cocteau. Since this reading is offered by Riffaterre himself to illustrate the manner in which a text achieves significance by developing the semantic possibilities of a single paragram, its relevance to our discussion should be apparent. The text of the poem is as follows:

> Car votre auberge, ô mort, ne porte aucune enseigne.
> J'y voudrais voir, de loin, un beau cygne qui saigne.
> Et chante, cependant que lui tordez le cou.
> Ainsi je connaîtrais ce dont je ne me doute:
> L'endroit où le sommeil interrompra ma route,
> Et s'il me faut marcher beaucoup.

Riffaterre's commentary identifies the semantic given of the poem in the figure in the opening line: the road of life at the end of which lies the place of rest — death. There is a clear intertext (Baudelaire's 'La Mort des pauvres'), but it is unnecessary for the reader to know this due to 'the very logic of the word group's semantic configuration' (TP,78). The semantic reciprocity between *auberge* and *mort* will be apparent to anyone with even minimal lexical competence in French: 'But there is also a direct metaphoric relation between *mort* and *auberge*, for the "road of life" theme selects the "weariness" and "longing for rest" semes in in *auberge*. Consequently, *auberge* is to the tiring *road* what *death* is to *life*' (TP,78). The logic of the poem's narrative and semantic structure derives from this figural kernel.

The second move in the reading focuses on puns in the first two lines, one made explicit in the rhyme 'enseigne/saigne', the other submerged in the emblematic tradition of the roadside inn which bears a sign (*signe*) that is almost certainly what the traveller recognizes at a distance. What he sees, then, is the sign of the swan (*signe/cygne*), or, as Riffattere postulates, an inn named *Singing Swann* (TP,79). The pun even comes to infect Riffaterre's own language in a rare moment, for him, of stylistic abandon. In the original French of *La Production du texte*: 'Le cygne de l'enseigne est signe quand il saigne' (TP,82). On the relationship thus established by the poem between 'bleeding' and 'swan' Riffaterre comments: 'one cannot avoid perceiving *cygne* as the reverse of *saigne* and *saigne* as the observe of *cygne*. By modifying the existing semantic relationships this inversion-reversion variation replaces a rule of language with a rule of the ideolect' (TP,82).

The semantic or logical structure of the poem is commensurate

with this symmetrical reversability. Riffaterre omits the title of the poem until the final paragraph of his explication, but it has obviously governed the course of his reading from the beginning:

> The title, *L'Endroit et l'envers* is a cliché repeated verbatim by various death images ... This formal back-and-forth sway between contraries comes as a kind of semiotic confirmation — it is almost a grammatical pantomime transferred by reading to the plane of gesture — of the appropriateness of the cliché when applied to a meditation on Death. It replaces a commonplace about death as the great beyond (an all-purpose image) with a representation belonging to this text alone and serving as the earmark of Cocteau's manner: the representation of death as the reverse or the other side of life. (TP,82)

Riffaterre's reading is carried out with his customary confidence and with due speed, finding no obstacle to prevent the passage from the semantic given of the opening line to the clinching of the poem's grammatical and semantic structure in the analysis of the title just quoted. One's legitimate admiration for the ease with which the procedure can be mobilized in a reading is not sufficient, however, to preclude suspicions about the completeness of the exegesis.

What Riffaterre's reading overlooks is the fact that the poem is about an *absent sign,* or more precisely, about an event for which there is, as the poem itself states, no phenomenal representation — *la mort.* If death is a place at the end of life's road, and if it is an inn, as the poem figurally asserts, it remains true that, contrary to tradition, this inn carries no signboard: 'ne porte aucune enseigne'. This means that death cannot be the object of a cognition; it is precisely that which cannot be known, apprehended, understood: 'Ainsi je connaîtrais ce dont je ne me doute.' The impediment to the speaker's desire to know is indicated grammatically by the subjunctive: I ought to know about death, but I don't. The final clause in the line could mean either 'what I don't suspect' (the translator of *Text Production* has 'what I cannot even guess' [TP,78]), or 'what I don't think'. Death is the unthinkable, for it is, in Cocteau's poem at least, unrepresentable. The literal point of the poem, which Riffaterre's reading gracefully skirts but ultimately ignores, is that life and death are not symmetrical. If the poem as a whole is understood semiotically, then we are forced to conclude that this sign does not signify.

Riffaterre must overlook this aspect of Cocteau's text if his theory is to survive intact; to notice the non-signifying possibility of the sign threatens a death blow to the aesthetic unity of the

system of literature. If poems, like death, can appear anywhere or anytime, if the signs of poetry's poeticalness are perpetually absent, then nothing is to prevent the reader (like Cocteau in writing this poem) from constructing such visual icons of meaning wherever she pleases. Poems, like death, are where one finds them, and over the procedures of their discovery we may exercise very little influence.

* * * * * * * * *

The suspicion expressed in F. W. Galan's critique of Vodička and the history of reception turns out to have been warranted, although the hope that a more rigorous formalism might avoid the randomness introduced into interpretation by the historical praxis of reading has not proven well founded. Even so scrupulous and attentive a commentator as Riffaterre is unable to protect the aesthetic unity of the text from the potential aberrancy of reading. This is to say that the aesthetic, while it consistently sets forth to manage the contradictions inherent in the semantics of natural languages, inevitably encounters ideological obstacles to its hegemony over the text and its interpretation.

Riffaterre is perfectly lucid about the stakes in his formalist method. His wish is to maintain the disciplinary force and utility of literary history, but to control its procedures through the intervention of formal analysis:

> Literary history tends to interest itself in the genesis of literature, its contents, its relationship to external reality, and in the changes in the text's meanings wrought by time, which are dependent on changes in the reading public's ideology ...
>
> It seems further evident that literary history, ever on the verge of turning into the history of ideas, or sociology, or the historical study of literary matters, should find natural safeguards in these basic assumptions of formal analysis: that literature is made of texts, not intentions; that texts are made of words, not things or ideas; that the literary phenomenon can be defined as the relationship between text and reader, not the relationship between author and text. (TP,90)

Riffaterre's solution is to ground the analysis of literary texts in language, but this is an insufficient safeguard against history, which intervenes in language on the semantic level quite as violently and uncontrollably as it does in ideology. More adequately, we can say that language and ideology are not separable and distinct entities, but mutually implicated aspects of

a single theoretical space. One can call this space rhetoric, provided it is stipulated that the science upon which this art is founded is not psychology but history. Literary formalism may yet find its proper home, but not until it has passed through a more rigorous theorizing of the historicity of artifacts than any we have encountered thus far.

5

What Is Living and What Is Dead in Chicago Criticism

Anglo-American literary study, which became an established discipline during the 1920s with the reform of the Cambridge Modern Languages Tripos and the emergent hegemony of Ricardian New Criticism, has experienced a markedly uneven theoretical development. The scientific optimism inaugurated by Richards's *Principles of Literary Criticism* (1924) has remained more a hope, frequently revived, within the ideology of literary critics and theoreticians than an actual achievement. Within the ambit of British literary criticism, Richards's two most eminent pupils, Leavis and Empson, hardly carried forward the banner of a scientific criticism beyond the end of the decade. The techniques of close reading canonized in *Practical Criticism* (1929) survived more or less intact, but the intent to codify the procedures of reading and interpretation in a rigorous method fell by the wayside, as the moralism and aestheticism of *Scrutiny* came increasingly to dominate within the culturally central discipline of 'Eng lit'.[1]

1. On the history of English studies in Britain and the moment of its crisis during the 1970s, see Raymond Williams, *Writing in Society* (London, 1983), Part 4. The definitive study of *Scrutiny* remains Francis Mulhern's neglected classic, *The Moment of 'Scrutiny'* (London, 1979). The emergence of the ideological project of British criticism, including Richards's scientism and Leavis's aesthetic moralism along with the more openly atavistic criticism of T.S. Eliot, is thoroughly delineated in Pamela McCallum's *Literature and Method: Towards a Critique of I.A. Richards, T.S. Eliot, and F.R. Leavis* (Atlantic Highlands, 1983). The centrality of English studies to the formation of national ideology is persuasively argued by Perry Anderson in 'Components of the National Culture', *New Left Review* 50 (July-August 1968).

In the United States, formalism arrived somewhat later (although neither so late nor so exclusively among a single group as is often claimed), but its fate was no less complicated for having the British example from which to benefit. The call for a renewal of formal poetics, as well as the predictable accompanying attacks on the dead end of formalism, have been a recurrent feature of critical and theoretical debates in American literary study from Ransom's 'Criticism, Inc.' down to Jonathan Culler's *The Pursuit of Signs* and Frank Lentricchia's *After the New Criticism*. It is perhaps not terribly important, therefore, to locate the exact moment when American literary study began its long and still uncompleted journey away from positivistic literary history and philology toward formalism and theoretical poetics, since that moment seems to recur with the regularity of changes in the weather. Our choice for an inaugurating document in this controversy is somewhat arbitrary, although not entirely unjustified. R. S. Crane's 'History versus Criticism in the University Study of Literature' was first published in 1935; it is thus coeval with the emergence of the New Criticism of Ransom and his colleagues and students. The clarity with which Crane proposes to revolutionize the university study of literature, as well as the openly pedagogical intent of his program (by contrast, New Criticism only attained comparable programmatic unity with the founding of the Kenyon English School more than a decade later) recommends his essay as a likely point at which to open the consideration of American formalism:

> The remedy I propose is nothing less than a thoroughgoing revision, in our departments of literature, of the policy which has dominated them — or most of them — during the past generation. Ample provision should still be made, especially on the graduate level, for courses and seminars in literary history and the history of ideas. But there should be fewer of these, at least of lecture courses, even on the graduate level, than are now given ... For the parts of our present program thus displaced I would substitute, and this at all levels from the college through the Ph.D., studies of two distinct though closely related sorts. The first of these would comprise systematic work in the theory, generally of all the fine arts, and specifically of the art of literature; it would be of great advantage if this work could be organized and conducted, not by particular departments of literature separately, but by the division of the humanities as a whole ... But the end of theory, for criticism, is application; and so the second of our two groups of studies would consist of exercises in the reading and literary *explication* of literary texts ... The essential thing is that they (the explications) should not be allowed to degenerate into linguistic or historical

investigations or into mere occasions for the parading of personal tastes, but should be kept constantly directed toward their proper objective — *the text itself considered as a production of art to be read appreciatively for its own sake in the light of relevant knowledge and of the principles of its kind.*[2] (emphasis added)

One could not wish for a more patient, thorough, and prudent statement of the objectives of formalized literary study. Crane's assessment of the then current practice of literary criticism and his projection of the necessary turn towards theoretical poetics (the divergence announced in his title between 'history' and 'criticism') typifies the attitudes of a broad range of scholars and critics of his and subsequent generations towards the historical model of literary education which was the original emphasis in professional literary study when it emerged in the university during the 19th century. This model has remained a powerful, if largely unacknowledged, basis for curricula and for critical under-standing down to the present. It would be incorrect to say that in the wake of Crane's manifesto historical studies were routed — any more than they were after comparable prounouncements over the next two decades by Wellek and Warren, Brooks, Wimsatt and Beardsley, and others whose work came to dominate the criticism and pedagogy of literature in the American academy. Nonetheless, the hegemony of New Criticism's techniques of close reading, the general demise (partly for political reasons) of sociological criticism, and the acute crisis in the writing of literary history — these obvious features of the American critical landscape over the past half century all bespeak the broad success of Crane's pro-gramme within literary scholarship. Russian Formalism and Prague Structuralism may have met an untimely end in the lands of their birth, but the legacy of their theoretical advances would be kept alive or, as often, rediscovered and reformulated anew in Western Europe and North America. (This did not happen, of course, without significant deflections in the theory when it was translated into a foreign idiom and transported onto alien territory.) In the current conjuncture, when formalism is under attack seemingly from all quarters, it may be useful in assessing the possibilities and the limitations of formalist criticism to examine one of the most programmatic and disciplined attempts to ground the history and

2. R.S. Crane, 'History versus Criticism in the University Study of Literature', *English Journal* 24 (1935); rpt. in Crane, *The Idea of the Humanities and Other Essays Critical and Historical*, 2 vols. (Chicago, 1967), II:22-3; hereafter cited parenthetically as IH.

interpretation of literature in theoretical poetics. This may help us to understand better how literary study came to be constituted in its present form.[3]

We may begin, somewhat artificially and counter to the drift of Crane's own pronouncements, with an account of Crane's career. The genetic, biographical model in this case is only a convenience for illuminating the theoretical problems raised by Chicago poetics, although, as the case of Crane will illustrate (and as we observed previously in the treatment of the Prague School), formalist models of poetic structure are not necessarily incompatible with genetic modes of inquiry and description. Even Aristotle, no friend to historical science, found historical inquiry unavoidable in deriving the definition of Greek tragedy in the *Poetics*. The coercive power of historical models and methods of understanding over formalist thought is part of the point of the present chapter.

Crane was born at the end of the 19th century. He took degrees at the Universities of Michigan and Pennsylvania prior to the First World War. As he himself indicates in the essay on history and criticism, the hegemony of philology and literary history over literary study in the Anglo-Saxon world during this period was virtually unchallenged. Crane was to become, during the 1920s, among the foremost historical scholars in America. His special area of competence was the 18th century, for which period he almost single-handedly compiled and annotated the annual bibliography in *Philological Quarterly* from 1926-1932.

Crane's professional career spanned some six decades. He

3. Paul de Man's assessment of the bad repute into which formalism has fallen summarizes our point: 'To judge from various recent publications, the spirit of the times is not blowing in the direction of formalist and intrinsic criticism. We may no longer be hearing too much about relevance but we keep hearing a great deal about reference, about the nonverbal "outside" to which language refers, by which it is conditioned and upon which it acts. The stress falls not so much on the fictional status of literature ... but on the interplay between these fictions and categories that are said to partake of reality, such as the self, man, society, "the artist, his culture and the human community," as one critic puts it ... We speak as if, with the problems of literary form resolved once and forever, and with the techniques of structural analysis refined to near-perfection, we could now move "beyond formalism" towards the questions that really interest us and reap, at last, the fruits of the ascetic concentration on techniques that prepared us for this decisive step' ('Semiology and Rhetoric', in de Man, *Allegories of Reading: Figural Language in Rousseau, Nietzsche, Rilke and Proust* [New Haven, 1979], p. 3). De Man's essay was first published in 1970; it was reprinted without significant revision in 1979. Nor is there any compelling reason to revise his assessment today.

moved from Northwestern to the University of Chicago in 1924, and remained there until his death in 1967. From 1930-1952, he edited *Modern Philology*. The importance of Crane's editorial and bibliographic work, and the ways in which he sought to alter the direction of literary study by these means, should not be underestimated. As recent studies of the history of modern criticism have emphasized, the journalistic organs of 20th-century critical movements have been crucial to the maintenance of cohesion among the members of the group and to the ability of these groups to influence a wide spectrum of critical discourse.[4]

Equally important for Crane's revisionary project was that, at the very moment of writing his essay on history and criticism, he assumed the chairmanship of the English department at Chicago, a position he would hold for the next twelve years. As chairman, Crane was, in the words of Wellek and Warren (not entirely accurate words, as Crane would later observe, but not far off the mark), to have 'boldly reoriented' the graduate program at Chicago 'from the historical to the critical'.[5]

Crane plainly sought to redirect the study of literature not only through polemical interventions against the established discourse of scholars (the central documents are *Critics and Criticism* [1952], and *The Languages of Criticism and the Structure of Poetry* [1953]), but also by changing the graduate syllabus at one of the major institutions for training scholar-critics. These seem obvious enough points, but it is necessary to recall that the practice of criticism depends not only on the structure of critical discourse and its commonplaces, but also on two major institutions in which this practice is elaborated and sustained: the professional journal and the curriculum of study for apprentices. These material and institutional conditions for the production of discourse are quite as significant as its thematic focus — although the themes of a discourse are often closely related to the institutional structures within which the discourse is produced. The complexity of this problem can only be dealt with tangentially here.[6]

4. The list of studies on the professionalization of literature as a discipline has grown exponentially in recent years. The pioneering works in materialist analysis remain: Francis Mulhern's study of *Scrutiny* cited in note 1 above; John Fekete's *The Critical Twilight: Explorations in the Ideology of Anglo-American Literary Theory from Eliot to McLuhan* (London, 1977); Richard Ohmann's *English in America: A Radical View of the Profession* (New York, 1976).

5. Quoted by Crane himself in 'Criticism as Inquiry; or, the Perils of the "High Priori" Road', in IH,27).

6. A different version of the present chapter first appeared in *boundary 2* 13

One other fact should be noted apropos of Crane's position at the University of Chicago and in the profession of humane letters as a whole. It has long been accepted that one of the principal moving forces in the formation of the Chicago School was the late Richard McKeon, who came from Columbia to Chicago in 1934 under the sponsorship of Robert Hutchins. McKeon's essays soon began to appear in *Modern Philology*, along with those of his student Elder Olson. In addition, McKeon was in 1935 to be made head of the humanities division at Chicago. It cannot have been fortuitous for Crane's 1935 essay to suggest that 'it would be of great advantage if this work [in the theory of the fine arts] could be organized and conducted, not by particular departments of literature separately, but by the division of the humanities as a whole.'[7] The centrality of literary study to this program is apparent. Crane and his colleagues (and subsequently their students) sought methodological and ideological supremacy over the entire humanities curriculum and, beyond that, over the educational mission of the university. Chicago criticism can fruitfully be compared to other critical enterprises roughly contemporary with it: Leavis and the *Scrutiny* group; the fugitive agrarians; Trilling and the group around *Partisan Review*; Eliot's social criticism and his project for *The Criterion* in the late twenties and thirties. All shared a common goal to establish the claims of the humanities (or, more narrowly, the discipline of literature) against the growing cultural prestige of positivist science and its presumed ally, modern industrial society. The special interest of Crane's project, as distinct from these others, lies in the attempt to revolutionize literary study by making theoretical poetics its foundational discipline. It ideological mission can therefore be bracketed temporarily while we examine the theoretical trajectory Crane pursued.

In Crane's own terms, Chicago poetics was to have two distinct moments: history and theory (or criticism). The relationship of history to theory in Crane's proposal derives from McKeon's reading of Aristotle, and ultimately from Aristotle's account of the origins of tragedy in the first five chapters of the *Poetics*. The question turns on the means for establishing a method specific to a given subject matter:

(Winter/Spring 1985). More complete information about Crane's contributions as a bibliographer and editor is given in the notes to that paper.

7. See also Crane's introduction to *Critics and Criticism: Ancient and Modern* (Chicago, 1952), pp. 2-5; hereafter cited parenthetically as CC.

The basis of the whole work [of theory], indeed, is historical, inasmuch as its definitions, being simply inductions of the universal traits exhibited by particular works, must rest upon a wide acquaintance with what poets have done; we could never know, for example, what the peculiar 'power' of tragedy is without direct experience of poems in which this 'power' is manifestly present ... [T]he history of poetry, for Aristotle, is an essential means to the selection of those ends in poetry which give him the basis of his judgments of value. The ends are facts in the sense that they are reflected in the practice of poets when poetry ... has attained a stage of development in which the forms, or some of them, 'natural' to it exist in their fully differentiated state, even though they may be capable of further particular development.[8]

This passage, which established a normative position for Chicago poetics, is notable for two reasons. First, despite Crane's notorious contempt for all forms of Hegelian totalization, one recognizes here the eminently Hegelian notion of the necessity for theory to emerge in history — albeit that Crane's authority for this procedure is Aristotle.[9] Secondly, Crane rigorously focuses this conception of history on the history of poetry, and thus strictly delimits the field of inquiry in literary study to poetics (as opposed to rhetoric, metaphysics, or politics, all of which are possible methods for theorizing poems as objects of inquiry).[10] On this point, Crane is an orthodox Aristotelian, for Aristotle certainly conceived poetics as a distinct science whose subject matter is artificial things. PERI POIETIKES, it has been suggested, might be legitimately (and more literally) translated as 'Concerning Productive Science'.[11]

Crane's appropriation of Aristotle's poetic method proposes an inductive poetics, a science of literature in which the formal

8. R.S. Crane, *The Languages of Criticism and the Structure of Poetry* (Toronto, 1953), pp. 63-4; hereafter cited parenthetically as LC.

9. See also LC,xvi. Our invocation of Hegelian historical totalization refers to the canonical view of Hegel; it is far from certain that this concept of history is unproblematically asserted in Hegel's texts.

10. Crane's constant rebuke against what he termed the 'Coleridgean' orthodoxy of modern literary criticism was that it proposed a metaphysics of poetry, rather than a poetics: see his Prefatory Note to 'Two Essays in Practical Criticism', *University Review* 8 (1942): 199-202. On the discrimination among poetic, political, and rhetorical conceptualizations of literature, see LC,41, 49.

11. See Kenneth A. Telford, *Aristotle's Poetics* (Chicago, 1961), p. 1; Richard McKeon, Introduction to *The Basic Works of Aristotle* (New York, 1941), pp. xxix-xxxii; and Elder Olson, 'The Poetic Method of Aristotle: Its Powers and Limitations', in Olson, ed., *Aristotle's 'Poetics' and English Literature* (Chicago, 1965), pp. 175-91.

features of poems are theorized in light of their contributions to the production of poetic wholes. The end or final cause of poetry for Crane is the production of individual poems for their own sake:

> The criticism of poetry ... is, on this view, primarily an inquiry into the specific characters and powers, and the necessary constituent elements, of possible kinds of poetic wholes, leading to an appreciation, in individual works, of how well their writers have accomplished the particular sorts of poetic tasks which the natures of the wholes they have attempted to construct imposed on them. (CC,13)

This is an exemplary statement of the principles and the direction of the project of Chicago formalism. Nothing distinguishes these so-called Neo-Aristotelians, at this level, from Shklovskij and the early works of the OPOJAZ, or indeed from Riffaterre.

At the same time, two different research programs did emerge within the Chicago School. The formalist first principles that founded Crane's project engendered both the poetics Crane professed and the step outside poetics which he himself consistently castigated other contemporary critical practices for taking prematurely. The decisive split within Chicago criticism, which set Olson and McKeon off from Crane and later Sheldon Sacks and Wayne Booth, Crane's students, can be grasped by turning to the interpretation of the catharsis clause in Aristotle's definition of tragedy. Aristotle there established the *telos* of tragedy as the 'achieving through pity and fear a catharsis of such affections'. Crane's commentary became canonical for the more widely known and influential branch of Chicago criticism:

> The pleasurable catharsis — the setting of the soul into its normal state of rest after painful disturbance — will come about if the action is properly complete, with its incidents following one another, not by chance or by the arbitrary manipulation of the poet, but in an inherently probable or necessary order. Hence, assuming such a construction in well-made tragedies, Aristotle concentrates on the question of *what kind of plot will most successfully arouse the emotions of pity and fear, and these being respectively what we feel* when such a misfortune threatens one who is like ourselves in being neither wholly just and knowing nor wholly villainous. (LC,71-2; emphasis added)

Crane's swerve from poetics consisted in locating catharsis, not in the functional integration of the elements of the tragedy itself, but in the experience of the audience. Wimsatt's famous charge

against Chicago criticism of 'latent affectivism' is warrantable on a reading of Crane, and of Booth and Sacks as well.[12] Despite his explicit claim to discriminate rigorously between rhetoric and poetics, Crane rhetoricizes the *Poetics* by construing the end of tragedy to be its affective power on an audience; he thereby authorizes the research program of the next generation of Chicago critics (Booths, Sacks, Rader), whose work was, in the words of another heir to this tradition, to be dominated by a 'persistent emphasis upon purpose, inferred intention, the work's final cause.'[13] This swerve from poetic formalism will also prove to have consequences for the larger ideological project of Chicago criticism.

* * * * * * * * *

The divergence between a strictly formal analysis of plot and Crane's rhetorical conception of the power of a plot to affect an audience is evident in Crane's famous analysis of the plot of *Tom Jones.* The essay opens with an exemplary critique of neo-classical poetics (based on the research of fellow Chicagoan Bernard Weinberg) for having imposed rhetorical and ethical constraints upon Aristotle's poetic method. Crane then reasserts what he believes to be the more correctly Aristotelian concept of plot as this would apply to novels. He proposes that 'plots will differ in structure according as one or another of the three causal

12. William K. Wimsatt, Jr., 'The Chicago Critics: The Fallacy of the Neoclassic Species', in Wimsatt and Monroe Beardsley, *The Verbal Icon: Studies in the Meaning of Poetry* (Lexington, 1954), p. 60. When interpreting the catharsis clause in the *Poetics*, on the other hand, Wimsatt adopts the same affective view as Crane: see Wimsatt and Cleanth Brooks, *Literary Criticism: A Short History* (New York, 1962), pp. 36-7.

13. David H. Richter, 'The Second Flight of the Phoenix: Neo-Aristotelianism since Crane', *The Eighteenth Century: Theory and Interpretation* 23 (Winter 1982): 27-48. The rhetorical deviation from poetics in Booth's work is too obvious to require lengthy demonstration. His first book, *The Rhetoric of Fiction* (Chicago, 1961), presents a sustained defense of intentionalism and affectivism *tout court* (accompanied by a virulent attack on modern fiction for abdicating the responsibility of the artist to keep his intentions clear). Booth himself has noted the affectivism of *A Rhetoric of Irony* (Chicago, 1974): see his *Critical Understanding: The Powers and Limits of Pluralism* (Chicago, 1979), p. 78. Affectivism in Sack's work is treated in detail by Ralph W. Rader in 'The Literary Theoretical Contribution of Sheldon Sacks', *Critical Inquiry* 6 (Winter 1979): 183-92. Rader's essay usefully traces the genealogy of some recent work in the tradition of Chicago criticism by students of Booth and Sacks and in studies by sympathetic colleagues like Rader himself.

ingredients [action, character, thought] is employed as the synthesizing principle.' He then establishes a typology of three possible kinds of plot on this basis: plots of action (exemplified in *Oedipus Rex* and *The Brothers Karamazov*), plots of character (*The Portrait of a Lady*), and plots of thought (*Marius the Epicurean*). On Crane's view, *Tom Jones* is a plot of action (CC,620-1).

Crane's analysis of the plot of Fielding's novel belies this claim, for in his exposition, Crane turns it into, in the terms of his own schema, a plot of character. He defines this latter as follows: 'the principle [synthesizing the events] is a completed process of change in the moral character of the protagonist, precipitated or molded by action, and made manifest both in it and in the thought and feeling' (CC,621). Crane's understanding of the plot of *Tom Jones* hinges on the reader's estimate of the hero's character, in particular on the moral growth evident in Tom Jones which produces the change from bad to good fortune characteristic of the comic form: 'for the very same incidents proceeding from the affair at Upton which have so far been turned by Fortune against Tom have also had consequences which Fortune, bent upon doing nothing by halves, may yet exploit in his favor. The most important of these in the long run is *the moral change produced by his recent experiences in Tom himself* ...' (CC,629; emphasis added). Why, it may be asked, this patent contradiction between Crane's claim that *Tom Jones* is a plot of action and his own analysis of that plot as a plot of character?

The reason derives from Crane's extension, which has no explicit textual warrant in the *Poetics*, of the concept of plot to include the affective power of a plot on an audience. Crane writes:

> For a plot, in the enlarged sense here given to the term, is not merely a particular synthesis of particular materials of character, thought, and action, but such a synthesis endowed necessarily, because it imitates in words a sequence of human activities, with a power to affect our opinions and emotions in a certain way. We are bound, as we read or listen, to form certain expectations about what is coming and to feel more or less determinate desires relative to our expectations... This is a necessary condition of our pleasure in plots ... the power of which depends almost exclusively on the pleasure we take in inferring progressively, from complex or ambiguous signs, the true state of affairs. (CC,621)[14]

14. Cf. Ralph W. Rader, 'Fact, Theory, and Literary Explanation', *Critical Inquiry* 1 (December 1974): 245-72.

Nor is the affective power dependent solely on the formal qualities of the action (complexity, ambiguity); it derives also from the ethical features manifested in the characters and judged by the audience:

> What distinguishes all the more developed forms of imitative literature, however, is that, though they presuppose this instinctive pleasure in learning, they go beyond it and give us plots of which the effects derive in a much more immediate way from the particular ethical qualities manifested in their agents' actions and thoughts vis-à-vis the human situations in which they are engaged. When this is the case, we cannot help becoming, in a greater or less degree, emotionally involved. (CC,621)

The 'pervasively comic form' (CC,632) of *Tom Jones* is determined in large measure by 'the general estimate we are induced to form, by signs in the work, of the moral character and deserts of the hero, as a result of which we tend, more or less ardently, to wish for him either good or bad fortune in the end' (CC,632). In the *Poetics*, the form of a plot is the shape of its action; in Crane's revision (and in the work of his students and imitators), the form of a plot is an affection experienced by the audience. The structure of an action is thus determined, on a Cranean view, by the necessity to consistently evoke certain responses in an audience. This turns reading, and *a fortiori* criticism, into an intersubjective relation in which the reader, when she is sufficiently attentive to the features of the text, comes to identify her own emotional states with those of the characters portrayed in the plot. Crane's model of reading is ethical, as are the rhetorical principles upon which the persuasive power of plot depends. We shall observe further on how Crane's concept of plot entails a certain understanding of the perceiving subject. To anticipate, we can say that the subject of reading and criticism is the hidden center of Crane's concept of plot, the guarantor of the formal unity of the text.

Crane also deviates from a strictly poetic (i.e., formal) concept of plot in another way. Since on Crane's account the purpose of a plot is to build up by incremental means an emotional condition in an audience, the plot's structure is less a synthesis of disparate actions than an accumulation or progression of actions tending towards an anticipated *telos*. Crane claims that the distinctive mark of comedy in *Tom Jones* is its minimizing of pity and fear in the audience, an effect achieved in two principal ways: 'The first is our perception, which in each case grows stronger as the novel proceeds, that the persons whose actions threaten serious

consequences for the hero and heroine are all persons for whom, though in varying degrees, we are bound to feel a certain contempt ... A second ground of security lies in the nature of the probabilities for future action that are made evident progressively as the novel unfolds ... what steadily cumulates in this way, in spite of the gradual worsening of Tom's situation, is an opinion that, since nothing irreparable has so far happened to him, nothing ever will' (CC,634-5). So powerful is the expectation of Tom's ultimate good fortune, and so pervasive is it in the formal construction of the novel, that Crane will contend: 'the characteristic pattern emerges, even before the start of the complication proper, in the episode of Tom's relations with Molly and Sophia in Book IV and the first part of Book V ...' (CC,636). In Crane's presentation of comic plot, the *telos* is implicit in the initial incidents and character, and there cannot be, in *Tom Jones* at least, any genuine reversals of fortune. Crane's conviction about the teleological force of comedy necessitates his view that anything which might violate the formal unity of the plot or suggest that the characters are not entirely and always consistent in their actions (for instance, Tom's acceptance of the fifty pounds from Lady Bellaston, or the excessive interventions into the narrative by Fielding's narrator) be counted a fault in construction — these features are effectively declared *hors-texte*.

Crane's concept of plot implicates the understanding of history that will inform his programme for literary study. The full title of Fielding's novel, it will be recalled, is *The History of Tom Jones, a Foundling.* To the extent that Crane's exposition of the comic form of the novel theorizes the structure of its incidents, it projects a concept of historical totalization. Cranean hermeneutics depends on the capacity of the reader to grasp the unfolding of historical incidents as parts of a poetic whole whose formal complexity is comprehended only at the text's end, but whose structural tendencies are intuited virtually from the first. The hold of this teleological model of the temporal process of understanding over Crane's theory is disseminated throughout his project.

One could say that history enters Chicago criticism as an ethical and poetic concept: history is an object of knowledge only insofar as it can be said to have a plot (and a comic one at that — Hegel's 'cunning of reason' compares favourably with Crane's account of the plot of *Tom Jones*, in particular with Crane's naive citation of Fielding's remark that Fortune 'does nothing by halves'). History is ethical to the extent that the entities of which it is composed are stable and predictable, although capable of development and

growth (like the character of Tom Jones): their fundamental tendencies remain unaltered through time. It is therefore possible for Crane to assert that the plot of *Tom Jones* as conceived by Fielding in 1749, remains the same for all who encounter it, like Crane, in 1949. The consequences of this view of history are far from trivial.[15]

Some of these consequences can be observed by comparing Crane's claims for the power of Aristotle's method with the more restricted claims made by Elder Olson. Olson's essay, 'The Poetic Method of Aristotle: Its Powers and Limitations', outlines three limitations of Aristotelian poetics. First, the method considers only a small number of art forms: those available to Aristotle during the period in which he lived — comedy, tragedy, and epic. This limitation is non-essential, since the method could easily be extended to encompass the analysis of poetic forms not practiced in Greek culture up to the period of Aristotle's writing. Secondly, Aristotle's method does not propose an exhaustive theory of art or a general aesthetics, which would include a psychology of audience, social and political functions, *et cetera*. The poetic method could of course be supplemented by inquiries into the function of art in other sciences, as, for example, Aristotle himself did in discussing the uses of art in the *Politics,* but these inquiries are strictly speaking not a part of poetics. Finally, the poetic method of Aristotle is limited by his general method in philosophy, what McKeon has called the 'problematic method' or 'method of inquiry'. Aristotle's philosophy is rigorously anthropocentric, and thus it would be open to criticism from the standpoint of, for instance, philosophical or historical materialism.[16]

This final limitation is apparent in Aristotle's conception of the relationship between history and science:

> For history by [Aristotle's] problematic method is simply the material data relevant to the solution of a problem found in some science ... Ultimately, therefore, no essential difference exists between history and science, for when the facts are assembled in their relevance to the problem and their interrelations are established the problem is solved and science is attained. History is therefore the potentiality of which science is the actuality.[17]

15. Crane's affinity here is with Riffaterre, rather than with Jauss, Iser, and Vodička. But this is true only of Crane's concept of the poetic text; as a theoretician of literary history, Crane will part company definitively with the formalism of Riffaterre.
16. Olson, 'Poetic Method of Aristotle', pp. 188-90.
17. Telford, *Aristotle's Poetics*, p. 79.

The statement accords with the well-known assertion in the *Poetics* that poetry is more philosophical than history, because the latter deals only with particulars while the former concerns the universal. On a strict Aristotelian view, history could never be the object of a science, but could at most constitute the raw material out of which some science constructed its principles. Historical materials stand in relation to scientific principles much as the incidents stand in relation to the plot in a tragedy. If there were to be an Aristotelian historical science, it could only be a poetics of history. Thus conceived, history would be ineluctably anthropocentric: a product of willed action, an intentional structure with a determinate *telos*. This conception of history is not unknown to Marxism (as the following two chapters will illustrate), but as Elder Olson perspicaciously observes, the anthropomorphism that underwrites it conflicts with more rigorous forms of materialism. We will, however, defer this topic until we have made explicit the concept of history operative throughout Crane's project.

* * * * * * * * * *

During the final decade and a half of his life, Crane was engaged in constructing new principles for literary history in the light of the poetic formalism to which he had been converted in the thirties. This project would finally be published in the year of Crane's death as 'Critical and Historical Principles of Literary History'. Crane's scholarly scruples prevented its earlier appearance, and it is not clear that the project was ever completed to his satisfaction. Nevertheless, the text does not appear fragmentary in its present form, nor does it exhibit significant conceptual hesitations or lacunae that might disqualify it as a guide to Crane's mature thought on the relation of theoretical poetics to literary history. Moreover, the views presented are sufficiently consistent with those expressed elsewhere (for example, in the preface to *Critics and Criticism* or in *The Languages of Criticism and the Structure of Poetry*) to suggest that it can be taken as a sort of *summa* of Crane's theoretical project. The text most of all makes it clear that the problem of literary history was never entirely abandoned in Crane's shift towards formalism. Never was Crane further from orthodox Aristotelianism and the limits entailed by Aristotle's method for the study of poetry than when he attempted to integrate the discipline of theoretical poetics with an inquiry into the history of literary forms.

The first third of Crane's essay is a straightforward exposition and critique of existing dominant modes of literary history, which Crane divides into the 'atomistic', the 'integral' or 'organic', and the 'narrative-causal'. All of these modes fail to achieve what the formalist poetician considers to be the essential goal of literary interpretation: to comprehend 'the concrete wholeness of a work as the proximate end of its author's productive activity ...' (IH, II:66). Crane's correction and supercession of the regnant types of literary history proposes a 'narrative history of forms' (IH, II:82), based on his fourfold distinction of the elements that constitute poetic wholes: 1) their formal ends or purposes; 2) the materials out of which they have been constructed; 3) the devices or techniques used in transforming materials into given forms; 4) the actualizations achieved in particular works of the poetic transformation of given materials into proposed forms. The designation of this historical model as the 'history of forms' indicates the theoretical and explanatory priority granted to formal principles of construction over materials and devices (IH, II:81-2).

Crane's insistence on the theoretical priority of formal purpose has historical interest beyond its pertinence to his own project. On the one hand, despite Crane's persistent antagonism to the monistic conception of poems among the New Critics, the well-known insistence in New Criticism on the organic wholeness of authentic works of literature is not incompatible with Crane's conception of the formal integrity of poems. Crane could justly claim of the New Critics that 'the primary wholes with which [they are] concerned are dialectical compositions of qualities inhering in the author as unifying source' (IH, II:55), so that linguistic tropes like ambiguity and irony which the New Critics attributed to poetry become, in their ideology of form, psychological attributes of the author or of the period or style which his poems typify. The infamous banishment of intentions from the domain of criticism does not deprive poems of intentionality understood in a more technical sense, although this concept cannot be adequately accounted for in the model of organic form to which New Criticism remained committed.[18] New Criticism's notion of form may be comparatively unsophisticated and may lack a constitutive temporal dimension, but the fundamental intuition that poems are

18. See Paul de Man, 'Form and Intent in the American New Criticism', in de Man, *Blindness and Insight: Essays in the Rhetoric of Contemporary Criticism*, 2nd rev. edn. (Minneapolis, 1983), pp. 20-35.

integrated formal wholes is shared by both Crane and his antagonists.

On another front, Crane's criticism of what he dubs 'formalism' parallels the denunciation of Russian Formalism made by Pavel Medvedev, a collaborator of Bakhtin's and a staunch supporter of orthodox Marxism. Nothing in Crane's conception of the poetic text conflicts with the following:

> Form in art is a concept that is not arithmetical or mechanistic, but teleological and purposeful. It is not so much something given *(dannost')* as something posited *(zadannost')*, and the device is only one of the material indicators of this purposefulness of form. Each stylistic device taken by itself, and all of them taken together, are a function of the integral and unique creative task *(zadanie)* which the given work, the given school or given style has to realize.[19]

The passage indicates the coincidence of theoretical poetics with historical understanding that we have previously noticed in the foundational moment of Marxist aesthetics, at the same time as it suggests the ultimate compatibility (Crane's open and unremitting hostility notwithstanding) between Crane's project and certain forms of Marxism.

Putting aside the obvious potential for misunderstanding the term in this context, we can say that Crane's conception of the literary object was undeniably formalist, and that this was his most authentic continuation of the legacy of Aristotelian poetics. But in pursuing his project beyond the domain of theoretical poetics into literary history — in passing, as it were, from the problematic of early Russian Formalism to that of Prague Structuralism — Crane transgressed the boundaries established in the Aristotelian system. The relationships among the parts of a poem are clearly defined in the *Poetics,* but except for occasional hints (for example, in the genealogy of tragedy from the dithyrambic chorus), Aristotle is silent on the historical relations between individual poems or between poetic genres and species. Crane's intuition that rigorous descriptions could be developed to link together conceptually and developmentally the disparate works that have made up the history of European literature necessitated his positing an entity, history, which exhibited some of the formal coherence that Aristotle reserved for poetry. To elaborate the principles for a

19. Pavel Medvedev, 'The Formal (Morphological) Method or Scholarly Salieri-ism', trans. Ann Shukman, in *Bakhtin School Papers*, ed. Ann Shukman, Russian Poetics in Translation No. 10 (Oxford, 1983), p. 58.

history of literary forms required that Crane return to methods of inquiry which he had ostensibly repudiated some fifteen years previous. Let us see how this is so.

'Critical and Historical Principles of Literary History' offers an exemplary critique of the methodological naïveté of what used to be called *Geistesgeschichte*. Crane's insistence on the relative autonomy of literary history from other historical series, his careful discrimination of the differential force of the various causal factors that come together in the production of literary works, his consistent refusal to posit any single explanatory principle as sufficient to account for the production of literary art in any epoch — all these aspects of his essay mark it as a distinctive break with the schemes of Hegelian totalization that have dominated literary histories since the 19th century. At the same time, Crane must, if he is to make literary history into an intelligible sequence of related events, establish principles of historical explanation that attribute common properties to literary objects which allow them to be related in a temporal and causal sequence. Crane is as eager to avoid atomism, the dull, staccato recitation of sheer chronology, as he is to criticize the illicit homologies and premature totalizations of the ideologues of organic history. Correctly judging that the causation of literary works is not exhaustively accounted for by appeals to extra-literary factors, Crane bends the stick in the opposite direction and discovers in the history of forms internal principles of development. These principles propel the literary series towards ends which, if they are not foreordained in every detail, nonetheless appear as a determinate *telos* in the historical sequence of individual works. If all historical entities and forces cannot be subsumed under a single set of explanatory principles, *literary* history can be totalized, in Crane's view, as a progressive, evolutionary sequence of formal problems and their solutions: 'The history of poetic arts considered as arts is the history of the gradual discovery by poets of such principles for one new literary form after another ... It is the history also of the refinement of such principles and their extension to new materials, of the invention of new techniques for their more effective operation in new subject matters or on the sensibilities of poets and readers weary of the older techniques, of their partial or complete neglect ... of their rediscovery for particular forms ... and so on ...' (IH, II:108).[20]

. 20. Cf. the similar statement in LC, 63-4, cited above.

Crane is properly hesitant to give a premature account of the specific manifestations of this entelechial motive within the history of literature, but the force of the principle is never in doubt:

> We may thus say theoretically, though with the proviso that in any given situation in history the order may be reversed, that there is a tendency in the literary arts to move from generality to particularity in the construction of plots (or their lyric equivalents) and in the definition and depiction of characters, from a concern with the immediate and external aspects of actions to a concentration on their internal aspects or their indirect consequences in the feelings of the agents or their friends, from simple and explicit indications of character, thought, or motive to elaborate and subtle indications, from highly articulated modes of speech to more ellipitical and suggestive modes, from a fashion of imagery in which the reference is primarily to objects to one in which the inner state of the characters is more fully involved, from simple metaphors to complex and difficult ones, from verse having relatively few rhythmic dimensions to verse having many, from contentment with 'statement' to insistence upon 'rendering', from a minimum reliance on inference or indirect representation to a maximum reliance on these ... (IH, II:89)

The whole of literary history will exhibit in the long term the same kind of purposiveness as is readily observed, on the view of Cranean/Aristotelian poetics, in particular works. Crane's concept of literary history is unabashedly Whiggish.[21]

If the derivation of the specific structures of poetic construction from extra-literary determinations is disallowed in Crane's poetics, the opposite movement of replacing the literary work in other historical series presents no serious obstacle:

> The principles of method, it is true, are the internal causes of poems, viewed as artistic products, in analytical separation from the activities that produced them, but it requires only a relatively easy shift in causal perspective to combine 'poetic' propositions about particular poems with philological, biographical, or historical propositions about their materials and the conditions and circumstances of their making. We cannot infer the 'poetic' nature or value of any artistic whole from its antecedents in the poet's life or in contemporary or earlier culture; but, having determined critically what the poem is in itself, we can then replace it in its setting of events and other writings and eventually develop a history of poetry in terms of the interaction of artistic and extra-artistic causes of change. (CC, 22)

21. Crane is unequivocal about grounding the concept of history in narrative at the outset of 'Critical and Historical Principles of Literary History': see IH, II:4-5.

Crane's assertion of the causal priority of formal poetic features over other historical determinants of literary texts has consequences which exceed the comparatively narrow limits of literary criticism and theory. The potential for rigor which Crane attributes, with some justice, to poetics and formal literary history establishes literature as the pilot science among what since Crane's day have come to be known as the human sciences. Literature in Crane's conception of it as a discipline projects a model of the human subject as free, creative, and relatively unconditioned by the material circumstances of given socio-historical formations. Crane was perfectly lucid about the ideological stakes of his project, nowhere more explicitly than in his understanding of the disctinctiveness of the humanities as a subject matter:

> But what are the aspects of human experience that distinguish men most completely, now and in the past, from the animals? ... [T]hey are those human achievements, like Newtonian or modern physics, the American Constitution, or Shakespearean tragedy, to which we agree in attributing that kind of unprecedented excellence that calls forth wonder as well as admiration.
>
> These, wherever we find them, are the distinctive objects of the humanities: and the aim of the humanities is precisely such an understanding, appreciation, and use of them as will most completely preserve their character as human achievements that cannot be completely resolved into either natural processes common to men and animals or into impersonal forces affecting all the members of a given society. (IH, I:8)[22]

22. Philosophy, too, since its constitution as a professional discipline at the end of the 18th century, has aspired to a similar self-image: see Richard Rorty, *Philosophy and the Mirror of Nature* (Princeton, 1979), and idem, *Consequences of Pragmatism* (Minneapolis, 1982). Samuel Weber's comment on the two conflicting projects which remained at play in Crane's work — that of a formal, scientific poetics and that of a normative discipline of the humanities distinct from the natural sciences — is entirely just: '... Crane would like to have it both ways: he wants to assign the humanities a normative, value-setting function, and this leads him back beyond the etymological origins of the humanities in the Roman orators, to Greek philosophy, to Plato and above all to Aristotle ... However, such normative performance is hardly conceivable without cognitive capability ... The normative power of the humanities to preserve "distinction" as much as possible from the levelling of scientific generalization, still requires the recognition of what things are: of what makes a poem a poem, of what distinguishes "histories as histories, philosophical works as philosophical works." Such awareness, in turn, is difficult to conceive without recourse to the very generalizing procedures that the humanities, according to Crane, should seek to avoid' ('Ambivalence, the Humanities and the Study of Literature', *Diacritics* 15 [Summer 1985]: 14).

The humanities become, on this view, the primary locus of resistance to the intellectual hegemony of the natural sciences (especially biology and the behavioral sciences) and sociology. They protect the human subject from being absorbed into the instrumentalist discourses of these disciplines. The humanities are empowered to compete against the sciences by establishing rigorous methods of investigation and demonstration specific to their own objects of study — based on an Aristotelian poetics — at the same time that their very purpose is to undermine the authority of instrumentalist conceptions of man which the sciences were effectively elaborating. Chicago formalism culminates in an ethical concept of history which capably defends and preserves literary tradition, scholarly discipline, and the institution of the university itself as the principal model for maintaining the historical continuity of culture.[23] Human history resembles nothing so much as the plot of a novel like *Tom Jones,* which unfolds towards its determinate *telos* driven by the inexorable force of its comic form. The conservation of the centred subject of bourgeois aesthetics, repristinated by Crane initially in the formal intentionality of the poetic text, then in the mind of the reader emotionally affected by plot, and subsequently in the teleological impulse towards greater formal perfection in literary history, underwrites the humanist ideology of his project.

* * * * * * * * * *

The historical interest of Crane's projection of the narrative history of forms is readily grasped when we recall the work of *Rezeptionsästhetik* and of Riffaterre discussed in the previous chapter. Riffaterre resolutely declined to theorize the intersection of the formal structures of texts with the historical process of

23. Consider, for example, the following passage from 'Critical and Historical Principles of Literary History' on the character of tradition: 'That there is a peculiar causal force in tradition will scarcely be doubted by any one who has been a member for a decade or more of two universities, or for that matter two well-established institutions of any kind, and has reflected on the different fates which generally befall the same proposals for change, in no matter what aspect of their life, in the one as compared with the other. Each has its own "spirit", hard enough even for those most sensitive to its differentiating effects to formulate and nearly impossible to explain to outsiders, constantly undergoing subtle alteration as new things are done or as new men replace the old yet always exerting, for good or ill, a certain compulsive force on individual and collective choices so that these tend to fall into a general pattern which does not greatly vary, despite external events, from that determined for the institution by its founders' (IH,II:152-3).

reading and understanding. For him, literary history was subject to the controls available in the methods of formal poetics, but there was no attempt on his part to explain the historicity of the artifact. The step into the history of reception dissolves the structural fixity of the aesthetic object, while recuperating its accessibility to understanding by positing the phenomenal stability of aesthetic signs and the progressive totalization of the past in the history of aesthetic experience. Crane imparts a novel spin to this problematic by maintaining the rigidity of formal poetic structures (*Tom Jones* is the same thing for readers today as it was in the 18th century), at the same time as he projects the progressive development of literature as a system. As a poetician Crane is as rigorous a formalist as Riffaterre; as a literary historian and ideologue of the humanities, he more closely resembles the Prague Structuralists. The link between the two passes through the figure of the reader and proceeds via the affective power of the text upon her. The educative power of poetry derives from its capacity to move its audience emotively.

It would be premature at this point in our argument to begin the exposition of a historical model that would maintain the relative autonomy of literature among the range of socio-historical practices without falling into either methodological atomism (which Crane rightly avoided) or into a historical teleology of literary form (which he did not). Nevertheless, some indication of the direction our inquiry will ultimately pursue can be suggested by comparing Crane's formalism with one of the most penetrating critiques of purely formal poetics made in this century.

Commenting negatively on the methodological assumptions among extrinsic causal historians like Taine and Cazamian (whom he compares parenthetically to Marxists), Crane remarks on the concept of literary production which they assume. Crane analogizes the making of poems to building a fire, thus invoking the artisanal model of *poiesis* that underlies Aristotle's system: 'It is as if [for authors of the extrinsic causal type of history], seeking to explain the fact that I sometimes make good fires in my fireplace and sometimes poor ones, I should take into account only the shape and size of the chimney and the economic origins of the logs' (IH, II:96).[24] On a historical materialist account, those causes of

24. Fredric Jameson's summary of Marx's claim that Aristotelian philosophy was historically determined by its position within an artisanal mode of production in which 'an agent, imitating a given pattern, forms a certain material in order to create an object which then has some determinate use, such as a cooking pot, an article of clothing, a piece of jewelry, or a spear' (*Marxism and Form: Twentieth-*

poems that Crane declares to be secondary at best are just the ones (the material, understood not merely as physical matter but as socially produced and economically conditioned objects and means at the poet's disposal) which are determinate in the last instance. For Crane, the skill of the poet, which can be inferred from the reconstruction of his intentions as they have been embodied in the literary text, is the decisive factor in the successful realization of the poem. For a historical materialist, by contrast, the ingenuity of the individual artist is the outcome of socio-economic determinations which have provided him with certain materials and have, as well, produced him. To anticipate our further development of this hypothesis later on: the human subject is a text that is produced, not a natural entity with historically invariant features and capacities.

This line of argument was remarkably anticipated by P. N. Medvedev and M. M. Bakhtin in response to Shklovskij's claim, made in the latter's preface to his *Theory of Prose,* that the formalist critic focuses exclusively on 'the intrinsic laws of language. To draw an industrial parallel, I am not interested in the state of the world cotton market, nor in the politics of trusts, but only in the thread count and the methods of weaving.' Medvedev/Bakhtin reply as follows: 'It is hardly necessary to prove that the intrinsic laws of this or that phenomenon cannot be explained without being related to the general laws of social development. The methods for the preparation of thread are conditioned by the level of technical development and the laws of the market.'[25] The literary text is not only historical in the trivial sense that, for example, prior to Fielding's composition, *Tom Jones* did not exist, but also in the more complex sense that the historical event of *Tom Jones* was the product of a broad range of material conditions and forces, all of which themselves were the outcomes of different historical series whose systematic description depends upon the architectonic concept of mode of production which founds Marxist historical science. For the rigorous materialist, no aspect of human existence is outside the domain of historical determination.

Despite the ostensibly revolutionary programme announced by Crane in 1935 to transform the practice of literary study, the

Century Dialectical Theories of Literature [Princeton, 1971], p. 393) is pertinent here.

25. P. N. Medvedev/M. M. Bakhtin, *The Formal Method in Literary Scholarship: A Critical Introduction to Sociological Poetics,* trans. Albert J. Wehrle (Baltimore, 1978), p. 70.

theoretical foundations in aesthetic historicism, which have effectively underwritten the project of literary criticism since the 18th century, remained in force in the work of Crane and his students. Situated historically, Crane's programme can be understood as a mode of principled resistance to the economic and political forces that were transforming universities, more and more rapidly after the Second World War, into structures for the maintenance and extension of corporate power.[26] Crane's defense of the humanities and his attempt to ground them in a rigorous method can be judged politically as an instance of the struggle against the logic of a certain form of capitalism — even if the form which Crane's resistance took was regressive, dominated by nostalgia for an archaic, artisanal mode of production and the ideological image of art as a product of individual imaginative skill.[27] This is one part of the living legacy of Chicago criticism that has persisted through various changes in critical fashion. Its dominance over the theory and practice of professionalized literary study in the Anglophone world, while not unchallenged, is still secure.

But as we have observed, Crane's project was from the first shot through with contradiction. While Crane's humanism has had the more lasting impact on literary study, nothing in the concept of theoretical poetics as a discipline entails its becoming an indentured servant to the type of historicism Crane envisaged. Literature could in principle be the object of a relatively autonomous discipline, a regional science within a global science of history unimagined in Crane's dismissal of the vulgar Marxism with which he was familiar. We can elaborate on what such a project would involve briefly here, and more extensively in our concluding chapter.

Poetic objects can be viewed as complex structured wholes, like modes of production in Althusser's conception of historical science. Such a theory of poetry entails that the specificity of

26. See Sheldon S. Wolin, 'Higher Education and the Politics of Knowledge', *democracy* 1 (April 1981): 38-52; and Richard Ohmann, *English in America*, chapters 11 and 12.

27. Hence Crane's location of the ideal environment for humanistic inquiry in the Enlightenment, noted by Booth in *Critical Understanding*, pp. 96-7. Booth's own nostalgia for a relatively homogeneous class of readers is pointedly analyzed by Fredric Jameson in *Marxism and Form*, pp. 355-9. The obvious contemporary analogue to this ideology is Habermas's theory of communication, the range and complexity of which forbid our treating it in detail here. But see the excellent introduction by Peter Dews to *Habermas: Autonomy and Solidarity* (London, 1986).

poems is determined by the mode of articulation among the various features comprising them. Some of these are material in a physical sense (for instance, the phonetic features of language or the means of production and dissemination of texts), but many are semantic or discursive (like genre, theme, and point of view). Historical materialism claims that some, perhaps all of these features are traversed by history, that the structure of a text is no more permanent than that of a mode of production. This is to say that poetic things must be constantly re-produced, not only in the sense that they must persist as material artifacts, but also that their interpretation and comprehension, their effectivity as texts, depend upon the continual reproduction of the capacities required to understand them. Just as a mode of production demands the reproduction of the relations of production in order to persist, so poetic texts require that subjects be trained in the necessary skills (syntactic, phonological, and semantic) required for reading. These skills are reproduced in the pedagogical and scholarly apparatuses through which poetic texts are primarily disseminated. These apparatuses possess a history and, as became obvious during the 1960s in a number of places in the West and in some of the socialist countries as well, the educational apparatus itself is never far removed from political struggles over control of the state as a whole. In other words, historical materialism claims the following: 1) poetic texts persist as things (in part) because they are reproduced in the interpretive labor of readers; 2) readers acquire the requisite skills to interpret texts by means of institutional apparatuses; 3) these apparatuses have histories which play a role in and are therefore conditioned by the more encompassing history of social formations, but which are not unilaterally determined by or coincident with, for example, the progressive expansion of the forces of production. This is to say that the historical 'time' of literature (and, a fortiori, of the apparatuses for disseminating literary texts) can have a distinct rhythm of its own; it is a relatively autonomous instance within the structure of a social formation.

One can therefore say, contrary to Crane's positing of the unified and historically invariant subject who produces or reads poetic texts, that the subject is just what must be continually produced; its powers and limitations are historical and contingent, not natural and given. This, after all, is what Crane's own project for altering the bases of literary study implicitly recognized in its aim of producing a particular kind of subject to read and comprehend texts. Our claim is that the materialism entailed by

(even if unimagined in) Crane's project can be mobilized by reconstituting the theoretical concepts of poetics within the global science of history. This theoretical reorientation can even find a use for what has been too quickly and too often thought to be the most idealist of contemporary critical languages: deconstruction. Paul de Man's judgment on traditional literary history may ulitmately prove less objectionable then it at first sounds:

> To become good literary historians, we must remember that what we usually call literary history has little or nothing to do with literature and that what we call literary interpretation — provided only it is good interpretation — is in fact literary history. If we extend this notion beyond literature, it merely confirms that the bases for historical knowledge are not empirical facts but written texts, even if these texts masquerade in the guise of wars and revolutions.[28]

To disclose the materialist kernel within the idealist shell in this passage would be among the first tasks of an authentically historical poetics, a project that remains at best a wished for achievement nearly half a century after R. S. Crane put it on the agenda for the future of literary study as a discipline.

28. Paul de Man, 'Literary History and Literary Modernity', in *Blindness and Insight*, p.165.

PART TWO

Marxism

6

The Part and the Whole:
Jameson's Historicism

'I have never been able to tell a story'
Jacques Derrida

It may seem rather abrupt to move directly from the domain of American formalism, exemplified in the project of R. S. Crane, to what appears on the face of it to be its polar opposite: the historical and dialectical criticism of Fredric Jameson. Jameson fairly burst on the theoretical scene in 1971 by offering a sympathetic exposition of the Hegelian Marxist tradition in *Marxism and Form*, soon to be followed by a searing critique of formalism in *The Prison-House of Language*. Nearly a decade later, he would appear unrepentant and unreformed (a 'shamelessly unreconstructed Hegelian Marxist', in the words of Terry Eagleton), opening his *summa* of contemporary criticism, *The Political Unconscious*, with the following proclamation: 'Always historicize! This slogan — the one absolute and we may even say "transhistorical" imperative of all dialectical thought — will unsurprisingly turn out to be the moral of *The Political Unconscious* as well.'[1] No theoretician or critic on the contemporary scene seems a more suitable candidate for Crane's scorn, none less likely to concede Crane's definition of the object of literary criticism as 'the text itself considered as a production of art to be read appreciatively for its own sake in the light of relevant knowledge and of the principles of its kind.'[2]

1. Fredric Jameson, *The Political Unconscious: Narrative as a Socially Symbolic Act* (Ithaca, 1981), p. 9; hereafter cited parenthetically as PU. Eagleton's remark is quoted from his review of this text, 'The idealism of American Criticism', *New Left Review* 127 (May-June 1981): 60.
2. R. S. Crane, 'History versus Criticism in the Study of Literature', in Crane, *The Idea of the Humanities and Other Essays Critical and Historical,* 2 vols. (Chicago, 1967), II:23

Putting aside these obvious differences, however, one observes an odd congruence between Jameson and Crane in their positing of the methodological importance of literary study among the human sciences. We saw in Crane's project the emergence of literature as the pilot science for the humanities, and, more distantly, for the social sciences. Jameson's political and theoretical inclinations, so different from Crane's in other ways, envision a comparably lofty mission for literary criticism:

> [Today] the literary fact, like the other objects that make up our social reality, cries out for commentary, for interpretation, for decipherment, for diagnosis. It appeals to the other disciplines in vain: Anglo-American philosophy has long since been shorn of its dangerous speculative capacities, and as for political science, it suffices only to think of its distance from the great political and Utopian theories of the past to realize to what degree thought asphyxiates in our culture, with its absolute inability to imagine anything other than what is. It therefore falls to literary criticism to continue to compare the inside and the outside, existence and history, to continue to pass judgment on the abstract quality of life in the present, and to keep alive the idea of a concrete future. May it prove equal to the task![3]

Jameson and Crane privilege literary criticism as a mode of inquiry for overtly different political and theoretical ends, but for both, literature occupies a decisive position among the practices of social life. In Jameson's recent work, the literary has devolved into the more broadly cultural, a development very much in the spirit of Crane's enlargement of the power of literary criticism's methods to encompass all the humanistic disciplines.

Jameson's unabashed eclecticism would undoubtedly have enraged Crane, but this superficial difference in their critical styles should not obscure the more profound theoretical affinities that unite them. Jameson's mature work (we may arbitrarily fix its origin at *Marxism and Form*, especially the final chapter, 'Towards Dialectical Criticism') begins with the problem which only emerged fully for Crane in 'Critical and Historical Principles of Literary History': the relationship between the intrinsic poetic structures of literary texts and the extrinsic factors that enable their production. Moreover, Jameson's location of the site on which this problem can be most effectively engaged recalls the similar postulation of the object of literary study in Chicago

3. Fredric Jameson, *Marxism and Form: Twentieth-Century Dialectical Theories of Literature* (Princeton, 1971), p. 416; hereafter cited parenthetically as MF.

criticism from Crane to Sacks and Rader: 'The strategic value of generic concepts for Marxism clearly lies in the mediatory function of the notion of a genre, which allows the coordination of immanent formal analysis of the individual text with the twin diachronic perspective of the history of forms and the evolution of social life' (PU,105). The difference between genre criticism of the Chicago variety and that proposed by Jameson for historical materialism lies in the provenance of the categories in each system. For Sacks and Rader (not, it would seem, for Crane), generic categories manifest deep structures of the human mind; Chicago criticism is grounded at this level in psychological realism.[4] For Jameson, by contrast, generic categories are *ad hoc* hypotheses constructed to model material artifacts whose ultimate causality lies elsewhere: '*all* generic categories, even the most time-hallowed and traditional, are ultimately to be understood (or "estranged") as mere ad hoc, experimental constructs, devised for a specific textual occasion and abandoned like so much scaffolding when the analysis has done its work' (PU,145). In the case of romance (Jameson's topic here), the reasons for the genre's emergence are social and historical: 'As for romance, it would seem that its ultimate condition of figuration ... is to be found in a transitional moment in which two distinct modes of production or moments of socioeconomic development, coexist. Their antagonism is not yet articulated in terms of the struggle of social classes, so that its resolution can be projected in the form of a nostalgic (or less often, a Utopian) harmony' (PU, 148)[5]. Jameson's account of the causality of genre shifts the ground from transhistorical cognitive

4. See Sheldon Sacks, 'The Psychological Implications of Generic Distinctions', *Genre* 1 (April 1968): 106-15; Ralph W. Rader, 'The Literary Theoretical Contribution of Sheldon Sacks', *Critical Inquiry* 6 (Winter 1979): 183-92; and Rader, 'Fact, Theory and Literary Explanation', *Critical Inquiry* 1 (December 1974): 249-50. The coincidence with Mukařovský's work here is striking; see above chapter 4.

5. The point is repeated in a subsequent exercise in genre criticism, Jameson's attempt to define the category of magic realism: 'I will therefore advance the very provisional hypothesis that the possibility of magic realism as a formal mode is constitutively dependent on a type of historical raw material in which disjunction is structurally present; or, to generalize the hypothesis more starkly, magic realism depends on a content which betrays the overlap or the coexistence of precapitalist with nascent capitalist or technological features. On such a view then, the organizing category of magic realist film is not the concept of the generation (as in nostalgia film) but rather the very different one of modes of production, and in particular of a mode of production still locked in conflict with traces of the older mode (if not with foreshadowings of the emergence of a future one)' ('On Magic Realism in Film', *Critical Inquiry* 12 [Winter 1986]: 311).

structures to the contingent structure of a particular socio-historical conjuncture. Genre therefore designates a different kind of thing in each discourse: for Rader and Sacks, it refers to something like the specifies-specific capacity of all human beings to master the grammar of at least one natural language; on Jameson's account, it more closely resembles historically contingent discoveries like quantum theory or the internal combustion engine. The divergence between the psychological realism projected in Chicago criticism and the materialism instanced in Jameson's conception of genre indicates the different paths towards a global theory of artifacts pursued by each.

This is not to say, as will become apparent in our exposition of Jameson's project, that a commitment to the fundamental principles of historical materialism is necessarily proof against idealism. No epistemological break, as Althusser came ultimately to realize, is once and forever secure against the temptations of ideology. The class struggle at the level of theory is as likely to be a permanent feature of any human society, even a communist one, as any other ideologically conditioned instance. Jameson's relation to historical materialism is far from settled. To lay out some of the principal themes and the theoretical implications of his work is our sole purpose here. The interest of his project, aside from the numerous powerful historical analyses of texts which it has realized, resides mainly in the way it focuses the tension between aesthetic totalization and historical contingency that has remained a persistent dilemma for Marxist theory from the classics to the present day.

In focusing on Jameson's *oeuvre*, we have finally and permanently returned to the terrain of historical materialism proper (although, in truth, we have never allowed it to vanish entirely from the horizon of our discourse). On this ground, the categories of bourgeois aesthetics which we have been considering until now, if they are not always entirely *aufgehoben*, are nonetheless positioned and grasped in a different way. It will not be possible, henceforward, to presume naively that aesthetic perfection possesses a transhistorical dynamism which places it outside or beyond the material determinations of history.[6] By

6. Jameson comments in passing on the necessary historicizing, which Marxism must posit, of Freud's breakthrough: 'The conditions of possibility of psychoanalysis become visible, one would imagine, only when you begin to appreciate the extent of psychic fragmentation since the beginnings of capitalism, with its systematic quantification and rationalization of experience, its instrumental reorganization of the subject just as much as of the outside world.

replacing the architectonic category of the aesthetic with that of history, Marxism opens the way towards a long deconstruction of the anthropomorphism which has dominated literary theory in the West since Aristotle. This process will not be without certain complications which continue to entangle Marxist discourse in the categories and the ideology it ostensibly rejects. One comparatively direct way of understanding how this is so is to examine the concept of history that underlies Jameson's theory and criticism.

* * * * * * * * *

Any consequent historical criticism must of necessity confront the claims of, on the one hand, a transhistorical logical model of history (which for purposes of notation can be identified with the name of Hegel), and, on the other, the existential historicism of Dilthey and Ranke which was introduced into literary studies largely via the work of art historians during the first half of the 20th century. To cite a specific instance in Fredric Jameson's writings, the latter historical model can be denoted by the name of Michelet. In commenting on a famous passage in the *Histoire de la révolution française,* Jameson explicitly contrasts this latter with the historical project of Marxism. He movingly evokes Michelet's personal and epochal relationship to the historical events of August 4, 1789, and contends that Marxism can itself be positioned historically, although its historical determination bears little resemblance to the personal pathos apparent in Michelet's writings and inscribed in his concept of history. Marx's discoveries, while they are scientific and objectively verifiable, are nonetheless historically conditioned in their own right. They are less the personal property of Marx himself than the outcome of centuries of human struggle:

> What needs to be stressed here is that we no longer have to do with the contemplative relationship of an individual subject to the past, but rather with the quite different relationship of an objective situation in the present with an objective situation in the past. Indeed, insofar as

That the structure of the psyche is historical, and has a history, is, however, as difficult for us to grasp as that the senses are not themselves natural organs but rather the results of a long process of differentiation even within human history' (PU,62.) He then cites in a note the passage from Marx's *Economic and Philosophical Manuscripts* on the historicity of human sense perception. The historicizing alluded to here is comparable to Jameson's account of the emergence of the Marxist theory of economy discussed below.

Marxism is itself a historicism — not to be sure a geneticism or a teleology in Althusser's sense of this word, but rather as I have termed it elsewhere, an 'absolute historicism' — its historical grounding is analogous, and Marx takes pains at various places in *Capital* to underscore the objective and historical preconditions of his discovery of the labor theory of value in a social situation in which for the first time labor and land are fully commodified ... Marx's 'personal' discovery of this 'scientific truth' is therefore itself grounded within his system, and is a function of the originality of a historical situation in which for the first time the development of capital itself permits the production of a concept — the labor theory of value — which can retroactively 'recover' the truth of even millenia of precapitalist human history.[7]

Jameson would appear to be drawing on a significant moment in contemporary Marxist theory: Althusser's essay 'On the Evolution of the Young Marx', where it is argued that Marx's discovery of the theory of surplus value is at once a description of the mechanisms of historical transformation and at the same time a product of the novel historical conjuncture we recognize as industrial capitalism. Althusser's summary formulation is as follows: 'it was by *moving* to take up absolutely new, proletarian class positions that Marx realized the possibilities of the theoretical conjunction from which the science of history was born.'[8]

We shall defer for some pages the direct engagement between Jameson and Althusser, but it will be useful here to remark on the difference between Althusser's account of the emergence of Marxist historical science and Jameson's conception of Marxism as an absolute historicism. Empirically, of course, Jameson is on solid ground: only with the emergence of mature industrial capitalism were the necessary concepts for theorizing previous modes of production (preeminently surplus-value) 'discovered'. The anatomy of man really does provide a key to the anatomy of the ape! But why then was Marx's 'discovery' not made by classical economy? Or, to paraphrase Sartre, Marx was a political economist, but not every political economist (even today) is Marx.

7. Fredric Jameson, 'Marxism and Historicism', *New Literary History* 11 (Autumn 1979): 57-8; hereafter cited parenthetically as MH. A minor philological quibble with Jameson's formulation: Marx did not discover the labor theory of value (which was already a conceptual tool in classical economy), but the concept of surplus-value, the 'secret' of the labor theory which classical economy had systematically to overlook.

8. Louis Althusser, *Essays in Self-Criticism,* trans. Grahame Lock (London, 1976), p. 157.

The mere appearance of certain phenomena on the stage of history is insufficient to account for the theoretical revolution which Marx initiated for historical materialism. Marx's mutation of the problematic of classical economy depended crucially on his occupying different positions *in theory*, what Althusser identifies in the passage cited as 'proletarian class positions', and elsewhere as '*revolutionary class theoretical positions*'.[9] But historical materialism is not, as it were, the spontaneous ideology of the proletariat (the historicist view which would be theorized by Lukács in 'Reification and the Consciousness of the Proletariat'). Marx's shift in class theoretical positions enabled him to produce a novel theory of historical process, but the theory itself is not the direct expression of those class positions. The 'immense theoretical revolution' inaugurated by Marx constitutes a unique historical event, the precise determinations of which remain to be explained after one has recognized its preconditions. Jameson's absolute historicizing of Marxism risks collapse into empiricism and expressive causality.

Jameson is not unaware of the epistemological and political liabilities that threaten to entrap and dissolve his equation of Marxism with absolute historicism. He perceptively observes some pages later: 'this would seem at best to reinvent some "place of truth," some ethnocentric privilege of our present as inheritors of world culture and as practitioners of rationalism and science, which is not visibly different from the imperializing hubris of conventional bourgeois science, and which would tend at the same time to confirm the current line of the *nouveaux philosophes* on the innate or intrinsic "Stalinism" of the Marxist world view' (MH,69).

Three strategies are offered for overcoming the dilemma thus posed by this conception of Marxism. First, the category of the subject itself must be reoriented along the lines developed by Althusser (via Lacan): 'It is not a question of dismissing the role of individual subjects in the reading process, but rather of grasping this obvious and concrete individual relationship as being itself a mediation for a nonindividual and more collective process: the confrontation of two distinct social forms or modes of production. We must try to accustom ourselves to a perspective in which every act of reading, every local interpretive practice, is grasped as the privileged vehicle through which two distinct modes of production confront and interrogate one another. Our individual reading thus becomes an allegorical figure for this essentially collective

9. Ibid., p. 130.

confrontation of two social forms' (MH,69-70). The conditions of possibility for this hermeneutic are worked out in the discussion of nonsynchronous development in *The Political Unconscious* (PU,95-9).

Second, and as a consequence of the first, is a revision of what it means to study the social formations of previous epochs. Rather than contemplating the past with aesthetic detachment as a distant positive or negative reflection of the present (like Michelet or Burckhardt or Spengler), or appropriating it as an instrument to serve the political needs of the present (as is urged in the work of Hindess and Hirst and in the writings of Terry Eagleton subsequent to his *Criticism and Ideology*), Jameson asserts that the past must 'begin to come before us as a radically different life form which rises up to call our own form of life into question and to pass judgment on us, and through us, on the social formation in which we exist' (MH,70).

Finally, drawing once more on Bloch, Jameson urges his most distinctive, but also most problematic, concept — one that will come to dominate the projection of a wholly revamped Marxism in *The Political Unconscious*. In Jameson's conception, Marxism does not meditate upon or appropriate the past; rather, it must envision and represent the possible, if as yet imperfectly realized and only vaguely discernible, future. This final strategy does not definitively solve the dilemma of historicism (for only history itself will 'solve' it), but, Jameson avers, such a conceptualization restructures the problem so that the opposite pitfalls of historical relativism and idealist totalization are equally neutralized:

> [Marxism] is, however, also the anticipatory expression of a future society, or ... the partisan commitment to that future or Utopian mode of production which seeks to emerge from the hegemonic mode of production of our own present. This is the final reason why Marxism is not, in the current sense, a 'place of truth,' why its subjects are not centered in some possession of dogma, but are rather very precisely historically decentered: only the Utopian future is the place of truth in this sense, and the privilege of contemporary life and of the present lies not in its possession, but at best in the rigorous judgment it may be felt to pass on us. (MH,71)

Whether this final gambit relieves the Marxist hermeneutic of the familiar idealist burden borne by other philosophies of history remains undecided in the context of this passage. What is at stake is the category of totalization and its power not merely to recover the truth of the past (as is postulated in traditional religious

hermeneutics), but also proleptically to point towards the shape of the future and thus effectively to preempt the contingencies of the present. We shall have occasion to return to this question with reference to some of the political judgments that issue from Jameson's position.

For the moment, however, the crucial consideration raised by 'Marxism and Historicism' involves the relationship between a utopian projection of future social forms and a mode of understanding specific to historical materialism. Jameson's writings are littered with references to Ernst Bloch and the utopian principle that guided the latter's work,[10] but in many ways Bloch is a screen figure for a more fundamental determinant of Jameson's theoretical project. *Geist der Utopie*, it will be recalled, was occasioned by a quite specific milieu and moment — the disaster that had befallen European civilization with the First World War — and as such it has been linked to other texts and events of that same period which sought to redeem the historical trajectory of European high culture from the apocalypse. One such text is Lukács's *Theorie des Romans*.

Originally conceived as the introduction to a study of Dostoevsky, Lukács's essay has remained to the present day a milestone in the speculative tradition of literary theory and philosophy, as well as an especially revealing instance of the rebellion among certain strata of the European intelligentsia against the facile optimism evident in social democratic support for the war. Lukács himself would subsequently remark on the book's 'fusion of "left" ethics and "right" epistemology (ontology, etc.)', while linking it to the itinerary during the 1920s of German intellectuals like Bloch, Adorno, and Benjamin.[11] The text's ambiguous position with respect to Lukács's 'path toward Marx' has long been a matter of controversy, not least because of the ambivalence exhibited by the author himself in his retrospective accounting of its significance. By calling it 'the first German book in which a left ethic oriented towards radical revolution was coupled with a traditional-conventional exegesis of reality',[12] Lukács effectively stamped *Theory of the Novel* with a

10. See MF, 116-59; Fredric Jameson, 'Introduction/Prospectus: To Reconsider the Relationship of Marxism to Utopian Thought', *Minnesota Review* N.S. 6 (1976): 57-8; and PU, 157, 236, 285-91.

11. Georg Lukács, Preface to *The Theory of the Novel: A historico-philosophical essay on the forms of great epic literature,* trans. Anna Bostock (Cambridge, Mass., 1971), p. 21.

12. Ibid.

pre-Marxist insignia that has allowed Marxists and anti-Marxists alike to place it outside the ambit of Lukács's later work. One's assessment of the text will depend principally upon one's attitude towards this latter body of writings, which will be seen either to overturn and correct the idealism of the pre-Marxist works, or to regress from true theoretical boldness to a sterile orthodoxy and dogmatic prescriptivism. In either case, the relationship of early to late, or a pre-Marxist to a Marxist Lukács is theorized as a rupture or break in the conceptual problematic ordering his work.

Jameson's squaring of this circle is not only ingenious but arguably more convincing than Lukács's own retrospective evaluation (not to mention those of Lukács's critics):

> Thus in the very working out of the problems of the *Theory of the Novel* itself there are decisive signs of that shift from a metaphysical to a historical view of the world that will be ratified by Lukács' conversion to Marxism. Indeed, I would be tempted to reverse the causal relationship as it is generally conceived, and to claim that if Lukács became a Communist, it was precisely because the problems of narration raised in the *Theory of the Novel* required a Marxist framework to be thought through to their logical conclusion. (MF,182)

This judgment follows directly from Jameson's architectonic claim in this essay that 'Lukács' work may be seen as a continuous and lifelong meditation on narrative' (MF,163), and it accords as well with his assessment of the methodological outcome of *History and Class Consciousness*: 'for the Lukács of *History and Class Consciousness* the ultimate resolution of the Kantian dilemma is to be found not in the nineteenth-century philosophical systems themselves, not even in that of Hegel, but rather in the nineteenth-century *novel*: for the process he describes bears less resemblance to the ideals of scientific knowledge than it does to the elaboration of plot' (MF,190).[13] And it is narration, thus posited without being

13. The claim underwrites the most recent — and arguably most exhaustive — commentary on Lukács's text by J. M. Bernstein, who discovers in *Theory of the Novel* not only its manifest continuity with *History and Class Consciousness* and the 'rudiments of a Marxist theory of the novel', but the basis for an architectonic conception of human *praxis* that solves the Kantian dilemma of how understanding organizes the world: 'The novel ... contends that unless we are able normatively or ethically to narrate our experience we are unable to say who we are. Conversely, the world as the novel finds it, the world prior to the novel's ethical figuration or constitution of it, the world where freedom is exiled into subjectivity, is a world we cannot narrate (except fictionally), a world in which we are unable to say who we

named in Lukács's first mature work of Marxist theory, which, as his *Ästhetik* will demonstrate in detail some forty years later, 'anticipates the life experience of a Utopian world in its very structure' (MF,190).

Jameson thus programmatically resists the familiar periodization of Lukács's career into its Kantian, Hegelian, properly Marxist, and ultimate Stalinist phases by arguing for the continuity of the problematic imposed by narrative from *Theory of the Novel* through the essays on realism and the historical novel. These latter constitute the empirical studies which, at least in intent, will validate the typological categories of the earlier work (MF,200). Lukács's polemical championing of realism over modernism, or narration over description, is but the continuation of the project 'to reestablish epic narration' in *Theory of the Novel*, and the logical development of the historical epistemology of *History and Class Consciousness*. Literary realism 'like revolutionary praxis itself, [is shown] to depend on those privileged historical moments in which access to society as a totality may once again somehow be reinvented' (MF,204-5). Lukács's originality and importance, which are confirmed by a variety of projects in contemporary thought from Danto's *Analytical Philosophy of History* to Greimas's structural semantics (and, as *The Political Unconscious* will argue, the structures of myth, folklore, and romance anatomized in the work of Lévi-Strauss, Propp, and Northrop Frye), derive from his having insisted on 'the relationship between narrative and totality' (MF,205). This relationship forms the bedrock of Marxist theory, and of Jameson's own project, from his early study of Sartre down to *The Political Unconscious* and his recent meditations on the culture and politics of the sixties and on postmodernism.[14]

At this point, it is worth remarking that Jameson's view of Lukács's career as the working through of a continuous problematic is not wholly original. Leaving aside Lukács's own late assessments (which, despite their reservations about his pre-1926 writings, including *History and Class Consciousness*, tend to imply some degree of evolutionary development in his writings), it

are' (Bernstein, *The Philosophy of the Novel: Lukács, Marxism and the Dialectics of Form* [Minneapolis, 1984], pp. x, xix). Bernstein's argument compares with Jameson's identification of 'the all-informing process of narrative' as 'the central function or *instance* of the human mind' (PU,13).

14. Jameson's own testimony concerning the dependence of the Sartre book on narrative as an organizing concept is given in his Afterword to the new edition of *Sartre: The Origins of a Style* (New York, 1984), pp. 205-33.

is perhaps surprising to recall that Paul de Man had argued a similar case for the conceptual coherence and continuity in Lukács's project several years prior to the publication of Jameson's essay. De Man's commentary locates the centre of the Lukacsian theory of narrative in a certain concept of temporality, which he dubs the 'irresistible feeling of flow that characterizes Bergsonian *durée*'.[15] Narrative time for Lukács is continuous, uninterrupted, totalizing, 'a concrete and organic continuum'.[16] As such, it resists the fragmenting enforced by reification on human experience; it organizes and harmonizes the dissonance of an otherwise random concatenation of events into a meaningful whole. Lukács's concept of history, as well as the political and social theory which his historical scheme incarnates, derive from the notion of time developed at the end of *Theory of the Novel*:

> Time in this essay acts as a substitute for the organic continuity which Lukács seems unable to do without. Such a linear conception of time had in fact been present throughout the essay. Hence the necessity of narrating the development of the novel as a continuous event, as the fallen form of the archetypal Greek epic which is treated as an ideal concept but given actual historical existence. The later development of Lukács's theories on the novel, the retreat from Flaubert back to Balzac, from Dostoevsky to a rather simplified view of Tolstoi, from a theory of art as interpretation to a theory of art as reflected imitation (Wiederspiegelung) should be traced back to the reified idea of temporality that is so clearly in evidence at the end of *Theory of the Novel*.[17]

Jameson's ascription to Lukács of the master category of narrative is far from innocent. It not only allows the unification of Lukács's own career within a single, developing problematic (i.e., it reads Lukács's texts as parts of a narrative whole), but it also, and more significantly, enables the rectification of concepts like reification, typicality, and reflection in an aesthetic totality. For our purposes, it is less important to decide whether or not Jameson has correctly interpreted the texts of Lukács and the arc of his theoretical development, than it is to recognize the theoretical stakes in the concept of narrative which Jameson's reading

15. Paul de Man, 'Georg Lukács's *Theory of the Novel*', in idem, *Blindness and Insight: Essays in the Rhetoric of Contemporary Criticism*, 2nd edition (Minneapolis, 1983), p. 58. Jameson's essay, 'The Case for Georg Lukács', was first published in *Salmagundi* (1970); de Man's piece originally appeared in MLN (1966).

16. Lukács, *Theory of the Novel*, p. 125.

17. De Man, 'Lukács's Theory of the Novel', pp. 58-9.

proposes. Nor is the theory without consequences for the political judgments of both. Lukács himself was perfectly lucid about this latter dimension of his early work. In 1967, he wrote about *History and Class Consciousness*, identifying this text as the *terminus a quo* of his political and theoretical thinking from 1919 up through the decisive *terminus ad quem* of the directly political Blum Theses. The candor and the perspicacity of Lukács's self-criticism are exemplary:

> [The] conception of revolutionary praxis in [*History and Class Consciousness*] takes on extravagant overtones that are more in keeping with the current [i.e., mid-1960s] messianic utopianism of the Communist left than with authentic Marxist doctrine. Comprehensibly enough in the context of the period, I attacked the bourgeois and opportunistic currents in the workers' movement that glorified a conception of knowledge which was ostensibly objective but was in fact isolated from any sort of praxis ... What I failed to realise ... was that in the absence of a basis in real praxis, in labour as its original form and model, the over-extension of the concept of praxis would lead to its opposite: a relapse into idealistic contemplation.[18]

The explicit political consequences, the strategic lapse into a messianic voluntarism which Lukács would later condemn, is entailed in the book's theoretical focus and conceptual bases, particularly in its privileging of the category of alienation and the equation of this historically specific condition with objectification in general — what Lukács calls his 'attempt to out-Hegel'.[19] Perry Anderson's commentary on this aspect of the text is acute:

> For two of the most basic theoretical theses of *History and Class Consciousness* were derived from Hegel, rather than from Marx: the notion of the proletariat as the 'identical subject-object of history,' whose class consciousness thereby overcame the problem of the social relativity of knowledge; and the tendency to conceive 'alienation' as an external objectification of human objectivity, whose reappropriation would be a return to a pristine interior subjectivity — permitting Lukács to identify the attainment by the working class of true consciousness of itself with the accomplishment of a socialist revolution.[20]

18. Georg Lukács, *History and Class Consciousness: Studies in Marxist Dialectics,* trans. Rodney Livingstone (Cambridge, Mass., 1971), p. xviii.
19. Ibid., p. xxiii.
20. Perry Anderson, *Considerations on Western Marxism* (London, 1976), pp. 61-2. The contrary view is argued by Michael Löwy in his *Georg Lukács – From Romanticism to Bolshevism,* trans. Patrick Camiller (London, 1979): '*History and*

The line from this empiricist historicism to the worst abuses of 'proletarian science' is direct and clear. Lukács's self-criticism of the epistemological and strategic naiveté of his own text stands as a sober condemnation of the distance separating the theoretical concepts of *History and Class Consciousness* from historical materialism.

That said, one must inevitably inquire why Jameson seems to think otherwise — and not only in his earlier work. The categories of totality and reification are taken over directly from Lukács and deployed in *The Political Unconscious* to organize the scheme of literary history for which the central chapters of that book argue, as well as to establish the grounds for a properly Marxist positive hermeneutic which is the book's signal theoretical aim. Jameson would appear to be singularly untroubled by the incipient idealism of these categories, except that he does in the end draw back from the brink of Hegelianism, i.e., from the always suspect temptation to predict the end of history and the forms of social life which that moment will assume. In writing about the imagined classless society of the future, Jameson invokes Roussseau on festival, Durkheim on religion, his own concept of the utopian dimension to culture, and Heidegger on the work of art, only to condemn them all as 'false and ideological' when experienced in the present structures of reified life under capitalism. But he immediately goes on to claim that 'they will know their truth and come into their own at the end of what Marx calls prehistory. At that moment, then, the problem of the opposition of the ideological to the Utopian, or the functional-instrumental to the collective will have become a false one' (PU,293).

The difficulty with this projection, as Jameson observes, is its reliance on a concept of the subject which, after Althusser, is highly suspect. Conceding the 'Althusserian and post-structuralist critique of these and other versions of the notion of a "subject of history,"' he recuperates this concept by placing it 'under erasure':

> What is wanted here — and it is one of the most urgent tasks for Marxist theory today — is a whole new logic of collective dynamics, with categories that escape the taint of some mere application of terms

Class Consciousness is a Leninist work insofar as it is a philosophical expression of the revolutionary dialectic informing Lenin's political writings and his 1914 *Philosophical Notebooks'* (p. 189). Löwy criticizes Gareth Stedman Jones for asserting a break in thinking between Lukács's 1924 study of Lenin and *History and Class Consciousness* (pp. 189-90). Cf. Stedman Jones, 'The Marxism of the Early Lukács', in *Western Marxism: A Critical Reader* (London, 1977).

drawn from individual experience (in that sense, even the concept of praxis remains a suspect one). Suggestive work has been done in this area; I think, for example of the perhaps ultimately unsatisfactory but still largely undiscovered machinery of Sartre's *Critique of Dialectical Reason*. But the problem has rarely been focused in an adequate way. Until this task is completed, it seems possible to continue to use a Durkheimian or Lukacsean vocabulary of collective consciousness or of the subject of history 'under erasure,' provided we understand that any discussion refers, not to the concepts designated by such terms, but to the as yet untheorized object — the collective — to which they make imperfect allusion. (PU,294)

In an astute commentary on *The Political Unconscious*, Robert Wess has suggested that this passage indicates Jameson may be 'on the verge' of an 'epistemological break', that the historicizing totalization which governs the dialectic of desire and history and structures this text (see, e.g., PU,184, and the entire final chapter, 'The Dialectic of Utopia and Ideology') has been to some degree cancelled in the gesture towards a purely regulative use of the category of utopia — the projection of an authentic collectivity in a future classless society.[21] While it is possible to remain charitable on this point, Jameson's subsequent work raises considerable doubt about whether the concept of history as a 'structure of structures', an object, if not of direct experience, then of figural projection, has been categorically dismissed from his conceptual armature.[22] Moreover, in its unabashed assertion of the Marxist understanding of history as 'a single great collective story', an 'unfinished plot' and 'uninterrupted narrative' (PU,19, 20), *The Political Unconscious* fails to break at all with its Lukacsian heritage, while it merely circumscribes the Althusserian critique of expressive causality which would pose the most fundamental challenge to Jameson's own scheme of historical totalization.[23]

* * * * * * * * * *

21. Robert Wess, 'A New Hermeneutic in Old Clothes', *Works and Days* 2,2 (1985): 60.

22. See, for example, Jameson's new Afterword to *Sartre: The Origins of a Style* referred to above (n. 14), his Foreword to Jacques Attali, *Noise: The Political Economy of Music,* trans. Brian Massumi (Minneapolis, 1985), and, most tellingly, his essay on 'Postmodernism, or the Cultural Logic of Late Capitalism', *New Left Review* 146 (July-August 1984). Apropos of the latter, Mike Davis's reply, 'Urban Renaissance and the Spirit of Postmodernism', *New Left Review* 151 (May-June 1985), establishes the relevant coordinates for a materialist critique.

23. Wess discusses these passages from *The Political Unconscious* intelligently, showing precisely how Jameson has appropriated without being disturbed by

The methodological interest of Jameson's work must rest on the strength of its intervention within literary, or more broadly, cultural anaysis and criticism. Above all, Jameson's success will be judged by the degree to which he can support his claim for the greater 'semantic richness' (PU, 10) of Marxism in relation to other hermeneutic models. The most sustained defense of this claim is the reading of Conrad elaborated in the penultimate chapter of *The Political Unconscious.*

Briefly, Jameson theorizes the Conradian narrative apparatus as one powerful solution to the dilemma of modernist aesthetics, which had proposed to overcome the reification of everyday life at the very moment at which capitalism was conquering all hitherto existing sanctuaries of aesthetic experience: not only the private realm of aesthetic production and contemplation itself, but also those heretofore exotic regions of the world to which Western aesthetes like Gauguin and Rimbaud had been able to escape. Part of the lesson of Jim's unsuccessful flight in *Lord Jim* is just this recognition that the possibility for private redemption has been foreclosed by the penetration of the market into the most remote regions of the world and of the self — for both of which Patusan stands as the symbolic representative. Conrad's narratives present this tension between the public and the private in their contradictory mixture of popular romance and high modernist technique. They seek to fulfill the aesthetic and ideological mission of modernism: to offer compensatory private gratification for the degradation of public virtues and massified labor characteristic of everday life under capitalism. At the same time, these narratives strive to remain accessible to a wide reading audience and thus to participate in that very public life against which the narrative and stylistic techniques of modernism are in open rebellion.

Jameson presents the essay on Conrad as an instance of what is

Althusser ('A New Hermeneutic', p. 59). The other figure who looms large over *The Political Unconscious* — and over all of Jameson's work — is Sartre. It will not be possible to trace Jameson's itinerary through Sartre's *oeuvre* here (although some indication of how this would proceed can be gleaned at the end of this chapter and from chapter 7 below). The relevant texts for this investigation would be the following: *Sartre: The Origins of a Style* (1961); 'The Ideology of the Text', *Salmagundi* 31-32 (Fall 1975-Winter 1976); 'Sartre and History', in *Marxism and Form* (1971); 'Three methods in Sartre's Literary Criticism', in *Modern French Criticism: From Proust and Valéry to Structuralism,* ed. John K. Simon (Chicago, 1972); 'On Aronson's Sartre', *minnesota review* N. S. 18 (Spring 1982); and the Afterword to the second edition of the Sartre book already cited. The key concept in this itinerary is the model of narrative which Jameson locates, not without warrant, in Sartre's theoretical as well as in his literary and critical texts.

here and elsewhere termed 'metacommentary', the purpose of which is to comprehend the functioning of various interpretive strategies proposed for reading texts within the englobing category of mode of production.[24] Surveying the history of interpretation of Conrad's texts, Jameson identifies eight major interpretive options: impressionistic, mythic-archetypal, Freudian, ethical, ego-psychological, existential, Nietzschean, and structural/textualist (PU, 208-9). Jameson's strategy is not to demolish or invalidate any of these others, but to show that each expresses a partial truth about Conrad's texts. Each of the hermeneutic strategies can be seen to compose a cultural space within the history of commodity production that serves the needs of capitalism; at the same time each fails to totalize (and thus comprehend) the historical situation of which it is one of the products. All these different hermeneutics can be shown to operate within the Conradian narrative apparatus itself, because each expresses an objective feature of the mode of Conrad's writing, which poses a complex response to the material situation of cultural production within capitalism.

For example, there is that staple of Conradian exegesis, of literary histories of the 19th and 20th centuries, and of New Critical valorizations of modernist texts: impressionism. The *locus classicus* in the Conrad canon for generating this interpretive strategy is the preface to *The Nigger of the 'Narcissus',* with its rehearsal of a Paterian *aesthesis* that found countless other avatars in the literature and philosophy of the late 19th century, and which has been ritually repeated in a variety of critical manifestoes and programmes ever since. Conrad (along with Henry James, Flaubert, Joyce, and Virginia Woolf) has come to occupy a central and privileged place within this tradition in the history of the novel. Jameson's summary comment on Conrad's 'aestheticizing strategy' in style is to the point: 'the term is not meant as a moral or political castigation, but is rather to be taken literally, as the

24. The first essaying of this method was offered in Jameson's article, 'Metacommentary', *PMLA* 86 (January 1971): 9-18. This pre-Althusserian text, however, lacks the methodological sophistication of the more mature theory presented in *The Political Unconscious*. Jameson's account of interpretation in the earlier essay comes perilously close to empiricism pure and simple. For example, he there observes: 'all stylization, all abstraction in the form, ultimately expresses some profound inner logic in its content, and is ultimately dependent for its existence on the structures of the raw materials themselves... *Content does not need to be treated or interpreted because it is itself already and immediately meaningful...'* (p. 16; Jameson's emphasis).

designation of a strategy which for whatever reason seeks to recode or rewrite the world and its own data in terms of perception as a semi-autonomous activity' (PU, 230). The ideological function of impressionism is 'to derealize the content [of the material world of the narrative] and make it available for consumption on some purely aesthetic level,' to render the 'ground bass of material production ... conveniently muffled and intermittent, easy to ignore ...'(PU, 214, 215).

At the same time, however, impressionism can be seen as 'a Utopian compensation for everything reification brings with it'. Impressionism is part and parcel of the bourgeois cultural revolution, which both overthrows the social and individual experiences of the past and opens up new horizons: 'The perceptual is in this sense a historically new experience, which has no equivalent in older kinds of social life' (PU, 237). The stylistic practice of impressionism in Conrad (and in modernism generally) is thus *both* ideological and utopian:

> Seen as ideology and Utopia all at once, Conrad's stylistic practice can be grasped as a symbolic act which, seizing on the Real in all of its reified resistance, at one and the same time projects a unique sensorium of its own, a libidinal resonance no doubt historically determinate, yet whose ultimate ambiguity lies in its attempt to stand beyond history. (PU, 237)

The classic figure for this transformation of personal life under capitalism is the character of Stein in *Lord Jim*. His early career as a heroic capitalist entrepreneur has freed him from the necessity to engage in productive labor and has driven him into a life of aesthetic contemplation, symbolized by his consuming passion for collecting butterflies. Commenting on the famous passage in which Marlow sympathetically reflects on Stein's monomania, Jameson links the character's aestheticism to Conrad's historical situation as a writer: 'the passion for butterfly collecting must be read as the fable and the allegory of the ideology of the image, and of Conrad's own passionate choice of impressionism — the vocation to arrest the living raw material of life, and by wrenching it from the historical situation in which alone its change is meaningful, to preserve it, beyond time, in the imaginary' (PU, 238). Literary impressionism need be neither celebrated nor denounced, but can be positioned historically as a comprehensible response to the reification of everyday life under capitalism. Moreover, the vestiges of the repressed reality of mechanical

production and exploited labor remain visible in Conrad's narratives, constituting the materials out of which the historical subtext of capitalist commodification can be constructed. Everyday life is cancelled yet preserved in the narrative apparatus of Conrad's fiction.

The various other hermeneutic strategies that have been employed in the tradition of interpretation to resolve the dilemma Conrad poses for literary history are folded into Jameson's reading of *Lord Jim* and *Nostromo*, from which emerges the system of meanings that is now familiarly known as the Conrad tale. Crucial to this system, and symptomatic of the status of cultural production under capitalism, is the discrimination between so-called 'high' and 'mass' culture. Conrad occupies a virtually unique position in relation to these two modes, since his work seems to inhabit both cultural spaces at once.[25]

This split or schizophrenia, which is the very condition of subjectivity under capitalism, is made manifest in the narrative rupture in *Lord Jim* between the events surrounding and consequent upon the *Patna* episode and the subsequent history of Jim's career in Patusan. The shift, as F. R. Leavis noted, is from high modernist psychological exploration to pure romance. As such, it can be compared to the early episodes of *Nostromo*, with their characteristic Conradian time-shift and high impressionist finish culminating in the episode of Decoud's suicide, but which yield to the comparatively melodramatic romance of Nostromo's concealment of the treasure and his eventual death resulting from the 'curse' the silver has put on his life. A psychoanalytic reading of *Lord Jim* (say, that of Gustav Morf) would locate the cause of this narrative disjunction in the contradictions of Conrad's personal life, specifically in his abandonment of homeland and family and his effective repudiation of the paternal legacy. Jameson, while not inattentive to this dimension of Conrad's texts, sees the disjunction in the plot as evidence of a contradiction in modern history, for which the second half of *Lord Jim* is the not entirely successful ideological resolution.

25. If one follows out Jameson's structural equation between modes of cultural production and historical epochs (or modes of production proper), it would appear that Conrad's texts are the privileged instance of the transition from modern to postmodern cultural production which will ultimately be realized in the architectural pastiche that dominates the buildings of the postwar boom in the US; see Jameson, 'Postmodernism', pp. 54-8, 64-6, 76-85. Further clarification of this periodization of what Jameson terms 'cultural dominants' in relation to Marxist theory is given in Jameson, 'Science versus Ideology', *Humanities in Society* 6 (Spring-Summer 1983).

The romance of Patusan is not merely the projection of a writer who felt himself to have tried vainly to escape from his own past; it is also the nostalgic fantasy of an entire class in crisis. The military-administrative class of the British Empire, which was to embark in 1914 on its ultimate destructive adventure, is represented in the novel by Jim and by all those figures (preeminently Brierly and Marlow) who affirm the values of individual heroism and solidarity under a code of honour that binds together what would otherwise remain an anarchic band of egoistic warriors. *Lord Jim* can thus be compared to that apparently quite different cultural object, the movie *Breaker Morant*, in which the tragedy of the hero expresses not merely his personal fate as a 'scapegoat of empire', but the necessary ruination of an entire class. In *Lord Jim*, the romantic narrative allows the bourgeois reader to swallow this bitter pill and remain untouched by its scathing critique of his own values and institutions, just as, it would seem, Jim is able to reaffirm the code of honour despite the unmasking that this code endures in the taunting gibes of Gentleman Brown. The personal fantasy of the hero (thematized in the novel's opening chapter by Jim's manifest *bovarysme*), or indeed of the author as psychoanalytic subject (Conrad's own complex psychological investment in the romance of the sea and of the imperial British administrative class represented in its merchant seamen), is rewritten by Jameson as the collective fantasy of this class in crisis.

We hasten to add at this point that our exposition of Jameson's reading of this ideological vector in Conrad's narratives is not intended to convict him of any premature homologizing of a Goldmannian sort. Jameson's reconstruction of the complex ideological structures of Conradian narrative precisely emphasizes the conflicting pressures of different ideological forces upon Conrad's fiction. It would be incorrect to charge Jameson with a similar class reductionism to that associated with vulgar Marxist ideological critique or with Goldmann's derivation of the tragic vision of Racinean drama and in Pascal from the crisis of the 17th-century *noblesse du robe*. Conrad's class identifications are multiple and contradictory, not univocal and consistent. Their representation in narrative can only present an imaginary relation to real conditions of social existence.

What is not imaginary, however, what is susceptible to representation and to more or less direct understanding by the interpreter, is Conrad's position within the sequence of modes of production. What *we* know (even if Conrad remained blind to it) is that Conradian narrative marks the crucial historical cusp

separating realism from modernism proper, while it prefigures that mode of cultural production which is our own; what we *know*, in short, is the architectonic structure of History (the capitalizing of which now seems unavoidable),[26] that 'single great collective story' of the 'struggle to wrest a realm of Freedom from a realm of Necessity' (PU, 19). Moreover, we know that that struggle has until now always and everywhere failed. The strain of historical pessimism which recurs persistently throughout Jameson's writings (and whose source we shall consider in a moment) is apparent at the end of the essay on Conrad, as the moment of Conradian heterogeneity gives way to the 'perfected poetic apparatus of high modernism' and its successful repression of history. This is that moment (to be succeeded by the even more outrageously anti-historical pastiche of postmodernism) when 'the political, no longer visible in the high modernist texts, any more than in the everyday world of appearance of bourgeois life, and relentlessly driven underground by accumulated reification, has at last become a genuine Unconscious' (PU, 280).

Nowhere, however, is Jameson's theory gloomier, his prognostications for the immediate prospects of revolutionary transformation less hopeful, than in the last paragraphs of the opening chapter of *The Political Unconscious*:

> [The] most powerful realizations of a Marxist historiography — from Marx's own narratives of the 1848 revolution through the rich and varied canonical studies of the dynamics of the Revolution of 1789 all the way to Charles Bettelheim's study of the Soviet revolutionary experience — remain visions of historical Necessity in the sense evoked above. But Necessity is here represented in the form of the inexorable logic involved in *the determinate failure of all the revolutions that have taken place in human history:* the ultimate Marxian presupposition — that socialist revolution can only be a total and worldwide process (and that this in turn presupposes the completion of the capitalist 'revolution' and of the process of commodification on a global scale) — is the perspective in which the failure or the blockage, the contradictory reversal or functional inversion, of this or that local revolutionary process is grasped as 'inevitable', and as the operation of objective limits.
>
> History is therefore the experience of Necessity ... Necessity is not in that sense a type of content, but rather the inexorable *form* of events; it is therefore a narrative category in the enlarged sense of some properly narrative political unconscious which has been argued here ... History is what hurts, it is what refuses desire and *sets inexorable limits to*

26. See Samuel Weber, 'Capitalizing History', *Diacritics* 13 (Summer 1983).

individual as well as collective praxis, which its 'ruses' turn into grisly and ironic reversals of their overt intention. (PU, 101-2; emphasis added)

The obvious source for the theoretical pessimism expressed in this passage is Sartre's *Critique of Dialectical Reason*, with its theorization of the 'inexorable limits to individual as well as collective praxis' in the ontological category of 'scarcity' and its historical consequence, the 'practico-inert'. The reference to Bettelheim suggests the common historical situation which has determined the theoretical horizon for both Sartre and Jameson: the degeneration of the Bolshevik Revolution into Stalinism. From this sobering, but punctual and arguably unique, historical phenomenon, Sartre and Jameson have drawn a metaphysical lesson that sets the theoretical trajectory for their own projects and places inviolable barriers in the road of political *praxis*.

Jameson's response to this impasse within Marxist theory and politics is to posit a ceaseless 'dialectic between utopia and ideology', and to argue that every literary text, every cultural artifact is at once both ideological in its origins and potentially utopian in its function. His own work has consistently kept faith with both terms of this dialectic, while carving out a large territory within which other Marxists can now effectively intervene. His consistent struggle on behalf of materialist analysis has effectively enabled Marxism to compete, if still on generally unequal terms, in the *Kampfplatz* of contemporary criticism and theory. In that sense, his own work and its political effectivity testify powerfully to the value of a theory which, while perhaps not fully revolutionary in itself, nevertheless contributes vitally to the revolutionary project. This, we might say, is the utopian dimension of the Jamesonian text.[27]

27. A similar case is made in James H. Kavanagh's excellent assessment and critique of *The Political Unconscious*, 'The Jameson-Effect' (*New Orleans Review* 11 [Spring 1984]). He correctly points out the degree to which *The Political Unconscious* depends upon, without adhering rigorously to, the programme of Althusserian theory. His happy formulation for this peculiarity is that 'Jameson's text does not seem to recognize what it produces' (p. 26). At the same time, Kavanagh defends the special power of Jameson's project, which 'must be understood as — *exactly what it claims to be* — an attempt at constructing a meta-*ideology*' (p. 26; Kavanagh's emphasis). Jameson's intervention in the contemporary political and ideological conjuncture of the Anglophone First World is effective precisely because it remains *at the level of ideology*, and because it appears *as a theory* to be comfortably distanced from the political *praxis* which Marxism seems otherwise to demand of its partisans. This, as Kavanagh suggests, is

And yet the ideological limits of this theory remain. We can discern the extent of this limitation by once more comparing Jameson with Sartre, and this with the aid of Althusser. In Althusser's judgment, Sartre's ceaseless rebounding between the poles of revolutionary optimism and historical pessimism derived from the latter's incapacity to abandon the historicist and humanist problematic which was sustained from his earliest to his latest writings. Voluntarism inevitably alternated with defeatism. The requisite categories for theorizing an effective political practice — the properly Marxist categories adapted by Lenin in postulating the role of the party, the weakest link in the imperialist chain, the nature of the present conjuncture, *et cetera* — fall in Sartre's theoretical work under the metaphysical veto of a totalizing philosphy of history:

> This historicist humanism may, for example, serve as a theoretical warning to intellectuals of bourgeois or petty-bourgeois origin, who ask themselves, sometimes in genuinely tragic terms, whether they really have a right to be members of a history which is made, as they know and fear, outside them. Perhaps this is Sartre's profoundest problem. It is fully present in his double thesis that Marxism is the 'unsurpassable philosophy of our time,' and yet that no literary or philosophical work is worth an hour's effort in comparison with the sufferings of a poor wretch reduced by imperialist exploitation to hunger and agony. Caught in this double declaration of faith, on the one hand in an idea of Marxism, on the other in the cause of all the exploited, Sartre reassures himself of the fact that he really does have a role to play, beyond the 'Words' he produces and regards with derision, in the inhuman history of our times, with a theory of

as much the result of the historical situation in which Jameson has been compelled to intervene (the absence in the US of a 'politicized working class and a concomitant revolutionary politics' [p. 27]), as of Jameson's own theoretical determinations.

But Kavanagh concludes his piece with a judgment that flies in the face of his own generous defense of Jameson's project. The present horizon of Marxist theory is not limited in quite the way Jameson's ideological intervention would seem to suggest: '... Jameson's properly ideological discourse must be completed by an "other" Marxist theory that recognizes the very limited validity of looking for "untranscendable horizons" on the battlefield of theory' (p. 28). To have recognized the limits of Jameson's theoretical project is already in some sense to have glimpsed the possibility of a more adequate scientific theory. Whether the move beyond Jameson's totalizing gesture and utopian projection can be made ideologically effective within the present historical conjuncture remains an open question. But the proper rebuttal to the claim that ideological effectivity is paramount over theoretical correctness is Lenin's riposte to pragmatism: Marx's theories are not true because they work; they work because they are true.

'dialectical reason' which assigns to all (theoretical) rationality, and to every (revolutionary) dialectic, the unique transcendental origin of the human 'project'. Thus in Sartre historicist humanism takes the form of an exaltation of human freedom, in which by freely committing himself to their fight, he can commune with the freedom of all the oppressed, who have always been struggling for a little human light since the long and forgotten night of the slave revolts.[28]

It would be an error to identify directly and unequivocally Fredric Jameson's position within contemporary Marxist theory and politics with that of Jean-Paul Sartre, the more so because Althusser's criticisms apply with equal justice to more names on the left than just these. It is nonetheless necessary to be lucid about the limits of the theoretical project which Jameson's work incarnates, as well as about the political consequences which such a theory undoubtedly entails. We shall explore these limits and project some of the consequences in our next chapter apropos of Sartre himself. It is only possible to bar Jameson from his path by closing the one Sartre opened for him.

28. Louis Althusser and Etienne Balibar, *Reading Capital*, trans. Ben Brewster (London, 1970), p. 142.

7

Politics and Theory:
Althusser and Sartre

If Fredric Jameson's appropriation of Althusser fails in the end to keep strict faith with the anti-totalizing spirit of Althusserian theory, it nonetheless has the merit of presenting Althusser sympathetically and with considerable subtlety on the political level. Jameson's commentary on the political resonance of the concepts of semi-autonomy and expressive causality is astute:

> The insistence on the 'semi-autonomy' of these various levels ... may now be understood as a coded battle waged within the framework of the French Communist Party against Stalinism. As paradoxical as it may seem, therefore, 'Hegel' here is a secret code word for Stalin (just as in Lukács' work, 'naturalism' is a code word for 'socialist realism'); Stalin's 'expressive causality' can be detected, to take one example, in the productionist ideology of Soviet Marxism, as an insistence on the primacy of the forces of production ... Another crucial example can be found in the theory of the state: if the state is a mere epiphenomenon of the economy, then the repressive apparatus of certain socialist revolutions needs no particular attention and can be expected to begin to 'wither' when the appropriate stage of productivity is reached. The current Marxist emphasis on the 'semi-autonomy' of the state and its apparatuses, which we owe to the Althusserians, is intended to cast the gravest doubts on these interpretations of the 'text' of the state (seen as simply replicating other levels), and to encourage attention both to the semi-autonomous dynamics of bureaucracy and the state apparatus in the Soviet system, and to the new and enlarged apparatus of the state under capitalism as a locus for class struggle and political action, rather than a mere obstacle which one 'smashes.'[1]

1. Fredric Jameson, *The Political Unconscious* (Ithaca, 1981), pp. 37-8.

Althusser has not always been so fortunate in his commentators. A variety of unsympathetic expositions in France, Great Britain, and the United States have charged that Althusserian theory is in league with, necessarily culminates in, or is in some way the product of Stalinist politics.[2] The grounds for this charge have most often been left unclear, except in the guilt by association which holds that Althusser's membership in the French Communist Party convicts him without the necessity for a trial. In order to decide whether Althusser's position within Marxist theory is indeed a direct expression of the political line and bureaucratic organization of the PCF, one must at a minimum reconstruct the political and philosophical conjuncture of Althusser's early works, relying in part on the explicit statements

2. The literature condemning Althusser on political grounds is too vast for useful summary and consideration here. Of those that are not simply scurrilous, the following are representative: Jacques Rancière, La Leçon d'Althusser (Paris, 1974), especially the final essay, 'Pour memoire; Sur la théorie de l'idéologie,' (available in English translation as 'On the Theory of Ideology — the Politics of Althusser', Radical Philosophy Reader, ed. Roy Osborne and Roy Edgley [London, 1985], pp. 102-36); Valentino Gerratana, 'Althusser and Stalinism', New Left Review 101-2 (February-April 1977); 110-2; Bernard Lisbonne, Philosophie marxiste ou philosophie althussérienne? (Paris, 1981); Norman Geras, 'Althusser's Marxism: An Assessment', in Western Marxism: A Critical Reader, ed. New Left Review (London, 1977), pp. 232-72; Alex Callinicos, Althusser's Marxism (London, 1976); R. W. Connell, 'A Critique of the Althusserian Approach to Class', Theory and Society 8 (1979): 305-6, 340-1; Pierre Fougeyrollas, 'Althusser: la scolastique de la bureaucratie', in idem, Contre Lévi-Strauss, Lacan et Althusser: Trois essais sur l'obscurantisme contemporain (Rome, 1976); and most infamous of all in the Anglophone world, the title essay in E. P. Thompson's The Poverty of Theory and Other Essays (New York, 1978). Thompson has been definitively answered by Perry Anderson in the latter's Arguments within English Marxism (London, 1980).

Sympathetic estimates of Althusser's politics, in addition to Jameson's already cited, can be found in: John Mepham, 'Who Makes History? Althusser's Anti-Humanism', in Radical Philosophy Reader, pp. 137-57; the 'Interview with Etienne Balibar and Pierre Macherey', trans. James H. Kavanagh, Diacritics 12 (Spring 1982): 46-51; Kavanagh's original contribution to the same issue of Diacritics, 'Marxism's Althusser: Toward a Politics of Literary Theory', pp. 25-33; and Ted Benton, The Rise and Fall of Structural Marxism (New York, 1984), pp. 2-19. The most sustained defense is Perry Anderson's in the chapter on Stalinism in Arguments (pp. 100-30).

Althusser's texts will be cited parenthetically hereafter and are identified by the following abbreviations: ESC-Essays in Self-Criticism, trans. Grahame Lock (London, 1976); FM-For Marx, trans. Ben Brewster, 2nd edn. (London, 1977); PM-Pour Marx (Paris, 1965); RC-Reading Capital, trans. Ben Brewster (London, 1977); ISA-Ideology and Ideological State Apparatuses ('Notes towards an Investigation'), in Lenin and Philosophy and Other Essays, trans. Ben Brewster (New York, 1971); P-Positions (Paris, 1976). Translations have been checked against the

of Althusser himself, but also through a 'symptomatic reading' of certain passages in *Pour Marx* and *Lire le Capital*. This seemingly circuitous approach is necessary, not only because the charge of theoretical totalitarianism is precipitous, but more importantly because the direct line from political practice to theoretical practice which hostile critics have asserted against him is the very mode of thinking and analysis that Althusser has ranged his theoretical weapons against. To attack Althusser from within what after him can only be termed the historicist problematic is hardly to engage the full force of his intervention. A consequent critique of Althusser demands a level of theoretical rigor in the exegesis of his works comparable to that which Althusser himself attained in reading Marx.[3]

In his introductory note 'To My English Readers' in *For Marx*,

French originals and are occasionally modified for the sake of a more literal rendering.

3. The only work to date which has risen to this level and which has, while criticizing Althusser, nevertheless presented a judicious and thorough exposition of the historical conjuncture that produced his works is Gregory Elliott's 'Louis Althusser and the Politics of Theory' (Ph.D. thesis, Oxford University, 1985; forthcoming from Verso Editions, 1987). His first chapter, 'The Moment of Althusser', is the first really careful and detailed exegesis of Althusser's texts in the light of the complex determinations of French philosophy, the politics of the PCF, and the conjuncture in the international Communist movement which we sketch more hastily here.

That said, one is constrained to notice the inopportune veering towards a more directly political reading of Althusserian theory which dominates the remainder of Elliott's thesis. His work takes up a line of argument set out more briefly by others (notably Alex Callinicos in his *Is There a Future for Marxism?* [Atlantic Highlands, 1982], and Perry Anderson in his Wellek Library lectures, *In the Tracks of Historical Materialism* [London, 1983]; on the latter see chapter 7 below): to wit, that Althusser's project emerged under the shadow of Maoism and collapsed with this latter's demise during the mid-1970s. Elliott gives considerable weight to an anonymous text written by Althusser and published in the *Cahiers Marxistes-Léninistes* in 1966, 'On the Cultural Revolution', which testifies to Althusser's enthusiasm for the Chinese experiment. Whether this text can then bear the weight of being held directly and primarily responsible for the whole of Althusser's post-1966 writings is more dubious. Our point in this and the following chapters is to insist once more on the evaluation of Althusser's project in terms of the relative autonomy of theory, and thus to cast suspicion on those readings, even generally sympathetic ones like Elliott's and Callinicos's, which tend to derive theoretical concepts directly from the politics which they are said to underwrite.

On a related point, however, one must concede the justice of Elliott's and Callinicos's criticisms of Althusser: Althusser's failure along with his most famous students to consider the theoretical legacy of Trotsky. Trotskyism is undoubtedly one of the most serious blind spots of the Althusserian research program. Althusser's judgments on the history of Stalinism are regrettably marred by this lacuna in his texts.

Althusser identifies two principal contexts for the essays in that volume (originally collected and published in French in 1965): the theoretical situation within the French Communist Party and French philosophy on the one hand, and developments in the international Communist movement in the wake of de-Stalinization and the Sino-Soviet split on the other. Nor were these two contexts unrelated to each other. The political and theoretical positions developed in the PCF during the early sixties were significantly affected by these major events in Soviet and international Communist politics. In line with the Soviet strategy of 'peaceful coexistence', PCF political strategy and philosophical doctrine had shifted towards a kind of popular frontism that was to lead within a decade to collaboration with the socialists in the Common Programme, and ultimately to the proclamation of a 'peaceful road to socialism' and official expulsion from the PCF statutes of the phrase and concept 'dictatorship of the proletariat'. Against this PCF revisionism, Althusser took a hard line: citing Mao and recalling Lenin, Althusser wrote 'Contradiction and Overdetermination' in order to intervene theoretically in PCF strategic debates; on another front, he attacked Garaudy and a broad movement among Marxist intellectuals (primarily but not exclusively western) by asserting Marx's 'theoretical anti-humanism'.

But Althusser also cites in this introduction the situation in French philosophy, its theoretical poverty and historical backwardness. This context is elaborated at greater length in the original introduction to the French edition of *Pour Marx*. Commenting on the 'theoretical vacuum' that existed in the PCF throughout the 1950s, Althusser remarked on the necessary orientation of French intellectuals on the left towards practical politics, to the exclusion of scientific research. The paradigmatic instance of this tendency was Sartre: 'In his own way, Sartre provides us with an honest witness to this baptism of history: we were of his race as well ... *Philosophically* speaking, our generation sacrificed itself and was sacrificed in its intellectual and scientific work' (FM, 27). For Althusser, Sartre epitomized the immediate determination of Marxist philosophy by politics, and this determination is readily visible in the latter's postulation of the master philosophical category of *praxis*. The rallying cry for this familiar theoretical move is given in the eleventh of the *Theses on Feuerbach,* which 'counterposes the transformation of the world to its interpretation'. Althusser's judgment on this tendency (today more visible than ever in the work of English Marxists like Terry

Eagleton, Edward Thompson, and, Thompson's scorn for them notwithstanding, Hindess and Hirst) is curt: 'It was, *and always will be*, only a short step from here to theoretical pragmatism' (FM, 28). The case against this temptation within Marxism is put most forcefully in Althusser's introduction to Dominique Lecourt's study of Lysenko.[4]

Althusser's own project, his guerilla war against the residual Stalinism of the PCF, pursued an opposite course to this 'theoretical pragmatism'. It was, put simply, to elaborate and specify what Marx had at most sketched the possibility of — Marxist philosophy. The questions posed by him apropos of Marx's relation to Feuerbach demarcate the terrain of his own work: 'what is at stake in this double rupture, first with Hegel, then with Feuerbach, is the very meaning of the word *philosophy*. What can Marxist *"philosophy"* be in contrast to the classical models of philosophy? Or, what can be the theoretical position which has broken with the traditional philosophical problematic whose last theoretician was Hegel and from which Feuerbach tried desperately but in vain to free himself?' (FM, 48). What remains most curious in this formulation, given Althusser's characterization of Sartre as the philosopher who abandons philosophy proper for political *praxis*, is that this was precisely Sartre's project as well, announced in the very text Althusser will later cite against him as evidence of Sartre's residual Hegelianism, that is, of his continued commitment to the traditional problematic of philosophy.

This is certainly not the place to recount in detail the political and philosophical itinerary of Sartre from *L'Être et le néant* through the *Critique de la raison dialectique*.[5] But it can be observed summarily that Sartre's affinities with Althusser (which Althusser understood only too clearly), as well as the former's authority among left intellecturals in France and throughout the West, constituted for Althusser one of the chief obstacles to his own theoretical programme.[6] In particular, it was Sartre who had

4. Louis Althusser, 'Unfinished History', in Dominique Lecourt, *Proletarian Science? The Case of Lysenko*, trans. Ben Brewster (London, 1977).

5. See Ronald Aronson, *Jean-Paul Sartre: Philosophy in the World* (London, 1980), pp. 271-92; Fredric Jameson, *Marxism and Form* (Princeton, 1971), pp. 230-74 — the best accounts in English.

6. See Perry Anderson, *Considerations on Western Marxism* (London, 1976), p. 72; and Steven Smith, *Reading Althusser: An Essay on Structural Marxism* (Ithaca, 1984), pp. 59-70. Smith correctly notices the general significance of Sartre for Althusser's work, but he signally fails to recognize the specificity of Althusser's criticisms of Sartrean historicism, simply lumping Sartre among other 'humanist Marxists' whom Althusser attacked in his essays of the early 1960s.

intervened on the side of the PCF in 1952 in *Les communistes et la paix*; had, in the aftermath of the Soviet invasion of Hungary in 1956, proposed (in *Le fantôme de Staline*) a materialist historical analysis of Soviet politics to account for the phenomemon of Stalinism and what Sartre would later call 'the monstrosity of socialism in one country', without relying on facile slogans about 'the cult of personality'; and had set out in *Question de méthode*, and more fully in subsequent sections of the *Critique*, to establish the claim of Marxism to philosphical priority over the human sciences. Althusser's political and theoretical agenda thus closely paralleled Sartre's. It is important to acknowledge this at the outset, the more accurately to determine the intent and effect of Althusser's critique of Sartrean philosophy — and, not incidentally, to drive a wedge between the political and theoretical claims made by Althusser's critics about the determination of Althusserian theory by Stalinist politics. For if Althusser's work was launched from much the same position (albeit for quite different ends) as the post-war theorizing of Sartre, it is difficult to maintain that this work was directly intended to justify the political practice of Stalinism. No one since Merleau-Ponty has seriously presumed that Sartre's work was in league with Stalinist politics, and it is no more plausible to assert this of Althusser.[7]

Althusser's project was doubly determined, by politics *and* by philosophy. The failure to distinguish between these two related but distinct social practices is just that theoretical sin and political error for which Althusser castigates Sartre most sharply. Althusser's theoretical work in the early and middle sixties was not (contrary to the claims of numerous critics) unilaterally guided or determined by the immediate political context within the French Communist Party and the international Communist movement, important as they were. It was equally influenced by the situation

7. Gregory Elliott's summary assessment is perfectly just: 'Althusser's Leninism may have been neo-Maoist, but Marxist/socialist humanism was in general anti-Leninist. To adhere to its positions, Althusser believed, was to wrench political practice from its orientation towards the class struggle and consecrate in theory the practical abandonment of the revolutionary project. The real danger was political. But its *site* for Althusser was *theoretical:* was Marxism a humanism? In the theoretical conjuncture of Althusser's intervention, most answers to this question were in the affirmative. An apparently Marxological issue, it was far from trivial in its practical implications. It was precisely the political content and effects of this theoretical position within the Communist movement which determined the implacability of Althusser's opposition to it. In combatting it theoretically, Althusser was contributing to a political cause' ('Louis Althusser and the Politics of Theory', pp. 25-6).

in French philosophy. Althusser's programme represented in the first instance an attempt to reformulate the mode of articulation between philosophy and political practice, to carry on the class struggle at the level of theory (as Althusser himself would later express it). This situation and this articulation in their then current form were readily exemplified by the recent philosophical interventions of Sartre within Marxism. For Sartre could be said to stand for Hegelianism, in particular for its phenomenological variant, so powerful in France since the thirties when the reading of Hegel was legitimized there by Kojève and Hyppolite. Althusser's polemic against Sartre, brief and guarded in both *Pour Marx* and *Lire le Capital*, more open and aggressive in the later works of *auto-critique*, may be taken as the crucial instance of the Althusserian project to establish a properly Marxist philosophy in the face of, on the one hand, a tendency towards theoretical pragmatism on the French left, and, on the other, the prevailing influence of phenomenology within French philosophy.[8] This is to say, once again adopting the language Althusser himself helped to introduce into Marxian discourse, that the conjuncture of Althusser's early works was precisely overdetermined. Its causal prius is to be found neither in the history of philosophy (his much publicized debt to Spinoza) nor in the political history of the international Communist movement (his alleged support for the Stalinist policies of the PCF), but in a complex articulation of politics with theory for which simple labels like 'Stalinism', 'economism', and 'idealism' are totally inadequate.

* * * * * * * * * *

Althusser's first substantial engagement with Sartre comes in the appendix to 'Contradiction and Overdetermination' that Althusser added when he collected it in *Pour Marx*. The appendix explicates and criticizes Engels's famous account to Josef Bloch of the concept of 'determination in the last instance by the economy'. Althusser criticizes Engels in great detail, but the fundamental argument involves an interrogation of the latter's use of the category of '*individual wills* interrelated according to the physical

8. Rancière writes: 'Wasn't it [Althusser] who, in the 60s, pulled us out of the phenomenological fogs which dominated philosophy at that time? Didn't he make possible for us an approach to a Marx who was neither the guarantor of the rightness of the Soviet State nor the partner of theologians or philosophical dilettantes?' (*La Leçon d'Althusser*, p. 10). See also Michael Kelly, *Modern French Marxism* (Baltimore, 1982), pp. 118-44.

model of the parallelogram of forces' (FM,124). As Althusser suggests, this is the founding concept of *'classical bourgeois ideology and bourgeois political economy'* (FM,124). Engels's project thus reverts to pre-Marxist principles of explanation to comprehend the mechanism of historical process. This problematic is also Sartre's; it is the traditional problematic of philosophy when philosophy is conceived as the foundation for and guarantor of knowledge:

> ... Engels is merely a *philosopher*. His use of a reference 'model' is philosophical. [But also, and above all, philosophical in its *foundational project*.][9] I insist on this point deliberately, for there is a more recent example of the same kind, that of Sartre, who also tries to find a *philosophical* basis for the epistemological concepts of historical materialism (he has one advantage over Engels in this respect, he *knows* it and *says so*). It is enough to refer to certain pages from the *Critique de la raison dialectique* (for example, pp. 68-9) to see that if Sartre rejects Engels's answer and his arguments, he basically approves of the *attempt itself*. All that separates them is a quarrel over the means employed, but on this point they are united in the same *philosophical* task. It is only possible to bar Sartre from his path by closing the one Engels opened for him. (FM,127; emphasis in the original)

The 'task' that binds Engels to Sartre is the attempt to specify philosophical, as opposed to scientific, principles for the intelligibility of history. Althusser sees this as the foundation of Sartre's *Critique,* and Sartre himself testifies to the fact often. Nowhere more explicitly than in the *Critique* itself: 'But our real aim is theoretical. It can be formulated in the following terms: on what conditions is the knowledge *of a History* possible? To what extent can the connections brought to light be *necessary*?'[10] (emphasis in the original). Sartre's project is, Althusser argues, a Kantian one, for it proposes to demonstrate the apodicticity of the knowledge of history. The *Critique* offers a philosophical grounding for historical science, a prolegomenon to any future

9. This sentence, which appears in the French text of *Pour Marx* (p. 127), has been omitted in the English translation.

10. Jean-Paul Sartre, *Critique of Dialectical Reason,* ed. Jonathan Rée, trans. Alan Sheridan-Smith (London, 1976), p. 40; hereafter cited parenthetically as *CDR-E.* Other Sartre texts cited frequently will be identified by the following abbreviations: *CDR-F-Critique de la raison dialectique,* t. 1 (Paris, 1960); *SM-Search for a Method,* trans. Hazel Barnes (New York, 1963), the prefatory work which forms the first part of the *Critique; JSR-'Jean-Paul Sartre Répond', L'Arc* 30 (1966); *IT-'*Itinerary of a Thought', *New Left Review* 58 (November-December 1969).

philosophy of history.[11] Despite certain reservations concerning
Engels's reduction of human *praxis* to a statistical average (see the
passage referred to by Althusser above [SM,100]), Sartre's project
to comprehend the diversity of *praxes* in history presupposes as its
object of investigation the identical objects posited by Engels to be
agents of historical process: 'The dialectic, if it exists, can only be
the totalisation of concrete totalisations effected by a multiplicity
of totalising individualities' (CDR-E,37).

Sartre's theorization of history originates in Marx's famous
sentence from the *Eighteenth Brumaire*:

> 'Men make their own History ... but under circumstances ... given and
> transmitted from the past.' If this statement is true, then both
> determinism and analytical reason must be categorically rejected as
> the method and law of human history. Dialectical rationality, the
> whole of which is contained in this sentence, must be seen as the
> permanent and dialectical unity of freedom and necessity. (CDR-E,35)

The Althusserian reply is summarized in the slogan, variously
repeated in the later texts, 'History is a process without a subject or
goals.' This would seem initially to correspond to the famous
Sartrean phrase about history being a 'totalization without a
totalizer'. But the originality of Althusser's exposition of historical
materialism lies in his absolute rejection of the notion of historical
totalization: 'just as there is no production in general, there is no
history in general, but only specific structures of historicity ...'
(RC,108).[12] Althusser's characterization of Sartre as 'the
philosopher of mediations *par excellence*' (RC,136) points to
Althusser's definitive break with the Sartrean notion of
totalization. The rejection of mediation theory is the cornerstone
of the Althusserian concept of structural causality, as well as the
key to Althusser's exposition of the specificity of the materialist
dialectic.[13] The Althusser-Sartre debate can be focused, in the first
instance, on the problem of totalization.

11. Sartre himself at one point calls the *Critique* a 'Prolegomenon to Any Future
Anthropology' (CDR-F, 153).
12. See also Althusser's citation from *Capital* illustrating the nature of historical
process in Marx, 'Lenin before Hegel', in *Lenin and Philosophy*, p. 121.
13. We must disagree with Fredric Jameson who suggests that the 'true target of
the Althusserian critique would seem to [b]e not the practice of mediation, but ...
the structural notion of *homology* (or isomorphism, or structural parallelism)' (*The
Political Unconscious*, p. 43). Jameson's exposition of structural causality in this
text (pp. 23-58) fails to differentiate this notion sufficiently from the expressive
causality which is its primary target. The attempted *rapprochement* with both

Sartre's commitment to a totalizing concept of history is announced in the opening pages of the *Critique* when he defines the function of philosophy: 'But if it is to be truly philosophical, [philosophy] must be presented as the totalization of contemporary knowledge. The philosopher effects the unification of everything that is known, following certain guiding schemata which express the attitudes and techniques of the ruling class regarding its own period and the world' (SM,4). The continuing force of a philosophy, on this view, depends upon the political effectivity of the class whose interests it expresses. Philosophy sets the agenda for the various intellectual projects in an epoch, but philosophy itself derives directly from politics and from the ideological requirements of the dominant class.

It would be difficult to distinguish Sartre's argument at this level from familiar forms of vulgar Marxist ideological critique from Plekhanov down to Lukács and Goldmann, what is known these days as 'the dominant ideology thesis'.[14] In the passage cited, Sartre baldly asserts a homology between philosophical concepts and ruling-class ideology. Against critics of this thesis, Sartre could retort that if his view reincarnates vulgar Marxism, it was Marx himself who taught us to think in this way: 'The ideas of the ruling class are in every epoch the ruling ideas ... The ruling ideas are nothing more than the ideal expression of the dominant material relations, the dominant material relations grasped as ideas ...'[15] Sartre proposes that Marx founded his own philosophy on 'the priority of action (work and social *praxis*) over *knowledge*' (SM,14), and that this notion is the basis of Marx's materialism. *Praxis,* then, becomes the key concept for Sartre, the linchpin in

Sartre and Lukács is a decisive mistake, in our view. Gregory Elliott's account of structural causality is more authentically Althusserian ('Louis Althusser and the Politics of Theory', pp. 157-65).

14. See N. Abercrombie, S. Hill, and B. S. Turner, *The Dominant Ideology Thesis* (London, 1980), and idem, 'Determinacy and Indeterminacy in the Theory of Ideology', *New Left Review* 142 (November-December 1983): 55-66. Their claims have been usefully rebutted by Göran Therborn in 'The New Questions of Subjectivity', *New Left Review* 143 (January-February 1984): 97-107.

15. Karl Marx and Friedrich Engels, *Collected Works,* vol. 5 (New York, 1976), p. 59. The citation should not be taken unilaterally as the final word of Marx and Engels on the topic. As György Markus has argued, the concept of ideology in Marx is textually ambiguous, admitting of three different and conflicting formulations: 'Concepts of Ideology in Marx', *Canadian Journal of Political and Social Theory* (Hiver/Printemps 1983): 84-103. This essay confirms the Althusserian claim that Marx's texts require symptomatic reading and reconstruction of the logic of their concepts.

his philosophy of history and the mechanism of mediation between knowledge and being. *Praxis* is the actuality that realizes the possibility of dialectic reason; *praxis* just *is* totalization.[16]

The problem is somewhat more complicated than the summary here indicates. A passage near the end of the first volume of the *Critique* evidences the complexity of Sartre's theory, while proving the ultimate justice of Althusser's criticisms. Philosophical thought at any given moment will express class struggle 'as a *conflict of rationalities*' (CDR-E,802): for example, the dialectical thought of the proletariat in conflict with the positivism of the bourgeoisie. This is also Lenin's position in *Materialism and Empiriocriticism*, picked up and elaborated in the formula of the post-1965 Althusser texts: philosophy is class struggle carried forward at the level of theory. Sartre develops this point in what appears to be an exemplary Althusserian manner: 'But let us be spared the classic imbecility which consists in contrasting science to bourgeois idealism. Since is not dialectic ...' The discrimination of science from dialectic corresponds to Althusser's distinction between Marxist science (historical materialism) and Marxist philosophy (dialectical materialism). But Sartre's sentence goes one step further, and thereby undoes the force of the distinction: 'until the historical emergence of the USSR, [science] was exclusively bourgeois' (p. 802).

The reduction of science to a discursive practice determined by the ideological needs of the ruling class is inadequate on two counts. First, to say that science prior to the historical emergence of the USSR was 'exclusively bourgeois' asserts what on one level is tautologically true: that in bourgeois societies the practice of

16. Cf. the following passages: 'the end of my research will therefore be to establish if the positivist Reason of the natural sciences is the same as we find in the development of anthropology, or if the knowledge and comprehension of man by man implies not only specific methods but a new Reason, that is to say, a new relation between thought and its object. In other words, is there a dialectical Reason?' (CDR-F, 10; my translation); 'The essential [thing] is not what made man, but *what he makes of what made him.* What made man is the structures, the signifying ensembles that the human sciences study. What he makes is history itself, the real surpassing [*dépassement*] of these structures in a calculating *praxis*. Philosophy is situated at the point of articulation. *Praxis* is in its movement a complete totalization, but it only ever adds partial totalizations which will, in their turn, be surpassed [*dépassées*]. The philosopher is the one who attempts to think this surpassing [*dépassement*]. For that, philosophy lays out a method, the only one which gives an account of the ensemble of historical movement in a logical order: Marxism. Marxism is not a congealed system. It is a task, a project to be accomplished' (JSR, 95; my translation).

science (like every other social practice) tends on the whole to serve the interests of the bourgeoisie. In this sense, the practice of science is no different from any of the other instruments of bourgeois domination, and there is no reason on this account to discriminate between scientific practice under capitalism and religious practice under feudalism. But this leads to the second point about Sartre's conception of science. The conception is unilateral, that is, it takes 'science' to be a methodologically unified discourse, the products of which generate conceptual agreement without reference to political and ideological determinations: 'in spite of the unfortunate theory of proletarian science, [science] remained the one area of agreement between Soviet and bourgeois scientists' (p. 802). Not only does this view of science contradict the apparent reduction of science to an effect of ideology, it also conflates the historical development of the sciences with the emergence in history of the dialectic: 'The contradiction is between the bourgeois determination to stick at scientific positivism, and the progressive effort of the proletariat, of its theorists, and of socialist countries, to dissolve positivism in the dialectical movement of human praxis' (p. 802). This is, quite literally, to invert Hegel; the dialectic here is the class consciousness of the proletariat realized through its political practice in class struggle with the bourgeoisie: 'So class struggle as a practice necessarily leads to dialectical interpretation; ... class struggle is necessarily produced on the basis of historically determined conditions, as the developing realisation of dialectical rationality. Our History is intelligible to us because it is dialectical and it is dialectical because the class struggle produces us as transcending the inertia of the collective towards dialectical combat-groups' (p. 805). Sartre's conception of science and philosophy incarnates the historicism of his entire project. On this level Sartre is at one with Lukács, thus confirming the perspicacity of Althusser's tarring them with the same brush in *Reading Capital*.

Consider further Sartre's comments to the *New Left Review* in 1969. The interviewers posed the following question: 'How can individual acts result in ordered structures, and not a tangled labyrinth — unless you believe in a sort of pre-established harmony between them?' Sartre replied thus:

You are forgetting the level of power and therefore of generality ... In the second volume [of the *Critique*], I was going to take the elementary example of a battle, which remains intelligible after the confusion of the two armies engaged in combat in it. From there I planned to

develop a study of the objects constituted by entire collectivities with their own interests. In particular, I want to analyze the example of Stalin to see how the objects which constituted Stalinist institutions were created through the ensemble of relationships between groups and within groups in Soviet society, and through the relationship of all these to Stalin and of Stalin to them. Finally, I was going to end by studying the unity of objects in a society completely rent asunder by class struggle, and considering several classes and their actions to show how these objects were completely deviated and always represented a detotalization while at the same time preserving a determinate intelligibility. Once one has reached this, one has reached history ... There is an institutional order which is necessarily — unless we are to believe in God the father or an organicist mythology — the product of masses of men constituting a social unity and which at the same time is radically distinct from all of them, becoming an implacable demand and an ambiguous means of communication and non-communication between them. Aesop once said that language is both. The same is true of institutions. (IT,60)

Sartre's answer plainly does not meet the objection raised by the question, but rather presumes that the order of intelligibility is manifest and that one need only examine the phenomena (a battle, Stalinism, a 'society completely rent asunder by class struggle') to produce the principles of order unifying them. Of the examples adduced, Stalinism leaps out immediately, since on Sartre's own testimony this historical event's legacy within Marxism motivated the writing of the *Critique*. Sartre's concept here of the Stalinist state reveals the weakness of his solution for producing appropriate concepts to describe the mechanisms of history. He locates the principles of intelligibility, the ordered structures, in the figure of Stalin himself. Perry Anderson's account of the conclusion reached in the second volume of the *Critique* supports this reading: '[in Sartre's account] Soviet society was held together by the dictatorial force wielded by Stalin, a monocentric sovereignty imposing a repressive unification of all the conflicting praxes within it. Hence the logic of the *Critique*'s terminus in the figure of the despot himself. The effective upshot is thus paradoxically a totalization *with* a totalizer — undermining that very complexity of the historical process which it was Sartre's express purpose to establish ... Sartre's centre of integration was the command of a coercive State.'[17] A similar methodological

17. Anderson, *Arguments*, p. 53. Anderson's interpretation is based primarily upon the manuscript of the second volume of the *Critique* (recently published by Gallimard). For a more circumstantial account of this text, see Aronson, *Jean-Paul*

strategy sustains the progressive-regressive method in the Flaubert project. As Althusser remarks, the study of Flaubert, for all its sophistication, remains 'pre-Marxist and pre-Freudian ... from the philosophical point of view' (ESC,60).

Anderson's line of argument opens up an area of investigation that illuminates the otherwise curious final remarks in the passage from 'Itinerary of a Thought' quoted previously. Sartre ends his account of the nature of historical order with a reference to communication and language, suggesting that institutions, like language, are simultaneously means of communication and non-communication. Anderson's point about the despot being Sartre's illegitimate means for squaring the circle of historical intelligibility underlines the fact that Sartre's conception of history requires the unifying principle of the subject, for that is what the despot is. Like linguistic utterances, political or historical actions on a Sartrean view are intentional structures. Intentions may of course fail to be realized, they may misfire — Sartre hardly differs in this way from Austin and Searle — but intentionality nonetheless governs the production of history and of language. The point is confirmed in the *Critique* itself, when Sartre identifies Man as a 'signifying being, since one can never understand the slightest of his gestures without going beyond [*dépasser*] the pure present and explaining it by the future ... What we call freedom is the irreducibility of the cultural order to the natural order' (SM,152). Sartre's concept of the subject depends crucially on a theory of language.[18]

* * * * * * * * *

Sartre, pp. 272-86; and idem, 'Sartre's Turning Point: The Abandoned *Critique de la raison dialectique,* volume two', in *The Philosophy of Jean-Paul Sartre,* ed. Paul Arthur Schilpp (Carbondale, 1981), pp. 685-707.

Anderson's argument is supported by Sartre's preliminary analysis of Stalinism in *Le fantôme de Staline:* 'Thus the cult of personality is above everything the cult of social unity in one person. And Stalin's function was not to represent the indissolubility of the group, but *to be* that very indissolubility, and to forge it as a whole' (*The Spectre of Stalin*, trans. Irene Clephane [London, 1969], p. 57). In the second volume of the *Critique,* however, the problem is complicated by Sartre's understanding of Soviet planning and the relationship of the state apparatus to the historical conditions of post-revolutionary Soviet society. It is less clear by the end of the manuscript whether the despot or some overarching ontological conceptualization of *praxis* has determined the arc of Sartre's analysis of Stalinism. Detailed study of the second volume in comparison with, say, Charles Bettelheim's work on the same period would clarify the differences between Sartrean and Althusserian theorizations of Stalinism as a historical phenomenon.

18. The coincidence with Kenneth Burke's definition of man as 'the symbol-using animal' is striking. Note also Fredric Jameson's claim that the triadic

The famous passages on language in *Search for a Method* (SM,113, 172) are sufficiently familiar not to require full quotation. What has seldom been noticed, however, is their continuation of the problematic of *L'Être et le néant*, that is, their postulation of an intentional structure here located in the subject's use of language: 'The signifying movement — inasmuch as language is at once an immediate attitude of each person in relation to all and a human product — is itself a project' (SM,172).[19] In the *L'Arc* interview, Sartre links this theory of signification to the *praxis* of the subject: 'There is [the] subject, or subjectivity if you prefer, from the very instant when there is effort to surpass [*dépasser*] the given situation while conserving it. The true problem is that of this surpassing [*dépassement*]. It is knowing how the subject or subjectivity is constituted, on a base which is prior to it, by a perpetual process of interiorization and reexteriorization. One cannot say, therefore, that language, for example, is what *is spoken* in the subject. For the linguist himself defines language as totality by his acts. There must be a linguistic subject in order to go beyond [*dépasser*] the structures of language towards a totality which will be the discourse of the linguist' (JSR,93; my translation).[20] The familiar inside/outside distinction, the subject-object problematic, the attribution of intentionality to the speaker — all the constitutive

structure of human relations outlined in the *Critique*, the recognition that 'We never are all alone with each other; every confrontation always takes place against the background of swarms of other human relationships', is most often realized in the relationship of the subject to language, which 'is itself this third party'. Jameson then continues by opposing the Sartrean model of language and signification to that of structuralism: 'It is in this sense that Sartre's triadic model is an implicit challenge to structuralism, whose binary oppositions fail to take into account precisely the movement of the exchange itself as a third element, as a mediation' (*Marxism and Form*, pp. 242-3). But of course the 'problem of mediations' is just the issue, whether the system in question is the exchange of gifts in primitive societies or the possibility of communication in language. On this point, there is no substantive difference between the classical forms of structuralism and Sartrean mediation theory — a fact that should be kept in mind when one considers Sartre's attribution to Althusser of the label 'structuralist'. Althusser's structural Marxism, however much it may have 'flirted' with terminology from linguistics and anthropology, explicitly and rigorously rejects the model of a homeostatic system of exchange characteristic of classical structuralism.

19. Perry Anderson notes the continuity at the level of concepts between *L'Être et le néant* and the *Critique (Considerations*, p. 57), but does not pose it in terms of the theory of language.

20. The concept of *praxis* as an intentional structure organizing the data of experience into a phenomenal object of comprehension is repeated in numerous passages in the first volume of the *Critique* that posit an immediate accessibility of knowledge to the subject; see CDR-E, 391, 696, 706-7, 735.

features of the discourse of linguistics adduced here by Sartre simply transpose the phenomenological description of the subject into the field of language. Language is a form of *praxis; praxis* is per definition *dépassement; dépassement* is that which characterizes Man in his existence as a cultural, as opposed to a purely natural being. Althusser has made this point most trenchantly: 'nor are we surprised to see Sartre make the same *necessary reduction* [as Gramsci] of the different practices (the different levels distinguished by Marx) to a single practice: for him ... it is not the concept of experimental practice, but the concept of "praxis" as such, which is responsible for the unity of practices as different as scientific practice and economic or political practice, at the price of innumerable mediations (Sartre is the philosopher of mediations *par excellence*: their function is precisely to ensure unity in the negation of differences)' (RC,136; emphasis in the original).

Sartre's riposte, that 'Althusser maintains that man makes history without knowing it. It is not history which requires him, but the structural ensemble in which he is situated which conditions him' (JSR,93), is superficially correct: for Althusser, the subject *is* an effect of structures. Hence the Althusserian thesis on the constitution of subjects, 'Ideology interpellates individuals as subjects' (ISA,170), which is elaborated as follows:

> Ideology 'acts' or 'functions' in such a way that it 'recruits' subjects among the individuals (it recruits them all) or 'transforms' the individuals into subjects (it transforms them all) by that very precise operation which I have called *interpellation* or hailing, and which can be imagined along the lines of the most commonplace everyday police (or other) hailing: 'Hey, you there!'
>
> Assuming that the theoretical scene I have imagined takes place in the street, the hailed individual will turn round. By this mere one-hundred-and-eighty-degree physical conversion, he becomes a *subject*. Why? Because he has recognized that the hail was 'really' addressed to him, and that 'it was *really him* who was hailed' (and not someone else). (ISA,174; P,113-14; emphasis in the original)

A Sartrean objection to this account of subject formation would argue that it conceives of human beings as inert, more or less passive effects of structures. Pressed a bit, one might extend this reasoning to the conclusion reached by E. P. Thompson: that Althusserianism is merely a new version of economism. This is the charge Paul Hirst has levelled against Althusser's theory of ideology: '... Althusser's position in the ISAs represents a failure to

break with economism and class essentialism.'[21] Hirst's claim (and by extension Sartre's and Thompson's) depends upon his interpreting the Althusserian concept of structure as strictly functionalist. This is to say that the ISAs are simply and only a means of securing the reproduction of the relations of production. The argument proceeds as follows: 1) the unity of the structure (mode of production) is secured by the reproduction of the relations of production; 2) reproduction is the province of the state, which is divided into the repressive apparatus and the ideological apparatuses under the domination of the ruling class; 3) the unity of the ideological apparatuses is guaranteed in their domination by the ruling class (which is itself unified by virtue of its position in the relations of production); 4) ideology is therefore merely an expression of the basic relations of domination in the infrastructure.

An example here may clarify the point. The recent offensive in Britain and the US against the educational apparatus could be accounted for on a Marxist/functionalist view as one means by which the bourgeoisie attempts to maintain its hegemony over the working class: first of all by limiting access for working-class students to education (particularly post-secondary education); secondly, by ensuring that the education students receive is primarily technical and dominated by ideological notions consonant with bourgeois political and social theory (preeminently the sharp demarcation of politics from the arts). Hirst's point is that in the Althusserian theory of ideology there is no alternative to this scenario in which the bourgeoisie simply reproduces its hegemony in education uncontested because its hegemony over the state as a whole gives it a monopoly over all the ideological apparatuses, and also because ruling-class ideology is unified in its intention and in its functioning. In Hirst's exposition of Althusser, the ruling class not only holds all the cards, its members never disagree about how to play them.

This ought to be a rather surprising conclusion, since Althusser himself certainly intended his essay on ideology to contribute to the Marxist theory of the state and thus to aid in Marxist political

21. Paul Q. Hirst, *On Law and Ideology* (Atlantic Highlands, 1977), p. 42. This reading of the ISAs has assumed the status of dogma among Althusser's commentators, even sympathetic ones: see Benton, *The Rise and Fall of Structural Marxism*, pp. 104-7; Göran Therborn, *The Ideology of Power and the Power of Ideology* (1980), pp. 8-9; Erik Olin Wright, 'Giddens's Critique of Marxism', *New Left Review* 138 (March-April 1983): 14; Callinicos, *Is There a Future for Marxism?*, p. 75; Elliott, 'Louis Althusser and the Politics of Theory', p. 260.

practice's avowed goal: the overthrow of the bourgeois state apparatus. But perhaps Hirst's reading is not entirely unexpected, since this has been just the charge put forward by a number of Althusser's critics (notably Callinicos in *Althusser's Marxism*): that Althusserianism cannot sustain any genuine political initiatives, that in its very essence it is non- or even anti-revolutionary. The charge depends, however, on a highly tendentious reading scarcely entailed by the ideology essay itself. Hirst and others cite those statements from the postscript Althusser appended one year after writing the first version which emphasize the reproduction of the relations of production as a 'class undertaking' (ISA, 184), without giving sufficient weight to the final sentence of the postscript: 'For if it is true that the ISAs represent the *form* in which the ideology of the ruling class must *necessarily* be realized, and the form in which the ideology of the ruled class must *necessarily* be measured and confronted, ideologies are not "born" in the ISAs but from the social classes at grips in the class struggle: from their conditions of existence, their practices, their experience of the struggle, etc.' (ISA,186; emphasis in the original). The ISAs are not the 'expression' of ruling-class domination (thus they are not unified by ruling-class ideology — even if such a thing existed), but are, rather, the *site* and the *means* of that domination. It follows that ISAs are not simply *at stake* in the class struggle, they are constantly traversed by, and are therefore *constituted in,* class struggle. This is why, as the late Michel Pêcheux argued, the ISAs both *reproduce* and *transform* the relations of production, and why Hirst's charge about the class essentialism of the ISAs is not entailed by the theory.[22]

Consider again the example of the assault on the educational apparatus in Britain and the US. On an Althusserian view, the funding cuts, the ideological offensive against left-wing and progressive curricula and teachers, and the increasingly narrow technicization of the curriculum can be seen in part as symptoms of crisis within ruling-class ideological solidarity and in the

22. Michel Pêcheux, *Language, Semantics and Ideology: Stating the Obvious*, trans. Harbans Nagpal (London, 1982), pp. 92-129. Erik Olin Wright puts the issue sharply: 'To say that the capitalist state is necessary for the reproduction of capitalist economic relations is not to say that the capitalist state always functions in a perfectly optimal way for the reproduction of those economic relations. It is quite possible for the effects of the state to be far less than optimal, and even under certain circumstances, for it to become non-reproductive. Reproduction/non-reproduction must therefore be understood as a variable relation of determination, not an absolute one' (*Class, Crisis, and the State* [London, 1978], p. 19).

hegemony of the ruling class as a whole. The analysis would proceed as follows. The sixties were a period when the state momentarily lost its absolute grip over the universities, and indeed over large segments of the masses who refused to accept the necessity for the imperialist war in Indochina. The effects of this momentary weakening of bourgeois hegemony went far beyond the immediate goals of the anti-war movement, and beyond the walls of the universities where it was focused: the movement for deschooling, for broadening the educational franchise, for changing the curriculum and textbooks to promote non-racist, non-sexist ideologies — all these developments of the sixties and seventies can be seen as fall-out from the explosion on campuses during the sixties (and of course in the ghettoes of the inner cities as well). When the troops had to be brought in to restore order at Kent State and elsewhere, it became manifest that the students had exposed the face behind the mask of bourgeois ideology: the schools really were (and are) part of the state, education was (and is) political in every sense of the word. The present strategy for reasserting control over the educational apparatus attempts to recover the pre-sixties ideological structure in which schools were said to be 'above' or 'outside of' politics.

But the situation contains a contradiction, for the only means to reinstate the ideology of separation between politics and education is the state apparatus itself. Not the overtly violent apparatus of police and militia, to be sure, but boards of education, local authorities, and even the national government. One example of the latter's intervention was Sir Keith Joseph's crusade against the sociology department at North London Polytechnic, which was compelled to defend itself against charges brought by a former member of staff that its curriculum was politically biased (in favor of Marxism, it should be noted). Sir Keith was empowered to institute an extraordinary investigation — the department had recently been examined and certified under the ordinary review procedures of the CNAA — precisely because the department was alleged to have overstepped its charter and engaged in a form of political practice. Only through the overtly repressive political action of the state could the educational apparatus be saved from politics. In the US, the Reagan administration's efforts to reinstitute voluntary school prayer instance a similar contradiction, as do the various initiatives of William Bennett at the National Endowment for the Humanities and more recently at the Department of Education. The political motivation of the former campaign is patent: it appeals to the

sympathies of religious fundamentalists who make up an important segment of the Reaganite electoral bloc. Nevertheless, the right to pray in school is being defended as a *civil* liberty, guaranteed under constitutional protections of religious freedom — just the argument that was used to eliminate prayer in schools during the sixties.

It could of course be argued that in none of these cases is class struggle directly implicated in the formation of the particular ideological practice at stake: the protection of freedom of religious expression on the one hand, the separation of politics from education on the other. But in fact, class practices are not so far removed as one might at first think. The attainment of universal civil liberties, 'inalienable rights' in the language of the Declaration of Independence, which forms so basic a component of the political and social consciousness of citizens in the western democracies, was historically an achievement of the bourgeois revolutions. In that sense, one can justly claim that what is being asserted here is part and parcel of bourgeois ideology, even if it is not primarily bourgeois class interests which are directly being protected. (The bourgeoisie can, in any event, send their children to private schools and are literally 'free to choose' whether their scions be allowed to pray in school and to study Marxism or not.) The contradiction that has inhabited the ideological and political practices of the bourgeoisie from the beginning, as Marx and Engels saw clearly, lies in their claim to universality. The bourgeoisie as a class must appear to represent everyone. The rights for which the bourgeoisie historically fought are not merely their rights, but the natural rights of all citizens. But the one right which they can never allow to be exercised for long is the right to question the legitimacy of their power to rule. The teaching of Marxism, when it poses a threat (however indirect) to the hegemony of the bourgeoisie, must therefore be suppressed, even if the exercise of state power effectively suppresses freedom of inquiry. It is unlikely that Sir Keith Joseph would have been equally zealous in investigating a department that had tilted its curriculum in favor of Ricardo and Adam Smith. Nor is it insignificant that this investigation was directed at a polytechnic, rather than at one of the older universities.[23] The polytechnics

23. An instructive comparison can be drawn between the persecution of North London Polytechnic and the McCabe affair in Cambridge some three years previously. The university's refusal to admit Colin McCabe to the English faculty, while it attracted more publicity (making the pages of *Newsweek*, for instance),

have become sites of working-class militancy in Britain, and polytechnic lecturers make up a significant fraction of support for the left wing of the Labour Party. Sociology in particular, until recently a moribund discipline in Britain,[24] has emerged as a place for contesting the hegemony of the ruling class.

The case illustrates the Althusserian claim that ideology is a site of and is produced in class struggle. The apparatus of the state is plainly attempting to secure the legitimacy of class rule by dictating the structure of the curriculum, while working-class students and their teachers strive to retain control over their own education. Both sides can legitimately appeal to the liberal ideal of academic freedom, although the meaning of this ideal for each is quite different. For the bourgeoisie and its functionaries, it signifies freedom from the menace of hostile political ideologies, while for the working class and its allies it signifies the freedom to question the extent to which they are actually free in a class-divided society.

So much for the charge of functionalism and economism. Hirst, however, also accuses Althusser of a second theoretical sin, one which, if Althusserian theory were directly guilty of it, would put the theory of ideology squarely within the Sartrean problematic. Hirst contends that Althusser stands convicted of residual Cartesianism, that the notion of interpellation on which the theory of ideology rests recovers the traditional conception of the subject as a unitary consciousness by postulating a decisive moment of 'recognition': 'something which is not a subject must already have the faculties necessary to support the *recognition* which will constitute it as a subject. It must have a *cognitive* capacity as a

never involved the direct intervention of the organs of the state apparatus. The university was left to clean its own house — and of course did so with considerable dispatch. McCabe's work, associated with *Screen*, was quite as Marxist as anything the North London sociologists might possibly teach, but no one ever suggested that the English faculty at Cambridge was in danger of becoming a venue for agitprop, and this despite the presence of Raymond Williams as Professor of Drama. Cambridge, after all, remains Cambridge, a bastion of ruling-class privilege and ideology both among its faculty and its students. This university poses no threat to the hegemony of bourgeois ideology over education. The consensus at the 'ancient universities' seems to be that the sons and daughters of the ruling class can be exposed to Marxism without fear of their being transformed *en masse* into class traitors. Marxism for the working class is another matter.

24. See Perry Anderson, 'Components of the National Culture', *New Left Review* 50 (July-August 1968): 7-9. The recent emergence of Marxist sociology, particularly in the polytechnics, and the formation of a left stratum among polytechnic lecturers are chronicled in Michael Rustin, *For a Pluralist Socialism* (London, 1985), chapters 1 and 2.

prior condition of its place in the process of recognition.'[25] The claim is not without warrant, although ultimately it reflects a unilateral reading of Althusser. Nonetheless, Hirst's contention is useful in helping to focus the difference between Althusserian and Sartrean conceptions of the subject.

Sartre grounds his theory of history in *praxis*, the human capacity for *dépassement* which is evident, for example, in language. What Hirst calls a 'cognitive capacity' is just what Sartre posits as the necessary condition for the intelligibility of history. This is made explicit in the analysis of 'comprehension' in the second volume of the *Critique*. *Praxis* is a capacity prior to any particular determinations or circumstances. Hirst construes Althusserian 'recognition' in just this way: it is a faculty of consciousness, prior to all instances of ideological interpellation, which enables the individual to become a subject. But Hirst's reading encounters a problem: to wit, Althusser's seemingly paradoxical proposition that '*individuals are always-already subjects*' (ISA,176; emphasis in the original). From the womb? Well, yes in fact, as Althusser goes on to explain (ISA,176-7). The discourses in which subjects 'recognize' themselves operate on the individual prior to its birth. The classic instance is the family, with its nurturant practices, sex-gender system, *et cetera*. But how does the child come to know or experience these discourses as its own? How does the child 'recognize' itself in the interpellations of family ideology? Hirst claims that Althusser answers this question by positing the existence of an innate mental faculty historically prior to the subject's being interpellated. But on the evidence, no such mental faculty need be assumed, since recognition/ interpellation is coextensive with the formation of the subject, and therefore with the biological existence of the individual: individuals are always-already subjects.

Rather than construing the phenomenon recognition/ interpellation as an innate mental faculty, one should think of it as a 'causal power', a term we borrow from the philosophy of science.[26] Causal power designates an entity that just *is* what it *can do* — like gravity or electro-magnetism. Causal powers are therefore not things in the ordinary sense of the term (that is,

25. Hirst, *On Law and Ideology*, p. 6; Hirst's emphasis.
26. R. Harré and E.H. Madden, *Causal Powers: A Theory of Natural Necessity* (Oxford, 1975); and Roy Bhaskar, *A Realist Theory of Science* (Sussex, 1978), pp. 179-85. Strictly speaking, recognition/interpellation falls somewhere along the continuum between liabilities and powers which Harré and Madden argue characterizes the natures of things (p. 89).

substances with qualities — as Hirst's 'cognitive capacity' would be — roughly, Ryle's 'ghost in the machine'), but structures: they are knowable only in their effects. Recognition/interpellation on this view is an observable potential of a structure whose nature remains unknown in the present state of research in neuro-physiology and cognitive psychology. This is what Althusser has in mind when, both in the ISAs and in his article on Freud and Lacan, he compares the mechanism of ideology to the unconscious. One can legitimately rewrite Lacan's famous slogan, 'the unconscious is structured like a language', in historical materialist terms as 'the subject is structured like a mode of production.' And one can therefore accept Hirst's characterization of an adequate concept of the subject, but with the proviso that this concept is just the one enabled by Althusser's theorization in the ISAs of a subject posterior to discourse: 'It is possible, however, to conceive the human individual not as the unitary terminal of an "imaginary" subject, but as the support of a decentred complex of practices and statuses which have distinct conditions of existence.'[27] The subject in Althusserian theory is historical and material in much the same way as the unconscious is for psychoanalysis. The Althusserian subject which recognizes itself in the interpellation of discourse is not the centred subject of bourgeois ethics and epistemology (much less aesthetics), but is precisely decentred to the degree that it is the bearer of different, often contradictory structures.[28]

* * * * * * * * *

27. Hirst, *On Law and Ideology*, p. 60.

28. The point is argued persuasively in Warren Montag's essay, 'Marxism and Psychoanalysis: The Impossible Encounter', *minnesota review* N.S. 23 (Fall 1984). Robert Wess, in an otherwise judicious exposition of the concept of ideology in Althusser, too quickly accepts Hirst's characterization of Althusser on recognition/interpellation, asserting that 'in the "recognition" mechanism by which Althusser constitutes the subject there are subjective attributes, silently presupposed, that preexist the social formation and are the enabling condition of the "recognition" that signals the entry into it' ('Notes toward a Marxist Rhetoric', *Bucknell Review* 28, 2 [1983]: 144). Wess goes on to assert the superiority of Hirst's 'problematic of signification' over the Althusserian mechanism of recognition, characterizing the former in the following way: 'Within the problematic of signification ... the subject is constituted in the field of signifying practices involved in the multiple alignments and divisions characteristic of any complex social formation. Entry into the field and self-definition within it presuppose nothing more than the irrefutable fact that human beings master symbol systems' (p. 144). As is suggested above, Althusser's insistence that 'individuals are always-already subjects' effectively makes the very point Wess and Hirst assert against him: that

Alhusser's decisive break with a psychological or phenomenological theory of the subject has consequences beyond the theory of ideology. In particular, his rejection of the unity of the subject is fundamental to his critique of historicism.[29] Consider the end of the original version of 'Contradiction and Overdetermination', where Althusser takes up the topic of 'survivals' in Marxist political practice:

> The term *'survival'* is constantly invoked, but it is still virtually uninvestigated, not in *its name* (it has one!) but *in its concept*. The concept it deserves (and has fairly won) must be more than a vague Hegelianism such as 'supersession' [*dépassement*] — the *maintenance-of-what-has-been-negated-in-its-very-negation* (that is, the negation of the negation). If we return to Hegel for a second we see that the survival of the past as the *'superseded'* [*dépassé*] (*aufgehoben*) is simply reduced to the modality of a *memory*, which, furthermore, is merely the inverse of (that is, the same thing as) an *anticipation*. (FM,114-15; emphasis in the original)[30]

the subject is posterior to discourse and to the social formation that produces it. Recognition need entail 'nothing more than the irrefutable fact that human beings master symbol systems.' Thus, when Wess goes on to cite the advantages of the 'problematic of signification' in 'enabl[ing] one to conceptualize clearly ... that even when a signifying practice has an identifiable class origin, it does not always and forever necessarily serve that class' (p. 144), he makes the identical point illustrated previously in the example of Sir Keith Joseph's vendetta against North London Polytechnic. Freedom of inquiry is a historical achievement of the bourgeoisie, but it can be used to serve the interests of the working class.

29. The point is made often by Althusser. It motivates, for example, his polemical 'Reply to John Lewis', which ends, not surprisingly, with a critique of Sartre's reading of the *Eighteenth Brumaire*. Arguing against what he calls Sartre's 'vulgar philosophical psycho-sociology', Althusser rejects the view that Marx's 'Men make their own history' authorizes the postulation of a historical subject. In addition, he ridicules the concept of the practico-inert (see also RC,172-3) as the repository of subjectivity by citing Marx's 1869 Preface to the *Eighteenth Brumaire*: ' "I show something quite different [from Hugo and Proudhon — and, in Althusser's view, also from Sartre] ..., namely how the *class struggle* (Marx's emphasis) in France created the circumstances (*Umstände*) and the relations (*Verhältnisse*) which allowed (*ermöglich*) a person (a subject) so mediocre and grotesque to play the role of a hero" ' (emphasis in the original). The consequence of this theorization of history as a product of class struggle (which does, after all, possess some famous textual warrant) is the proposition on which Althusser bases his claim that Marx inaugurated the science of history: 'History really is a "process without a Subject or Goal(s)", where the given *circumstances* in which "men" act as subjects under the determination of social *relations* are the products of the *class struggle*. History therefore does not have a Subject, in the philosophical sense of the term, but a *motor*: that very class struggle' ('Reply to John Lewis', in ESC, 99; emphasis in the original).

30. Apropos of memory, one should consider Sartre's analysis of the class

And further, Althusser makes perfectly plain the political stakes in this theoretical quarrel:

> It seems to me, for example, not to elude the most burning [issue], that when one poses the question of understanding how the Russian people, so generous and proud, could have supported on such a vast scale the crimes of Stalinian repression; of seeing how the Bolshevik party could tolerate them; never mind about the last question: how a communist leader could have ordered them? — it is necessary to give up the entire logic of 'supersession' [*dépassement*], or else give up saying anything at all about these things. (PM,116; my translation)

Not only is the Sartrean definition of *praxis* as *dépassement* ridiculed, but the very project Sartre himself envisioned as the centrepiece of the historical investigations in the second volume of the *Critique*, the history of Stalinism, is undermined and stigmatized as mere 'vague Hegelianism', devoid of any explanatory power within historical materialism. Sartre's project is historicist and, like many other historicist homogenizations of the object of history, utopian in its motivation. Although Althusser does not cite it, he must surely have had in mind the passage from *Search for a Method* in which Sartre's 'anticipation' of the historical future posits a specific teleology for history and enlists theoretical and practical activity in its creation:

> Thus the plurality of meanings [or directions — *des sens*] of History can only be discovered and posed for itself on the basis of a future totalization, functioning with it and in contradiction to it. It is our theoretical and practical duty to bring this totalization closer each day. Everything is still obscure, and, nevertheless, everything is in full light. We have the instruments for grasping the theoretical aspect; we can establish the method. Our historical task, at the heart of this polyvalent world, is to bring nearer the moment when History will have only *a single meaning* [or direction — *un seul sens*] and when it will tend to dissolve itself into the concrete men who make it in common. (CDR-F,63; my translation; Sartre's emphasis)

Nor is the totalization of history through *dépassement* without consequences in other domains — in literature, for instance. Sartre

struggle between bourgeoisie and proletariat in 19th-century France (CDR-E, 754-70). The key concept here, as in the *Critique* as a whole, is the practico-inert. Althusser's criticism of this concept (which, as the negatively determining counter-concept to *praxis*, is fundamental to Sartre's philosophical anthropology) is well-known; see previous note.

himself asserted that 'literature only lives through this *dépassement*' (JSR,96), and in a note near the end of the Introduction to the first volume of the *Critique*, the totalizing activity of *praxis* is exemplified in a theory of reading:

> It is worth recalling... that the reading of novels and plays is a totalisation (as is the life of the reader). On the basis of the double totalisation effected by History, and as his own individual life, the reader approaches the work as a totality to be re-totalised in its own individuality. The understanding of actions or of dialogues must, if the work is to satisfy the mind, be both the translucidity of the unforeseen ... and, in so far as each moment falls within a past of inertia, the impossibility suffered (by immediate memory) that this moment should not have been what it was. (CDR-E,73; translation modified)

The passage highlights that which was implicit in Sartre's concept of history from the first, a consequence of his grounding the intelligibility of history in *praxis:* Sartre's theory of history is a poetics. History according to Sartre is what men make; poetics, we know since Aristotle, is the science of man-made things. Sartre's poetics, like Aristotle's, focuses on tragedy, for the intelligibility of history appears in the *anagnorisis* of the historical subject who discovers what he could not have foreseen (the turn of events that has produced the present), but which is nonetheless suffered as necessary. To the extent that history is intelligible, it possesses a plot which the actors of the drama suffer and come to know — like Oedipus, they attain a poetic knowledge of their own historical past.

What is at once surprising and yet might well have been anticipated is the coincidence between Sartre's conception of the poetic form that a totalizing *praxis* assumes in the unfolding of history and the instances of historical totalization we have encountered previously in bourgeois aesthetics. Sartre's literary criticism (and indeed his original literary works) has generally, and not without justice, been seen as an affront to the pieties of the bourgeois ideology of art, a conscious attack on the authority and unity of conventional conceptions of literature and aesthetic education. The devaluation of poetry in *What Is Literature?* is, among other things, a calculated blow against the hegemony of Mallarmé, Valéry, and Symbolist poetry over aesthetics and literary criticism in the French tradition. But the task of resisting aesthetic totalization is by no means completely resolved in a straightforward polemical gesture of repudiation. If for Sartre the characteristic form of history is that of a totalization without a

totalizer, it can be said that the entire project of his later years was already figured proleptically in a famous passage from *Les chemins de la liberté* in which the apparent randomness of historical events is recuperated in that hypostatized unity of historical process Sartre will later equate with the order of intelligibility in dialectical reason:

A vast entity, a planet, in a space of a hundred million dimensions; three-dimensional beings could not so much as imagine it. And yet each dimension was an autonomous consciousness. Try to look directly at that planet, it would disintegrate into tiny fragments, and nothing but consciousness would be left. A hundred million free consciousnesses, each aware of walls, the glowing stump of a cigar, familar faces, and each constructing its destiny on its own responsibility. And yet each of those consciousnesses, by imperceptible contacts and insensible changes, realizes its existence as a cell in a gigantic and indivisible coral. War: everyone is free, and yet the die is cast. It is there, it is everywhere, it is the totality of all my thoughts, of all Hitler's words, of all Gomez's acts; but no one is there to add it up. It exists solely for God. But God does not exist. And yet the war exists.[31]

* * * * * * * * *

This, then, is the point at which the Sartrean concept of the subject intersects with the whole range of problems and questions

31. Jean-Paul Sartre, *The Reprieve*, trans. Eric Sutton (New York, 1973), p. 326. The passage is cited by Jameson in *The Political Unconscious* to illustrate the common ground between the Lukácsian notion of totality and its ostensible Althusserian contrary, the concept of history as an 'absent cause' (p. 55). The more properly Althusserian concept of history would originate in the observation cited above: 'just as there is no production in general, there is no history in general, but only specific structures of historicity' (RC,108).

Similar objections apply to Philip Wood's assimilation of Althusserian concepts to the theoretical project of Sartre's *Critique*, in particular to Wood's equation of 'the structure in dominance' with Sartrean 'totalization' ('Sartre, Anglo-American Marxism, and the place of the Subject in History', in *Sartre after Sartre, Yale French Studies* 68 [1985]: 29). Despite Wood's asseveration that 'there is no sense in which Sartrean freedom participates in some extrahistorical *essence* or the "human nature" of a full subject' (p. 39), his equation of freedom with the ceaseless movement of *dépassement* in history and his contention that this movement is the very action which every reader enacts with a text (p. 47) lead one to suspect that the moment of totalization here, as always, slips back into that teleological historicism which Althusser repeatedly claimed Sartre's conception of *praxis* entailed. A certain congruence with Jauss and *Rezeptionsgeschichte* is also noteworthy in this context.

constituting the Althusserian problematic. Sartre's poetics of history can be opposed to Althusser's (and Marx's) science of historical materialism; the Sartrean category of comprehension, the modality of dialectical reason, must be measured against the Althusserian strategy of 'symptomatic reading', indeed against the entire theory of ideology as a non-subjective process of subject formation; the fundamental philosophical category of *praxis* in which Sartre's theory of history is grounded should be judged in light of the Althusserian/Marxist axiom that class struggle is the motor of history. All of these tasks have been inaugurated by Althusser on the level of theory — which, to return to the question with which we began, is not to say that they have taken place in a region entirely external to politics.

The question of Sartre versus Althusser is therefore not properly posed in the stark opposition of political commitment to theoretical rigour. It devolves, rather, onto the relation between strategic political calculation and the theoretical programme which both underwrites any particular political intervention and is in turn subject to modification and correction by the changing exigencies of political events. To counterpose Sartre's manifest political activity to the supposed mandarinism of Althusser's theoretical project is an error of just the sort that Althusser himself originally accused Sartre.[32] The correct mode for conceptualizing the relation of theory to politics is not, on an Althusserian view, to read off from theory the transparent evidence of a determining political practice, nor to translate immediate political commitments into a theory of political action and historical agency; rather, political practice and theoretical practice are two instances of a complex structured whole in which the development of each instance may proceed according to different historical rhythms. There seems to be every evidence that the political initiatives of Althusser and his students ran out of steam during the 1970s, but this did not immediately produce a synchronized retardation of

32. The latter claim constitutes the basic thrust of Rancière's critique in *La leçon d'Althusser*. It has been taken as the last word on the politics of Althusser more than once (see, for example, Jeffrey Mehlman, 'Teaching Reading: The Case of Marx in France', *Diacritics* 6 [Winter 1976]: 16-18). A curious echo of this position is even apparent in Perry Anderson's defence of Althusser against Thompson: 'Strangely, of two unbalanced sets of generalizations, Althusser's inclines better towards history, Thompson's towards politics. The classical equipoise of the founders of historical materialism is some distance from both' (*Arguments*, p. 58). Anderson's underestimation of the political utility of the Althusserian research program is discussed in the following chapter.

the theoretical programme Althusser inaugurated. Theoretical practice can, as Lenin observed, be one step ahead of political practice; the only error is to believe that theory can move forward on its own, that it can be *several* steps in advance of political practice. Althusserian theory stands at the horizon of Marxist theoretical practice, providing the instruments with which Marxist political practice can advance. The task of Marxist ideological labourers is to make these instruments available to the masses, who, as Althusser has continually insisted, finally are the ones who make history.

8

Between Science and Ideology: Historical Determination in the Work of Perry Anderson

The regression from a truly rigorous historical materialism plagues some of the most advanced work in Marxist theory to date. It is most often evidenced in claims to have mastered the structural heterogeneity of historical processes by means of totalizing concepts that control and distribute elements of the historical field along a continuum whose entire trajectory is both intelligible and phenomenally present to the observer. We have conveniently, and with the warrant of philological tradition, called such totalizations aesthetic. Thus far our privileged means of access to this moment in Marxist theory has been through aesthetic forms. It would be incorrect to claim that the disciplinary and vocational commitments of the thinkers considered up to now (Althusser excepted from this grouping) necessarily and irrevocably oriented them towards a poetics of history which they were unable to avoid. Nonetheless, it would not be false to assert that Sartre's and Jameson's (as equally Crane's, Jauss's, and Mukařovský's) philosophies of history came ultimately to be grounded in the formal model provided by aesthetic objects, i.e., with historical forms whose structures seem to manifest an unusual degree of internal coherence and purposiveness. The tendency to homogenize different historical series, to, in Althusser's terms, reduce the variety of social practices to a single overarching concept of human *praxis,* may derive in part from a privileging of certain objects of investigation over others. Marx himself (and Engels, Lenin, and Trotsky no less) is probably least interesting, and certainly least materialist, when discussing art. It is perhaps not surprising that the historical models which have

characteristically emerged from Marxist aesthetics and literary criticism have on the whole leaned in the direction of idealism, rather than towards a more authentically materialist concept of the historicity of artifacts.

When we enter the domain of history and historiography proper, however, one would expect somewhat different results to be achieved. The recent literature on the theory of historical materialism is too vast and complicated for any useful survey or even adequate bibliographic summary here. The debate, as always, concerns the extent to which historical materialism can reasonably claim, as Marx himself believed it was, to be an empirical science. Among the salient features of Perry Anderson's work has been his unstinting commitment to and defence of the claims to scientificity sustained by historical materialism. Moreover, his writings have consistently exhibited the patience and care in exposition of an opponent's argument which have distinguished the best examples of critique in the Marxist tradition. The extent of his intellectual generosity, the degree to which he avoids sectarian prejudice, the scope of his willingness to engage in reasoned debate — all are features of Anderson's work obvious to any reader. Mindful of his example, we undertake here a rather lengthy critique of Anderson's most recent book, *In the Tracks of Historical Materialism.*[1] As an overview and assessment of the current situation in Marxist theory written by a practicing Marxist historian, this text presents an opportune occasion to survey the theoretical terrain which historical materialism has staked out among the empirical sciences.

* * * * * * * * * *

In a review of *Arguments within English Marxism,* Robert Wess remarked the centrality, as well as the ambiguity, of the concept of agency in Perry Anderson's work.[2] The final paragraph of *In the*

1. This chapter was first conceived as a review of *In the Tracks of Historical Materialism* (London, 1983), which text was originally delivered as the Wellek Library lectures at the University of California at Irvine. In attempting to account for the particular emphases and the political and theoretical theses set forth there, it was necessary to come to terms with Anderson's work as a whole. Subsequent references to Anderson's writings, unless otherwise noted, are incorporated in the text and refer to the following editions: *Passages from Antiquity to Feudalism* (London, 1978); *Lineages of the Absolutist State* (London, 1979); *Considerations on Western Marxism* (London, 1976); *Arguments within English Marxism* (London, 1980).

2. Robert Wess, review of *Arguments, minnesota review* N.S. 18 (Spring 1982).

Tracks of Historical Materialism confirms this judgment in a programmatic statement of Marxism's 'Archimedean vantage-point', which Anderson asserts it has 'no reason to abandon': '[historical materialism is] the search for subjective agencies capable of effective strategies for the dislodgement of objective structures' (pp.105-6). Intended as an axiom for Marxist political practice, the science of politics which Anderson argued in a previous study *(Considerations on Western Marxism)* was inaugurated by Lenin, the proposition is immediately qualified in its applicability to the present moment: 'But amidst pervasive changes within world capitalism today, those three terms can only be successfully combined if they have a common end that is at once desirable and believable for millions who are now hesitant or indifferent to them' (p.106). The transition to socialism will require more than rigorous scientific description of the conditions under which the current situation has arisen, followed by calculation of the best means available for overthrowing capitalism. It will also involve persuading masses of men and women not immediately disposed to do so to participate in a revolutionary transformation of existing social structures.

Marxism is, indeed it has always been, both a scientific theory (of the history of social formations) and an ideology (of the revolutionary transformation from capitalism to socialism). *In the Tracks of Historical Materialism* is a masterful defence of the claims of the former against contemporary rivals. If it fails ultimately to produce an adequate concept of the latter, this is perhaps due to a theoretical blind spot in, surprisingly, the book's exposition of Althusser.[3] Aware of Anderson's long-standing respect for the French philosopher and for the work his theoretical interventions have inaugurated (not least Anderson's own books of historical synthesis, *Passages from Antiquity to Feudalism* and

3. The point was made by Shlomo Avineri in his review of *Tracks* in the *New York Times Book Review* (May 27, 1984): 19, albeit not in reference to Althusser. For Avineri, Anderson's failure in *Tracks* is specifically and limitedly political: 'Mr. Anderson's treatise fails to provide [the] key to a future-oriented *praxis.*' Avineri's own political *praxis* is hardly exempt from censure: he was among the intellectuals who aided the Israeli military in preparing troops psychologically for the 1982 invasion of Beirut.

A similar objection to Avineri's, occasioned by Anderson's critical evaluation of his own book *All That Is Solid Melts into Air*, is raised by Marshall Berman apropos of Anderson's pessimistic judgment on the post-war horizon for culture in the industrialized West. See Marshall Berman, 'The Signs in the Street: A Response to Perry Anderson', and Perry Anderson, 'Modernity and Revolution', both in *New Left Review* 144 (March-April 1984).

Lineages of the Absolutist State), and mindful of his spirited defense of Althusser against Edward Thompson, one is initially puzzled by an apparent inability in this latest text to assess the Althusserian achievement justly. This lapse is symptomatic of more fundamental problems in the book's conception and execution, problems that outweigh the question of whether or not Anderson has gotten Althusser right. In order to advance a just overall evaluation of the position presented in *Tracks,* it will be necessary to summarize the general argument of the lectures (including the postscript added after their oral delivery), to consider the relationship of this book to Anderson's previous work, and finally to weigh the validity of his historical judgments on the itinerary of Marxist theory in relation to contemporary politics. In each instance, Anderson's divergence from Althusserian theory will provide the necesary optic for locating the specificity of Anderson's own position.

In the Tracks of Historical Materialism opens with a claim for the distinctiveness of historical materialism as a critical theory: 'it includes, indivisibly and unremittingly, *self*-criticism. That is, Marxism is a theory of history that lays claim, at the same stroke, to provide a history of the theory' (p.11).[4] Anderson then proceeds directly to his own self-criticism: he reviews his judgments and predictions about the course of Western Marxism proposed in *Considerations* and assesses the extent to which they have proven justified by ensuing history. On most counts, he finds that he was correct in his predictions. The characteristic Western Marxist reversal of the classic heritage's emphasis on politics and economics was, as Anderson foresaw it must be, reversed in its turn. Mandel, Aglietta, Braverman and others once again situated Marxism's centre of gravity in politics and economy, rather than in philosophy and aesthetics. The dominance of the Latin nations in Marxist theory came to an end, while original work was increasingly to emanate from previously fallow ground — the United States and Britain. Finally, the long-delayed recognition of historiography's centrality to Marxism burst on the horizon. This was due perhaps in part to the geographical shift just noted, since the strong suit of Marxism in the English-speaking world had for some time been its historians. Their achievements now either reached maturity or were accorded the importance previously denied them in the long twilight of Western Marxist hegemony.

4. The similarity to Fredric Jameson's account of the emergence of Marxist theory is unmistakable; see above, chapter 6.

Allowing for some local disagreements and minor adjustments in comparative value and importance, it would be difficult to fault this retrospective assessment.[5]

But in one major instance, Anderson recognizes that he failed as a seer: 'The reunification of Marxist theory and popular practice in a mass revolutionary movement signally failed to materialize. The *intellectual* consequence of this failure was, logically and fatally, the general dearth of real *strategic* thinking on the Left in the advanced countries — that is, any elaboration of a concrete or plausible perspective for a transition beyond capitalist democracy to a socialist democracy' (p.27). This deficit assumed a highly visible shape in what was called during the late seventies 'the crisis of Marxism', but which Anderson argues was in fact 'the crisis of a certain Marxism, geographically confined to Latin Europe' (p.28). The remainder of the book ranges over this terrain: the conditions for the senescence of Marxism in France and Italy (with a lengthy detour through the work of Habermas), and the potential for creating anew among contemporary Marxists the crucial strategic perspective characteristic of the generation of Lenin, Trostky, and Luxemburg. What have been the particular deflections of Marxist thought during the past decade, and what are the current possibilities it offers?

Anderson commences this analysis by limiting his focus principally to France (a plausible move, given the leading role of Parisian culture during the sixties and early seventies in propelling the trajectories of Western intellectuals), and by initially offering an internalist account of the changing problematic in French Marxist theory. His hypothesis is straightforward: the ascendancy

5. Anderson's optimism about the recent growth in American Marxism arguably overstates the case. Anderson himself has previously noticed how the site of Marxist theorizing in the West shifted after 1923 from the streets to the university (*Considerations*, pp. 40-50), and this is not less true of the United States today where, as Edward Said and others have lamented, Marxism has largely been confined to an academic specialization. Moreover, in commenting critically on the 'dilution or diminution of [Marxism], pervaded by an increasing scepticism towards the very idea of a revolutionary rupture with capitalism' (*Tracks*, p. 29) in Latin Europe, Anderson ignores the extent to which the same phenomenon has come to dominate the majority of left thinking and writing in the United States as well. The constellation of socialist intellectuals concentrated in the orbit of *Dissent, Socialist Review*, and the various organs and intiatives of DSA has come increasingly to resemble the anti-Leninist, anti-Soviet, and finally anti-Marxist current that enjoys hegemony in Western Europe. Anderson's knowledge of the situation within British Marxism is incomparably more informed than our own, but for a differing account, see Ellen Meiksins Wood, *The Retreat from Class: A New 'True' Socialism* (London, 1986).

of Marxism within post-war French thought was eclipsed when Marxism lost out in a theoretical battle with structuralism and the latter's temporal and conceptual successor, post-structuralism. Where Marxism was, there structuralism/post-structuralism shall be. The ground for this theoretical combat was the common problem shared by both: 'the nature of the relationships between structure and subject in human history and society' (p.33). The terminus of the effort among French intellectuals to solve this problem under the sign of historical materialism was Sartre's *Critique of Dialectical Reason* (1960), which provoked an immediate counterblast from the structuralist camp: the postscript to Lévi-Strauss's *Savage Mind* (1962). Moreover, the relevant Marxist reply, *For Marx* and *Reading Capital,* represented 'no repudiation [of Lévi-Strauss], but a counter-signature of the structuralist claim' (p.37). May '68 delivered the quietus to Althusserianism, while structuralism 'contrary to every expectation, passed through the ordeal of May and re-emerged phoenix-like on the other side' (p.39) in the persons of Lacan, Foucault, and Derrida, who unfurled the banner of what would henceforth be known as post-structuralism, and whose collective enterprise would effectively occupy the Parisian intellectual high ground throughout the seventies and beyond. What were the contours of this theoretical revolution that emerged from the ashes of French Marxism during the sixties and seventies?

Anderson identifies four characteristic features of structuralism/post-structuralism: its *'exorbitation of language'* (p.40); its *'attenuation of truth'* (p.45); *'the randomization of history'* (p.48); and 'the *capsizal of structures* themselves' (p.51). Ample evidence is marshalled from the texts of structuralist and post-structuralist writers to support these claims, and a convincing case is made for the *theoretical* necessity of structuralism's passage into post-structuralism, which latter accomplished the 'self-cancellation of structuralism' (p.53) that had always been latent in the 'aporia of the [structuralist] programme' (p.52) itself: its incapacity to guarantee the objectivity of structures without recourse to a transcendental subject. Thus, the *'unbridled subjectivity'* (p.54) Anderson attributes to Derrida and Deleuze and Guattari was a necessary consequence of the original structuralist strategy undermining the claims of the subject to mastery over language, history, and its own acts. But with the advent of canonical post-structuralism, the secret of structuralism's true relation to the central Marxist problematic of structure and subject is revealed: 'The unresolved difficulties and deadlocks within Marxist theory,

which structuralism promised to transcend, were never negotiated in detail within this rival space. The adoption of the language model as the "key to all mythologies", far from clarifying or decoding the relations between structure and subject, led from a rhetorical absolutism of the first to a fragmented fetishism of the second, without ever advancing a theory of their *relations.* Such a theory, historically determinate and sectorally differentiated, could only be developed in a dialectical respect for their independence' (p.55). Thus the internalist explanation for the demise of French Marxist theory falls. Structuralism/post-structuralism did not so much conquer Marxism as it simply refused the latter's problematic. Anderson is therefore compelled to account for the historical trajectory in another way.

The alternative, not surprisingly, is a political and social explanation of the decline of Latin Marxism. But before embarking on this analysis in detail, Anderson detours through a related body of work that emerged athwart, rather than in response to or in collaboration with, Parisian thought of the past two decades.[6] Initially it seems that Habermas will provide the requisite tools for a historical materialist riposte to structuralism/post-structuralism, and on the very ground that the latter had staked out as its special province: the theory of language. In spite of the greater respect accorded Habermas, and notwithstanding Habermas's own profession of faith in the theoretical and political project of historical materialism, Anderson in the end firmly rejects what he aptly terms the German's 'angelism of language' (p.64), and for determinate political reasons. Habermas's most serious failing lies in 'the complete absence in [his] account [of the crisis of moral legitimation in the western democracies] of any collective *agency* for converting a delegitimation of the existing social order into an advance towards the new legitimacy of a socialist order' (p. 67). Habermas is unable to theorize

6. The reasons for the relative isolation of post-war French and German thought from each other — to the loss of both, one surmises — exceed the scope of this chapter. The late Michel Foucault once remarked, in response to inquiries about the relationship of his work to that of the Frankfurt School, that his discovery of their writings was significantly delayed by the political atmosphere pervading French intellectual life during the forties and fifties. Hostility to everything German, an understandable legacy of the Occupation, prevented access even to the work of opponents of Nazism like Adorno and Horkheimer. A symptomatic reflection of this situation is visible in the refocusing of Sartre's intellectual horizons from his pre-war immersion in Husserl to his post-war concentration on French and American thinkers, particularly historians and social scientists. The numerous references to these latter in the *Critique* are striking.

revolutionary social transformation, and his work therefore
possesses no hold on Marxist politics, whatever its ultimate
implications for the science of historical materialism.

The problem of the declination of Latin Marxism in the
seventies remains. Anderson's explanation assumes a somewhat
startling form — startling in light not only of previous statements
made in *Arguments* (to which we shall return) that seem to qualify
severely the very explanatory power of the causes he now cites, but
also when one considers that among the *bêtes noires* of *Tracks*,
Althusser had some fifteen years previously offered a similar
(although not identical) account of the trajectory of his own and
his generation's development.[7] Neither the questions intrinsic to
the problematic of French philosophy, nor the local triumph of
political reaction in France under Pompidou and Giscard
d'Estaing can sufficienty explain the shift in the centre of gravity
among French intellectuals from left to right. Rather, 'the fate of
the international communist movement' (p. 68) proves to have
been the decisive determinant in deflecting French thought from
the orbit of historical materialism. This 'crisis of Marxism'
emerged from the 'cumulative failures' of the apparent
alternatives to Soviet-style socialism that appeared so promising
during the early seventies but had become all too easily burst
bubbles by the end of the decade. Eurocommunism and Maoism
each signally proved to be a god that failed. Anderson's
denunciation of both is eloquent: 'Each of these alternatives had
presented itself as a historically *new* solution, capable of
overcoming the dilemmas and avoiding the disasters of Soviet
history: yet each of their upshots proved to be a return to familiar
deadlocks. Maoism appeared to debouch into little more than a
truculent Oriental Khruschevism. Eurocommunism lapsed
into what looked increasingly like a second-class version of
Occidental social democracy, shamefaced and subaltern in its
relation to the mainstream tradition descending from the Second
International' (p.76) Even Trotskyism, the principal historical
rival to the Soviet model for nearly half a century, came up
short in producing 'an alternative scenario for defeating
capitalism in the West. The blockage stemmed from too close
an imaginative adherence to the paradigm of the October
Revolution, made against the husk of a feudal monarchy, and
too distant a theoretical concern with the contours of a

7. See 'To My English Readers', in *For Marx*, trans. Ben Brewster (London,
1977), pp. 9-10, and the discussion of this text in chapter 7 above.

capitalist democracy the Bolsheviks never had to confront' (p. 79).

Trapped in a historical *cul de sac*, the long march of Western Marxism would seem to have reached its terminus in an inevitable political quietism, a reformist accommodation to the existing structures of capitalist democracy. Anderson's Marxist assessment of the itinerary of Marxist theory in the West has produced a rather melancholy judgment on the current horizon of Marxist politics, as if the 'subjacent pessimism' (p. 17) which he has long attributed to Western Marxism had come to infect even his own vision of the present and future. Needless to say, for anyone even minimally acquainted with Anderson's writings over the past two decades, the argument does not rest here. The pessimism of the intellect that sounds the dominant chord of the first three quarters of this book gives way in the concluding pages of the original lectures, but even more strikingly in the postcript Anderson appended to them for publication, to a measured but insistent optimism of the will. For all its shortcomings, regressions, and current impasses, historical materialism retains for Anderson its preeminent force as a theory of revolutionary socialism. Three features entitle it to this distinction: 1) 'its sheer scope as an *intellectual system*'; 2) its superiority to all other accounts as 'a *theory of historical development*'; 3) its historical record as 'a *political call to arms*, in the struggle against capitalism' (pp. 86-7). It is easy to see that the dual claims of Marxism to be a scientific theory and a revolutionary ideology are once again being defended here, although now not against Marxism's traditional enemies in bourgeois thought, but against competing conceptions of strategy and morality within socialism itself.

None of the three characteristics of Marxism cited above has been exempt from challenge in recent years. In particular, Marxism's theoretical and political preeminence within revolutionary socialism has encountered a significant rival in the emergent theory and political practice of feminism. Indeed, inquiry into the nature and function of patriarchy and gender has seemed potentially to deprive Marxism of its irreplaceable cornerstone: the primacy of class as an analytic category in the historical study of social formations. Anderson measures the extent of this challenge with some care, conceding the now obvious point that class and gender distinctions are neither coeval nor causally linked in an expressive totality. Sexual domination is a semi-autonomous practice with respect to exploitative relations of production: it is neither an epiphenomenon of more fundamental relations between the classes, nor wholly distinct in its structure

and action from the forms of economic exploitation in class societies. The more potent threat to Marxism posed by recent feminism, however, derives less from its theoretical claims than from its notable political strength. For the edge in political initiative, historically the prerogative of mass parties of the working class in Western Europe, has passed over to feminist politics, and of course to other non-Marxist political movements such as END, CND, the Greens, and various anti-nuclear and ecological movements in North America. On the face of it, contemporary politics, to the extent that it holds any hope for the transformation to a socialist future, is dominated less and less by orthodox Marxist parties and more and more by political movements cutting across class lines and often openly proclaiming their indifference to the labour movement as a whole.[8]

Anderson's defence of historical materialism is unlikely to satisfy any of these contemporary recusants to Marxist orthodoxy.[9] But it is the only responsible line a Marxist can take: the post-war cooptation of a majority of workers into quiescence within the existing institutions of the Western democracies notwithstanding, the working class remains, by virtue of its 'structural position within the process of capitalist machino-facture as a whole' (p. 93), the only conceivable historical agent capable of generating the cohesive mass force required to confront the repressive apparatus of the bourgeois state that will surely be unleashed when the moment of possible transition from capitalism to socialism arrives. Pressing as other matters of moment surely are (the threat of global nuclear war, the necessity to conceive workable socialist futures at the level of the economy), nothing can remove the necessity for strategic thought to project the political agenda and mobilize the mass forces of the proletariat that this transition will need. On this point, Anderson stands firmly, even intransigently, behind the basic tenets of historical materialism, urging once more the priority of its claims: 'For historical materialism remains the only intellectual paradigm capacious enough to be able to link the ideal horizon of socialism to come with the practical contradictions and movements of the present, and their descent from structures of the past, in a theory of the distinctive dynamics of social development as a whole' (p. 105).

* * * * * * * * * *

8. See, for example, the interviews with Rudolf Bahro, *From Red to Green* (London, 1984), pp. 209-38.
9. A symptomatic reply to Anderson's critique of feminism from an otherwise

Such is the argument of *In the Tracks of Historical Materialism*. To what extent can we affirm its assessments of the recent past and its urgings about the present and future? With some adjustments in Anderson's views concerning certain figures (Althusser and the work he fostered), and by developing a concept he leaves largely in abeyance throughout this text (ideology), Anderson's claims for the continuing vitality of Marxism as both a scientific theory and a revolutionary ideology are sustainable. In order to reach this end, it will be useful to compare certain of the analyses and judgments in the present text with places elsewhere in Anderson's writings that address similar questions and problems, and to situate *Tracks* in the sequence of Anderson's works.

First, and most obviously, *Tracks* presents the sequel to *Considerations on Western Marxism*. The former, as we have observed, commences with a backward glance at the predictions made near the end of the latter. Throughout *Tracks*, Western Marxism remains the focal concern, as its sins, failings, and potential for redemption are chronicled and soberly judged. Less obvious, but not less significant, is the book's relation to its immediate predecessor, *Arguments within English Marxism*. *Tracks* continues the problematic of *Arguments*, while subtly shifting some of the earlier book's emphases to produce a somewhat altered theoretical position. Together, the books make up a trilogy on the history of Marxism in the 20th century, complementary to Anderson's earlier historical works, at the same time that they intervene in conceptual debates inaugurated in those earlier works from the quite different domain of historiography proper. *Passages* and *Lineages* represented an attempt to try the validity of historical materialism as a scientific theory of the history of social formations across some two and one-half millenia of the past of the Occident, a detailed projection from the plans sketched by Marx in the *Formen* section of the *Grundrisse* and fitfully supplemented by Engels in some of his later writings. The trilogy on post-classical Marxism can be seen, from one angle, as an even finer grained illustration of the explanatory power of historical materialism. Not only can historical materialism account for the massive, epochal transformations from one mode of production to another, observing the canonical sequence from slavery to feudalism to capitalism, but it possesses sufficient dexterity and finesse to sketch the trajectory over a comparatively compressed time-span of distinct levels of the superstructure as well —

sympathetic quarter is Terry Eagleton's review of *Tracks*, 'Marxism, structuralism and post-structuralism', *Economy and Society* 13,1 (1984).

notably, in the case at hand, that level Althusser has dubbed theoretical practice. In their broad commitment to the scientificity of Marxism as a 'theory of the distinctive dynamics of social development as a whole' (*Tracks*, p. 105), Anderson's writings from *Passages* to *Tracks* exhibit a remarkable consistency in purpose and execution.

Surely, however, different conceptual tools are required to explain the history of a theoretical problematic from those deployed to comprehend transformations in entire social formations. Initially one might think so, and the difference would reside precisely in the subjection of a theory to its own internal constraints. Unlike a mode of production, the various levels of which develop unevenly — the classic example is the superstructural hypertrophy of antique civilization that coexisted with comparatively primitive means of production[10] — scientific theories, once they have emerged on the other side of their *coupure épistemologique*, most often proceed in relatively linear and rational fashion. As Anderson remarks in the Foreword to *Passages*: 'rational knowledge ... is necessarily cumulative' (p. 9). This faith underpins Anderson's entire enterprise and provides the *raison d'être* for his defense of the scientificity of Marxism: sober consideration of the achievements of Marxist historiography will, in the long run, prove Marxism's theoretical superiority to other existing theories of history.

Stated thus, it would be difficult to differentiate Anderson's view of Marxist science from the 'theoreticist' pronouncements of the early Althusser. It is clear from the argument of *Tracks*, however, and even more explicit in *Considerations*, that the destiny of Marxist theory after Lenin has not been simply a matter of solving problems that the theory has set for itself. Marxist theoretical practice, as Althusser's later reflections on his own early writings suggest, is ever only *relatively* autonomous from the history of, above all, the political instance. In *Considerations* Anderson had characterized Western Marxism as ineluctably 'a product of *defeat*' (p. 42); its unremitting pessimism and retreat from the domain of politics and economy into the isolation of philosophical reflection was a legacy of the historical disasters suffered by the European working class in the wake of the Bolshevik Revolution. Even its very conceptual innovations —

10. This, be it said in passing, is the more fruitful — and more authentically materialist — path to follow in accounting for the efflorescence of Greek art over which Marx puzzles in the Introduction to the *Grundrisse*.

Gramsci on hegemony, Althusser on the permanence of ideology, Sartre on scarcity — were deeply marked and ultimately determined by the ebbing of working-class militancy in Western Europe (*Considerations*, pp. 79-89).

What then is the specific relationship between political history and theoretical practice in Anderson's exposition of the development of the latter within Marxism? On an Althusserian/ Marxist view, no *a priori* answer is conceivable, just as there can be no ideal type of the revolutionary situation which, once discovered, will provide a blueprint for all social revolutions to come. Still, Anderson does confront this question directly in *Arguments* and again in *Tracks*, and in at least one instance he completely inverts his account of the relationship between politics and theory from one text to the other. The case concerns Sartre's *Critique* and the reasons for Sartre's inability to bring to completion that work's second volume.

In *Arguments* Anderson presents a wholly internalist accounting of the demise of Sartre's project. Sartre's failure in the second volume derived from a conceptual impasse that could not be resolved in the terms established by the *Critique* itself:

> The reason for this final loss of direction, which perhaps prevented publication of the study, is clear enough. For all the ambition and ingenuity of his exploration of the successive contradictions of Soviet society, Sartre was unable actually to demonstrate how the ravaging struggles [in the Soviet Union during the 1920s] generated an ultimate structural unity. In the absence of any extended principle of explanation, the needle of his account swings back to the shortest and simplest answer: Soviet society was held together by the dictatorial force wielded by Stalin, a monocentric sovereignty imposing a repressive unification of all the conflicting praxes within it. Hence the logic of the *Critique*'s terminus in the figure of the despot himself. The effective upshot is thus paradoxically a totalization *with* a totalizer, undermining that very complexity of the historical process which it was Sartre's express purpose to establish. Nowhere spelt out as such, the unhappy silence that suddenly falls across the work bespeaks Sartre's unease with the conclusion his argument had arrived at. (p. 53)

This passage occurs in the midst of a long critique of Edward Thompson's conception of agency in historical process. Significantly, the necessary correction to Sartre's theoretical impasse (and by implication Thompson's) comes from Althusser, whose assertion of the primacy of objective conditions of crisis in a

mode of production (contradiction between the forces and relations of production) repeats the classical Marxist critique of the voluntarism both Thompson and Sartre in their different idioms articulate (*Arguments*, pp. 53-5).

Admittedly, the occasion for this account of the *Critique*'s theoretical impasse is not an assessment of Sartre's work *per se*, but a consideration of the general problem of historical agency and the most adequate means for theorizing it in historical materialist terms. Nonetheless, the effectively internalist or intra-theoretical explanation towards which the passage gestures echoes other moments in Anderson's long engagement with Sartre's project. In *Considerations* Anderson had remarked on the perdurance of the categories governing the structure of *Being and Nothingness* in the ostensibly different theoretical matrix of the *Critique* (p. 57) — essentially that legacy from phenomenology observed and criticized in Althusser's early essays. In accounting for the ineluctable pessimism Sartre shared with other avatars of Western Marxism, Anderson focused on the master category of the *Critique*'s ontology: scarcity (*rareté*). His analysis of this concept's force across Sartre's historical theory culminates in an exposition of the latter's indictment of the Marxist-Leninist notion of the 'dictatorship of the proletariat', which is fatally compromised by the fact of continuing scarcity (pp. 87-8). While the principal emphasis in *Considerations* falls upon the political conditions that engendered Western Marxism, the exposition of Sartre's most important theoretical text rests, finally, on the vicissitudes of a concept within a theoretical problematic that never broke with its philosophical heritage in the bourgeois tradition.

Not long after, Anderson authored the 'Introduction to Sartre' prefacing the *New Left Review*'s translation of a section from volume two of the *Critique*. In that document, two explanations are presented side by side as reasons for Sartre's failure to bring his project to completion. On the one hand, it is asserted that 'Sartre's reflections obviously remain at a philosophical rather than a historiographic level.' This orientation is judged to have imposed severe methodological limitations which ultimately forced upon Sartre labours he could not sustain: 'It was because he was conscious of the need for much more controlled and careful documentation that Sartre — when he was subsequently unable to undertake the latter — abandoned the work, rejecting any idea of publication.' At the same time, however, Anderson hypothesizes political reasons for Sartre's forsaking the second volume:

It is also possible that by the later sixties, Sartre had reservations about the political stance of the book. Written at the height of Khruschev's liberalization within the USSR, the second volume of the *Critique* shares certain of the hopes — offical or unofficial — of the Communist movement of the time, and certain of its indulgences towards a Stalinist past that was thought to be much more easily transcendable than it in fact proved to be.[11]

If we turn now to *Tracks*, we see that Anderson has apparently opted for exclusively externalist principles of explanation. The internal problematic of Sartre's theory, which proposed the unsatisfactory concept of 'totalization without a totalizer' for the unifying principle of historical order, only to abrogate this very principle when theorizing the class conflicts in an actual historical society, has yielded to politics *tout court*. Anderson now locates the ultimate causes of Sartre's failure to finish his project precisely there:

> The real intellectual horizon of the *Critique* was political: Sartre's hope for a developing democratization of the USSR under Khruschev expressed exactly that optimistic perspective on Soviet history as a whole so eloquently set out in his long essay of 1956, *The Ghost of Stalin*, which in and through its very excoriation of the Russian intervention in Hungary, held firm to the prediction that 'destalinization will destalinize the destalinizêrs.' It was almost certainly the disappointment of this expectation by the early sixties which broke off the intention of the second volume. (p. 71)

Nor is it only the *Critique* that lost direction as the result of an objective blockage in the history it sought to comprehend. Sartre's career as a political writer was dealt innumerable severe blows by the failures of the final years of Khruschev and the succeeding 'bleak Brezhnevite conservatism'. It received its final quietus with the invasion of Prague by Warsaw Pact forces in August 1968, which occasioned 'Sartre's last political essay of weight — *The Socialism that Came in From the Cold* — [which] was an obituary of the Czechoslovak experiment. It is no accident that he thereafter lost his compass and never produced a major political statement again, his pronouncements in the seventies becoming ever more occasional and erratic' (p. 72).

It would be tempting to explain this apparent *volte face* in terms of Anderson's own altered sense of the political context in which

11. Perry Anderson, 'Introduction to Sartre', *New Left Review* 100 (November 1976-January 1977): 141.

he wrote the two texts. In 1979, the true strength of the counter-revolutionary politics of Thatcher and Reagan had yet to be felt; the continuing weight of an abject and reformist labourism seemed to drag down all political initiatives from the left, so that a somewhat doctrinaire assertion of the claims of orthodox Marxist concepts of class and politics was on the immediate agenda to act as a counterweight to the incipient spontaneism represented by Thompson's and Sartre's conception of historical agency. The intervening three years saw the triumph of reaction in Britain and the United States, similar (if less revanchist) developments in Italy and Germany, and a growing foreboding about the imminence of global disaster, exemplified by the publication of Thompson's essay on exterminism. Anderson's response was then to privilege the political instance, as he came increasingly to recognize the urgency of the current crisis and, perhaps, glimpsed the possibility that a new space for revolutionary political action had been opened.

If the last paragraph sounds speculative, even fanciful, it is meant to. Barring some later retrospective *auto-critique* by Anderson of his political thinking, there simply is not sufficient evidence in the published work to date for one to extrapolate the political agenda that has directly motivated his most recent writings.[12] Moreover, it highlights the danger of too readily judging the trajectory of theoretical work as an expression of the political environment immediately adjacent to its production. Anderson himself has uttered the most appropriate caution in this respect in rejecting Thompson's claim that Althusser's work is the instantiation in theory of quiescence in the global class struggle (*Arguments*, p. 103). It will be more fruitful to attribute the divergence in the accounts of Sartre's *Critique* among the various texts from *Considerations* and the 'Introduction to Sartre' to *Arguments* and *Tracks* to an unresolved tension that has haunted Anderson's work for more than a decade.

When we turn to *Passages* and *Lineages* and consider the explanations given there for the transformation from one mode of production to another, precisely the same difficulty concerning the relative weights to be accorded, respectively, to internal and external factors appears. In the case of the transition from antique slavery to feudalism, the relationship between the forces of

12. One place where Anderson begins such a retrospective, however, is in his presentation of the concept of revolution that has been generally regnant in the *New Left Review* during the period of his editorship; see *Arguments*, pp. 194-5.

barbarian invasion and internal decay in the Roman Empire marks out the space of Anderson's inquiry. Not surprisingly, the balance tilts toward an internalist account, which is given first categorically (*Passages*, pp. 25-8), then in a brilliant compressed portrait of the evolution of the slave mode of production in the Western Empire (where it predominated) from the beginning of the third century up to the eve of the Germanic invasions (pp. 76-103).[13] The causal priority granted to internal over external factors is evident in the concluding sentence of this narrative: 'The social polarization of the West thus ended in a sombre double finale, in which the Empire was rent from above and below by *forces within it*, before forces from without delivered their quietus' (p. 103; emphasis added).

Mutatis mutandis, a similar accounting is presented of the demise of western feudalism, a story continued at considerable length in *Lineages*, which chronicles the long period between the general crisis of feudalism during the 14th century and the emergence of the bourgeois states from the middle of the 17th to the end of the 19th centuries. Absolutism proved to be the decisive hinge enabling the gradual transition from feudalism to capitalism, a state form that continued the structures of the feudal polity while allowing the new forces and relations of production to mature in the womb of the old, in Marx's famous image from the 1859 *Preface (Lineages*, pp. 17-24). But when Anderson confronts the problem of feudalism in Eastern Europe, the balance shifts. The history of the East, cut off from the salient power of antique civilization which never extended to any great depth beyond the Elbe and the Danube, paralleled that of the West in a retarded movement of imitation and forced adaptation: 'For the ulterior political development of the whole region was [from the Dark Ages forward] to come under critical exogenous influence. Both the rise of West European feudalism and the impact of Scandinavian expansionism were to be largely felt beyond the Elbe. Henceforward, in fact, the continental proximity of more advanced economic and social systems adjacent to it must always be remembered in assessing the course of events in Eastern Europe itself' (*Passages*, p. 230).

A comparable moment occurs near the end of *Lineages*, when

13. This analysis is confirmed in the most recent scholarship. See Anderson's 'Class Struggle in the Ancient World', *History Workshop* 16 (Autumn 1983): 57-73; the piece reviews Geoffrey de Ste. Croix's *Class Struggle in the Ancient Greek World*.

Anderson is compelled to admit that the example of Japan demonstrates how the emergence of capitalism from feudalism was far from a historical necessity. There, a native feudalism developed along a quite different and, until the 19th century, totally isolated path from the one followed in Europe; unlike its European counterpart, Japanese feudalism did not evolve inherently towards capitalism (p. 420). Moreover, the transition itself could, as the case of Japan exemplified, be compelled by exogenous forces propelling the internal dynamic of a decaying feudalism in a revolutionary direction (p. 458). Despite the irreducibility of the concept of mode of production in Marxist historical analysis, modes of production are not self-directed organisms, programmed to evolve towards specific determinate goals. The forces necessary for historical development, in particular the conditions under which one mode of production is transformed into another, remain contingent and variable, impossible to predict in advance and irreducible to any algorithm of historical necessity. In his own historical writings, Anderson is thus united with Edward Thompson in eschewing any methodological reductionism of historical understanding.[14]

* * * * * * * * * *

We have wandered quite far from the main concerns of *Tracks*, namely, the reasons for the observable decline of Marxist theory in Latin Europe. But this detour through Anderson's studies of European history from antiquity to the emergence of capitalism has thrown into relief the central difficulty that shadows all of Anderson's writings: how to account for the ordered nature of changes in historical entities. Whether the object of investigation is the itinerary of a scientific theory, or the evolution of a mode of production, the problem is the same: the extent to which a historical entity is propelled by forces and contradictions intrinsic to its own structural make-up, as opposed to the role extrinsic or exogenous factors play in affecting the course of its development. In *Tracks*, Anderson has bent the stick back too far towards an extrinsic accounting of the causes for the 'crisis of Marxism'.

14. Robert Wess remarks in the review of *Arguments* previously cited (n. 2 above) that Anderson and Thompson remain committed to a common empiricism that is often at loggerheads with Althusser's epistemology. The extent to which an empirical moment remains constitutive for Althusserian (or any historical materialist) research is discussed in chapter 10 below.

Moreover, by devaluing the post-1968 work of Althusser, he has effectively closed down the one path open to materialist analysis which would allow for an incorporation of both extrinsic and intrinsic factors in comprehending the history of a theory. Let us now take up Anderson's judgments about Althusser in *Tracks*, comparing these with his earlier assessments in *Arguments* and *Considerations* in order to arrive at an evaluation of the validity of Anderson's current views and a sense of the pertinence of the Althusserian research program to solving the problems *Tracks* sets for itself.

The initial criticism of Althusser presented in *Tracks* is plainly political. Althusser (along with Poulantzas) is said to symbolize that 'dilution or diminution of [Marxism in Latin Europe], pervaded by an increasing scepticism towards the very idea of a revolutionary rupture with capitalism' (p. 29) which Anderson is concerned to explain. A single text from each is cited; no further discussion of Althusser's political pronouncements ensues, save for a brief noting of his ill-judged enthusiasm for Maoism (p. 73), and a cryptic remark about his acquiescence in the drift of the PCF towards Eurocommunism (p. 75).[15] A thorough assessment of Althusser's political itinerary during the seventies exceeds the scope of our argument here,[16] but what seems curious is the complete reversal in Anderson's view from *Arguments*. Some of that book's most eloquent and passionate pages are devoted to defending Althusser's political record against the intemperate charges of unreconstructed Stalinism levelled at him by Edward Thompson. Anderson's judgment is not uncritical. He takes Althusser to task for the latter's Maoist tendencies (p. 110), and for a gratuitous knee-jerk anti-Trotskyism expressed in the *Reply to John Lewis* (p. 111). Yet the burden of the defence is not merely to acquit Althusser on the charge of Stalinism, but positively to

15. The point is made more explicitly, apropos of the ISAs, by Gregory Elliott in 'Louis Althusser and the Politics of Theory' (Ph. D. Thesis, Oxford 1985), pp. 261-2. Ellen Meiksins Wood, in *The Retreat from Class,* presses the argument further by, in effect, laying the recent truancy of Hindess and Hirst, Laclau, and others from historical materialism at the feet of Althusserian theory itself. The charge must be taken seriously, although the comparatively unilateral reading of the Althusserian legacy advanced by Wood entirely ignores the positive developments among another group of Althusser's students cited below. The case of Poulantzas is more complicated. While it is true that Althusser promoted his work, it is incorrect to lump the two together without qualification. Most important of all — and a fact which Wood signally neglects to mention: Althusser himself never wavered in his political commitment to class struggle.

16. The most thorough account to date is to be found in Elliott, passim.

establish the strength of his claims as an independent political thinker and a consistently oppositional force within the PCF. Moreover, Anderson singles out for extreme praise the text of *Ce qui ne peut plus durer dans le Parti Communiste* (pp. 113-14), which was in fact written *after* the text cited in *Tracks* to support an indictment of Althusser's political betrayal in the late seventies.[17] It scarcely seems plausible that the author of 'the most violent oppositional charter ever published within a party in the post-war history of Western Communism' (*Arguments*, p. 113) can now be made into a servile spokesman for PCF accommodationism. Putting aside the personal disaster that would befall Althusser two years later, it is unjust, on the basis of the evidence adduced, to include him among a rogues' gallery of faithless turncoats exemplifying the rightward drift in French Marxism.

This tendentious representation of Althusser's politics could be dismissed as a mere lapse were it not for its coalescence with the argument of *Tracks* as a whole. Althusser's political regression is made into a necessary correlate of his theoretical errors, which are in turn to be understood as a consequence of Althusserianism's 'intimate and fatal dependence on a structuralism that both preceded it and would survive it' (*Tracks*, p. 38). Anderson assimilates Althusser to structuralism *tout court*, and indicts both for their inability to produce conceptual instruments capable of comprehending the events of May '68. Anderson's pronouncement on the fate of Althusserianism is terse and final: 'Althusser did attempt to adjust his theory by belatedly granting space to the role of the "masses," who, he now conceded, "made history," even if "men and women" did not. But since the overall direction of Althusser's enquiries was neither corrected nor developed, the introduction of the problem of the historical subject into the machinery of structural causality set out in *Reading Capital* simply resulted in incoherence. No new synthesis comparable to his earlier work appeared. The consequence was the progressive effacement and dissolution of Althusserian Marxism, as a current, by the mid-seventies' (p. 39). The last sentence is plainly false, and it is Anderson himself who has told us so. The list of works cited in *Arguments* (p. 126), which Anderson admits is 'far from

17. The text in question is 'The Crisis of Marxism', which first appeared in English in *Marxism Today* (July 1978) but was originally given as a lecture in Venice in 1977. I am grateful to Perry Anderson who, in response to an earlier draft of this chapter, clarified the chronology of these texts, and to Gregory Elliott for making available to me some of Althusser's less well-known political and theoretical writings.

exhaustive' (p. 127), and many of whose dates of publication postdate the supposed mid-seventies disappearance of Althusserianism, build a *prima facie* case for Anderson's judgment there that 'the overall balance-sheet of Althusser's impact has in this sense been positive for the real development of historical materialism' (p. 127). Nor is it the case that all those more directly under the influence of Althusser's teaching became, like Foucault and Glucksmann, outright enemies of historical materialism, mouthpieces of the new Cold War's Gulag chic. Macherey, Balibar, and Pêcheux all continued to produce new work into the eighties under the aegis of the theoretical program inaugurated by Althusser in the early and middle sixties. Althusserianism is far from moribund, even in France, where it may have lost some of the *éclat* with which it came on the scene in 1965, but where it remains a real, if currently unfashionable and largely submerged, influence.[18]

As for Althusser's work itself, Anderson has seriously underestimated the degree to which its theoretical space was altered between *Reading Capital* and the publication of 'Ideology and Ideological State Apparatuses'.[19] In addition, Anderson has missed the originality and importance of the ideology essay itself, while failing to take into account the subsequent work it generated. In the first place, the text's politico-theoretical aim is patent: to contribute to the Marxist theory of the state,

18. Ted Benton's otherwise useful book, *The Rise and Fall of Structural Marxism* (New York, 1984), repeats the error made in *Tracks* of hypostatizing the 'internal decomposition' (pp. 173, 201) of Althusserianism. No persuasive case is made for this claim, and Benton flatly ignores the continuing legacy of Althusser's theoretical breakthrough in the subsequent work cited by Anderson in *Arguments*. The 'rise and fall' chronicled by Benton applies with some justice to the moment of Althusser in Britain, particularly if one focuses on the Hindess and Hirst phenomenon, or what Ellen Wood has dubbed the New 'True' Socialism.

19. The conceptual shift in Althusser from his early (self-confessed) 'theoreticism' to his later views on the political function of philosophy, as well as the general significance of this shift for the concept of ideology, is lucidly explained in Robert Wess's essay, 'Notes toward a Marxist Rhetoric', *Bucknell Review* 28 (1983): 126-48. After Wess's article, it is no longer possible to accept the common accusation that Althusser's conception of science is positivist (see, for example, Michael Löwy, 'Stalinist Ideology and Science', in Tariq Ali, ed., *The Stalinist Legacy: Its Impact on 20th-Century World Politics* [Harmondsworth, 1984], pp. 178-81). The exposition of Althusser that follows builds upon the foundations established by Wess. My disagreements with his piece have to do with the limited issue of the Althusserian concept of the subject in the ISAs (see above, chapter 7, n. 28). References to 'Ideology and Ideological State Apparatuses' are given parenthetically and refer to the text in Louis Althusser, *Lenin and Philosophy and Other Essays,* trans. Ben Brewster (New York, 1971).

specifically, to reformulate the concept of the state such that the production of ideology can be seen to be as much within the state's province as is the latter's overt monopoly on the means of repression. Althusser's strategic reduction of the levels of the superstructure to two (politico-legal and ideological) has been criticized (for example, by Poulantzas in *State, Power, Socialism*), but the point of this move should be recalled. Contrary to bourgeois political theory from the Englightenment onward, which has tended to distinguish sharply between the realms of public and private life, on an Althusserian view all social institutions are implicated in reproducing the structure of a given society. All institutions are part of the state, which for Althusser coincides with the political structure of society.

Secondly, one should bear in mind when reading the ISAs that the Parisian May events loom large over the history of the essay's production, as well as over the particular emphases it exhibits. For instance, when Althusser writes that 'it is the [ideological state apparatuses] which largely secure the reproduction specifically of the relations of production, behind a "shield" provided by the repressive State apparatus' (p. 150), he is trying to account for the somewhat astonishing fact (from an orthodox Marxist perspective) that the revolt in 1968 began in the schools, where the contradictions between the ideological façade of bourgeois society and the reality of its practices were at that moment most clearly evident. Similarly, when Althusser opines (pp. 151-4) that the dominant ideological apparatus under feudalism, the church, has been replaced under capitalism by the educational apparatus, he is not only reflecting upon the origin of the 1968 revolt in the schools, but is at the same time urging the proletariat (and, *a fortiori*, the PCF leadership) to recognize in the capitalist educational system a primary site of struggle. Today this may sound like a very sixtiesish notion, but it isn't altogether false for that. Moreover, subsequent work in this area has confirmed Althusser's hypothesis about the imbrication of educational practices in the maintenance of class domination by the bourgeoisie, and shown the extent of its lengthy history in France, dating from the Revolution and brought to fruition by the educational reforms at the inauguration of the Third Republic nearly a century later.[20]

20. See Renée Balibar and Dominique Laporte, *Le français national* (Paris, 1974), and Renée Balibar, *Les français fictifs* (Paris, 1974). Each of these texts is introduced with an essay by Pierre Macherey and Etienne Balibar that makes plain the relationship of this research to Althusser's initiatives in the area of ideology. In addition, the introduction to *Les français fictifs* notes the historical occasion for the

Finally, one must closely attend to the postscript Althusser appended to the ISAs approximately one year after its original completion, but prior to its first publication. Althusser's cautions concerning a functionalist conception of ideology, which the first part of the essay might otherwise underwrite, have often gone unheeded. Perhaps this was to be expected. But as Pêcheux's work has shown, a functionalist reading of the ISAs is not entailed by the concept of ideology proposed there.[21] When Althusser argues (pp. 184-6) that the ideological apparatuses are not only at stake in, but are themselves constantly traversed by class struggle, he reaffirms the political aim which motivated the writing of this essay and remains its most lasting contribution to Marxist theory. Far from being a recipe for defeatism and abject submission before the existing powers of bourgeois domination, the ISAs is a call to arms, an assertion of the necessity for continued struggle to shape and control the educational apparatus in the bourgeois state.[22]

Crucial to this political reading of the ISAs is the concept of the subject Althusser develops there. By not considering this aspect of Althusser's work with sufficient care, Anderson has missed an opportunity to square the circle he himself identifies as crucial both to Marxist theory and to Marxist political practice: the relations between subject and structure. If, as we have suggested, Anderson's own analysis of the itinerary of Marxist theory during the 1970s tends to flatten out into a plainly historicist account in which the evolution of theory is made to appear as the expression of an overarching political history, what alternative description of these events is conceivable by following a more strictly Althusserian line? Obviously it will not be possible to redraw

research (conducted in a provincial university from 1969-72) leading up to the writing of that book: the reaction against the 1968 student revolt and the 'down with the schools' sloganizing it spawned.

21. See Michel Pêcheux, *Language, Semantics and Ideology: Stating the Obvious*, trans. Harbans Nagpal (London, 1982), pp. 92-129; idem, 'Ideology: Stronghold or Paradoxical Space?' trans. Eugene Holland, *minnesota review* N.S. 23 (Fall 1984): 156-66; and Warren Montag's essay, 'Marxism and Psychoanalysis: The Impossible Encounter', published in the same number of *minnesota review*, pp. 70-85.

22. Cf. Althusser's letter of 15 March 1969 to Maria Macciocchi (in *Letters from inside the Italian Communist Party to Louis Althusser*, trans. Stephen M. Hellman [London, 1973], pp. 301-20), where he observes that the Communist parties of Western Europe had generally lost touch with students and young intellectuals since the 1950s, and that this was an important factor in the incapacity of the May '68 student revolt to achieve fusion with the mass strike of 10 million French workers. See also: Althusser, 'Note on the ISAs', *Economy and Society* 12, 4 (November 1983).

Anderson's sketch in its entirety, but some limited suggestions for reconceptualizing the relationship between politics and theory within French Marxism during the sixties and seventies can be briefly and schematically set forth.

A convenient means to this end will be to reconsider the itinerary of Althusserian theory itself, for its development and destiny were arguably quite different from what Anderson recounts. First, Anderson's characterization of Althusserianism's theoretical impasse will be recalled: 'But since the overall direction of Althusser's enquiries was neither corrected nor developed, the introduction of the problem of the historical subject into the machinery of structural causality set out in *Reading Capital* simply resulted in incoherence. No new synthesis comparable to his earlier work appeared' (*Tracks*, p. 39). The last sentence is of course true, but one wonders why a 'new synthesis' ought to have been anticipated in the first place. Rather, the text in question here (the ISAs) might just as plausibly be seen as a continuation, on a new terrain dictated by history, of Althusser's ongoing inquiry into the nature of the social whole, what he refers to in the ISAs as 'my old question' (p. 134).

In *For Marx* and *Reading Capital*, Althusser had straightforwardly asserted, on the authority of Marx himself, that individuals are the subjects or bearers of structures. This is the hypothesis that so scandalized Edward Thompson and provided the basis for charging Althusser with economism. However, Althusser's aim, as Anderson has pointed out (*Arguments*, pp. 54-5), was not to deny historical agency as such, but to demolish the claims of voluntarism. Althusser never doubted that there are subjects or historical agents, men and women who make their own history, but he insisted from the first that for Marxism the other half of that oft-quoted sentence from the *Eighteenth Brumaire* is decisive: they don't make it just as they please, but out of circumstances encountered and given from the past. It is not, therefore, any species-specific capacity of human nature (Sartre's *praxis*, for example) that produces historical subjects, but the forces and circumstances of the given social whole. 'My analytical method does not start from man but from the economically given social period', Marx wrote in the *Marginal Notes on Wagner*, a sentence Althusser quotes as the epigraph to 'Marxism and Humanism'. The ISAs does not mark a theoretical break with the problematic of earlier Althusserian texts over the concept of the subject (the break involved a different conception of philosophy, not of the subject; see n. 19 above); it continues the project

inaugurated in 'Contradiction and Overdetermination', 'On the Materialist Dialectic', and 'Marxism and Humanism', of developing theoretical concepts specific to the materialist conception of history. Under the pressure of the given historical circumstances, the terrain of Althusser's investigation shifted from Marxist theory to problems posed immediately by the composition and power of the state. But nothing in the ISAs is incompatible with the axiom that guided Althusser's researches from the beginning: history is a process without a *telos* or a subject.

In order to understand the path taken by Althusser from the early 1960s through the middle 1970s, it is necessary to go back to his own retrospective accounting of the origins of his work given in the Introduction to *For Marx*, written in 1965, and in the 'Note to My English Readers', written in 1967.[23] At the risk of redundancy, we shall repeat here the account of Althusser's intellectual itinerary canvassed in chapter 7. In addition to the pertinence of the texts to our present argument, these remarks could well be accorded the same canonical status as the famous pronouncement by Lenin on the triple determination of Marx's theoretical development by French socialism, German philosophy, and English political economy. The complex, overdetermined historical conjuncture in which Althusser locates the moment of his early essays exemplifies in an especially pointed way the theory of historical structures and their transformation which remains Althusser's unrivalled contribution to historical materialism.

In the first instance, these texts must be understood as '*philosophical* essays', although in a distinctively Marxist mode, for they are conceived as 'interventions in a definite conjuncture' (p. 9). The two main events that shaped this conjuncture were the beginnings of de-Stalinization with the Twentieth Congress of the CPSU in 1956, and the Sino-Soviet split, events that decisively altered the political programme of the Western Communist Parties, including the PCF. Althusser is quite explicit about the political charge of these early essays: they are responses, at the level of theory, to the Western Communist parties' initiatives in the early sixties in pursuit of 'unity with socialists, democrats and Catholics, guided by certain slogans of related resonance, in which the accent

23. Althusser, *For Marx*, pp. 9-38; subsequent references are given in the text. Anderson's recounting of the context of Althusser's early work (*Arguments*, pp. 105-8) focuses on a single determinant: the 'conjuncture at the time in the international Communist movement' (p. 105), foregrounding the Sino-Soviet split, which is said to be 'the real political background to the writing of *For Marx* and *Reading Capital*' (p. 106).

is put on the "peaceful transition to socialism," on "Marxist" or "socialist humanism," on "dialogue," etc.' (p. 11). Against the current of these developments, Althusser proposed a theoretical defence of an intransigent Leninism. Crucial to this defence was the assertion of the permanence of ideology. The implication of this notion for politics and strategy is patent: the continuing necessity, in defiance of all proclamations in the Soviet Union and from the PCF leadership to the contrary, for class struggle. The legacy of this intransigence in the seventies was to be Etienne Balibar's sustained and eloquent protest against dropping the phrase 'dictatorship of the proletariat' from the PCF statutes.[24]

But it was not only politics, be it the national strategy of the PCF or currents in the international Communist movement drifting towards humanism and abandonment of the classical tenets of class struggle, that determined the nature and scope of Althusser's interventions. Althusser's work was never directly political in the ordinary sense of the term, but was always a theoretical reflection upon problems presented by history. It is important to emphasize, as Althusser himself does, the determination of his work by the history of philosophy, and not only Marxist philosophy, but what Althusser characterizes as 'the pitiful history of French philosophy in the 130 years following the Revolution of 1789' (p.25). For this history profoundly affected the PCF, which 'was born into this theoretical vacuum' (p.26) and was compelled by it to privilege politics over theory. For Althusser, the symbol of this determination of theory by the immediate demands of political action was none other than the most important philosophical presence in post-war France, a Marxist philosopher whose position outside the PCF did nothing to diminish the influence of his work over Marxist thinkers internationally and nationally. The *philosophical* target of Althusser's early work, attested by numerous passages in *For Marx* and *Reading Capital,* was undoubtedly Sartre, 'the philosopher of mediations *par excellence',* whose *Critique of Dialectical Reason* attempted to capture the essence of all the different social practices distinguished by Marx in a single philosophical concept of human nature: *praxis.*[25]

Where does this leave us in our attempt to describe the itinerary

24. Etienne Balibar, *On the Dictatorship of the Proletariat*, trans. Grahame Lock (London, 1977).

25. Louis Althusser and Etienne Balibar, *Reading Capital*, trans. Ben Brewster (London, 1970), p. 136.

of Althusserian theory? Althusser's work began with an effort to produce an authentically materialist concept of the social whole that would allow for the differentiation of historical processes into distinct periods or times; this was the point of the concept of mode of production. In order to produce this concept, Althusser undertook a lengthy philological investigation of Marx's texts; at the same time, he measured the distance of Marxist theory since Lenin from the principles Marx had established. The latter part of the project was surely determined by the then (c.1960) emerging hegemony of various celebrations of Marxist humanism in both the East and the West, themselves late developments of a long tradition of philosophical reflection within Marxism that began with Korsch, Lukács, and Gramsci (the moment of what Anderson has called 'The Advent of Western Marxism', *Considerations,* pp.24-48). The latest incarnation of this tradition, and its most sophisticated exposition (by comparison Garaudy and his supporters were hacks) was to be found in Sartre's *Critique.* The strategic choice to cite Mao against these opponents was dictated by the political conjuncture within international Communism, but it would be wrong to interpret Althusser's Maoism unilaterally in political terms, or to attribute to it sole responsibility for the altered focus in his theoretical work after 1968.[26]

Althusser's subsequent shifting of the axis of his thought involved altering his early conception of philosophy from 'theory of theoretical practice' to his later view that philosophy is the class struggle carried forward at the level of theory. The decisive moment came in a text that Anderson to my knowledge nowhere mentions: *Philosophie spontanée et philosophie spontanée des savants.*[27] In these lectures, Althusser formulated his revised conception of philosophy, which was, he now saw, to be placed among the forms of ideological practice. The whole theory of knowledge, which had been a problem (arguably *the* problem) for Althusser from 'On the Materialist Dialectic' onward, was now to

26. This thesis is advanced by Gregory Elliott, op. cit. Elliott's tendency to discount the relative autonomy of theory and to locate the origins of theoretical developments in political positions alone mirrors the image of Althusserian theory presented in *Tracks.*

27. Louis Althusser, *Philosophie spontanée et philosophie spontanée des savants* (Paris, 1974). This is the text of lectures Althusser gave in a course offered during 1967-8 at the Ecole Normale Supérieure. He and his students undertook to explain to scientists the utility and theoretical validity of the Marxist conception of science. The course was interrupted by the outbreak of the May events.

be completely recast from within Althusser's renewed understanding of the permanence and pervasiveness of ideology, a notion that his earlier 'theoreticist tendency' had conveniently ignored when it came time to explain how theory itself produced knowledge in history. Althusser's next major pronouncement, the ISAs, can therefore be seen as a response to political questions raised by the May events (why the revolt began in the schools, etc.), as well as a continuation of the questions raised in *Philosophie spontanée* about the provenance of theoretical knowledge from within ideology. Far from producing 'incoherence' with the theory of *Reading Capital,* as Anderson has it, the conception of the subject produced in the ISAs situates the production of knowledge, including the knowledge that *Reading Capital* itself produced, within the general field of social relations as Althusser has formulated them. Like the 'specific structures of historicity' themselves, which Althusser had theorized as complex structures in dominance, theoretical conjunctures too (for example, Marx's discovery of historical materialism)[28] were now seen to be overdetermined. They were understood to be neither the direct expression of political struggles waged elsewhere, nor simply the result of a rational progress within the history of the theory, but *interventions* in ongoing political struggles *at the level of theory.* Althusser's own retrospective on his theoretical development emphasizes this view pointedly:

A philosophy does not make its appearance in the world as Minerva appeared to the society of Gods and men. It only exists in so far as it occupies a position, and it only occupies this position in so far as it has conquered it in the thick of an already occupied world. It therefore only exists in so far as this conflict has made it something distinct, and this distinctive character can only be won and imposed in an indirect way, by a detour involving ceaseless study of other, existing positions ... If philosophy is, in the last instance, class struggle at the level of theory, as I have recently argued, then this struggle takes the form, proper to philosophy, of theoretical demarcation, detour and production of a distinctive position. To prove it, I need only refer, aside from the whole of philosophical history, to Marx himself, who was only able to define himself by reference to Hegel and by marking himself off from Hegel. And I think that, from afar, I have followed his example, by allowing myself to refer back to Spinoza in order to understand why Marx had to refer back to Hegel.[29]

28. See Louis Althusser, 'On the Evolution of the Young Marx', in idem, *Essays in Self-Criticism*, trans. Grahame Lock (London, 1976), pp. 151-61.
29. Althusser, *Essays in Self-Criticism*, pp. 165-6.

Althusser continued to teach through the seventies, carrying on what must have been an increasingly lonely theoretical battle inside an educational apparatus that was moving further and further to the right. His students, meanwhile, taught as well, while producing the studies Anderson cites and others he does not. Rather than proclaiming the 'progressive effacement and dissolution of Althusserian Marxism, as a current, by the mid-seventies' in France, it would be more just to say that what ensued after the tremendous *éclat* which greeted the birth of Althusserianism in the mid-1960s was a slow, patient consolidation of its gains, and a series of projects extending the range and instances to which Althusserianism could be said to apply (notably the economy in the early work of Aglietta). And this, we may say by way of conclusion to our consideration of Althusser, is just what is to be expected of any progressive research programme: the long labour of testing its hypotheses and expanding its purview.[30]

So we return to that 'Archimedean vantage-point' of historical materialism which Perry Anderson asserts it 'has no reason to abandon'. If Marxism is 'the search for subjective agencies capable

30. Some indication of the continuing importance of Althusserianism to current Marxist theory and of the fertility in Marxist historical studies modelled, either explicitly or implicitly, on Althusserian concepts can be gleaned from the following recent examples of historical monographs dealing with markedly disparate topics. Mike Davis's *Prisoners of the American Dream: Politics and Economy in the History of the U.S. Working Class* (London, 1986) outlines an Althusserian history of class struggles in the US by analyzing the shifting balance of class forces from the late 19th century through the Reagan revolution. The theoretical armature for this analysis draws significantly on the work of the Althusser-inspired *Ecole de Régulation*, particularly on Aglietta and Lipietz. On another front, and inspired by a different strand of Althusserianism (Nicos Poulantzas), David Abraham's *The Collapse of the Weimar Republic: Political Economy and Crisis* (Princeton, 1981) charts the trajectory of fascism's rise to power in Germany in the decade from 1923 to 1933. The hallmark of Abraham's account is its rejection of uni-causal explanation in favor of a class fractional analysis of German politics during the period. From Abraham's study there emerges a picture of the Weimar Republic as a complex, overdetermined whole, a structure whose vector of development was far from certain up to the very eve of the Nazi seizure of power. Finally, and most massively of all, there is the signal example of Ken Post's monumental study of Jamaica, two volumes of which have been published to date: *Arise Ye Starvelings: The Jamaican Labour Rebellion of 1938 and Its Aftermath* (The Hague, 1978); and *Strike the Iron: A Colony at War – Jamaica, 1939-1945* (The Hague, 1981). The interest of Post's project, from our perspective, lies in its having effectively melded the narrative verve of Trotsky's *History of the Russian Revolution* with a structuralist model of class and mode of production. Althusser's own notorious blind spot on Trotskyism need not foreclose this coalescence in theoretical traditions.

of effective strategies for the dislodgement of objective structures', then after Althusser, it can be said that these 'subjective agencies' can — indeed must if Marxism is to retain its legitimate claim to be a science of the history of social formations — be analyzed as 'objective structures' in their own right. The concept of ideology opened up by Althusser's essay on ideological state apparatuses remains one of the most fruitful areas for research in contemporary Marxism. In order to advance towards the particular 'dislodgement of objective structures' which Marxism as a political practice has made its proximate goal, i.e., the transformation from capitalism to socialism, Marxists will have to continue to think strategically about the limits and possibilities of transforming existing ideological apparatuses in the capitalist states. There would seem no reason as yet for historical materialism to reject Althusser's Copernican revolution in this area. Its Galileo may yet be waiting in the wings.

9

Politics and Language:
Paul de Man and the Permanence
of Ideology

The decisive break with narrative totalization, we have claimed in
our previous two chapters, constitutes the most important
contribution of Althusserian theory to historical materialism.
Whereas in bourgeois aesthetics, the tendency has been to isolate
the products and the process of art from the more or less chaotic
events and forces of material history, Marxism has most often
conceived of history itself as a work of art, the product of human
ingenuity and will. For Sartre, Jameson, and many others, history
is an intentional structure which exhibits, in the long run, the kind
of purposiveness that is readily apparent in poetic wholes. In this
they scarcely differ from bourgeois humanists like Jauss and
Crane, whose concepts of history are also narrative and
teleological. To the extent that Althusser has laid the basis for a
definitive rupture with this notion of historical understanding, he
has recovered for Marxism the requisite starting-point for
materialist practice in the human sciences.

The next step on the road towards an authentically materialist
aesthetics would involve an interrogation of the concept of poetic
or aesthetic texts which would be entailed by a materialist theory
of historical artifacts. We have seen how formalist theory from
Aristotle down to Michael Riffaterre, in positing the unity and
homogeneity of poetic wholes, is compelled to overlook those
moments in a text when the self-identity of its structure is either
threatened or disrupted, when the epistemological assurance
which the aesthetic as a modality of understanding seems to
promise is undermined by the irresistible force of the text's
rhetorical motions. This defensive movement of understanding

which denies what the text itself says (e.g., in the steadfast refusal to acknowledge the incommensurability between the Apollonian and the Dionysian in Nietzsche's *Birth of Tragedy,* or in the resistance to the disruptive force of the word 'spell' in Hopkins's 'As kingfishers catch fire') we have termed, following Paul de Man, aesthetic ideology. Its continuing power over the theory of the arts should not be underestimated, for it remains the single most intractable obstacle in the path of a science of aesthetic texts.

Marxist literary criticism has often recognized its vocation in the unmasking of the ideological sources of literature, a critical practice given famous sanction by Marx's own critique of Sue's *Mystères de Paris* in *The Holy Family* and validated by such canonical moments in the Marxist tradition as Lenin's essays on Tolstoy, Lukács's attacks on naturalism and modernism, and the Frankfurt School's analyses of mass culture. This activity, while it is undoubtedly indispensable to any revolutionary project seeking to overthrow the hegemony of bourgeois ideology within contemporary culture, has generally failed to gain significant purchase on literature as a distinct, semi-autonomous social practice. The ideologues of conventional literary study have often been able to point, with some justice, to the fact that Marxist criticism in the arts overlooks the specificity of aesthetic practice when it characterizes this or that text or author in terms of the ideological project of an entire class. While it is certainly true that literary texts produced in capitalist societies are marked by and have generally promoted ideologies serving the interests of the bourgeoisie, it is less certain that the specificity of literature is susceptible to description in terms of a univocal ideological effect.

At this point the Althusserian concept of overdetermination intervenes as the crucial feature in a theory of aesthetic texts as historically produced and ideologically determined, and yet materially distinct from other products of social labor. Before turning to Althusser's own writings on art, however, it will be necessary to consider a mode of critical interrogation of texts that has, in Western Europe and the United States at any rate, achieved a notoriety and a power within the theory and criticism of the arts which Marxism itself can only (and on occasion openly does) envy. Deconstruction is widely recognized as an affront, even a threat to conventional humanistic pieties about the capacity of aesthetic texts to deliver us from the contingencies of history and the constraints of ideology. To the degree that it has partially dislodged aesthetic ideology from its dominating position within the academy, deconstruction can be said to have struck a crucial

blow on behalf of a materialist theory of art. The extent to which its project can be made to serve that of materialist aesthetics will be the burden of the following pages, while the limits of its conception of language vis-à-vis the materialist concept of history will bring this chapter to a close.

* * * * * * * * *

At the time of his death in December 1983, Paul de Man was at work on the theory of ideology in Marx, a project that was to complement several of his late essays on aesthetic theory in the age of Kant and Hegel. It was also related to another of his late papers on Benjamin's 'Die Aufgabe des Übersetzers', which was presented as the last of the Messenger Lectures de Man delivered at Cornell University early in 1983.[1] It is of course impossible to predict what the outcome of these investigations would have been, but there are some indications in the existing published texts, notably in the essay on Kleist from which we earlier quoted a passage on the relationship of aesthetics to politics (see chapter 1 above), of the direction de Man's research was taking. Sceptics have tended to dismiss de Man's late interest in Marx, referring to earlier pronouncements like the one quoted at the end of chapter 5 above to show that de Man's entire theoretical (or indeed personal) trajectory travelled in the opposite direction from politics. They assert that the mode of reading with which he became identified renders political engagement at best unlikely, at worst futile. Terry Eagleton's judgment speaks for the consensus among de Man's critics on the left:

> It is only by virtue of an initial Nietzschean dogmatism — practice is necessarily self-blinded, tradition necessarily impeding — that de Man is able to arrive at his politically quietistic aporias. Given these initial definitions, a certain judicious deconstruction of their binary opposition is politically essential, if the Nietzschean belief in

1. These essays will be published in two collections: Paul de Man, *The Aesthetic Ideology*, and idem, *The Resistance to Theory*, both from the University of Minnesota Press. Other texts by Paul de Man, unless otherwise indicated, will be cited parenthetically and identified by the following abbreviations: AR-*Allegories of Reading: Figural Language in Rousseau, Nietzsche, Rilke, and Proust* (New Haven, 1979); RR-*The Rhetoric of Romanticism* (New York, 1984); BI-*Blindness and Insight: Essays in the Rhetoric of Contemporary Criticism*, 2nd edn., revised (Minneapolis, 1983). The lecture on Benjamin has been published in *The Lesson of Paul de Man, Yale French Studies* 69 (1985), under the title ' "Conclusions": Walter Benjamin's "The Task of the Translator" '. Citations from this text are given parenthetically.

affirmative action is not to licence a radical politics; but such deconstruction is not permitted to transform the metaphysical trust that there is indeed a single dominant structure of action (blindness, error), and a single form of tradition (obfuscating rather than enabling an encounter with the 'real') ... De Man's resolute ontologizing and dehistoricizing of modernism ... is of a piece with the steady, silent anti-Marxist polemic running throughout his work...[2]

This view is injudicious on at least two counts. First, it assumes a direct, unilateral relationship between politics and theory which is, or ought to be, suspect among Marxists (although the example of Althusser's critics cited in chapters 7 and 8 suggests that Marxist credentials are no insurance against the premature reduction of a theoretical itinerary to the vicissitudes of immediate political concerns).[3] Secondly, it is astonishingly inattentive to de Man's texts, which, whatever else might be said about them, never lost sight of the political instance as a decisive feature in aesthetic or philosophical systems. From his early essays on Keats and Hölderlin and formalist criticism, down to the mature texts on Shelley, Kleist, and Rousseau, de Man never ceased to meditate upon the concepts of history, politics, and ideology which are at the centre of Marxist theory.

Still, one would certainly concede that the obstacles standing in the way of a political reading of de Man's work are not negligible. The privileged term in the de Manian lexicon is clearly not history,

2. Terry Eagleton, 'Capitalism, Modernism and Postmodernism', in idem, *Against the Grain: Essays 1975-1985* (London, 1986), pp. 137-8. The same overall judgment is advanced elsewhere in the same volume in Eagleton's essay on William Empson, 'The Critic as Clown' (pp. 158, 160-1, 165), and also in Eagleton's *The Function of Criticism* (London, 1984), pp. 101-2. See also Frank Lentricchia, *After the New Criticism* (Chicago, 1980), pp. 310-11, 317; and idem, *Criticism and Social Change* (Chicago, 1983), pp. 38-52. Even sympathetic commentators have been inclined to attribute to de Man an unmitigated hostility towards historical inquiry. For example, Andrew Parker has written: 'de Man tends to consider history *singly* in its negative, "metaphysical" sense as that which always assures a final suppression of *différance* — a tendency that ultimately will incline him to reformulate the question of history as a function of a certain negative epistemology ...' (' "Taking Sides" [on history]: Derrida Re-Marx', *Diacritics* 11 [Fall 1981]: 68).

3. We may now restore one of the omitted portions from the passage cited above in which Eagleton dismisses de Man's political project as anti-Marxist in its motivation: 'The Marxism of Louis Althusser comes close to this Nietzscheanism: practice is an "imaginary" understanding, theory a reflection upon the necessary fictionality of such action. The two, as with Nietzsche and de Man, are ontologically disjunct, necessarily non-synchronous' (*Against the Grain*, p. 138). See also p. 160 in the same volume.

much less politics, but language. So much is apparent from even some of the earliest essays. The development of de Man's project, from his youthful association with the Parisian intellectuals gathered around *Critique*, to the decisive engagement with Derrida over the last fifteen years of his life shifted focus more than once. But de Man remained remarkably consistent in tracking the evasions of the linguistic dimension of literary and philosophical texts characteristic of the overwhelming bulk of modern literary criticism and theory. Wherever one's reading of de Man may finally come to rest, it cannot but commence with the concept of language presented in his mature writings. Our surmise is that, to paraphrase Marx, the anatomy of language in de Man's texts will prove the key to the anatomy of his politics — a politics quite different from the supposed quietism with which he has often been impugned.

* * * * * * * * * *

The point at which one begins the investigation of a theoretical problematic is never innocent or free from prior determinations. Our decision to open a reading of de Man's corpus with a passage from one of the final essays he produced is no exception to this rule. Whether or not the choice is judicious, the temptation to privilege the last utterances of an author is very strong indeed. When the text in question is itself a meditation upon another text whose explicit topic is the theory of language, one can scarcely avoid citing it as the definitive formulation of an authentically linguistic philosophy governing the whole of this author's *oeuvre*.

De Man's essay on Benjamin's 'The Task of the Translator' closes with the following lapidary formulation concerning the relationship between the Benjaminian theory of language and the supposed messianism which has been a dominant theme in recent European and North American reception of Benjamin:

> The non-messianic, non-sacred, that is the political aspect of history is the result of the *poetical* structure of language, so that political and poetical here are substituted, in opposition to the notion of the sacred. To the extent that such a poetics, such a history, is non-messianic, not a theocracy but a rhetoric, it has no room for certain historical notions such as the notion of modernity, which is always a dialectical, that is to say an essentially theological notion. (Conclusions, 46; emphasis in the original)

This passage condenses an essential and recurrent theme in de

Man's work, in particular his long-standing suspicion of the appropriateness of concepts of historical periodization for understanding literature.[4] What is most noteworthy here, however, is not the more familiar, although characteristically misunderstood, opposition between literary language and historical understanding that de Man often cites as constitutive of the pattern of blindness and insight or resistance to theoretical rigour in most literary criticism, but the explicit equation of the political with the poetic. The assertion of what de Man would once, in more programmatically Heideggerian terminology, have called the authentically temporal destiny of literature is in this late text not opposed to political *praxis*, but rigorously identified with it. More striking still is that the irreducible politicality of poetic language is attributed to a writer whose interest in theological notions of history and language is well attested, and whose concerns in 'The Task of the Translator' would seem the very opposite of those proposed by de Man. Finally, and perhaps what could least have been anticipated, de Man's reading of Benjamin resembles nothing so much as the most iconoclastic and self-confessedly tendentious among recent commentaries on Benjamin's work: Terry Eagleton's *Walter Benjamin, or Towards a*

4. The most celebrated moment in this regard is probably the passage from 'Literary History and Literary Modernity' quoted above at the end of chapter 5, but other citations from every period of de Man's writings could be readily invoked — e.g., the following two from among his latest and earliest writings, respectively: 'The terminology of traditional literary history, as a succession of periods or literary movements, remains useful only if the terms are seen for what they are: rather crude metaphors for figural patterns rather than historical events or acts' (RR,254); 'Strictly speaking, Marxist criticism is not historical for it is bound to the necessity of a reconciliation scheduled to occur at the end of a linear temporal development, and its dialectical movement does not include time itself as one of its terms. A truly historical poetics would attempt to think the divide in truly temporal dimensions instead of imposing upon it cyclical or eternalist schemata of a spatial nature' (BI,242). Eagleton is thus not entirely wrong to insist upon the opposition between de Man and a certain Marxism (and it is indeed the very essay just cited, 'The Dead-End of Formalist Criticism', which he takes to task for its illicit ontologizing of Marxist historicism). He is merely too peremptory in his judgment that de Man's work was from beginning to end implacably opposed to the basic tenets of historical materialism.

Periodizing de Man's project is a tricky business. My inclination is to see it in a manner similar to that proposed in the previous chapter apropos of Althusser: i.e., as the unfolding of a continuous problematic which, while it was not without shifts in emphasis and terminology, nevertheless exhibited a remarkable consistency of purpose and aim. A provisional attempt at characterizing differences between 'early' and 'late' de Man has been undertaken by Jacques Derrida in his Wellek Library lectures, *Memoires: For Paul de Man* (New York, 1986).

Revolutionary Criticism. De Man's silence over Eagleton's parallel intervention was undoubtedly deliberate, for he certainly knew Eagleton's book. It raises the possibility that the real opponent in this highly polemical piece is not the acknowledged targets of Benjamin's French and English translators, still less the openly theological appropriation of Benjamin by Geoffrey Hartman, but the more theoretically formidable opponent of a certain concept of historical materialism and the humanist and voluntarist ideology of history and politics which has often been promulgated in its name. Tracking the parallel itineraries of de Man and Eagleton interpreting Benjamin will allow for the explicitation of the former's conception of language and politics in relation to that form of Marxism which de Man had opposed from his earliest essays.[5]

At the outset, de Man and Eagleton would appear to have undertaken diametrically opposed tasks. Eagleton openly confesses his refusal to explicate or produce a scholarly commentary on Benjamin's texts; his tactic is rather 'to manhandle them for my own purposes, blast them out of the continuum of history, in ways I think [Benjamin] would have approved'.[6] De Man, by contrast, commences his exegesis of 'The Task of the Translator' with what he calls 'the simplest, the most naive, the most literal of possible questions in relation to Benjamin's text ...: what does Benjamin say?' (Conclusions, 32). But de Man's humility in undertaking such a mundane job of paraphrase and textual explication soon runs up against the most complicated and irresolvable of dilemmas, revealing semantic depths in even apparently straightforward locutions — for example, in the rendering of Benjamin's German *übersetzbar* (translatable) in Gandillac's French version as *intraduisable* (untranslatable). The problem of translating Benjamin and therefore of construing him on even the literal level, turns out to be

5. See ' The Dead-End of Formalist Criticism', especially the passage cited in the prevous note and de Man's comment on Empson some pages earlier (BI, 240). The mediating figure between these utopian (or pastoral) versions of Marxism and de Man's more authentically materialist conception of history is Heidegger, as Wlad Godzich points out in his introductory essay to *The Resistance to Theory*, 'The Tiger on the Paper Mat'. De Man's formation by the French Heideggerians during the late 1930s is ably discussed in Allan Stoekl, 'De Man and the Dialectic of Being', *Diacritics* 15 (Fall 1985): 36-45. Stoekl's essay definitively refutes Lentricchia's view that de Man's work continues the problematic of the early Sartre and something called 'French existentialism'.

6. Terry Eagleton, *Walter Benjamin, or Towards a Revolutionary Criticism* (London, 1981), p.xi; hereafter cited parenthetically as WB.

a far from easy matter, and, as de Man observes, this is what 'The Task of the Translator' itself has argued: 'The text about translation is itself a translation, and the untranslatability which it mentions about itself inhabits its own texture and will inhabit anybody who in his turn will try to translate it, as I am now trying, and failing, to do. The text is untranslatable, it was untranslatable for the translators who tried to do it, it is an example of what it states, it is a *mise en abŷme* in the technical sense, a story within the story of what is its own statement' (Conclusions, 39). It may be, then, that Eagleton's 'manhandling' and craven appropriation of Benjamin's texts is no less faithful to their meaning than the most rigorous of scholarly exegeses. Eagleton's deployment of Benjamin in the service of producing a contemporary 'revolutionary criticism' is merely the positive enactment of the distorting negativity that characterizes all textual inter-pretation.

But it is not only that Eagleton has more or less unwittingly (if one is to take at face value his acerbic differentiation of the spirit of Benjamin's project from that of deconstruction, in particular his hasty remarks on de Man's conception of rhetoric and its incompatibility with materialism; see WB, 108-9) reproduced the very process of translation which de Man claims Benjamin's essay proposes. De Man and Eagleton share the further suspicion that the interpretation of Benjamin hangs on the question of the latter's 'messianism', and that in taking this aspect of Benjamin's thought uncritically most of his readers have gone wrong. Eagleton's pronunciamento, while it lacks some of the finesse with which de Man negotiates the same ground, is not out of tune with the passage cited earlier from de Man on the thoroughly secularized concept of history that is at work in Benjamin's texts: 'There is no way in which the apocalyptic aspects of Benjamin's historical imagination may be neatly harmonized with his Marxism, though the struggle to reconcile them, or to reduce him to either pole, will doubtless continue' (WB, 81).[7] The importance of Benjamin lies in the pertinence of his historical thought to Marxism and in the example he offers of a rigorous resistance to the seductions of historical totalization and the concept of history as narrative.

The crux of Eagleton's argument is summarized in several pages that outline the competing conceptions of history available within

7. Eagleton himself has been accused of just such a reduction in the direction of a crass subservience to immediate political goals; see Marcus Bullock's review of *Walter Benjamin* in *minnesota review* N.S. 18 (Spring 1982).

the Marxist tradition. Recognizing that Marx himself was scarcely untainted, particularly in his earlier writings, by the image of history as an unfolding teleological narrative, Eagleton contrasts this view of history with the more mature (and more authentically materialist) concept adumbrated in the *Grundrisse* and in the *Eighteenth Brumaire*. In the latter text, Marx contrasts the historical philosophy characteristic of bourgeois revolutions (taking their poetry from the past) with the materialist position achieved by socialist revolution (which takes its poetry from the future). Bourgeois historicism projects the outcome of the revolutionary process as a continuation of the temporal order of the present, while materialism posits the necessity of a radical break with the past that precludes its being represented in a narrative:

> For Marxism ... the 'text' of revolutionary history is not foreclosed ...; it lacks the symmetrical shape of narrative, dispersed as it is into a textual heterogeneity ('the content goes beyond the phrase') by the absence around which it turns — the absence of an *eschaton* present in each of its moments. The authority of socalist revolution, then, is not to be located in the past, least of all in the texts of Marx himself, but in the intentionality of its transformative practice, its ceaseless 'beginning'. (WB,68-9)

This properly Marxist conception of history is explicitly linked to the practice of a materialist (and thus, *ex hypothesi*, revolutionary) criticism: 'Historical materialism stands to its object somewhat as a materialist criticism stands to its text. Its task is to refuse the phenomenal coherence of that text's narrative presence so as to expose the generative mechanisms that produce its repressed heterogeneity' (WB,69). Leaving aside for the moment the obvious source of this view of Marxist historical science in Althusser (whose conception of differential historical temporalities is later acknowledged, albeit not without some nervousness; WB,70-1), we note the unexpected congruence between what Eagleton here calls a materialist criticism and the notion of translation adumbrated in 'The Task of the Translator'. For in that text, Benjamin is quite explicit about the non-coincidence between translation and original (which, as de Man observes, renders the task of translating any text an impossibility), and this in part for explicitly temporal reasons: 'For a translation comes later than the original, and since the important works of world literature never find their chosen translators at the time of their origin, their translation marks their

stage of continued life.'[8] Nor is this imaging of translation in terms of the continuing life of the original anything to do with the organic model of the historical transmission of artifacts which we noticed in chapter 2 and which has been most fully exploited in the works of *Rezeptionsgeschichte*. History is the key to understanding the structure of life, not the other way round, Benjamin avers: 'The idea of life and afterlife in works of art should be regarded with an entirely unmetaphorical objectivity ... In the final analysis, the range of life must be determined by history rather than by nature, least of all by such tenuous factors as sensation and soul. The philosopher's task consists in comprehending all of natural life through the more encompassing life of history.'[9] Benjamin's notion of translation is precisely an instance of the materialist practice of criticism which Eagleton projects in his book; it refuses the phenomenal appearance of the text, and is governed by laws other than those of a historicist hermeneutic in which the present has emerged organically from the embryonic condition of the past.

But surely translation only *resembles* history in this regard. Is it not a category mistake to confuse the specifically linguistic process of translation with the material process of history? The problem can be restated as follows: is the discrepancy between a translation and its original the result of the temporal dislocation in the system of language (*langue*) caused by the material factors of social change, or does the demonstrable historicity of the natural languages (of which translation is one instance) derive rather from intra-linguistic principles that determine the non-coincidence between any utterance and its interpretation? Without trying to answer this question definitively (the standard, hasty Marxist retort, 'It is not the consciousness of men that determines their being, but their social being that determines their consciousness', merely restates it in another mode without solving the difficulty), one can say that for Benjamin the condition of historicity governing the nature of translation is a fact of language. The historical difference between translation and original derives from an internal divergence within language as a semantic system. The system of language can never be self-identical. De Man's commentary makes this point unequivocally:

8. Walter Benjamin, 'The Task of the Translator', in idem, *Illuminations*, trans. Harry Zohn (New York, 1969), p. 71.

9. Ibid. De Man comments on this passage: 'To understand the importance of this pattern would be the burden of any reading of this particular text' (Conclusions, 36). See also Jacques Derrida, 'Des Tours de Babel', trans. Joseph F. Graham, in *Difference in Translation*, ed. Graham (Ithaca, 1985), pp. 178-83.

Now it is this motion, this errancy of language which never reaches the mark, which is always displaced in relation to what it meant to reach, it is this errancy of language, this illusion of a life that is only an afterlife, that Benjamin calls history. As such, history is not human, because it pertains strictly to the order of language; it is not natural, for the same reason; it is not phenomenal, in the sense that no cognition, no knowledge about man, can be derived from a history which as such is purely a linguistic complication; and it is not really temporal either, because the structure that animates it is not a temporal structure. Those disjunctions in language do get expressed by temporal metaphors, but they are only metaphors. The dimension of futurity, for example, which is present in it, is not temporal, but is the correlative of the figural pattern and the disjunctive power which Benjamin locates in the structure of language. History, as Benjamin conceives it, is certainly not messianic, since it consists in the rigorous separation and the acting out of the separation of the sacred from the poetic ... (Conclusions, 44-5)[10]

De Man's assertion will sound immediately scandalous to historical materialist ears. It would seem to open him up to all the charges of anti-Marxism and ultimately of political quietism that Eagleton and others have laid at his feet. The claim that 'history is not human, because it pertains strictly to the order of language' would seem to fly in the face of any conception of revolutionary historical change, which remains the goal and the foundation of Marxist politics. But if we bracket momentarily the problematic term 'language' (for it is far from clear yet what is meant by this

10. Leaving aside the slight ambiguity in his use of the term 'translation' as well as the complex problem of the non-temporality of translation asserted by de Man, Rodolphe Gasché's summary of de Man's notion of the text formulates with great precision the temporal structure of meaning recommended in the passage just quoted: 'A text from this perspective represents the temporal process of detotalizing operations, of de-translations of totalizing translations or metaphorical substitutions. Within a text there is no translation from one moment to another. A text is constituted by the repetitive deferral of its translations' ('"Setzung" und "Übersetzung": Notes on Paul de Man', *Diacritics* [Winter 1981]: 48).

The equivalence suggested in the commentary on Benjamin here, which could be supported by citations elsewhere in Benjamin himself (notably in his *Theses on the Philosophy of History*), between the historical and the contingent recurs throughout de Man's work. See, for example: 'Introduction', John Keats, *Selected Poetry* (New York, 1966), p. xxi; 'Shelley Disfigured', in RR,122. More recently, this theme has been linked to the materiality of signs, their random and irresistible disruption of phenomenal and semiotic systems of controlled meaning. See: 'Hypogram and Inscription: Michael Riffaterre's Poetics of Reading', *Diacritics* 11 (Winter 1981): 27-35; 'Phenomenality and Materiality in Kant', in Gary Shapiro and Alan Sica, eds., *Hermeneutics: Questions and Prospects* (Amherst, 1984), p. 144.

key concept in the de Manian lexicon), de Man's assertion of the inhumanity of history may not prove incompatible with a certain Marxism, for it claims no more than: 'history is a process without a subject or goals'. Further, the apparent appeal to timeless processes (history is not a temporal structure) can be translated (in a non-Benjaminian sense of the term) into another Althusserian slogan: 'Ideology has no history.' The permanence of ideology and the exogenous position of history in relation to the power of human will are admittedly not uncontroversial principles within historical materialism, but it is surely too soon to declare them un- or anti-Marxist *tout court*.

We are not claiming any simple identity between the de Manian concept of language and the Althusserian deconstruction of Marxian humanism, although the theoretical itinerary of each will bear further comparison (undertaken in the following section of this chapter). But we are contending that the emergence of an anti-historicist concept of history in de Man's exposition of Benjamin's theory of language can be squared with the materialist conception of history and the theory of revolutionary *praxis* which Eagleton's rather different account of Benjamin's anti-historicism recommends.

Eagleton closes his book with one of his boldest innovations in historical criticism: the explicit comparison of Benjamin with Trotsky, and the attribution to Benjamin of the equivalent to the theory of permanent revolution. Eagleton's account of this concept foregrounds what will become in the language of later Marxist theory (to which Eagleton's own earlier work, especially *Criticism and Ideology* and *Myths of Power*, owes a considerable debt) the notion of overdetermination, or what in Trotsky's terms was the 'combined and uneven development' of the Russian social formation that rendered it ripe for revolutionary transformation during the second decade of the 20th century:

> The proletariat, assuming leadership of the bourgeois-democratic revolution in hegemonic alliance with other subordinated classes and groups, releases the dynamic that will carry the revolution beyond itself into workers' power. The epochal strata laid neatly end to end in an official Marxist imagination are seized and stacked rudely one upon the other, transfiguring the geology of revolution by a violent upheaval ... With its eyes turned towards the future, the revolution makes a tiger's leap into the past — the archaic feudalism of Tsarist Russia — in order to configurate it violently with the present. The result, as Benjamin notes in his essay on Moscow, is a 'complete interpenetration of technological and primitive modes of life.' A ripe

moment of the homogeneous time of bourgeois revolution becomes the strait gate through which the proletariat will enter, the *Jetztzeit* in which differential histories — feudalist, bourgeois-democratic, proletarian — are impelled dramatically into contradictory correspondence. (WB,178)

For Trotsky (and Lenin), this event emerged punctually in Russia, but as the historical process which 'permanent revolution' came to designate was generalized across the theory and practice of historical materialism, it was transformed into a concept for the analysis of political and historical conjunctures of distinctly different types and rhythms. This is to say that permanent revolution, like the universal principle of disruption in the linguistic field of translation elaborated by de Man, passes from the phenomenal or empirical level of observation to the theoretical domain of scientific concepts and hypotheses. Eagleton's precipitous judgment on de Man effectively repeats the comparable charge laid at the feet of Althusser by Edward Thompson: both instance that resistance to theory which de Man has noticed as a constitutive tension within the domain of theory itself.[11]

Finally, it is important to note that in the passage just cited, the 'official Marxist imagination' against which Trotsky's theory is aimed is scarcely to be distinguished from the Marxism that de Man consistently criticized throughout his career, even if the name of Stalin never (to my knowledge) occurs in de Man's writings. The eschatological or teleological conception of history that has served Marxist ideology from the *Communist Manifesto* down to Jameson and Sartre can be shown to operate in theoretical speculation generally, just as the explicitly political consequences of such a theory of history (on which Althusser has commented with some acerbity; see above, chapter 7) arise from conceptual problems that run deeper than the immediate experiences of this or that political struggle can hope to master. If the 'text' of revolution (Eagleton's own term; WB,179) is to be understood in its full theoretical and practical complexity, it may be necessary to consider those aspects of explicitly political texts that appear least likely to yield immediate political insights. The site of political engagement need not always be 'the streets'. In the de Man *oeuvre*, no site is more embattled and none more theoretically and

11. See de Man, 'The Resistance to Theory', in *The Pedagogical Imperative: Teaching as a Literary Genre, Yale French Studies* 63 (1982): 3-22.

practically fruitful than that designated by the name 'Rousseau'.

* * * * * * * * * *

De Man's lengthy meditation on Rousseau comprises more than half of *Allegories of Reading*. It opens with a reading of the *Discourse on the Origin and Foundations of Inequality among Men* (1754), which in turn commences by recounting the difficulty of situating this text within the Rousseau canon. The *Discourse on Inequality* crystallizes a set of problems presented to interpreters by the whole of Rousseau's writings involving the intersection of specifically linguistic questions (the origin of language) with programmatically political subject matter. At stake in the reading is the relation of Rousseau's literary to his political texts, and the consequent division of labour that has been imposed on Rousseau's commentators who hail from different disciplines. The split is apparent in the *Discourse* in the contradictory attitudes displayed by Rousseau with respect to 'the inescapable *a priori* of the text itself, what Rousseau calls the "state of nature" ' (AR,136). De Man comments: 'Rousseau seems to want to have it both ways, giving himself the freedom of the fabulator but, at the same time, the authority of the responsible historian' (AR,137). De Man observes that this is a recurrent judgment in the history of Rousseau interpretation and cites as a typical contemporary instance the conclusion to Althusser's essay on *Du contrat social,* where it is argued that the entanglement of Rousseau's writings in literature necessitates their failure as guides to political action — there is no conceivable pathway from the ultimately circular displacement of the ideology of the text to the real world. This reading has been historically productive because it allows one to link fictional (including autobiographical) texts to political texts via psychological categories like repression (for literature represses the real contents of the world in its *mimesis,* as is already plain in Aristotle's *Poetics,* 1447a.10-14, 1460b.14-21) and transference (Althusser's term). De Man observes that the *Discourse on Inequality* offers an especially useful instance of this aspect of Rousseau's writings in the contradiction between Parts I and II. The bifurcation in the intent of the text would appear to convict Rousseau of just that inconsistency which has been noticed by his detractors and admirers alike and which has been taken as possibly the most distinctive feature of his thought. De Man's reading of the *Second Discourse* (and, by extension, of the entire Rousseau canon) commences by putting this interpretation into question.

We shall first want to follow closely the steps in de Man's argument in order to see how he establishes the underlying coherence of Rousseau's text through the latter's presentation of the tension between figural and literal language. But we shall want to return at the end of this exposition to de Man's summary dismissal of Althusser, and, which is part of the same problem, to Althusser's reading of Rousseau. Above all, we should wish to consider more carefully what de Man rightly calls the 'complex relationship between Rousseau's and Marx's economic determinism' in light of de Man's assertion that 'Althusser remains short of Engels' treatment of Rousseau in the *Anti-Dühring*' (AR,158). To do so, we must treat in combination de Man's separate accounts of the *Discourse on Inequality* and the *Social Contract,* and the linguistic and political concepts that these two readings articulate.

The first steps in de Man's exposition are readily summarized. In the first part of the *Discourse on Inequality,* Rousseau characterizes the state of nature in dynamic terms, for man possesses preeminently the transgressive power of freedom. This Sartrean moment in Rousseau does not lead, as it does in Sartre, directly to the political discussion in the second part of the essay. No 'rationally enlightened anthropology' (AR,141) can be generated from the concept of freedom adumbrated in Part I of the *Discourse.* This is why the text must 'leap into fiction, since no past or present human action can coincide with or be under way towards the nature of man' (AR,141). The question then remains why Part II returns to a straightforward referential vocabulary that establishes normative conditions for human action, after the authority of such concepts has been explicitly denied in Part I. De Man's pragmatic solution to this textual crux is to focus on the section on language, which has been generally overlooked in political commentaries on the *Discourse.* Anticipating a bit, we may cite de Man's programmatic conclusion about the relationship between the digression on language and the political judgments of this text: 'the system of concepts at work in the political parts of the *Second Discourse* are structured like the linguistic model described in the digression on language. This makes the passage a key to an understanding of the entire text. For nowhere else do we find as detailed a structural analysis of the concepts involved in the subsequent narrative' (AR,143).[12] The

12. The decision to focus on this part of the *Discourse* is scarcely fortuitous. De Man's entire reading of Rousseau is conditioned by the prior history of Rousseau interpretation from Schiller down to Starobinski and Grosrichard (and of course

seemingly disparate domains of language and politics are articulated via the nature of conceptualization.

In the digression on language, Rousseau 'explicitly links language to the notion of perfectibility, itself derived from the primal categories of freedom and will' (AR,142). Perfectibility can be understood in two ways: either as a single quality which is characteristic of man and which he possesses by virtue of his language; or as a variety of qualities of which the linguistic (man's special power) is one. The crucial sentence in Rousseau reads as follows: 'C'est une des raisons pourquoi les animaux ne sauraient se former de telles idées, ni jamais acquérir la perfectibilité qui en dépend.'[13] De Man's commentary establishes the basis for his argument: 'Since the French language does not distinguish between "which" and "that," it is impossible to decide by grammatical means alone whether the sentence should read: "animals could never acquire perfectibility, since perfectibility depends on language" or, as Starobinski would have it, "animals could never acquire the kind of perfectibility that depends on language" ' (AR,143). If we take the former reading as the correct one, then language becomes decisive for all other features of human life and activity. The 'specifically linguistic act of conceptualization' (AR,144) separates men from animals (whose conceptualizing powers are sense-dependent). What distinguishes man in the state of nature from other species is his language, the source of all cognition that is not purely sensory.

But language itself is far from a univocal concept in Rousseau's text. Rousseau distinguishes two kinds of linguistic acts: denomination, which is literal or referential (the designation of things by their proper names or nouns: this particular tree as opposed to that one); and conceptualization, which is figurative, connotative, metaphorical. Moreover, in this text Rousseau quite clearly valorizes one mode of language with respect to the other: 'Since Rousseau asserts the temporal priority of the proper noun

Althusser). In the case of the present text, the crucial background is Derrida's reading of Rousseau in *De la grammatologie*, as well as de Man's own riposte to Derrida, 'The Rhetoric of Blindness', (BI, 102-41). As Wlad Godzich points out, the account of Rousseau's theory of metaphor in *Allegories of Reading* differs somewhat from that in 'The Rhetoric of Blindness'; see Godzich, 'The Domestication of Derrida', in *The Yale Critics: Deconstruction In America*, ed. J. Arac, W. Godzich, and W. Martin (Minneapolis, 1983), p. 40, n. 21.

13. Rousseau, *Discours sur l'origine et les fondements de l'inégalité parmi les hommes*, in J.-J. Rousseau, *Oeuvres complètes*, ed. Bernard Gagnebin and Marcel Raymond, vol. 3 (Paris, 1964), p. 149.

over the concept ..., it would indeed follow, within the genetic logic of the narrative, that he separates the literal from the metaphorical forms of language and privileges the former over the latter' (AR,146). But such a valorization of the literal over the figurative leads to the same incoherence in the text of the *Discourse* noted earlier, since the temporal priority of the literal to the metaphorical turns what is per definition only a figurative concept (the state of nature) into a real thing (i.e., a guide to the structures of civil society). This impasse, which has plagued Rousseau interpretation for some 200 years (the tendency is already apparent in Schiller's references to Rousseau in *Über naïve und sentimentalische Dichtung*), would seem insurmountable from within the conceptual structure of the *Discourse on Inequality*. Furthermore, the pattern is apparently repeated in the relation between the passages on the origin of language in the *Discourse* and the corresponding passages in the *Essai sur l'origine des langues*. For the latter asserts unequivocally that the first language was figural, in opposition to the former's equally unequivocal statement that the first language (individual words) was literal (denominative, or proper nouns). The apparent contradiction can only be resolved by means of a long demonstration of the claim which de Man makes summarily: 'It is impossible to say whether denomination is literal or figural' (AR,148). The steps in this argument must be traced with some care.

De Man's exposition of the *Essay* focuses on the third section and the example given there of the origin of the proper name *man*. The choice is hardly innocent, since this is the very concept that is so crucially at stake in the *Discourse*, a text which defeats the project of anthropology in its disruption of genetic totalizing schemes of human history. In brief, Rousseau's little fable imagines primitive man alone encountering other men, whom the primitive instantly and instinctively fears, labelling them 'giants'. The act of denomination, which in the *Essay* is said to be figural, 'displaces the referential meaning from an outward, visible property to an "inward" feeling. The coinage of the word "giant" simply means "I am afraid" ' (AR,150). But this fear cannot be based upon observable phenomena (the men encountered are *ex hypothesi* of similar size and comparable strength to the observer). Fear, or indeed any passion in Rousseau, is 'the result of a possible discrepancy between the outer and the inner properties of entities ... [it is] based not on the knowledge that such a difference exists, but on the hypothesis that it might exist, a possibility that can never be proven or disproven by empirical or by analytical means.

A statement of distrust is neither true nor false; it is rather in the nature of a permanent hypothesis' (AR,150). Rousseau's use of this example to illustrate the metaphorical origin of language suggests that fear itself is figural, for it expresses a comparison between two entities, however ill-founded the comparison may prove in the end. But the act of denomination which results from it (the naming of the other man 'giant') 'freezes hypothesis, or fiction, into fact and makes fear, itself a figural state of suspended meaning, into a definite, proper meaning devoid of alternatives' (AR,151). Denomination, which the *Discourse* had placed as temporally prior to figuration, turns out to be derived from a figural representation. This reading resolves the discrepancy between the *Discourse* and the *Essay* in terms of the logical priority of the latter over the former.

But as readers of Rousseau know full well, the parable does not stop here. The first impressions of the primitive are, Rousseau states, subsequently modified by further experience, such that the denominative, proper word 'giant' is ultimately transformed into the general concept 'man', and this because the primitive comes to observe that the men whom he had feared turn out to be neither larger nor stronger than himself. This comparison is not necessarily reliable: relative size has nothing to do with potential danger. Thus the calculation which transforms 'giant' into 'man' is itself just as figural or metaphorical as the original denomination which expressed the fear of the primitive in the word 'giant'. De Man comments: 'The second level of aberration stems from the use of number as if it were a literal property of things that truly belongs to them when it is, in fact, just one more conceptual metaphor devoid of objective validity and subject to the distortions that constitute all metaphors. For Rousseau, as for Nietzsche, number is par excellence the concept that hides ontic difference under an illusion of identity. The idea of number is just as derivative and suspect as the idea of man' (AR,154).

But the result of this motivated distortion (what for Rousseau is the literary or rhetorical use of the original figure; AR, 154-5) is nothing less than the possibility of human society: 'the invention of the word man makes it possible for "men" to exist by establishing the equality within inequality, the sameness within difference of civil society, in which the suspended, potential truth of the original fear is domesticated by the illusion of identity. The concept interprets the metaphor of numerical sameness as if it were a statement of literal fact. Without this literalization, there could be no society ... Society originates with the quantitative

comparison of conceptual relationships' (AR,155). Rousseau is quite explicit on this point in the *Discourse*, in a passage (3: 165-6) which de Man cites and then comments upon thus: 'The passage describes precisely the same interplay between passion (fear), measurement, and metaphor (inferring invisible properties by analogy with visible ones) as the parable from the *Essay on the Origins of Language* [sic]' (AR,156).[14] The structural homology between the two passages leads de Man to conclude that for Rousseau 'the political destiny of man is structured like and derived from a linguistic model that exists independently of nature and *independently of the subject*: it coincides with the blind metaphorization called " passion," and this metaphorization is *not an intentional act*. Contrary to what one might think, this enforces the inevitably "political" nature, or, more correctly, the "politicality" (since one could hardly speak of "nature" in this case) of all forms of human language, and especially of rhetorically self-conscious or literary language — though certainly not in the representational, psychological, or ethical sense in which the relationship between literature and politics is generally understood' (AR,156; emphasis added).

De Man's discovery of the constant articulation of language with society in Rousseau, which enables his claim that society is not the product of a willing subject but of a structural potential inherent in the human power to use language (and thus to engage in cognition), leads him to conclude (for Rousseau at least) that political action cannot be epistemologically assured in its outcome. To the degree that literature is, perhaps, the most rhetorically and epistemologically sophisticated mode of language use, it is therefore the most politically consequent of any mode of discourse. It will not be amiss at this point in the argument to remind the reader that much the same conclusions are drawn by Althusser at various points in his exposition of Marx. Like de Man, he maintains: '*ideology is as such an organic part of every*

14. Rousseau's text reads as follows: 'Cette application réiterée des êtres divers à lui-même, et les uns aux autres, dut naturellement engendrer dans l'esprit de l'homme les perceptions de certains rapports. Ces relations que nous exprimons par les mots de grand, de petit, de fort, de faible, de vite, de lent, de peureux, de hardi, et d'autres idées pareilles, comparées au besoin, et presque sans y songer, produisirent enfin chez lui quelque sorte de réflexion, ou plutôt ne prudence machinale qui lui indiquait les précautions les plus nécessaires à sa sûreté ... Les conformités que le temps put lui faire appercevoir entre eux, sa femelle et lui-même, le firent juger de celles qu'il n'appercevait pas, et voyant qu'ils se conduisaient tous, comme il aurait fait en de pareilles circonstances, il conclut que leur manière de penser et de sentir étatit entièrement conforme à la sienne ...'

social totality'; and '*historical materialism cannot conceive that even a communist society could ever do without ideology*.'[15] Equally harsh in judging the ethical and voluntarist schemes of politics that have been a persistent temptation within the Marxist tradition down to the present moment, Althusser's notorious slogan that history is 'a process without a Subject or Goal(s)'[16] corresponds to de Man's positioning of politics outside the domain of the subject and of human will. Finally, we cannot omit to observe once more that Althusser too, in addressing the relation between authentic works of art and ideology, opts for what would appear to be an idealist position that privileges art in much the same way de Man seemingly does here.[17] These parallels may lead us to suspect that de Man's terse judgment on Althusser obscures the real affinities between their projects.

That this is so can be seen from the three summary consequences de Man draws from his reading of the *Discourse on Inequality*. These at once establish the itinerary for his reading of Rousseau and lead directly to the *Social Contract* and the concepts of textuality and political action de Man discovers in that text. First, the passage from the fictional or figural language in Part I of the *Discourse* to the political judgments of Part II involves a shift from qualitative to quantitative concepts, with the following result: 'The inequality referred to in the title of the *Discourse*, and which must first be understood as difference in the most general way possible, becomes in the second part the inequality in the quantitative distribution of property. The basis of political thought, in Rousseau, is economic rather than ethical ...' (AR, 157). Second, political institutions are as devoid of epistemological authority as language, a fact that renders the political inherently unstable and subject to perpetual disruption (AR,158-9). Finally, the notion of a social contract 'can only be understood against the background of this permanent threat', and it is therefore 'by no means the expression of a transcendental law: it is a complex and purely defensive verbal strategy by means of which the literal world is given some of the consistency of fiction, an intricate set of feints and ruses by means of which the moment is temporarily

15. Louis Althusser, *For Marx*, trans. Ben Brewster (London, 1977), p. 232; emphasis in the original.
16. Althusser, *Essays in Self-Criticism*, trans. Grahame Lock (London, 1976), pp. 94 ff.
17. We refer to the famous passage from Althusser's 'Letter on Art in Reply to André Daspre', and the commentary on it by Terry Eagleton cited in chapter 1 above. The passage is treated in greater detail in chapter 10 below.

delayed when fictional seductions will no longer be able to resist transformation into literal acts' (AR, 159).[18] These three points can be rewritten in recognizably Marxist terminology as follows: 1) determination in the last instance by the economy; 2) history is the history of class struggles; 3) the permanence of ideology. Before concluding that de Man's project is inherently and irredeemably anti-Marxist, one should further consider the extent to which his reading of the *Social Contract* follows a parallel course to that of Althusser.

* * * * * * * * *

The chapters on the *Second Discourse* and the *Social Contract* in *Allegories of Reading* are separated by a considerable space in which other Rousseau texts are read in order to establish a general model of textual production that operates throughout the Rousseau canon. The methodological guide to this model is given in the exposition of the *Second Discourse* and the theory of rhetoric which it narrates (AR, 159). De Man summarizes the progress of his argument to this point as follows:

The difference between a fictional and a theoretical text carries very little weight in the case of Rousseau. By reading the unreadability of the *Profession de foi*, we found it to be structured exactly like the *Nouvelle Héloïse*: the deconstruction of a metaphorical model (called 'love' in the *Nouvelle Héloïse*, 'judgment' in the *Profession*) leads to its replacement by homological text systems whose referential authority is both asserted and undermined by their figural logic ... If we choose to call this pattern an allegory of unreadability or simply an allegory, then it should be clear that the *Profession de foi*, like *Julie*, is an allegory and that no distinction can be made between both texts from the point of view of a genre theory based on rhetorical models. The fact that one narrates concepts whereas the other narrates something called

18. The figure of defense and feinting recurs in de Man's essay on Kleist (RR, 281-5, 290), and also marks an important moment in the essay on Proust (AR, 59). The political resonance of this figure should be clear, but in light of the numerous assertions of de Man's imperviousness to political questions, it is perhaps useful to observe here that the undermining of the epistemological reliability of political action argued in de Man's account of Rousseau does not entail the abandonment of political commitments; it does, however, place politics within the domain of calculation, rather than under precept. Only in a world populated entirely by beings like Kleist's Kantian bear would political judgment not be subject to error. Prudence and realism are not the only, but they are certainly useful political qualities.

characters is irrelevant from a rhetorical perspective. (AR, 247)[19]

The question arises: can the same be said of the *Social Contract*? De Man's reading of this text will commence (after a long digression over a related text, 'Du bonheur public', AR, 250-7) in perfectly traditional fashion with the relationship of general will to particular will and the contractual system of government that is founded upon this relation.

The reading immediately encounters a difficulty. Contrary to all expectation, and to the received opinion that contract theories of government involve reciprocity between rulers and ruled, the general will and the particular will cannot be easily reconciled in Rousseau: 'the constitutive power of the contract, the manner in which it engenders entities, is no dialectical synthesis or any other system of totalization. The general will is by no means a synthesis of particular volitions. Rousseau starts out instead from the opposite assertion and postulates the incompatibility between collective and individual needs and interests, the absence of any links between the two sets of forces' (AR, 261).

De Man then explicates Rousseau's understanding of the state in terms of the concept of property which is its foundation and constitution: 'Considered from a geopolitical point of view, the State is not primarily a set of individuals, but a specific piece of land' (AR, 261). But the concept of property, which from John Locke to John Rawls has been held to be the foundation of political society and of individual rights, turns out in Rousseau to be far from univocal in its functioning. In brief, it signifies two

19. The characteristic denial of categorial differences with which this passage opens has been usefully analyzed by Rodophe Gasché in an unpublished essay, 'In-Difference to Philosophy: De Man on Kant, Hegel, and Nietzsche' (to appear in a collection of essays from the University of Minnesota Press tentatively entitled 'Reading de Man Reading'). Gasché writes: 'The levelling of differences — the subversion of all possible development through an annulment of differences — is itself only one prominent effect of de Man's more general "methodological" procedure of analogizing. More precisely, his "method" is based on positive analogy, i.e., one that emphasizes the likeness among instances and moments of a text, or different parts of a work, while neglecting the differences. Such analogical inference allows for comparisons between truly incommensurable elements, or more precisely, between two incompatible types of relationships, or proportions.' De Man's 'in-difference to philosophy' thus forecloses the possibility of distinguishing, for example, between literary and philosophical texts, or between any two types of discursive practice thought to be distinct in their structure and conceptual purview — for instance, between science and ideology. We shall have to consider this point more carefully in a moment. I am grateful to Rodolphe Gasché for providing me with a typescript of his essay in advance of publication.

entirely different relations when looked at from the point of view of the private citizen's ownership and when considered 'from a public point of view as part of the rights and duties of the State' (AR, 263). The same piece of property (or the same concept) circulates in two entirely different systems of meaning which are not necessarily (and in fact are most often not at all) compatible. The conceptual consequences of this dual functioning of property are summarized by de Man: 'The semiological systems at work within each of these systems are entirely different: the one [private property] is monological and controlled in all its articulations, the second [public or state property] at the mercy of contingencies more arbitrary even than the strength based on numerical power. Yet, in its absence, the first could never have come into being' (AR, 264). The social contract is thus necessarily grounded in this 'double rapport' which 'pervades all aspects of political society' (AR, 264). Rousseau dramatizes this structure in the conflict of obligations and rights between the individual and the sovereign or the executive power, a conflict that is inherent in the structure of social institutions whose authority is not naturally or divinely ordained. As de Man puts it: 'The divergence which prevails, within the State, in the relationship between the citizen and the executive is in fact an unavoidable estrangement between political rights and laws on the one hand, and political action and history on the other' (AR, 266). This was the claim that led to the *Social Contract*'s being condemned as subversive. The magistrates of Geneva may not have been especially sophisticated readers of Rousseau's text, but they were not entirely erring in their judgment (assuming that their purpose was, like any other politician's, to maintain their own personal power). What they no doubt recognized, if only instinctively, was the danger posed in Rousseau's understanding of government and the law and aptly formulated by de Man: 'Revolution and legality by no means cancel each other out, since the text of the law is, per definition, in a condition of unpredictable change. Its mode of existence is necessarily temporal and historical, though in a strictly nonteleological sense' (AR, 266-7).

What de Man's exposition of Rousseau elucidates, as he makes clear in the following paragraph, is the *textual* structure of the law, and the irreducible 'estrangement' that characterizes the relationship between particularity and generality in Rousseau's conception of political society. This structure of incompatibility will then become the very model of textuality towards which de Man's argument has been working and which he will continue to call allegory. Before quoting the definition of a text given a few

pages later, however, we must pause over the notion of estrangement identified by de Man as the foundation of Rousseau's political thought. This fundamental estrangement is neither contingent nor avoidable but 'is implied by the very notion of particularity itself. To the extent that he is particular, *any* individual is, as individual, alienated from a law that, on the other hand, exists only in relation to his individual being' (AR, 267).

We note here a certain congruence, overlooked in de Man's overly hasty references to Althusser, between the Althusserian exposition of the *Social Contract* and de Man's discovery of the structure of incompatibility inhabiting Rousseau's (and ultimately all) texts. Althusser opens his reading of the concept of contract in Rousseau by insisting on the alienation of the individual from himself (for the individual is also the law insofar as he is a party to the contract that founds the state as an entity; in this sense the individual functions as ambiguously as the concept of property in Rousseau's text).[20] The crux of this relation is succinctly, if somewhat gnomically, stated early in the essay: 'The total alienation of the Social Contract is the solution to the problem posed by the state of universal alienation that defines the state of war, culminating in the crisis resolved by the Social Contract. *Total alienation is the solution to the state of total alienation.*'[21]

Althusser's essay proceeds to unpack the series of contradictions and conceptual slides necessary to resolve them generated by this positing of the social contract as the solution to the absolute incompatibility between the general will and particular wills. That the solution will in the end prove inadequate to the problem derives from the basic discrepancy (or displacement, '*décalage*') which de Man claims inheres in the opposition between general will and particular wills, and which Althusser locates in the distance separating Rousseau's notion of the contract from that which it ostensibly represents: the real structure of society. Althusser and de Man agree about the effect of Rousseau's

20. Rousseau makes this point explicitly in Book II, chapter 1 of *Du contrat social*: 'for if the opposition of particular interests has rendered necessary the establishment of societies, it is the harmony of these interests which has rendered it possible' (*Oeuvres complètes*, 3:368). Cf. the symmetrical remark apropos of the origin of language in the *Discourse on Inequality*: 'for if men had need of speech to learn how to think, they had even greater need still to know how to think in order to discover the art of speaking' (*Oeuvres complètes*, 3:147). Translations are my own.

21. Louis Althusser, 'Rousseau: the Social Contract (The Discrepancies)', in idem, *Politics and History*, trans. Ben Brewster (London, 1972), p. 127; emphasis in the original.

political theory: it does not generate precepts for political action, but moves perpetually in a circle. De Man calls this circular motion in theory 'text'; Althusser labels it 'ideology'. De Man had cited Althusser's conclusion with some derision at the outset of his essay on the *Second Discourse*, but it is difficult to see how the following formulation, taken by itself, differs significantly from de Man's own claims concerning the irreducibly figural structure of Rousseau's texts:

> If there is no possibility of further Discrepancies — since they would no longer be of any use in the theoretical order which has done nothing but live on these Discrepancies, chasing before it its problems and their solutions to the point where it reaches the real, insoluble problem, there is still one recourse, but one of a different kind: a *transfer*, this time, the transfer of the impossible theoretical solution into the alternative to theory, literature. The admirable 'fictional triumph' of an unprecedented writing: *La Nouvelle Héloise, Emile*, the *Confessions*. That they are unprecedented may be not unconnected with the admirable 'failure' of an unprecedented theory: the Social Contract.[22]

One suspects that de Man has heard in this judgment only the familiar condemnation of Rousseau's political writings coupled with praise for his fictional texts which the tradition of Rousseau interpretation has repeated *ad nauseam*. But nothing of the sort is implied. Althusser is praising Rousseau for rigorously pursuing to their conclusion the implications of a theory that must be displaced from its ordinary domain (the goal of the theory was to realize principles for regulating practice) into that of fiction — or, in Althusser's terms, ideology. Althusser has thus discerned in the textual structure of the *Social Contract* that narrative or allegorical dimension which previous commentators have believed is confined only to Rousseau's more properly 'literary' texts. The ostensible claim to scientific generality made by texts like the *Social Contract* and the *Discourse on Inequality* is a result of their rhetorical mode, not an index of their truth value or scientificity.[23]

De Man's systematic blindness to the force of Althusser's reading of the *Social Contract* is understandable, for while the

22. Ibid., pp. 159-60.
23. De Man asserts the same: 'The theory of politics inevitably turns into the history, the allegory of its inability to achieve the status of a science. The passage from constative theory to performative history is very clearly in evidence in the *Social Contract*. The text can be considered as the theoretical description of the State, considered as a contractual and legal model, but also as the disintegration of this same model as soon as it is put in motion' (AR,271).

recognition of the ideological circle of Rousseau's texts marks their limit for Althusser, this is the sign of their having reached the highest degree of theoretical rigour for de Man. But it is curious that in comparing Althusser to Engels (AR, 158), de Man has seriously misunderstood the import of what Engels is saying. The favourable comparison of Rousseau to Marx, which de Man approves, does not yield anything like the result in theory de Man believes. In the *Anti-Dühring*, Engels wrote: 'Already in Rousseau, therefore, we find not only a sequence of ideas which corresponds exactly with the sequence developed in Marx's *Capital*, but that the correspondence extends also to details, Rousseau using a whole series of the same dialectical developments as Marx used: processes which in their nature are antagonistic, contain contradiction, are the transformation of one extreme into its opposite; and finally, as the kernel of the whole process, the negation of the negation.'[24] This method of course has a name, and Engels does not hesitate to invoke it: 'Dialectics is nothing more than the science of the general laws of motion and development of Nature, human society and thought.'[25] Rousseau was undoubtedly a dialectical thinker, but the concept of the dialectic proposed by Engels scarcely accords with de Man's account of the operation of Rousseau's texts. For Engels, the dialectic is a *scientific* method which establishes apodictic principles governing all historical processes from the maturation of plants and animals from germ plasm down to the history of philosophy (see *Anti-Dühring*, pp. 148-52). Had de Man attended more closely to the texts of Althusser (for example, to the comparison between Engels and Sartre cited above in chapter 7), he would have seen that Engels's notion of the dialectic incarnates the very totalizing and teleological scheme of history which de Man himself had resisted from his earliest writings. Whatever may be the affinities between Marx and Rousseau, they cannot be usefully characterized under the rubric of dialectical method as it is presented by Engels.

Up to a point, then, Althusser's characterization of Rousseau's texts as ideological coincides with de Man's understanding of them as texts. We should now consider the concept of the text that de Man derives from a reading of the *Social Contract*:

In the *Social Contract*, the model for the structural description of

24. Frederick Engels, *Herr Eugen Dühring's Revolution in Science (Anti-Dühring)*, trans. Emile Burns (New York, 1939), pp. 153-4.
25. Ibid., p. 155.

textuality derives from the incompatibility between the formulation and the application of the law, reiterating the estrangement that exists between the sovereign as an active, and the State as a static, principle. The distinction, which is not a polarity, can therefore also be phrased in terms of the difference between political action and political prescription. The tension between figural and grammatical language is duplicated in the differentiation between the State as a defined entity (Etat) and the State as a principle of action (Souverain) or, in linguistic terms, between the constative and performative function of language. A text is defined by the necessity of considering a statement, at the same time, as performative and constative, and the logical tension between figure and grammar is repeated in the impossibility of distinguishing between two linguistic functions which are not necessarily compatible. It seems that as soon as a text knows what it states, it can only act deceptively, like the thieving lawmaker in the *Social Contract*, and if a text does not act, it cannot state what it knows. The distinction between a text as narrative and a text as theory also belongs to this field of tension. (AR, 270)

This process is necessarily endless, and therefore endlessly productive. Texts generate further texts because, in contrast to the model of textual functions proposed by Riffaterre in which the text is 'a sequence of explanatory and demonstrative syntagms that drive arbitrariness from clause to clause, further and further away',[26] de Man's concept of text does not allow for closure. Action itself necessitates deception, which is in turn the condition for the text's statement.

Is this to say that we can safely set texts aside, consigning them to the harmless realm of 'fiction'? De Man accuses Althusser of intending this very thing in the latter's exposition of the ideological circle of the *Social Contract*. De Man seems to imply that, to the degree one considers a text ideological, its performative power has been denied. De Man himself is under no such illusions, as his conclusion to the chapter on the *Social Contract* makes plain. Rousseau's text may fail to establish clear and universally applicable principles for political action, but it nonetheless continually promises that it will do so. This promising is the distinctive act of the *Social Contract* as a text, and it is the source of its effectivity in the world. De Man is entirely unambiguous on this point: 'The redoubtable efficacy of the text is due to the rhetorical model of which it is a version. This model is a fact of language over

26. Michael Riffaterre, *Text Production*, trans. Terese Lyons (New York, 1983), p. 61.

which Rousseau himself has no control. Just as any other reader, he is bound to misread his text as a promise of political change. The error is not within the reader; language itself dissociates the cognition from the act. *Die Sprache verspricht (sich)*; to the extent that [it] is necessarily misleading, language just as necessarily conveys the promise of its own truth. This is also why textual allegories on this level of rhetorical complexity generate history' (AR, 277).

What does it mean for a text to 'generate history'? This is the point at which de Man's project intersects with Althusser's, for what they share is a common understanding of the material effects, indeed the material existence of ideology. The productivity of ideological fictions is never in doubt, for ideology is the means by which individuals (biological beings) become subjects, it is the motivating system for their actions: 'the subject acts insofar as he is acted by the following system (set out in the order of its real determination): ideology existing in a material ideological apparatus, prescribing material practices governed by a material ritual, which practices exist in the material actions of a subject acting in all consciousness according to his belief.'[27] Nor is it possible to escape this determination by ideology, to be, as it were, a non-subject: '*individuals are always-already subjects.*'[28] To say that Rousseau was bound to misread his own text is to say, effectively, that he, like all individuals, was necessarily interpellated by the ideology of the promise, which pre-existed him, and will, moreover, continue to operate as a fact of language for all eternity. As Althusser says: '*ideology is eternal*, exactly like the unconscious.'[29] The de Manian concept of the text is a theory of the permanence of ideology. To the extent that literary (or any) texts continue to convey the (demonstrably false) promise to transcend the conditions of their own possibility — in de Man's concept of the text as a result of complications inherent in the nature of language, all texts must necessarily perform this function — they instance the ideological relation to the real conditions of human existence which Althusser has claimed is a permanent feature of human society. Even a communist society, we might say, will be unable to do without texts.

27. Louis Althusser, 'Ideology and Ideological State Apparatuses (Notes towards an Investigation)', in idem, *Lenin and Philosophy and Other Essays*, trans. Ben Brewster (New York, 1971), p. 170.

28. Ibid., p. 176; emphasis in the original.

29. Ibid., p. 161; emphasis in the original.

This is the limit beyond which de Man's theorization of the text forbids one to go. Althusser, however, says more. What 'generates history' for Althusser (and for historical materialism as a theory) is not only the blinded and deceitful actions of subjects like Rousseau and textual allegories like the *Social Contract*, but the objective structures of society and history. Ideology, culture, philosophy, possibly even the state itself can be understood as texts in the sense de Man has made available to us, but the economic structure of society, that which Althusser continually insists is 'determinant in the last instance', remains objectively constituted and susceptible to rigorous, non-ideological description. For Althusser, there is such a thing as science which is outside of ideology, for its discourse is precisely subjectless. Knowledge of the real is possible, Althusser claims, even if the 'real in thought' can never coincide with the 'real concrete'. The discourse of science is therefore not a text in de Man's sense, even if its linguistic properties necessitate a certain imprecision that allows for misreadings and misappropriations. Althusser's entire labour over the texts of Marx was an effort to overcome the difficulties engendered by the persistence of certain metaphorical expressions employed by Marx in those texts to designate the scientific concepts he had discovered. (Nor is Althusser's own writing free from contamination by certain crucial metaphors, as we shall see in the following chapter.)

What of de Man's own text? I mean here specifically the second half of *Allegories of Reading*, although much the same might be said of several of de Man's texts. Jacques Derrida has insisted that the apparent claims to knowledge made by de Man must be read circumspectly, with careful attention to their rhetorical mode, above all with an eye to the potential ironies indicated by marks of punctuation, ambiguities of phrase, *et cetera*.[30] This caution is undoubtedly warranted, but one wonders whether it is sufficient to undo the legitimate conviction that de Man's reading of Rousseau has indeed produced a knowledge of Rousseau's texts. This knowledge derives from the superiority of de Man's hypotheses concerning the rhetoricity of those texts in comparison with previous attempts to account for their conceptual coherence, or more often incoherence. Moreover, if our comparison between de Man's and Althusser's expositions of the *Social Contract* is correct in its conclusions, then the hypothesis de Man has advanced

30. Derrida, *Memoires: For Paul de Man*. I refer to the galley proofs of this text; page references are therefore unavailable.

concerning the unavoidable linguistic complication that controls the textuality of Rousseau's concept of the state and society has in a way received independent confirmation (even though de Man did not recognize it as such). Whether the knowledge thus produced could lead to the formulation of a method of reading is beyond the scope of our present inquiry. Suffice it to say here that the lasting value of Paul de Man's work will reside in the contributions he has made to the theory of rhetoric and in the application of that theory to particular textual instances like Rousseau, Nietzsche, Rilke, and Proust. We can affirm with de Man that 'the allegory of reading narrates the impossibility of reading' (AR, 77), at the same time that we must insist upon the possibility that de Man's own text is not itself allegorical but scientific. The relationship between the structure of aesthetic texts and the nature of empirical inquiry will be the subject of our next, and concluding, chapter.

10
Imaginary Relations: Althusser and Materialist Aesthetics

Don't know much about history.
Sam Cooke, Jr.

In the opening paragraphs of one of his last essays, Paul de Man argued that the supposed antithesis between political effectiveness and aesthetic judgment fails to do justice to a range of modern thinkers whose work on literary or philosophical texts constitutes no substantial obstacle to their contributing significantly to the history of political thought. Derrida was on that occasion the immediate subject of de Man's defence against a growing chorus of critics who have taken Derrida to task 'not so much because of his declared political opinions or positions, but because he has arrived at these positions by way of a professional philosopher's skills and interests.' But more directly relevant to the purposes of the present inquiry is the list of figures whom de Man aligned with Derrida in this tradition of 'aesthetic thinkers': Marx (in particular *The German Ideology,* which is judged 'a model of critical procedure along the lines of Kant's Third Critique'), Walter Benjamin, Lukács, Althusser, and Adorno. Distinguishing their thought from what has traditionally been understood by the term 'aestheticism' in modern literary history, de Man averred: 'the work of these thinkers precludes, for example, any valorization of aesthetic categories at the expense of intellectual rigor or political action, or any claim for the autonomy of aesthetic experience as a self-enclosed, self-reflexive totality.'[1]

In the case of Althusser, the assessments of his work to date have tended to concur with de Man in classifying him an aesthetic

1. Paul de Man, 'Hegel on the Sublime', in *Displacement: Derrida and After*, ed. Mark Krupnick (Bloomington, 1983), pp. 139, 140-1.

thinker in the tradition of Western Marxism, while they have at the same time reached just the opposite conclusion from de Man about the political effect of this tendency in his thought.[2] Rancière in particular has taken Althusser severely to task for continuing to teach philosophy and for reproducing the norms and values of academic tradition in the aftermath of May '68.[3] Althusser's own defence of his continued devotion to the discipline of philosophy and the pursuit of theoretical work takes its warrant from Marx himself and rests upon the now infamous claim that 'philosophy is, in the last instance, class struggle at the level of theory.'[4] Nor is it just any politics, nor even the politicality of theory in general that is at stake in Althusser's intervention, as he himself has made plain:

> Let us not try to fool ourselves: this debate and argument are, in the last resort, political ... Who, really, is naïve enough to think that the expressions: Marxist *theory*, Marxist *science* — sanctioned, moreover, time and time again by the history of the Labour Movement, by the writings of Marx, Engels, Lenin and Mao — would have produced the storms, the denunciations, the passions which we have witnessed, if nothing had been at stake except a simple quarrel over words? ... To hang on to or to reject these *words*, to defend them or to destroy them — something real is at stake in these struggles, whose ideological and political character is obvious. It is not too much to say that what is at stake today, behind the argument about words, is *Leninism*. Not only the recognition of the existence and role of Marxist theory and science, but also the concrete forms of the fusion between the Labour Movement and Marxist theory, and the conception of materialism and the dialectic. (ESC,114-15; emphasis in the original)

The question nevertheless remains whether the region of aesthetic theory, which is hardly the centrepiece of Althusser's

2. The *locus classicus* for the view of Althusser's work as a turn away from the political emphases of classical Marxism is Perry Anderson's assessment in *Considerations on Western Marxism* (London, 1976). As we observed above in chapter 8, the political indictment of Althusser is continued in *In the Tracks of Historical Materialism* but it also crops up somewhat anomalously in *Arguments within English Marxism* (see above, chapter 7, n. 32). For a partial but representative bibliography of criticism of Althusser's politics, see chapter 7, n. 2.

3. Jacques Rancière, 'On the Theory of Ideology — Althusser's Politics', in *Radical Philosophy Reader*, ed. Roy Edgley and Richard Osborne (London, 1985), pp. 101-36.

4. Louis Althusser, 'Elements of Self-Criticism', in idem, *Essays in Self-Criticism*, trans. Grahame Lock (London, 1976), p. 166; hereafter cited parenthetically as ESC. For other abbreviations of frequently cited Althusser texts, see above, chapter 7, n. 2.

philosophical work, can be incorporated into the general project of Marxism-Leninism Althusser set out to defend in his development of a properly Marxist philosophy. The problem Althusserian theory poses for the concept of art is as follows: what is the relation between aesthetic practice and ideological practice? Or, more narrowly, what is the concept of art in the theory of historical materialism? Without pretending that Althusser has definitively solved all the difficulties that have beset the theory of art in the tradition of historical materialism, we will yet contend that the lineaments of a materialist aesthetics are available in Althusser's occasional essays on literature and art. Further, we will maintain that even though subsequent attempts to develop his hastily sketched outlines of this theory have arguably failed, the direction indicated in Althusser's fragmentary writings on art constitutes the current horizon of Marxist aesthetic theory. Moreover, the apparent distance separating aesthetic theory from other regions in historical materialism is to some degree reduced when one considers the position of theory itself and the epistemological problems it presents for a materialist conception of science. This latter line of investigation, which will bring our own inquiry to a close, demands further elaboration both in its theoretical implications and on the level of empirical research. It would be injudicious to speculate here upon the possible outcome of what must of necessity be a broad stretch of related research projects. The limits of our current knowledge prevent more than a tentative projection of some of the directions this research may productively take.

* * * * * * * * *

As we have had occasion to remark more than once, the Althusserian conception of aesthetic practice has generally been thought to lapse from the rigour of an authentically materialist theory of art. In positioning the aesthetic to some degree outside the domain of ideology, Althusser has been charged with reinscribing the categories of bourgeois aesthetics within Marxism. In chapter 4 we suggested, through a comparison to Jauss and the historical scheme underwriting *Rezeptionsästhetik*, that the Althusserian differentiation of aesthetic from ideological practice merely established the different modality of presentation in each. But what remains obscure, at least in the truncated version of Althusser's theory most often cited against him, is the precise connection between ideological practice and aesthetic practice as

these two are articulated in social wholes. If it is the case, as Althusser claims in the 'Letter on Art', that works of art do not simply replicate the ideological material of a given epoch, it is equally the case that they do take the ideologies as their material of construction. How they do so, and how their presentation of ideological materials is then reappropriated as an instrument in the project of this or that class — who are both products and purveyors of particular ideologies — is just the question that the materialist conception of art must in the end answer.

First question: what is ideology? We will not give an exhaustive account of the argument of Althusser's essay on 'Ideology and Ideological State Apparatuses', which in any event is probably sufficiently familiar in its principal theses not to require extensive exposition here. Let us simply recall a few points. Most important of all: the position of ideology and ideological state apparatuses is subordinate to Althusser's overall inquiry into the concept of society; the concept of ideology demarcates one region within the theory of historical materialism and the social determination of human consciousness. A signal consequence of this often neglected aspect of Althusser's essay is that, according to the hypothesis that social formations must reproduce their means and relations of production in order to survive materially, the production of ideology serves the function generally (although not unilaterally or without struggle, as we have seen) of reproducing the dominant relations of exploitation in a given social formation. The functional utility of ideologies, and therefore their very *raison d'être*, consists in their legitimizing and naturalizing the relations of domination and exploitation that maintain the position of the ruling class. The goal of all ideology is to produce subjects who 'work by themselves' (ISA,181) — even though, as Althusser himself has continually insisted, and as we argued in chapter 7 above, the attainment of this goal is never assured, the struggle in and for ideologies perpetual. At this level of conceptualization, the relevant distinction is between ideology and science. Althusser's thesis that ideology 'represents the imaginary relationship of individuals to their real conditions of existence' (ISA,162) differentiates the knowledge function of science, which is to produce descriptions of the real natures of objects, from the political function of ideologies, the purpose of which is to secure the conditions for reproducing the forms of social domination. Only on this condition, that ideology and science are rigorously discriminated from each other in their purpose and in their relationship to material reality,

is it possible for there to be any theory of ideology.[5]

A second point of some importance: the discrimination of historical ideologies, which 'whatever their form (religious, ethical, legal, political), always express *class positions*' (ISA,159; emphasis in the original), from ideology in general, which *'has no history'* and is *'eternal,* exactly like the unconscious' (ISA,159, 161; emphasis in the original). When Althusser says in the 'Letter on Art' that he does *'not rank real art among the ideologies',*[6] he is attempting to discriminate between two different modes of apprehending the same materials: art (or aesthetic practice) and ideology. The distinction is based upon a traditional form/matter relation: art is that which gives form to the materials of ideology. The relation is not, strictly speaking, epistemological, on the order of the distinction between science and ideology. The end or effect of art (as Althusser makes clear by distinguishing between aesthetic and scientific practice; LP, 222-4) is not to give a knowledge of ideology (in the sense of description by concepts), but only to make ideology stand out, to render it visible. Art does not give a scientific presentation of ideology, Althusser claims (although this relationship between aesthetic presentation and scientific practice will prove more complicated in other places in the Althusserian text, as we shall see below).

But the relationship of art to ideology is not wholly external either. It can happen that art becomes the matter of ideology, just as ideology is the matter upon which aesthetic practice works

5. We are arguing here for a relative privileging of the early Althusser texts in which the distinction between science and ideology is the condition for the production of knowledges. The relevant texts are 'On the Materialist Dialectic' and Althusser's contributions to *Reading Capital.* As we suggested above (chapter 8), the later texts, beginning with *Philosophie spontanée,* do not contradict the basic position laid out in earlier texts on the epistemology of the sciences but correct the theoreticism which placed philosophy (which is not a science) outside the domain of social determination. The later Althusser texts, inlcuding the ISAs, maintain the science/ideology distinction, while positioning philosophy itself within the historical field of class struggle — class struggle at the level of theory. To abandon the science/ideology distinction altogether would be to succumb to a version of Lysenkoism; Althusser has never been guilty of that, asseverations by hostile critics notwithstanding. Gregory Elliott's summary formulation coincides with the view maintained here: 'Cognitively autonomous, socially, theory is relatively autonomous' ('Louis Althusser and the Politics of Theory', [Ph. D. thesis, Oxford University, 1985], p. 89).

6. Louis Althusser, 'A Letter on Art in Reply to André Daspre', in idem, *Lenin and Philososophy and Other Essays,* trans. Ben Brewster (New York, 1971), p. 221; emphasis in the original. Subsequent references to this volume (except for the ISAs) will be included parenthetically in the text and designated LP.

(see LP,222-4). When works of art become the raw materials for ideological practice — for example, in the education of native colonial populations in the cultural traditions of the imperial metropole — their aesthetic modality is subordinated to their ideological function. The intrinsic nature of the work, its material poetic structure, will remain unaffected by its utilization as an ideological instrument. (The concept of art in materialist aesthetics is to this extent perfectly compatible with formal poetics as it has been elaborated from Aristotle down to R.S. Crane and Michael Riffaterre.) But to the extent that the works are appropriated for one or the other ideological project in a given society, they become an object for investigation in the materialist science of the history of social formations, in particular under the regional science designated by the theory of ideology.

We are saying, then, that the work of art will necessarily be the object of two distinct modes of inquiry, or sciences as Althusser designates them: one in its specifically aesthetic modality; the other in its function within the formal structure of particular historical ideologies. Inquiry into the former will be premised upon concepts pertinent to what might be termed 'art in general' (on the analogy with Althusser's assertion that there is such a thing as 'ideology in general'); inquiry into the latter will depend upon the theory of ideology, and will set aside the materiality of the work of art (i.e., its formal properties as a product of aesthetic practice; since ideology has a material existence, the work of art will continue to exist materially within ideological practice). That there can be different sciences pertinent to the understanding of one and the same object is a premise shared equally by Aristotle and Althusser. Althusser was never a methodological monist.[7]

7. The discussion hinges on the difficult concept of the different modalities of matter. Althusser does not elaborate on this notion at length, although he is well aware of its importance to his argument that ideology has a material existence (ISA, 166-9). A rough understanding of what is at stake can be obtained by thinking about the different modes of investigation appropriate to the same material substance when it has been transformed into a commodity. Physics (in the broad sense of the term) can describe the properties and predict the behavior of gold formed into a ring; economics will consider the same matter as a means for the realization of value and will give an account of how the same amount of gold will be differently valorized depending upon the form that it has assumed and upon conditions in the market at the moment of its being offered for purchase. One could go another step, of course, and say that the aesthetic or poetic properties of the gold ring, which are in some measure derived from its physical properties (e.g., its malleability) and to a lesser extent from its economic properties (the state of the market will exercise some limiting force upon the availability of materials for

On Althusser's account of what would be a properly materialist aesthetics, art has no history, just as ideology has no history. Although Althusser is not as explicit about this view in relation to art as he is in relation to ideology, it is plausible to infer that on an Althusserian view aesthetic practice is conceived as a more or less permanent aspect of human social existence. One can develop a precise theory of its mode of functioning, of its specificity as a practice, on the model of Althusser's projected theory of ideology. The analysis of particular works of art will of necessity depend upon the prior production of a set of concepts specific to aesthetic practice; as Marx says, the method of science is to 'rise from the abstract to the concrete'. Althusser does not produce such concepts, except in the most tenuous way by differentiating the *effect* of science from that of art. Both art and science take ideology as their object, but each works upon this raw material in a different way:

> The real difference between art and science lies in the *specific form* in which they give us the same object in quite different ways: art in the form of 'seeing' and 'perceiving' or 'feeling,' science in the form of *knowledge* (in the strict sense, by concepts).
>
> The same thing can be said in other terms. If Solzhenitsyn does 'make us see' the 'lived experience' ... of the 'cult of personality' and its effects, in no way does he give us a *knowledge* of them: this knowledge is the conceptual knowledge of the complex mechanisms which eventually produce the 'lived experience' that Solzhenitsyn's novel discusses. If I wanted to use Spinoza's language again here, I could say that art makes us 'see' conclusions without premises, whereas knowledge makes us penetrate into the mechanism which produces the 'conclusions' out of the 'premises'. (LP,223-4; emphasis in the original)[8]

aesthetic production), are nevertheless distinct from these other aspects of the thing. If the gold ring is melted down to make ingots, its physical properties (in this case, its atomic structure) are not altered, but its market value and its aesthetic structure are: the gold will be worth less as ingots than it will be when crafted into the shape of a ring (change in market value), and this as a direct result of modifications in its formal porperties (change in aesthetic structure). The tricky question of productive versus unproductive labor broached by Marx in *Theories of Surplus Value* (and which is beyond the scope of our inquiry here; we hope to take it up in another place) would be part of this same problem of the intersection of the aesthetic with the economic properties of a thing.

8. The fullest account of Althusser's conception of the way theoretical practice (science) 'works on' matter is given in 'On the Materialist Dialectic' (FM,182-93), but the examples adduced there to illustrate the general mode of knowledge production are determinedly political (Lenin's analysis of the current situation in Russia in 1917; Mao's explanation of the position of the party in relation to the

The passage is a difficult one, but we can illustrate the force of Althusser's distinction by returning to that section in the *Grundrisse* from which we set out to explore the relationship between aesthetics and ideology. Marx's observations concerning the aesthetic practice of Greek antiquity encompass the two modes of appearance of the aesthetic object posited by Althusser. On the one hand, the object of investigation (Greek art) is considered as non-ideological: it possesses 'eternal charm'. This is an awkward metaphor for expressing the fact that works of art remain cognitively available to readers and audiences beyond the moment and the immediate social context of their production. On the other hand, any given work of art certainly is the product of a particular historical epoch in a mode of production whose conditions can be more or less rigorously specified: 'the Greek arts and epic are bound up with certain forms of social development.' When Marx posits Greek art as 'a norm and unattainable model' for subsequent aesthetic practice, we can set aside the improbable historical assertion (a residue of the idealist philosophy of art in Winckelmann and some of the less astute disciples of Hegel), while retaining the more plausible claim that the material structures of aesthetic representation discernible in Greek art continue to be accessible to cognition even though 'the unripe social conditions under which it arose, and could alone arise, can never return.' What one recognizes immediately in Greek art, the source of its 'charm', is its 'childish naivete', which presents an image of 'the childhood of humanity'.[9] That is what is 'seen, perceived, felt' in Althusser's terms.

At the same time, however, Greek art is subject to understanding as an object in historical science. This science of the aesthetic object 'strive[s] to reproduce its [the object's] truth at a higher stage.' The 'truth' presented aesthetically in Greek art, i.e.,

masses in China during the 1930s). Moreover, Althusser is quite explicit about the relative 'backwardness' of Marxist theoretical practice in disciplines outside economics and history (see FM,169-70). We would not wish to dispute the point. Our own inquiry will suggest, however, that the 'importation' of concepts from the theory of art into the domain of other theoretical practices can provide the necessary means for the development of empirical theories generally. The argument is pursued apropos of Althusser's exposition of *Darstellung* below.

9. The *topos* upon which Marx draws here comes from Schiller's discussion of the 'naive' culture of ancient Greece in 'Über naive und sentimentalische Dichtung': 'The naive is *childlikeness where it is no longer expected*, and precisely on this account cannot be ascribed to actual childhood in the most rigorous sense' (Friedrich Schiller, *Naive and Sentimental Poetry and On the Sublime: Two Essays*, trans. Julius A. Elias [New York, 1966], p. 90; emphasis in the text).

its phenomenal forms, is transformed, or 'worked' in Althusser's metaphor for the production of knowledge, by scientific practice. The latter makes explicit the mechanisms by which Greek art was produced. This is the force of Marx's earlier claim that 'human anatomy contains a key to the anatomy of the ape. The intimations of the higher development among the subordinate animal species, however, can be understood only after the higher development is already known. The bourgeois economy thus supplies the key to the ancient, etc.'[10] Scientific concepts undoubtedly emerge in history, but their descriptive power is not limited to the historical forms that gave rise to them. It is only with the emergence of a scientific theory of art that the specificity of Greek aesthetic practice can be fully comprehended, the mechanism of its 'charm' laid bare.

Marx's point in this aphorism is not to construct a historical teleology of modes of production, as many commentators have mistakenly assumed, but to differentiate between different forms of appearance of the same object. Both human beings and apes possess opposable thumbs, but the significance of this anatomical specialization for the development of these species is known only to humans, or, more precisely, it is known only in the cognitive theory of anatomy which is a uniquely human attainment. Apes have opposable thumbs without possessing a concept for them, just as previous modes of production exhibited forms of surplus-value extraction without these being recognized as such. In another context, Althusser emphasizes this very point: 'what classical political economy does not see, is not what it does not see, it is *what it sees*; it is not what it lacks, on the contrary, it is *what it does not lack*; it is not what it misses, on the contrary, it it is *what it does not miss*. The oversight, then, is not to see what one sees, the oversight no longer concerns the object, but *the sight* itself' (RC,21; emphasis in the original). Just as classical political economy produced the concept of value without recognizing it, and just as apes possess opposable thumbs without fully understanding the significance of this fact, so the Greeks produced art, as it were, without knowing it, 'naively' in Marx's terms. What cannot recur after the emergence of the science of art is not aesthetic practice itself — Marx was far from believing that the production of art could not take place under capitalism — but the

10. Karl Marx, *Grundrisse: Foundations of the Critique of Political Economy (Rough Draft)*, trans. Martin Nicolaus (London, 1973), p. 105. Citations from the passage on Greek art occur on p. 111 of this edition.

naiveté with which it was once regarded, except of course in the childish view of those who consider the production of art as a mysterious or occult process to which only geniuses can aspire. Materialists can scarcely afford the luxury of such an obscurantist conception of art.

How, then, does aesthetic practice transform its raw materials? As we observed above, no general theory of art is advanced in the entire *oeuvre* of Althusser. Nevertheless, certain procedural protocols do emerge in the analyses he has undertaken of particular works. From these we can sketch the outline of an Althusserian aesthetics that is yet to be written. As Althusser himself has pointed out, one cannot embark upon scientific investigation of any object without first producing, even if only implicitly as Marx himself did, a quite rigorous concept of the object under investigation. Our aim is to give a preliminary account of the specificity of the aesthetic as it emerges in the two critical exegeses of art works that Althusser has produced. That this account may thrust us beyond the limits of what has conventionally been understood as the province of aesthetic artifacts is a possibility which the Althusserian concept of social practices opens up. The aesthetic understood as a modality of worked matter, rather than as a discrete class of objects, will prove to be implicated and operative in practices other than that of the so-called 'fine arts'.

* * * * * * * * *

Althusser's essay, 'The "Piccolo Teatro": Bertolazzi and Brecht (Notes on a Materialist Theatre)', was occasioned by a production of Carlo Bertolazzi's play, *El Nost Milan*, mounted by Giorgio Strehler at the *Théatre des Nations* in July 1962. The production drew howls of disgust from the bourgeois critics, and Althusser set himself the task of defending the production and the play as a theatrical triumph. At the same time, he was led to expatiate on the concept of a materialist theater which this production had brilliantly realized. His discussion devolved, naturally enough, onto a consideration of Brecht. The essay thus divides conceptually into two parts which reproduce the double focus of the Althusserian concept of art: its assertion of the simultaneously non-ideological and ideological character manifested by art works.

Althusser's exposition emphasizes the 'two forms of temporality, apparently foreign to one another and yet united by a

lived relationship' (FM,135) that coexist in the play. These different 'times' are, respectively, that of the lumpen characters who populate the stage during the long scenes depicting Milanese popular life, and that of the three tragic actors, Nina, her father, and the seducer Togasso. The key to Althusser's interpretation lies in his claim that this is 'a play remarkable for its internal dissociation', for 'there is no *explicit* relationship between these two times or between these two spaces. The characters of the time [i.e., the Milanese lumpen] seem strangers to the characters of the lightning [Nina, her father, Togasso]: they regularly give place to them (as if the thunder of the storm had chased them from the stage), only to return in the next act, in other guises, once the instant foreign to their rhythm has passed' (FM,134; emphasis in the original). The presentation of these two distinct temporal structures is brilliantly accomplished by the staging, in particular by 'Strehler's stroke of genius: to have made two acts one, and played two different acts *in the same decor*' (FM,137; emphasis in the original). The material level of the production, what is physically presented on the stage, enforces the spectator's apprehension of the play's 'internal dissociation'. The audience 'perceives' the co-presence of the two temporalities, the two different 'worlds' inhabiting the same space but having nothing to do with one another on the level of dramatic action.

But this immediate apprehension of the phenomena of the drama is not the limit of the audience's experience. Althusser argues that the action of the play enforces a deepening awareness of the contradiction between the two worlds, and an eventual recognition beyond the boundaries of the phenomena themselves (for the structure the audience apprehends is nowhere presented on stage) of the structural relations between the two worlds, of the contradictory unity which unites them, in a word, of the capitalist society into which Nina is about to venture when the curtain drops:

> When Nina goes through the door separating her from the daylight she does not yet know what her life will be; she might even lose it. At least *we* know that she goes out into the real world, which is undoubtedly the world of money, but also the world that produces poverty and imposes on poverty even its consciousness of 'tragedy.' And this is what Marx said when he rejected the false dialectic of consciousness, even of popular consciousness, in favour of experience and study of the other world, the world of Capital. (FM,140-1; emphasis in the original)

At the end of this process, as the reference to Marx in the passage indicates, the audience has gained a certain knowledge, not only of the characters and their lives, but of the world that lies beyond the limits of the play's action and ultimately determines it. What the audience recognizes, but which is 'nowhere ... perceived directly in the play' (FM, 142), is the 'internal relation of the basic elements of its structure' (FM, 141). But the audience's position differs from that occupied by the scientist (who produces knowledge by concepts), for their apprehension is 'unconscious' (FM, 141). Althusser suggests that the audience's reaction at the performance he attended, which, contrary to the reception among the critics, was unequivocally positive, signified a recognition, however inchoate, of the true object of the play's action. The work of art, aided by Strehler's shrewd staging, had allowed them to 'see', 'perceive', and 'feel' what they could not otherwise understand: the unity of the personal tragedy of isolated individuals with the social conditions of mass poverty in the capitalist mode of production. Althusser's clear distinction between scientific knowledge of the structures of the capitalist mode of production and the aesthetic apprehension of those structures as they are presented in the phenomenon of a theatrical performance is in line with his categorical assertion in the 'Letter on Art' of the different modes in which the same object is presented in art and to science.

The first part of the essay, which has concentrated on the empirical problem of the audience's favourable reception of Strehler's production, is succeeded by Althusser's meditation on Brecht and the theoretical problems posed by his major plays. The confrontation of two entirely distinct temporalities in Bertolazzi's play 'is in essentials also the structure of plays such as *Mother Courage* and (above all) *Galileo*' (FM,142). Althusser discovers in the 'asymmetrical, decentred structure' of Brecht's major plays the basis for any materialist theatre, the dramatic realization of 'Marx's fundamental principle that it is impossible for any form of ideological consciousness to contain in itself, through its own internal dialectic, an escape from itself, that, *strictly speaking, there is no dialectic of consciousness:* no dialectic of consciousness which could reach reality itself by virtue of its own contradictions; in short, there can be no 'phenomenology' in the Hegelian sense: for consciousness does not accede to the real through its own internal development, but by the radical discovery of what is *other than itself*' (FM,143; emphasis in the original). This is the motivation for the so-called 'alienation-effect' and

for Brecht's dissolution of what he called 'classical theater'.

The principal means for achieving this break with the classical theory of representation, Althusser argues, is neither technical nor psychological but structural. The basis for the alienation-effect is established in the poetic structure of the play itself: 'if a distance can be established between the spectator and the play, it is essential that in some way this distance should be produced within the play itself, and not only in its (technical) treatment, or in the psychological modality of the characters ... It is within the play itself, in the dynamic of its internal structure, that this distance is produced and represented, at once criticizing the illusions of consciousness and unravelling its real conditions' (FM,146-7). The aesthetic effect of Brechtian theater can only be comprehended from the point of view of poetics (understood in the canonical sense established by Aristotle): the systematic science of the nature of artificial things. This fact has been obscured by the vehemence with which Brecht denounced the supposed psychologism of the Aristotelian demand that tragedy effect a catharsis of pity and fear. What Brecht termed the alienation-effect results from an objective structure of cognition that is consequent upon a poetic relation realized in the material of the play itself. To the extent that aesthetic representation just *is* this achievement of distance between spectator and art work (for so classical aesthetics from Schiller down to Bullough and Adorno has maintained), the alienation-effect would provide a point of departure for theorizing the basic concepts of aesthetic science. The poetic structures which are the foundation of this effect are what distinguish the modality of aesthetic objects from the ideological representations of the world that constitute the materials from which aesthetic objects are constructed. 'Lived experience' is the object under investigation in the theory of ideology; the distantiation of lived experience in works of art which produces in spectators an effect of alienation is the object that a materialist aesthetics must seek to understand, i.e., produce concepts for.

The formalism of Brechtian aesthetics does not mark the limit of Althusser's analysis, however. His exposition of the alienation-effect as the outcome of poetic structures is succeeded by a concession to the obvious empirical fact (acknowledged earlier in the discussion of the audience's response to *El Nost Milan*) that spectators do experience variously 'projection, sublimation, etc.' (FM,148-9). Plays assuredly do evoke affective responses in audiences. Althusser's innovation, and his break with a classical aesthetics of representation, is to argue that the basis of

identification and affective behaviour in audiences is not primarily psychological, but social and ideological:

> Indeed, before (psychologically) identifying itself with the hero, the spectatorial consciousness recognizes itself in the ideological content of the play, and in the forms characteristic of this content. Before becoming the occasion for an identification (an identification with self in the species of another), the performance is, fundamentally, the occasion for a cultural and ideological recognition. This self-recognition presupposes as its principle an essential identity (which makes the processes of psychological identification themselves possible, in so far as they are psychological): the identity uniting the spectators and actors assembled in the same place on the same evening. Yes, we are first united by an institution — the performance, but more deeply, by the same myths, the same themes, that govern us without our consent, by the same spontaneously lived ideology. (FM,149-50)

The spectator recognizes herself in the characters of the drama in the first instance because she shares their ideology; the materials out of which the drama has been constructed, including the convention of identification with the protagonist, guarantee the operation of this self-recognition on the part of the spectator, and thus her participation in the action of the play.[11] If, as Althusser says elsewhere, 'ideology interpellates individuals as subjects' (ISA,170), then the individuals who file into the theatre become the subjects of the dramatic performance by responding to the call that the ideology of the play, its characters, their emotions, the actions they undertake and suffer, sends out to them. This spontaneous ideology of dramatic performance and the specific ideologies that constitute particular works of art together produce the subject of dramatic spectatorship.

11. Althusser understands perfectly well that it is, on occasion and under quite specific circumstances, possible to refuse the call of this or that particular ideology. The goal of ideology is to make subjects 'work all by themselves', but the mechanisms of ideological interpellation are constantly traversed by forces and influenced by conditions that are not necessarily in concert with the ideology: 'in the theatrical world, as in the aesthetic world more generally, ideology is always in essence the site of a competition and a struggle in which the sound and fury of humanity's political and social struggles is faintly or sharply echoed' (FM,149). One cannot, absent this notion of the contingent power of any specific ideology to interpellate subjects successfully, account for the different responses to the same production of *El Nost Milan* of the audience and the critics. The failure in aesthetic appreciation among the critics, their inability to 'perceive' what is 'there' before their eyes, is explicable in ideological terms: i.e., their particular ideology, what determines them to be the bourgeois theatre critics they are, prevents their

So formulated, nothing would distinguish Brechtian aesthetics from the classical theatre against which Brecht himself continually railed. Althusser goes on to suggest, however, a further dimension of Brechtian drama which exceeds the traditional concept of spectatorship as simple identification, and which locates the specificity of its aesthetic effect in the transformatory power of the dramatic action. Far from remaining within the ideological universe of the characters and their world, the audience at a Brecht play is thrust forward onto a new ideological terrain. If the initial premise of the play rests on the spectator's self-recognition of her position inside the world of the play, its ultimate outcome, which is an effect of its dramatic structure, is to produce a new subject that is no longer the subject of dramatic spectatorship:

> The play itself *is* the spectator's consciousness — for the essential reason that the spectator has no other consciousness than the consent which unites him to the play itself: the new result which the play *produces* from the self-recognition whose image and presence it is ... '[The] play is really the development, the production of a new consciousness in the spectator — incomplete, like any other consciousness, but moved by this incompletion itself, this distance achieved, this inexhaustible work of criticism in action; the play is really the production of a new spectator, an actor who starts where the performance ends, who only starts so as to complete it, but in life. (FM,150-1; emphasis in the original)

On Althusser's account, the ideological power of Brechtian drama resides precisely in its aesthetic distantiation of existing ideologies, its production of dissonance between its ideological materials and the development those materials undergo in the action of the play. A Brecht play is a certain product of ideology, but it is, as well, the production of a new ideology. Its ideological efficacy results precisely from the specificity of its aesthetic presentation. The

recognizing the structure of the play. The critics are in much the same position in relation to the play as were Smith, Ricardo et al. when confronted by the mystery of value production in capitalism (see the passage previously cited; RC,21). The audience, who saw things differently according to Althusser, were on the way to achieving a knowledge of the phenomena presented in the play comparable to that which Marx attained in his scientific exposition of the capitalist mode of production; they had 'heard the silences' in the play's discourse. Althusser's analysis of Strehler's production, coupled with his elaboration of the theoretical problems it raises when considered in the light of Brecht's major plays, pushes this recognition several steps further towards the production of the requisite epistemological break that will enable the materialist science of art to come into being.

aesthetic dimension of a work of art is the means by which it interpellates individuals as subjects, the basis of its 'quite particular and specific relationship with ideology' (LP,221).

Let us summarize the lineaments of the Althusserian concept of art we have been able to piece together up to this point. To begin with, Althusser's understanding of the specificity of the aesthetic depends upon the relations between art and ideology. As we have seen, these relations are ambiguous, admitting of different explanations depending upon the moment at which the work of art is encountered and the level of specificity at which it is considered. Both ideology and art present the 'lived experience' of a particular social formation at a given moment in history, albeit in distinct ways. The mode of presentation in art is perceptual or phenomenal: in it we see and feel the lived experience of ideology. Ideology thus appears in aesthetic presentation, but at a distance. The presentation of ideology in art places the reader or spectator, for the moment and within the context of the work's ideological materials, outside the particular ideology or ideologies being presented. The work of art thus allows for the recognition of ideology and sets the reader or spectator on the road towards understanding its nature, purview, and provenance. This road culminates in scientific knowledge, the explanation of the lived experience of ideology by concepts. Art itself is in turn subject to description in science. Aesthetics would be that discipline which gives us knowledge of art by concepts. The Althusserian science of art commences by giving the concept which would correspond to the phenomenon of the alienation-effect, since this effect is that which distinguishes the purely ideological from the aesthetic. (Subjects are not alienated from ideology; on the contrary, they are precisely interpellated by it.) But the alienation-effect can also serve as a means for ideological interpellation, so that the work of art can therefore be said to function in two different ways: as the distantiation of ideological materials and as the production of a new ideology. Here again, art is an object for investigation in a science — or sciences, since both the science of art and the theory of ideology would be involved in the investigation of aesthetic phenomena at this level.

We have moved into the realm of another distinction which is equally decisive to that between ideology and art: the distinction between art and science. On one level, art and science present the same object — e.g., 'lived experience'. We can loosely analogize the presentation of real objects in art with their description in science by saying that, in a certain sense, both the aesthetic and the

scientific presentation of real objects produce knowledge — with the proviso that the term 'knowledge' means different things in aesthetic presentation than it does in science. On a second level, that of aesthetics considered as a theoretical discipline, art is the real object which is investigated by the science particular to it. This is the limit of our exposition of Althusser to this point.

If we push our investigation one step further, however, we move to that level occupied by what Althusser once called Theory and identified with the traditional activity of Marxist philosophy: i.e., dialectical materialism. We are of course mindful of the shift away from this level in the Althusserian research programme, of Althusser's self-criticism of the 'theoreticism' it ostensibly instantiated, in short, the consensus that the enterprise of Theory itself is politically suspect as well as methodologically unsound. But perhaps for once we must deviate from the apparent letter of the Althusserian text. We must take him up, not where he left off, but in another place, or places, where his project speaks in ways that neither Theory nor the ideological class struggle would authorize. We shall in short, re-open the Althusserian inquiry into the mode of production of knowledges, but we shall do so on a different terrain from that on which he pursued his own inquiry into this question. To proceed thus is, we believe, to follow the example his own project has set.[12]

* * * * * * * * * *

12. We refer to the following passage from near the beginning of 'On the Materialist Dialectic': 'Any theoretical practice uses among other means knowledges which intervene as procedures: either knowledges borrowed from outside, from existing sciences, or "knowledges" produced by the technical practice itself in pursuance of its ends. In every case, the relation between technique and knowledge is an *external*, unreflected relation, radically different from the internal, reflected relation between a science and its knowledges. It is this exteriority which justifies Lenin's thesis of the necessity to *import* Marxist theory into the spontaneous political practice of the working class. Left to itself, a spontaneous (technical) practice produces only the "theory" it needs as a means to produce the ends assigned to it: this theory is never more than the reflection of this end, uncriticized, unknown, in its means of realization, that is, it is a *by-product* of the reflection of the technical practice's end on its means. A "theory" which does not question the end whose *by-product* it is remains a prisoner of this end and of the "realities" which have imposed it as an end' (FM,171; emphasis in the original). That we ourselves are impelled to 'import' knowledges from a theoretical practice 'external' to philosophy in which the very notion of theory is itself suspect in the dominant ideology of the field, indicates both the persistence of the ideological problematic of the aesthetic and its tenuousness when it is brought into conjunction with the theoretical practices in more advanced fields. The resistance to theory in the philological and historical disciplines is a sure sign of the imminence of their ideological crisis.

The ostensible occasion for Althusser's essay, 'Cremonini, Painter of the Abstract', was the attribution to that painter's work of the label 'expressionism'. Althusser begins by asserting what the remainder of the essay will attempt to demonstrate: that the traditional categories of aesthetics, above all those of pleasure and displeasure which have provided the grounds for establishing the validity of judgments of taste since the 18th century, are grossly inappropriate to understanding the project and the achievement of Cremonini's work. Cremonini's paintings do not represent objects which might evoke feelings of pleasure and judgments of their beauty — or, alternatively, disgust and the judgment that they are ugly. Cremonini's paintings are not subject to such descriptions, nor are they intended to evoke these feelings, because they depict relations:

> Cremonini 'paints' the *relations* which bind the objects, places and times. Cremonini is a *painter of abstraction*. Not an abstract painter, 'painting' an absent, pure possibility in a new form and matter, but a painter of the real *abstract*, 'painting', in a sense we have to define, real relations (as relations they are necessarily *abstract*) between 'men' and their 'things'; or rather, to give the term its stronger sense, between 'things' and *their* 'men'. (LP,230; emphasis in the original)

Cremonini is not Kant's ideal artist of ornamental arabesques; his paintings have a determinate content. But that content is nothing to do with the 'objects' that appear on his canvases. Cremonini represents virtual objects that are the products of juxtaposed phenomenal forms within the art work — and, as we shall see in a moment, between the different works in Cremonini's entire *oeuvre*. Cremonini's paintings represent the real, but in a manner that prevents their being grasped in an intuition. His paintings are not aesthetic representations in the traditional sense of the term. This accounts for their being misunderstood by conventional art critics.

Althusser's exposition of Cremonini's works commences with their history, i.e., with the development of Cremonini's artistic project as it can be reconstructed from the genealogy of his paintings. Althusser asserts that the paintings were constructed from within an ideological project evident in the sequence of subjects the painter chose: the geological, the vegetable, the animal, and finally the human. This humanist ideology of history, the ascending order of complexity in the history of things, demarcated the space in which Cremonini's project could emerge.

In other terms, the humanist ideology of history gave to Cremonini the *problematic* for his art. The project, however, became something totally different in its result. Cremonini may have intended that his sequence would exhibit similarities in form among the four orders, and thus that they could be assimilated in a teleological scheme of the emergence of consciousness from the brute facticity of nature — that they could, in sum, present the *Phenomenology of Mind* in painting. But what emerged in the paintings themselves was the 'quite different logic ... of the *differences* which Cremonini has constantly "painted", foremost among them, the *difference from this ideological project of the descent of forms*' (LP,233-4; emphasis in the original). As Althusser goes on to remark, the full significance of this turn away from the ideological project that motivated the sequence becomes apparent in the final stage of Cremonini's work to date: his paintings of human beings and, most particularly, in the depiction of 'the *relations* between the men' (LP,234; emphasis in the original).

The most recent paintings are dominated by two opposing figural systems. On the one hand, there are the mirrors, those circular forms which are the sign of and the means for relating the human figures in the portraits to the non-human objects: 'The circles of the mirrors "depict" the fact that the objects and their forms, though related among themselves, are only so related because they turn in the same circle, because they are subject to the same law, which now "visibly" dominates the relations between the objects and their men' (LP,235). The mirrors represent the 'circle of *ideological* existence' (LP,236; emphasis in the original). Athwart the mirrors and juxtaposed against their circularity stands another set of forms that Althusser identifies in the '*tall vertical lines*' and claims they pit against human lives 'the *weight* of matter' (LP,235; emphasis in the original). The secret of Cremonini's paintings lies in their representation of these two contradictory subjects, which are no longer quite objects in the sense that one could identify them as things in the world. The mirrors are not there to represent mirrors, but to signify the mirroring process of ideological representation; the vertical forms which appear as doors, windows, partitions, and walls break up the surface of the painting and suggest that there remains a final determining instance which cannot be mastered in the mirroring representations of ideological reflection. Out of this conflict between the ideological and the material emerges the projection of a '*determinate absence*' (LP,236; emphasis in the original), the

structure of relations that unites men with matter. Cremonini's paintings are the visible traces of this structure, the phenomenal manifestation of its effects.

It should be clear by now that the itinerary Althusser has followed in interpreting Cremonini's paintings is hardly unique to this subject. The conceptual apparatus deployed in the analysis of aesthetic objects, even the very terminology that is occasionally used (determinate in the last instance, visible in its effects), was first developed by Althusser to describe a quite different object: to wit, the Marxist theory of society as it is tacitly presented in Marx's mature texts. Even the genealogical account of Cremonini's career can be seen to conform to a familiar pattern in Althusserian thought: the emergence of a scientific problematic from out of the ideological problematic which constitutes its pre-history. The 'break' in Cremonini's work obviously comes with his turn to the human. The mature 'scientific' works emerge with his depiction of the abstract that is devoid of all naturalistic (i.e., ideological) content. The clear sign of this emergence of abstraction in the structures of his painting can be seen in the deformation of human faces in his most recent work:

> ... Cremonini's human faces are not expressionist, for they are characterized not by deformity but by *deformation*: their deformation is merely a determinate absence of form, a 'depiction' of their anonymity, and it is this anonymity that constitutes the actual cancellation of the categories of the humanist ideology ... If these faces are 'inexpressive,' since they have not been individualized in the ideological form of identifiable subjects, it is because they are not the expression of their 'souls', but the expression, if you like (but this term is inadequate, it would be better to say the *structural effect*) of an absence, visible in them, the absence of the structural relations which govern their world, their gestures and even their experience of freedom.
>
> All of 'man' is certainly present in Cremonini's work, but precisely because *it is not there*, because its double (negative, positive) absence is its very existence. That is why his painting is profoundly anti-humanist, and materialist. (LP,238-9; emphasis in the original)

Cremonini has effectively reproduced the epistemological break first achieved by Marx for the materialist concept of history. Cremonini has reopened the exploration of this continent, but from a different point of entry than the economy. Althusser is perfectly explicit about this comparison of the 'knowledges' produced by these two otherwise distinct practices:

We cannot 'recognize' [*reconnaître*] ourselves (ideologically) in his pictures. And it is because we cannot 'recognize' [*reconnaître*] ourselves in them that we can *know* [*connaître*] ourselves in them, in the specific form provided by art, here, by painting ... Cremonini thus follows the path which was opened up to men by the great revolutionary thinkers who understood that the freedom of men is not achieved by the complacency of its ideological *recognition* [*reconnaissance*], but by *knowledge* [*connaissance*] of the laws of their slavery, and that the 'realization' of their concrete individuality is achieved by the analysis and mastery of the abstract relations which govern them. In his own way, at his own level, with his own means, and in the element, not of philosophy or science, but of painting, Cremonini has taken the same road. (LP, 240-1; emphasis in the original)[13]

If it is the hallmark of scientific discourse to depict the world by means of concepts, then by painting abstractions, Cremonini has given phenomenal representation to the concepts of science. His paintings present a means for producing knowledge of the world. Perhaps more so even than Brecht's plays or Balzac's novels (to cite but two famous instances that have, in the Marxist tradition, been judged as art which transcends the limits of its immediate ideological determination), Cremonini's art is not to be 'ranked among the ideologies'. Whatever the possibilities for ideological appropriation which remain to menace the epistemological rigour of aesthetic practice (Althusser is entirely lucid on this point; see LP, 241-2), they are not more dangerous or in principle more prevalent in art than in science. The bad art of the *Proletkult* instances a similar ideological project to the mystical ideal of proletarian science. The goal of Althusser's theoretical work is to banish both from the discourse of historical materialism.

* * * * * * * * * *

Our exposition of the Althusserian theory of art has reached a peculiar pass, the more so since the trajectory of Althusser's own career went in just the opposite direction to the one we have been pursuing. Having in his early works staunchly defended the independence of theoretical practice from immediate political or ideological determination, Althusser tended increasingly in his post-1968 works to give ground and to concede the irreducibly

13. The French text of Althusser's essay, which originally appeared in *Démocratie Nouvelle* (1966), is also available in *Leonardo Cremonini: Mostra antologica 1953-1969* (Bologna, n.d.), pp. 36-42; the passage cited occurs on p. 41.

political and ideological position of philosophy (the class struggle carried forward at the level of theory), as well as the possibility that the epistemological breaks which inaugurated the various empirical sciences were perhaps more vulnerable to ideological reversal than he had once believed. Our own itinerary would seem to have reversed this trajectory, reproducing that very 'theoreticism' which Althusser himself was the first to recognize and to denounce in his earlier works. Most of all, Althusser was to become highly suspicious of the method of knowledge production in the historical sciences that he himself had advanced in *Reading Capital*. That text in particular seems most plagued by what Alex Callinicos once labelled Althusser's 'epistemological blues'.

We cannot pretend, in a work that, however much it has owed to Althusser and however often it has invoked his terminology, is nonetheless not a fully realized exposition and assessment of his work, to resolve completely the problems which the Althusserian hypostatization of theoretical practice and its relation to aesthetic practice can be seen to pose. We must be content here merely to suggest the moment of possible articulation in the Althusserian corpus between aesthetic representation and the production of scientific knowledge, and to project from this moment some of the consequences for a materialist inquiry into the history of aesthetic production. The equally important implications that this area of difficulty presents for the philosophy of science will have to be left to another occasion and to other inquiries than the present one, which has only ever aimed at a preliminary clarification of terms in the relations between aesthetics and ideology. If this much can be accomplished, we will have effectively settled accounts with historical materialism's erstwhile philosophical conscience.

At this comparatively late hour, no particular justification is required to assert that Althusser's signal contribution to Marxist theory hinges on the concept of structural causality. He has been both heralded and vilified often enough on this account to make further praise or blame superfluous.[14] Althusser himself was under no illusions about the decisiveness of this concept for his

14. See, *inter alia*, E.P. Thompson, *The Poverty of Theory and Other Essays* (New York, 1978), André Glucksmann, 'A Ventriloquist Structuralism', in *Western Marxism: A Critical Reader,* ed. New Left Review (London, 1977), pp. 302-8, and Alex Callinicos, *Is There a Future for Marxism?* (Atlantic Highlands, 1982), pp. 121-2, for the negative view; Erik Olin Wright, *Class, Crisis and the State* (London, 1978), pp. 12-26, Fredric Jameson, *The Political Unconscious* (Ithaca, 1981), p. 23-58, and Gregory Elliott, 'Louis Althusser and the Politics of Theory', pp. 157-65, for sympathetic expositions.

exposition of Marx. Near the end of his contribution to *Lire le Capital*, he identifies the central methodological problem that founds Marx's scientific theory of history and marks a definitive break with the problematic of classical political economy: the practical realization which enabled the writing of *Capital* was '*the determination of the elements of a structure, and the structual relations between those elements, and all the effects of those relations, by the effectivity of that structure*' (RC,186; emphasis in the original). The basis for Marx's 'immense theoretical revolution' is nowhere named or rigorously defined in his extant corpus, but it operates all the same as the conceptual armature for the empirical scientific analyses of the capitalist mode of production which, on Althusser's account, remain Marx's most important achievement for the foundations of historical materialism. Althusser's project, having recognized the existence of the concept in Marx, is to give it a name, structural causality, and to elaborate on its pertinence to the Marxist theory of history. The exposition of structural causality (and its distinction from linear and expressive causality) is familiar enough not to require full treatment here. Althusser himself draws attention to his previous attempt to think this concept in the notion of overdetermination (RC,188). In this context, however, he is eager to give it a somewhat different provenance, one not unrelated to the problematic of psychoanalysis to which he had earlier appealed, but nonetheless differently situated in the domain of possible epistemological systems. Althusser's summary judgment is as follows: '[Marx's epistemological innovation] can be entirely summed up in the concept of "*Darstellung*", the key epistemological concept of the whole Marxist theory of value, the concept whose object is precisely to designate the mode of *presence* of the structure in its *effects*, and therefore to designate structural causality itself' (RC,188; emphasis in the original).

In the English translation of this text, and in the 1968 edition of *Lire le Capital* on which the translation is based, the identification of *Darstellung* as the key concept in Marx's epistemology is glossed over lightly and is succeeded by a precising of the phrase 'immanent in its effects' (RC,188-9). But in the original edition published in 1965, the passage just quoted is succeeded by two lengthy paragraphs in which *Darstellung* is explained and elaborated. The excision of these paragraphs (whatever may have been Althusser's reasons for doing so) obscures not only the provenance of the concept (which in the 1968 version is referred solely to psychoanalysis in a footnote citing an essay by Jacques-

Alain Miller on Lacan), but also the theoretical domain it establishes for historical materialism. This domain, which is undoubtedly that of the social, is yet grounded in a set of concepts, a problematic, that is not exclusively political or economic. It is the domain of the aesthetic as a general epistemological category which, as Kant was perhaps the first to recognize, offers to bridge the gap between the precepts of practical being and the principles of rational understanding. That Althusser should appeal to just such a problematic at this point in his argument can scarcely have been fortuitous.

The burden of the excised passage is to give an exact description of the mode of existence of the structure. Some pages later, Althusser will appeal once more to the concept of *Darstellung*. In a passage that remained unaltered between 1965 and 1968, he invokes the figure of theatrical production, staging (*mise en scène*), to account for the immanence of the structure in its effects (RC,193). In 1965, he had referred the reader in a note to his essay on Bertolazzi and Brecht, and to the expression there employed to indicate the 'latent structure' that governs, in its absence, the action of Bertolazzi's play: the two temporalities which exist simultaneously in presentation without affecting each other directly are united by what Althusser had termed the 'dialectic in the wings'.[15] The theatrical metaphor, which is provocative enough in its intercalation of Marx's epistemology with the discourse of poetics, nevertheless fails to capture the full epistemological complexity brought out by Althusser's commentary on *Darstellung*. For the emphasis in the metaphor of the drama falls upon the relationship between the poetic structure and the actions of the players who are 'caught by the constraints of a script and parts whose authors they cannot be, since it is in essence *an authorless theatre*' (RC,193; emphasis in the original). The metaphor glosses Althusser's old assertion that human beings are, from the point of view of historical science, bearers of structures that determine the limits of their power to act as agents of history. So construed, the text or script of history (the absent structure which never ceases to act upon the human agents whose roles it determines) is, as it were, already written in advance and is, per definition, imposed upon the actors from outside the theatre. No matter that no one (God, the World Spirit, Reason, the iron laws of the economy) can be said to have written the script down; its existence prior to the performance is the necessary

15. Louis Althusser, et al., *Lire le Capital*, t. II (Paris, 1965), p. 171.

presupposition of the dramatic metaphor. The actors will not be allowed to improvise their parts. One sees why voluntarists like Edward Thompson and Norman Geras would find this scenario offensive.

Less offensive, perhaps, is Althusser's first and more extensive exposition of the concept of *Darstellung* which does full justice to the immanence of the structure in its effects and thus largely removes the stigma of determinism that has branded Althusser's writings from the first and allowed them, however unjustly, to be consigned to the mausoleum of Stalinist ideology. The commentary proceeds as follows:

> '*Darstellung*' signifies in German, among other things, *theatrical representation*, but the figure of theatrical representation adheres immediately to the sense conveyed by the word that signifies 'presentation,' 'exhibition,' and, in its most profound root, 'position of presence,' presence offered and visible. In order to express its specific nuance, it may be instructive to oppose '*Darstellung*' to '*Vorstellung*'. In *Vorstellung*, one certainly has to do with a position, but one which is presented *out front*, which thus supposes something which is kept *behind* this pre-position, something which is *represented* by that which is kept out front, [represented] by its emissary: the *Vorstellung*. *In Darstellung on the contrary, there is nothing behind*: the very thing is there, '*da*,' presented [*offerte*] in the position of presence. The entire text of a play is thus there, presented [*offert*] in the presence of the representation (the *Darstellung*). But the presence of the entire play is not exhausted in the immediacy of the deeds or the words of the character: we 'know' that it is the presence of a completed whole which lives in each moment and in each character, and in all the relations among the characters given in their personal presence. [It is] only to be grasped, however, as the presence of the whole, as the latent structure of the whole, *in the whole,* and only intuited [*pressentie*] in each element and in each role.[16]

From the point of view of aesthetic presentation, the text of history is not written out in advance. While the metaphor of theatrical production can take us a certain distance towards understanding the immanence of the structure in its effects, and can indeed provide a useful model for the disciplined inquiry into the nature of literary artifacts we call poetics,[17] it fails finally to encompass that possibility for changing the script of history which remains

16. Ibid., p. 170; emphasis in the original; my translation.
17. See, for example, Terry Eagleton, *Criticism and Ideology* (London, 1976), pp. 64-76.

the ultimate goal of revolutionary socialism. On another reading of the model of *Darstellung*, there really is nothing outside the text of history, nothing before or behind or beneath its presentational structure that might, if we dig deep enough, let us in on the secret. In the theory of historical materialism, the *fort* is ever always and already *da*.[18]

Kant proposed as the distinctive manner of making aesthetic judgments their subsumption of the particular under the universal when only the particular is given and the universal is that which must be discovered. Putting aside the dubious uses to which Kant himself put this principle in his own conception of how empirical science must proceed, we can nonetheless recognize how Althusser supposes just this sort of reflective judgment in grounding his epistemology in the apprehension of the structure in its immanence. The Althusserian/Marxist science of the history of social formations is not logico-deductive, but empirico-abductive.[19] It proceeds less in the manner of a programmed machine than like an organized being confronted continually by novel environmental situations. Its conclusions are only ever provisional, its hypotheses always open to revision. Its motto is the following: 'just as there is no production in general there is no history in general, but only specific structures of historicity ...' (RC,108). To say that the purposive wholes which historical science constructs (modes of production) are regulative categories for which precise equivalents are nowhere observable in reality is no more an impediment to the continued progress of the science than is the non-observability of an ideally competent native speaker of any natural language to generative grammar. One can hardly say that since the data indicate there has never been a pure instance of a capitalist social formation (not even Holland in the 17th century), therefore capitalism does not exist. Nor is it clear in the

18. Our exposition of *Darstellung* thus differs from the accounts in Glucksmann and Callinicos (see above, n. 12). The latter's case against Althusser's supposed 'ideologism' is fatally compromised in its conceptualization of *Darstellung*, which fails to register the two distinct senses of the term illuminated in the passage we have cited from the 1965 text of *Lire le Capital*. A more fruitful exposition of *Darstellung* that is properly attentive to the theoretical import of the concept in relation to *Vorstellung* can be found in Andrezej Warminski's discussion of the operation of these two terms in the texts of Hegel; see his 'Pre-positional By-play', *Glyph* 3 (1978): 105-6.

19. The reading of Althusser proposed here is therefore diametrically opposite to the use made of his work in standard sociological accounts of the relationship between theory formation and the investigation of empirical phenomena; cf. Wright, *Class, Crisis and the State*, pp. 25-6.

present state of empirical research whether the long-term tendency of the rate of profit is to fall or not. To determine that would require, as Ernest Mandel once remarked, a considerable broadening of the available data base to include the financial records of the transnational corporations whose real rates of profit remain a well-guarded secret. At least we know that capitalists exist![20]

To hazard some provisional conclusions of our own. If the structure really is immanent in its effects, if it may be 'intuited in each element and in each role', we have no reason to suppose that investigations of works of art, or historical ideologies, or any other empirically present phenomena will not yield considerable insight into the structures of a given social formation or a particular epoch. Marxist science is premised upon the hypothesis that in the last instance it is the economy which determines the structure, but, as Althusser reminds us, 'the lonely hour of the "last instance" never comes' (FM,113). Nothing in Althusser's programme for historical research would preclude the provisional construction of a model for a given society in a particular period from the evidence of its cultural artifacts. Not that the artifacts themselves will immediately disclose the 'truth' of their existence, i.e., the structure of society that determines them. But the scientific analysis of a sufficiently broad range of works of art can yield preliminary hypotheses about the nature and operation of the structure. Such an analysis can set one on the road towards a fully scientific account of the given phenomena in relation to the structure of the social whole of which they are an instance. Althusser's own essay on the paintings of Cremonini, while it may have benefited from a prior construction of a concept of the social whole which the paintings could be seen to illustrate or exemplify, nevertheless proceeds in an exemplary Kantian manner to construct the general principle of the paintings' structure from the particular data of their phenomenal manifestation. The

20. We hasten to add that the operation of a structural law does not depend upon empirical confirmation; a law may remain unconfirmed by available data indefinitely and still be working. The effects of the law will always be visible, of course, although not necessarily in a form that points to the law itself. Our only claim here is that empirical hypotheses (like the tendency of the rate of profit to fall) may be subject to confirmation once adequate data are made available. Confirmation or disconfirmation of hyptheses is not, *pace* Popper, a matter of apodictic principles of proof. One can never know what the conditions for testing and hypothesis formation will be in a given case. We are left, in historical materialism as in any empirical science, to infer the best explanation of a phenomenon on the basis of the axioms and postulates in force at the moment.

abstraction of capitalist relations of production may be the regulative category pointing the way towards Althusser's discovery of incommensurable formal features in Cremonini's work, but the persuasiveness of his exegesis depends ultimately on the degree to which the evidence can be made to fit the theory, and that is something which cannot be procedurally dictated in detail or in advance. That the structure of the social whole is precisely overdetermined necessitates the investigation of the different instances in their specificity, for it is by no means certain whether each instance is running along its historical trajectory at the same or at a different speed from the other instances in a social formation. The blindness of the ordinary viewer of Cremonini's paintings to their real significance suggests that those paintings are themselves in advance of the contemporary ideology of art which, on this evidence, would seem to be relatively 'backward' in relation to the aesthetic practice which it must try to explain, as well as in relation to the available theory (historical materialism) for establishing its own practice.

Similarly, were one to undertake an investigation of the formal structures of high bourgeois modernism across a range of cultures and historical periods (from its origins in France, England, and Germany, through its efflorescence in the international moment of the Anglo-American imperium, and down finally to its after-image in the major fiction of the contemporary Third World), it would be possible, in principle, to draw from this study the lineaments of the capitalist mode of production as it is lived and presented in the ideological experience, not only of the bourgeoisie itself, but also among its parasites and imitators, possibly even among its gravediggers. One thinks, for example, of Peter Weiss's massive work, *The Aesthetics of Resistance*, or of the Russian Constructivists' appropriation of the techniques of analytical cubism in the service of creating a popular revolutionary art. It might even be possible to advance a theory of capitalist production which could account for what remains one of the most puzzling difficulties confronting the project of Marxist historical science: to wit, the enormous vitality and considerable recuperative powers of capitalism, its capacity to endure successive shock waves of crisis and to reemerge more or less intact and with renewed accumulative capacities. Fashionable hypotheses about the degeneration of contemporary culture and the lack of originality that is built into the very structure of postmodernist art notwithstanding, it would seem that no epoch in history has been more aesthetically productive than our own. This is the particular

intuition with which we could begin; to find the general principle under which it could be subsumed would be the task of reflective judgment. In calling such a judgment aesthetic, we do not deprive it of any epistemological rigour or critical force. The time when such an ideology of art could hold unchallenged sway over the theory of historical materialism seems now to have passed.

Index